AFRICAN ART IN THE CYCLE OF LIFE

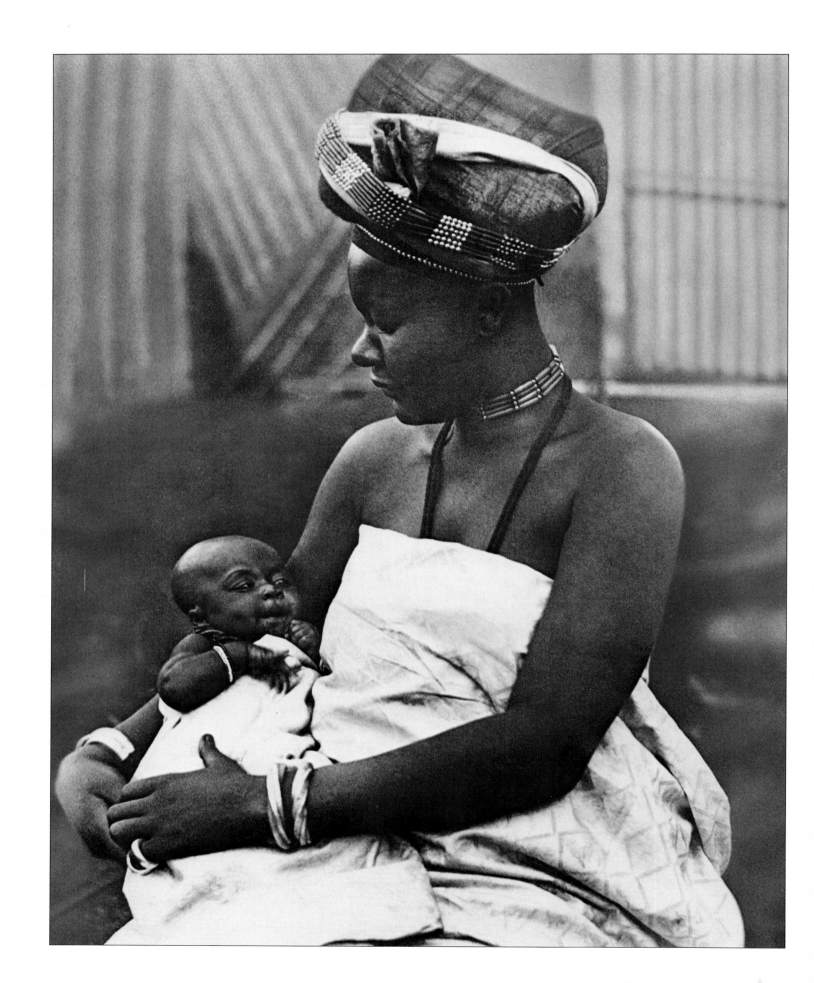

National Museum of African Art

AFRICAN ART IN THE CYCLE OF LIFE

Roy Sieber and Roslyn Adele Walker

Published for the National Museum of African Art
by the Smithsonian Institution Press

Washington, D.C., and London

This publication and the exhibition it accompanies
are supported by a generous grant from
the Morris and Gwendolyn Cafritz Foundation.

The exhibition is supported by an indemnity from the
Federal Council on the Arts and the Humanities.

This book is published in conjunction with an inaugural
exhibition, *African Art in the Cycle of Life,* organized
by the National Museum of African Art.
September 28, 1987–March 20, 1988

The paper used in this publication meets the minimum
requirements of the American National Standard for Permanence
of Paper for Printed Library Materials, Z39.48-1984.

Front cover: Maternity Group Figure, Afo peoples, Nigeria (cat. no. 8)
Frontispiece: Mother and child, Bamum Kingdom, Cameroon (fig. 8)
Back cover: Ancestor Memorial Screen, Kalabari group, Ijo peoples,
Abonnema village, Nigeria (cat. no. 77)

Text by Roy Sieber
Catalogue and Bibliography by Roslyn Adele Walker

Library of Congress Cataloging-in-Publication Data
Sieber, Roy, 1923–
African art in the cycle of life.
 "Published in conjunction with an inaugural exhibition, African
Art in the Cycle of Life, organized by the National Museum of
African Art, September 28, 1987–March 20, 1988"—T.p. verso.
 Bibliography: p.
 1. Sculpture, African—Africa, Sub-Saharan—Exhibitions. 2.
Sculpture, Primitive—Africa, Sub-Saharan—Exhibitions. 3. Art
and society—Africa, Sub-Saharan—Exhibitions. I. Walker, Roslyn
A. II. National Museum of African Art (U.S.). III. Title.
NB1091.65.S54 1987 732'.2'0967074153 87-20493
ISBN 0-87474-822-4 (alk. paper)
ISBN 0-87474-821-6 (pbk.: alk. paper)

CONTENTS

LENDERS TO THE EXHIBITION

Ernst Anspach
The Art Institute of Chicago
Trustees of the British Museum, London
The Brooklyn Museum
Cincinnati Art Museum
City of Antwerp, Etnografisch Museum
The Cleveland Museum of Art
Count Baudouin de Grunne, Belgium
Département de l'Afrique Noire, Laboratoire
 d'Ethnologie du Muséum National d'Histoire
 Naturelle (Musée de l'Homme), Paris
Detroit Institute of Arts
Norman and Shelly Mehlman Dinhofer
Harrison Eiteljorg Collection
Field Museum of Natural History, Chicago
André Fourquet
Murray and Barbara Frum
Marc and Denyse Ginzberg
Rita and John Grunwald
Horniman Museum, London
Indiana University Art Museum, Bloomington
Collection of Robert Jacobs
Collection of Amy and Elliot Lawrence
Linden-Museum Stuttgart
Drs. Daniel and Marian Malcolm
The Metropolitan Museum of Art, New York
The Minneapolis Institute of Arts

Mr. and Mrs. Alain de Monbrison
Musée national des Arts africains et océaniens, Paris
Museu de Etnologia, Lisbon
Museum Rietberg Zurich
Jack Naiman
The Trustees of the National Museums of Scotland,
 Edinburgh
The Nelson-Atkins Museum of Art, Kansas City,
 Missouri
Robert and Nancy Nooter
Peabody Museum of Archaeology and Ethnology,
 Harvard University, Cambridge
Rijksmuseum voor Volkenkunde, Leiden
Milton F. and Frieda Rosenthal
Royal Museum of Central Africa, Tervuren
Royal Ontario Museum, Toronto
Gustave and Franyo Schindler
Seattle Art Museum
Merton D. Simpson
Staatliches Museum für Völkerkunde, Munich
UCLA Museum of Cultural History
Ulmer Museum, Ulm
Virginia Museum of Fine Arts, Richmond
Collection Vranken-Hoet, Brussels
Raymond and Laura Wielgus
Patricia Withofs, London
Anonymous lenders

FOREWORD

The opening of the loan exhibition *African Art in the Cycle of Life* at the National Museum of African Art is an occasion for celebration as it heralds the inauguration of the museum's new building on the National Mall. It is also a time for reflection as we seek a better understanding of the creative impulse underlying African visual traditions and a deeper appreciation for the contribution of African cultures to mankind.

Since the 1950s, African art exhibitions in the United States have moved from the wings of relative obscurity to center stage. Art museums have had a major role in that development. They have been a catalyst for increased appreciation, research, and public involvement. They have sought international and interdisciplinary cooperation in an effort to unravel the cultural complexities that underlie African visual traditions. Museums have done so in the belief that one of the most enduring aspects of human genius is the ability to create images of extraordinary aesthetic power. It is in this context that this inaugural loan exhibition developed.

The universal theme of this exhibition was conceived by Roy Sieber, the museum's associate director of collections and research, and it was developed with him by Roslyn A. Walker, curator. It has been an extensive four-year project that has had the generous support of the Morris and Gwendolyn Cafritz Foundation for research planning, the accompanying catalogue, and the final installation. Every phase has also been enriched by the advice and help of many others in museums, universities, governments, and the world of private collectors. Their contributions, as recognized in the list of lenders and in the Acknowledgments, have been of inestimable value. This exhibition is supported by an indemnity from the Federal Council on the Arts and the Humanities, which has made it possible for many treasured works of art to be lent from abroad.

The world of African art is a world of content and form. This exhibition has been conceived to bring the significance and perfection of that world a little closer for all of us.

Sylvia H. Williams
DIRECTOR

ACKNOWLEDGMENTS

Exhibitions and the publications that accompany them come to fruition through the cooperation and assistance of many people and institutions. We wish to thank the Morris and Gwendolyn Cafritz Foundation for the generous support that allowed us the opportunity to produce the *African Art in the Cycle of Life* exhibition and this catalogue.

We express our gratitude for the generous loans from the individuals who are indicated on the list of lenders, and we are indebted to many institutions that accommodated our requests for loans. We thank the following museum directors, curators, and governmental agencies: James N. Wood and Dr. Richard Townsend, The Art Institute of Chicago; Sir David Wilson, Malcolm D. McLeod, Dr. John Mack, and the Trustees of the British Museum, London; Robert T. Buck and Diana Fane, The Brooklyn Museum; Millard F. Rogers, Jr., Dr. Otto Thieme, and Dr. Christine Mullen Kreamer, Cincinnati Art Museum; Samuel Sachs II and Michael Kan, Detroit Institute of Arts; Dr. Adriaan Claerhout and Frank Herreman, Etnografisch Museum, City of Antwerp; Professor Jean Guiart and Francine Ndiaye, Laboratoire d'Ethnologie, Musée de l'Homme, Paris, and the Embassy of France, Washington, D.C., with special thanks to Pierre Collombert, counselor of cultural affairs; Dr. Phillip H. Lewis, Field Museum of Natural History, Chicago; David M. Boston and Keith Nicklin, Horniman Museum, London; Thomas T. Solley (retired), Pat Darish, and Diane Pelrine, Indiana University Art Museum, Bloomington; Professor Dr. Friedrich Kussmaul (retired) and Dr. Herman Forkl, Linden-Museum Stuttgart; Philippe de Montebello, Douglas Newton, and Dr. Kate Ezra, The Metropolitan Museum of Art, New York; Alan Shestack and Louise Lincoln, The Minneapolis Institute of Arts; Henri Marchal and Collette Noll, Musée national des Arts africains et océaniens, Paris; Professor A. Lima de Carvalho, Museu de Etnologia, Lisbon; Dr. Eberhard Fischer and Lorenz Homberger, Museum Rietberg Zurich; R. G. W. Anderson, Dale Idiens, and The Trustees of the National Museums of Scotland, Edinburgh; Marc F. Wilson and Dr. David Binkley, The Nelson-Atkins Museum of Art, Kansas City, Missouri; Dr. Roelof Munneke, Rijksmuseum voor Volkenkunde, Leiden; Huguette van Geluwe, Royal Museum of Central Africa, Tervuren; James Cruise and Dr. Edward Rogers, Royal Ontario Museum, Toronto; Jay Gates and Pamela McClusky, Seattle Art Museum; Dr Walter Raunig and Dr. Maria Kecskési, Staatliches Museum für Völkerkunde, Munich; Doran Ross, UCLA Museum of Cultural History; Dr. Erin Treu and Dr. Brigitte Kühn, Ulmer Museum, Ulm; and Paul Perrot and Richard Woodward, Virginia Museum of Fine Arts, Richmond. We are indebted to Alice Martin Whelihan, indemnity administrator for the Museum Program of the National Endowment for the Arts.

In addition, we express our thanks to the following colleagues, scholars, collectors, and art dealers who assisted us in many ways: Pierre Dartevelle, Emile and Lin Deletaille, Louis de Strycker, Marc Leo Felix, Jean-Pierre and Anne Jernander, and Jean Willy Mestach, Brussels; Jacques Kerchache and Josette Nicaud, Paris; Professor Friedrich J. Gronstedt, Bad Homburg; Dr. Hans-Joachim Koloss and Dr. Angelika Rumpf Tunis, Museum für Völkerkunde, Berlin (Dahlem); Dr. Gisela Völger and Dr. Klaus Volprecht, Rautenstrauch Joest-Museum für Völkerkunde, Cologne; Professor Dr. Josef-Franz Thiel and Dr. Johanna Agthe, Museum für Völkerkunde, Frankfurt; Dr. Klaus Born, Reiss Museum, Mannheim; Dr. Jean-Loup Rousselot, Staatliches Museum für Völkerkunde, Munich; Dr. Erna Beumers, Museum voor Land-en Volkenkunde, Rotterdam; Harry Leyten, Tropenmuseum, Amsterdam; Dr. O. M. Njikom, Nigerian National Museum, Lagos; Dr. Renée Boser-Sarivaxévanis (retired) and Dr. Bernard Gardi, Museum für Völkerkunde, Basel; Udo Horstmann, Zug, Switzerland; Richard M. Foster and Yvonne Schulmann, National Museum of Liverpool; Hermione Waterfield and William Fagg, Christie's, London; Frank Willett, Hunterian Museum, Glasgow; Alan Brandt; Eli Bentor, Indiana University; Dr. Herbert Cole, University of California, Santa Barbara; David Crownover; Nina Cummings, Field Museum of Natural History, Chicago; Dr. Warren d'Azevedo, University of Nevada, Reno; Dr. Ivan Karp and Dr. Mary Jo Arnoldi, National Museum of Natural History, Smithsonian Institution; Embassy of the Federal Republic of Germany, Washington, D.C., with special thanks to Eleonore Linsmayer, cultural counselor; Ambassador and Mrs. John Loughran; Donald Morris; Dr. Arnold Rubin, University of California, Los Angeles; and William Rubin, Museum of Modern Art, New York.

We are indebted to Sylvia Williams, director of the National Museum of African Art, and the museum's staff and extend special thanks to Dean Trackman, editor, who was ably assisted by Andrea Merrill and Nancy I. Nooter; Richard Franklin, chief of design, and his staff; Christopher Jones, graphic designer; Dr. Philip Ravenhill, Bryna Freyer, Dr. Andrea Nicolls, Lydia Puccinelli, and Tujuanna Evans of the curatorial staff; Janet M. Stanley, librarian; Judith Luskey and Brenda Chalfin, Eliot Elisofon Photographic Archives; and Warren M. Robbins, founder and director emeritus. We also thank Dr. Christraud Geary, Rockefeller fellow at the National Museum of African Art; Smithsonian volunteers Hythema Jones and Monika Currothers; and curatorial interns Sherrie Bryant and Marie Durquet.

Finally, we thank our families, especially Jim Etta Lee, Sophie Sieber, and Ellen Sieber, for their assistance and moral support.

Ethnic Groups and Sites

1. Afo *(Nigeria)*
2. Asante *(Ghana)*
3. Baga *(Guinea)*
4. Bamana *(Mali)*
5. Bamileke *(Cameroon)*
6. Bande, also Gbande *(Liberia)*
7. Baule *(Côte d'Ivoire)*
8. Boa *(Zaire)*
9. Bondoukou region *(Côte d'Ivoire, Ghana)*
10. Buye *(Zaire)*
11. Chokwe *(Angola, Zaire)*
12. Dan *(Liberia, Côte d'Ivoire)*
13. Dogon *(Mali)*
14. Edo, Benin Kingdom *(Nigeria)*
15. Fang *(Cameroon and Gabon)*
16. Gola *(Liberia, Sierra Leone)*
17. Guro *(Côte d'Ivoire)*
18. Hehe *(Tanzania)*
19. Hemba *(Zaire)*
20. Hongwe *(Gabon)*
21. Ibibio *(Nigeria)*
22. Igbo *(Nigeria)*
23. Ijo *(Nigeria)*
24. Inland delta region *(Mali)*
25. Kissi *(Sierra Leone, Liberia, Guinea)*
26. Kongo *(Congo, Zaire, Angola)*
27. Kuba, Bushoong Kingdom *(Zaire)*
28. Kwele *(Congo)*
29. Lega *(Zaire)*
30. Lobi *(Burkina Faso, Côte d'Ivoire, Ghana)*
31. Luba *(Zaire)*
32. Lulua *(Zaire)*
33. Lumbo *(Gabon)*
34. Makonde *(Tanzania, Mozambique)*
35. Mangbetu *(Zaire)*
36. Mbole *(Zaire)*
37. Mende *(Sierra Leone)*
38. Mijikenda *(Kenya)*
39. Montol *(Nigeria)*
40. Mumuye *(Nigeria)*
41. Nalu *(Guinea)*
42. Nharo San *(Botswana)*
43. Nok style area *(Nigeria)*
44. Omdurman *(city in Sudan)*
45. Pende *(Zaire)*
46. Punu *(Gabon)*
47. Sakalava *(Madagascar)*
48. Senufo *(Côte d'Ivoire, Mali)*
49. Sherbro *(Sierra Leone)*
50. Songo *(Angola)*
51. Songye *(Zaire)*
52. Suku *(Zaire)*
53. Toma, also Loma *(Liberia)*
54. Vai *(Liberia, Sierra Leone)*
55. Wee, also Guere *(Liberia, Côte d'Ivoire)*
56. Yoruba *(Nigeria, Benin)*
57. Zande *(Zaire, Sudan)*

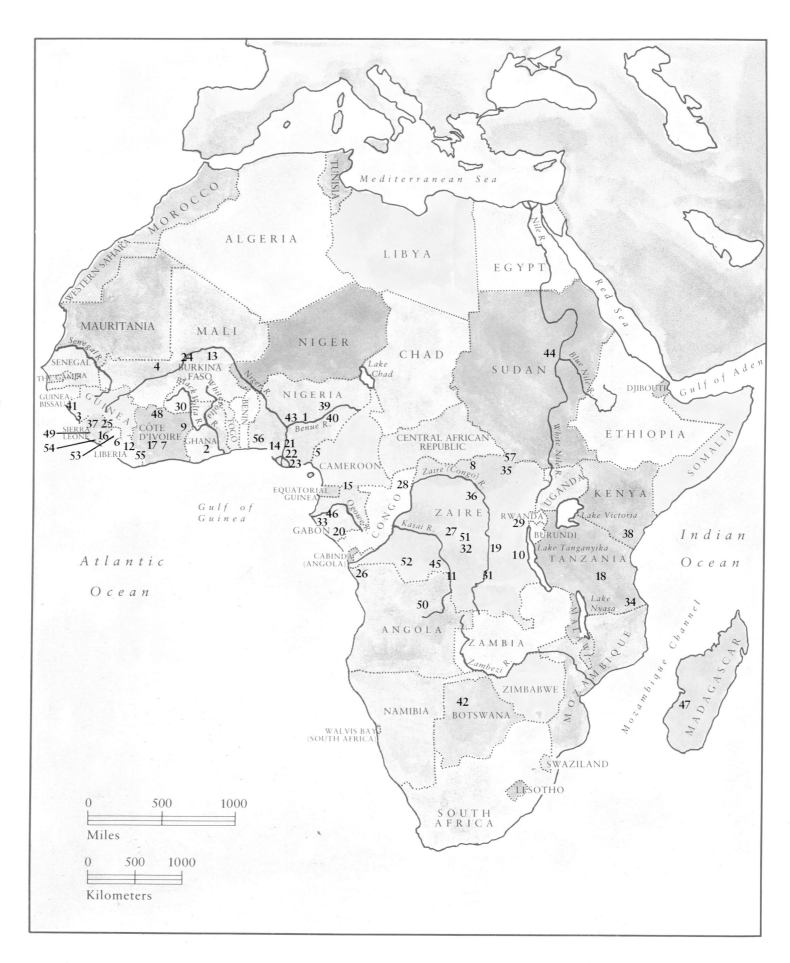

INTRODUCTION

Roy Sieber

The visual arts of Africa range from body decoration, such as scarification, body painting, jewelry, and dress, to architecture, household objects, musical instruments, and sculpture, usually in the form of figures and masks. This catalogue and exhibition focus on sculpture, that portion of African art that has prompted the strongest aesthetic reaction in the West.

The sculptures in the exhibition were produced by settled agricultural peoples living south of the Sahara. The peoples that produced these works live in a large area ranging from the Western Sudan and the Guinea Coast of West Africa to the equatorial forest stretching eastward from the Atlantic coast of Gabon across northern Zaire and to the drainage basin of the Zaire River reaching as far as the Great Lakes of Central Africa. Little sculpture is produced by cattle-keeping and nomadic peoples. Thus, except for a few outposts in East Africa and Madagascar, the concentration of sculpture-producing groups is in West and Central Africa.

To those who approach African sculpture for the first time, it will seem to bear little resemblance to the well-known forms of Western art that lend comfort when they are revisited. Far from contempt, familiarity breeds appreciation. In contrast to well-known forms of Western art, exotic forms in unfamiliar styles abound in African sculpture: oversized heads, squat bodies, conventionalized feet and hands, and stiff, often symmetrical, gestures. Human figures are usually frontal, nude, and unambiguously male or female. Masks may be human in form or a mixture of animal with animal or animal with human forms. The approach to these objects should be tempered with some tolerance until the aesthetics and the meanings become more familiar.

First encountered during the Renaissance and seen as curiosities made by exotic peoples, the sculptures were not considered by outsiders as art. Christian and Islamic missionaries, in their attempts to convert Africans from their traditional religions, dismissed the sculptures as evidence of benighted heathen savagery. Only in the early years of the twentieth century did artists and critics in Europe "discover" African sculpture. In their search for new forms to break away from what they considered an aesthetically bankrupt past, Western artists turned to the forms of non-Western and non-Oriental cultures. They clumped the arts of Oceania, particularly Melanesia, with the arts of Africa in their delight with forms that did not spring from Oriental traditions or European classicism or naturalism. Their adulation was based on the forms themselves; they had only the most nebulous and romanticized ideas of the cultures or contexts that produced them.

In general, art historians deal with a number of aspects of the art object. They may study the style or form of the works and how they change over time. They may deal with the artists, techniques, patronage, iconography, or the role of art in the place and time of its origin. At times, art historians may deal with the objects out of their time, as with the impact that classical works had on the Renaissance or African art had on the early twentieth century.

The approach of style has often been used in the study of the sculpture of Africa south of the Sahara. Distinct styles are discernible, and a presentation of these styles in a geographical pattern of distribution has been the norm since the mid-1930s, particularly after the publications of the Danish scholar and collector Carl Kjersmeier.

In addition, there have been several serious studies of the history and archaeology of the arts of African kingdoms but almost none of noncentralized societies. The

artist has been the focal point of several publications. In contrast, few studies of the form, patronage, or iconography of African art have been published.

This catalogue focuses primarily on the cultural meaning of the sculptures. Indeed, they have been selected with their cultural context as a major consideration. They are presented as agents of social stability, religion, and social control. However, neither history nor style is ignored. History is discussed when there is evidence for the age of the individual piece or its style.

Art historians and others have developed an interest in the relation of the objects to the societies that gave rise to them (see, for example, von Sydow 1930, and, posthumously, 1954). It has been particularly since about 1950 that many art historians have concentrated on the study of African art in its cultural setting. Many recent publications, articles, monographs, and exhibition catalogues have focused on the cultural role of the objects.

Much of what we see and discuss about African sculpture relates to a way of life that has been significantly affected in the past century by changes in transportation, economics, medicine, and education, as well as political change. Few of these attempted a frontal attack on traditional art and religion, as did the colonial policies and Christian and Islamic missionizing. Nonetheless, they had the subtle but demonstrable effect of undermining the old values that supported the arts and religion. For example, new, more accessible modes of transportation offered experiences and vistas that undercut the local sense of group unity, history, and style; imported medicine often undermined unqualified acceptance of divination and herbalism and the religious beliefs that supported them; and schools, especially boarding schools, separated children from the old ways of education, such as learning by working with parents, apprenticeship, and especially the semiformalized training that took place in the initiation schools. In those schools, values were transmitted as the children learned the history of the group, sex education, the morals and ethics of marriage and adult activities, "secrets" of the men or women, and, in some cases, the opportunity to learn a craft.

Political change has resulted in the substitution of the concept of nation for the older focus on the group, or tribe. Further, independence has, in many nations, replaced the attitudes of the colonialists and missionaries with a sense of the importance of traditional values, of the heritage of the past, such as the revival of older, pre-European forms of dress.

In dealing with the art of Africa, one is immediately faced with the question of which grammatical tense should be used with reference to the sculpture. To use the present tense would be to imply that all the objects and their supporting cultures were functioning today. This is patently not true. To use the past tense would be to speak as if all the objects and their settings were irretrievably a part of the past. This is equally untrue. It would be prudent to follow the lead of the Kenyan philosopher John Mbiti, who states in his book *African Religions and Philosophy*:

In my description I have generally used the present tense, as if these ideas are still held and the practices being carried out. Everyone is aware that rapid changes are taking place in Africa, so that traditional ideas are being abandoned, modified or coloured by the changing situation. At the same time it would be wrong to imagine that everything traditional has been changed or forgotten so much that no traces of it are to be found. If anything, the changes are generally on the surface, affecting the material side of life and only beginning to reach the deeper levels of thinking patterns, language content, mental images, emotions, beliefs and response in situations of need. Traditional concepts still form the essential background of many African peoples, though obviously this differs from individual to individual and from place to place. . . . the majority of our people with little or no formal education still hold on to their traditional corpus of beliefs and practices. . . . (1969, xi)
Beliefs connected with magic, witchcraft, the spirits and the living-dead (the ancestors) are areas of traditional religions which are in no danger of immediate abandonment. (ibid., 274)

Thus the present tense will be used in discussions concerning objects dating from the recent past, and the past tense will be used only for archaeological objects and those cases where we know that the objects reflect a way of life totally lost.

History

The study of history in sub-Saharan Africa is dependent on two sources: on the one hand, written reports of outsiders (travelers, missionaries, merchants, and colonial officers) and, on the other hand, oral traditions. Written reports are useful at times but are generally unsatisfactory because they are rare, scattered, and discontinuous. Few refer to the arts, fewer still offer useful illustrations that would relate to the history of styles or forms.

Oral traditions are a form of history that cannot be judged by the same rules as our Western sense of history. The precision that is characteristic of the latter is absent;

instead, time may be couched in terms of the memory of individuals who recall events or people, or it may be formalized in terms of recited histories of kings or dynasties. Oral traditions may unconsciously change over time, because memory is selective and fallible, or they may be consciously reinterpreted for political or other reasons. Mbiti suggests a further caution that in oral traditions time tends to be condensed:

> History and prehistory tend to be telescoped into a very compact, oral tradition . . . handed down from generation to generation. If we attempt to fit such traditions into a mathematical time-scale, they would appear to cover only a few centuries whereas in reality they stretch much further back; and some of them, being in the form of myths, defy any attempt to describe them on a mathematical time-scale. In any case oral history has no dates to be remembered. (ibid., 24)

He also notes that Africans do not look forward to an end of the world, only back to an endless rhythm of days, seasons, and years. To these there is no end. Further,

> human life has another rhythm of nature which nothing can destroy. On the level of the individual, this rhythm includes birth, puberty, initiation, marriage, procreation, old age, death, entry into the community of the departed . . . these are the key moments in the life of the individual. On the community or national level, there is the cycle of the seasons with their different activities like sowing, cultivating, harvesting and hunting. (ibid., 25)

In addition, there are abnormal, often traumatic, events such as droughts, disease, or infertility that interrupt the normal cycles of life or the seasons.

Therefore it is evident that oral traditions are open to a number of cautions. Because they are based on memory, they are constantly open to change and may reflect revisionist "history," akin perhaps to mythology, rather than objective history in the Western sense. Even when oral traditions seem trustworthy in describing the history of a type of object or its cultural support, such traditions never describe an object in so detailed a fashion that we can reconstruct its form or style from the oral evidence. Indeed, because most African sculptures are made of perishable substances—wood and other vegetable materials—they are usually easy prey to insects and the climate and rarely survive more than a generation or two before they disappear and must be replaced. Exceptions do exist where the wood used is hard, the care extensive, and the climate conducive to the preservation of the work. Such is the case with some of the

sculptures of the Bamana (cat. no. 5) and others (for example, cat. no. 73) who lived in the Western Sudan, where the dry climate has helped ensure the long life of some carvings.

In most instances only those objects in relatively durable materials—such as metal or fired clay—survive. Pottery, even broken, offers the archaeologist evidence of the cultures that once occupied a site or an area. Sequences of form and modeled, painted, impressed, or incised decoration reflect cultural changes and give some hint of the changing history of an area. Figures modeled in clay and then fired are among the earliest evidence of sculptural activity in sub-Saharan Africa. The Nok terra-cottas of northern Nigeria dating to perhaps two thousand years ago are one example (cat. no. 72). Later examples are known from the inland delta region of the Niger River, the Djenné terra-cottas (cat. no. 4).

Some metal objects have been recovered archaeologically from societies or periods now lost, such as at Igbo-Ukwu and Ife in Nigeria, and some have survived above ground, for instance, those from kingdoms that were known to early European travelers, such as the Nigerian kingdom of Benin (cat. nos. 45–46).

For the greater part the arts of Africa do not long survive, and most of what we know of the forms and styles has been derived from objects in perishable materials collected within the past century. And these rarely have seen more than a generation or two of use. One extremely rare exception is the wooden Yoruba divination board (cat. no. 30), which was collected before 1659.

Nearly every African sculpture in a museum, collection, or exhibition has had its life cycle interrupted. Made to be used and then used up or perhaps accidently destroyed by fire, climate, or insects, the sculptures were meant to be replaced. The replacement quite literally took the place of the lost piece, which in itself had most probably been a replacement. I once was shown a broken terra-cotta figure of a queen mother among the Kwahu of Ghana. The chief who showed it to me noted that it was newly broken and that it would now have to be replaced. The broken one was said to be the funerary terra-cotta made for the first queen mother of the village some two-and-one-half centuries earlier. However, it was, in style, clearly no more than about thirty years old. It was a replacement, removed an unknown number of times from the original, and yet was spoken of as if it were the original. The continuity was unbroken, the piece *did* represent the early queen mother, and the con-

cern of the art historian to date the particular work was quite clearly not the concern of the village chief.

Finally, we will make a major mistake if we attempt to see in African art some reflection of our own remote past. African art is not the echo of an early stage in human evolution, a historical remnant of a frozen culture. Rather, it springs from cultures that have at least as long a history, albeit a quite different one, as cultures anywhere else.

In the recent past the arts of non-Western and non-Oriental cultures have been grouped as "primitive," implying simpler or earlier in an evolutionary sense. In both meanings the term is misleading: "in matters of religion, as of art, there are no 'simpler' peoples, only some peoples with simpler technologies than our own. Man's 'imaginative' and 'emotional' life is always and everywhere rich and complex" (Turner 1969, 3). In Africa the "simpler technology" was based on fire and human muscle power as the sole sources of energy. "Before European contact in the nineteenth century, [Africans south of the Sahara] did not employ the wheel, the lever or the inclined plane, and writing was unknown" (Prince 1964, 85).

Thus, in this exhibition and catalogue, the focus is not on the Westernized history of the objects but rather on the "history" of African lives and events as they appear in traditional culture. Instead of showing art objects within a single African group, we have chosen to range over the subcontinent, selecting works quite arbitrarily—choosing a mask here and a figure there as they fit the focal points of the cycle of life.

Aesthetics

Each work of African art springs from an ethnic unit that has a particular history and that has made certain decisions about style, form, and aesthetics. It is necessary to realize that those choices guided the production of the objects with which we are concerned. It is necessary also to be careful in our use of the term *aesthetics,* which carries a great deal of associated baggage in our culture. The literal meaning, the perception of the beautiful or the tasteful, is often based on the arts of the Greeks, and that perception is carried as the canon for all works of art anywhere and anytime.

It is not therefore surprising that African sculpture was considered ugly, the antithesis of beautiful, by early observers. Further, it was condemned by Westerners on religious terms as the product of heathen savages. Thus a double rejection: ugly and un-Christian. The earliest expression of interest in African sculpture was as objects of curiosity from strange and distant peoples. Ignored as art, objects having widely differing uses and meanings for Africans were lumped together and exhibited in curiosity cabinets alongside exotica from botany, geology, and zoology. Even when the "natives" were believed to be close to nature and admirable in their simple lives as "noble savages," their sculpture was not regarded as art.

Western attitudes toward non-Western societies began to change with the development of anthropology, yet with this change the works of the African artist were relegated to the anthropological sections of natural history museums. In Europe today the finest African sculpture collections are part of larger anthropology collections in natural history museums.

African art was "discovered" by artists and critics early in the twentieth century. Its influence on modern Western art has been studied and reported from the point of view of its formal impact (Rubin, 1984). No serious early attempt was made to discern the role, meaning, or aesthetics from the point of view of the African producers.

Elsewhere in this catalogue the roles and meanings of the sculptures are discussed. Here we must consider the choices made and the decisions taken, the aesthetics that influenced their production.

Often, as in my experience among the Igala, when an African is asked to explain his preference for one sculpture over another, his reply will be that it is better carved. In short, the judgment seems based solely on skill. But this term used cross-culturally may be deceiving; it can mean significantly more than excellence of execution. It includes the degree of success with which a carver can produce a form in the style, size, color, and material expected of him by his audience. Daniel Crowley, writing specifically of the Chokwe, suggests that "knowing how to make an object well *includes* knowing how to make it beautiful, a standard which would hold for most craftsmen in other cultures, including our own" (1973, 228). In short, skill is the ability to create recognizable, acceptable variations of a shared stylistic, formal, and aesthetic norm. This may mean, in one African culture, that the sculpture may be quite simple (cat. no. 34) and in another highly complex and detailed (cat. no. 31) or that a head is carved abstractly (cat. no. 33) or naturalistically (cat. no. 59). Equal skill must be expended in the production of unlike forms, ranging from simple to complex and abstract to naturalistic.

The definition of skill must be enlarged to include the expectancy of the familiar, which results in acceptance and approval of the familiar and rejection and disap-

proval of the unfamiliar. The detail with which Africans discuss their expectancies varies considerably from group to group. As noted, the Igala seem to stop with the expression of the work as well carved. The Yoruba of Nigeria, however, have a set of criteria of excellence, as discerned by Robert Farris Thompson. He states that there exists, "locked in the minds of kings, priests and commoners, a reservoir of artistic criticism. Wherever tapped, this source lends clarity to our understanding of the arts of tropical Africa" (1973, 19). Based on interviews with eighty-eight informants, he arrived at eighteen criteria of excellence, among them the following: *midpoint mimesis,* the balance between resemblance and likeness, not too specific (for example, not to show the wrinkles of age) and yet not too abstract; *visibility,* the clarity of form and line; *shining smoothness,* a polished surface that plays against the shadows of incised lines; *emotional proportion,* the size of parts related to their emotional emphasis rather than naturalism, for example, oversized (from our point of view) heads; *positioning,* proper placement of the parts of the body, really a part of proportion; *composition,* which relates to positioning as the siting of the parts, both mimetic and emotional, in a composition; *delicacy,* the fineness of detail, small, narrow, slender (grossness is its opposite); *roundness,* a full rounding of small masses in relation to larger masses; *protrusions,* the pleasing bulge; *pleasing angularity,* an alternative to roundness; *straightness,* erectness of sculpture; *symmetry; skill;* and *ephebism,* perhaps the most important criterion, the depiction of a person in the prime of life (ibid., 31–57).

The depiction of people in the prime of life seems to be a criterion of a great deal of African art. Almost never are childlike qualities or the ravages of age depicted. Instead, an ideal adult age is suggested. Herbert Cole reports that his research among the Igbo in Nigeria agrees with Thompson's ephebism, that is, the depiction in sculpture of "*all* human beings at the productive age of young adulthood" (1983a, 21). Susan Vogel reports essentially the same attitude among the Baule of Côte

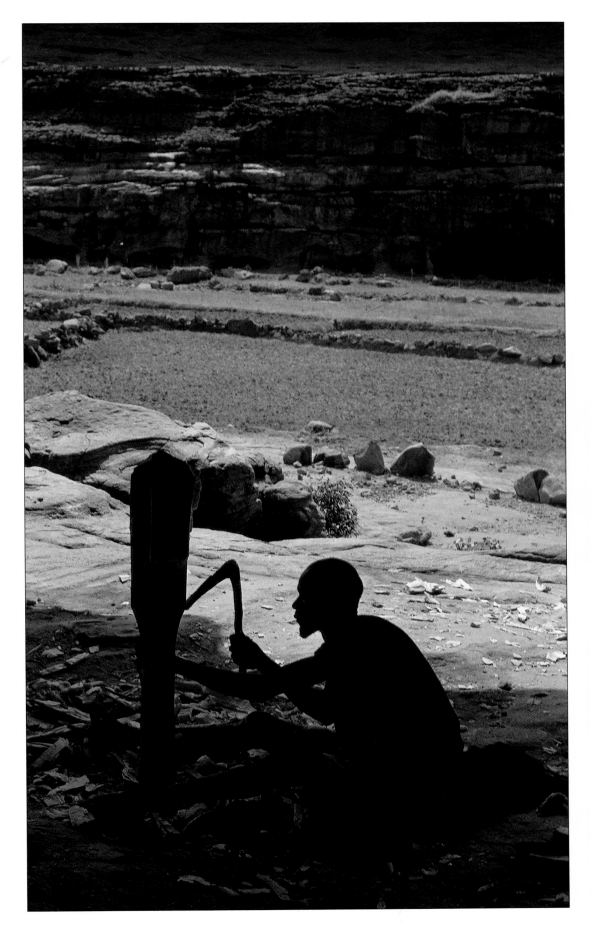

FIG. 1. **Dogon sculptor, Upper Ogol village, Mali, 1970.** Most African sculptors work in isolation away from the village proper. The most common wood-carving tool is the adze.

d'Ivoire: "their praise of youthful features and their disapproval of anything old looking is linked with their praise of fertility, health, strength and the ability to work hard" (1980, 13). In general, the images of royalty and ancestors are shown as youthful but fully developed adults, for example, the Benin queen mother (cat. no. 46) and the Hemba ancestor (cat. no. 81) from Zaire. When infants or children are shown, they are depicted as attributes of motherhood, not as discrete personalities.

No one else has presented as full a set of criteria as Thompson, but many other scholars refer to some that are similar: Crowley notes bisymmetry, smooth finish, efficient control of tools, figures that stand up, and fineness (1973, 246–47); Vogel notes symmetry, fineness, and delicacy and adds richness of materials such as gold and ivory (1985, XII); and James Fernandez discusses balance (1966, 56).

Vogel (1980), working among the Baule in Côte d'Ivoire, found remarkable agreement among the thirty-five informants she interviewed in their aesthetic ranking of eleven figure carvings. She notes that there emerged a number of similarities with Thompson's report of Yoruba aesthetics, including balance and moderation of forms and deliberation in the sense of placement (Thompson's *positioning*). Philip Ravenhill, also reporting on the Baule, notes the aesthetic of moderation or a "happy medium" thus: "a given physical attribute should ideally be 'just so' . . . being neither too pronounced nor too diminutive" (1980, 7). When the Baule state "a neck should not be too long ('like a camel') nor too short ('like a cricket'), nor too thick, they do not mean thereby that a neck should be average, rather it should approach the *ideal* of [an] elegant or beautiful . . . neck" (ibid.).

Both Vogel and Ravenhill report that the Baule relate the beauty of statuettes to the beauty of the idealized human figure (Vogel 1980, 19; Ravenhill 1980, 9). "Statuary form derives from an idealization of human form, but in turn the creation of wooden ideals has a feedback effect which affects the appreciation of human beauty, as, for example, when one says 'his nose is as straight as though it were sculpted'" (Ravenhill 1980, 9). At the same time, the Baule have a widespread preference for "slightly irregular and asymmetric forms," but this must be a "balanced" or "gentle" asymmetry to be acceptable (Vogel 1980, 16).

It should be noted that for several groups, including the Baule, the Ibibio, and the Igala, a damaged figure "is often considered unworthy of aesthetic judgment"

(ibid., 14). New figures are considered stronger than old figures. "The Baule consider a new thing as strong and vigorous whether it is a young person, a sculpture, or a cult" (ibid., 13; see Crowley 1973, 246).

In contrast, there are cultures that recognize that a decorated object is preferable to an undecorated one but do not make aesthetic comparisons between decorated objects. Fred T. Smith, for example, discusses the concept of *bambolse* among the Gurensi of northern Ghana. The term *bambolse,* which "means 'embellished,' 'decorated,' 'made more attractive,' or 'it looks good,'" refers only to deliberately aesthetic wall decorations made by Gurensi women (Smith 1979, 203). "But at the same time, the aesthetic quality . . . can not be openly praised or criticized" (ibid., 204). Smith argues that the Gurensi "do not have a definite voiced aesthetic for the visual arts. To criticize or to engage in formal analysis is considered a form of anti-social and disruptive behavior" (ibid.). Crowley notes that among the Chokwe, "undecorated objects have less value than decorated" (1973, 247). Among the Pokot of Kenya the critical point, as reported by Harold Schneider, is that a useful object becomes art *only* if it is decorated (1956, 104). It should be added that neither the Gurensi nor the Pokot produce figurative sculpture. Others have equated art with decoration, but mostly for two-dimensional objects rather than three-dimensional sculpture.

There are also those groups that do not evaluate the aesthetic appeal of what we would call works of art. For example, Daniel Biebuyck notes that when he was among the Lega,

after decades of harassment from Arab raiders and colonial administrators, traditional artists were no longer at work in Legaland. . . . The patrons of the arts, high ranking initiates who own, use and interpret the objects make no evaluation of quality; for them to speak about the relative aesthetic appeal of art objects would be an infraction of the bwami code, which claims that all *isengo* are *busoga,* good-and-beautiful, because they are accepted and consecrated in bwami. (1973, 177)

He summarizes the situation thus: "In the years I spent among the Lega, I never heard aesthetic evaluations of art objects" (ibid.).

Vogel notes that in some instances we would, from our Western point of view, have made the same aesthetic decision as that made by the African (1985, XI). Her example is the choice made by a Yoruba chief between two Yoruba carvers in which the work of the one selected is, to a Western eye, preferable to the one rejected

by the chief when works by both carvers have survived. Rarely do we have examples of this kind; they are, indeed, too rare to assume that our aesthetic taste and that of the Africans ultimately coincide. As Vogel notes, however, we "can consider the chosen artist's style a standard of excellence against which the efforts of other artists of the region must be measured" (ibid.).

Indeed, works that have survived and that show signs of use have obviously met some set of criteria. We may assume that they were at least basically acceptable in terms of form, style, and aesthetic quality.

It is apparent that there are differing degrees of verbalized aesthetic responses among Africans, but the degree to which we can assess their differences is limited by the few studies that have been published. It may, in some instances, be futile to search for the developed vocabulary with which the Yoruba and the Baule express their taste. Indeed, there are those who argue that without the words to express it, there can be no aesthetic (Crowley 1973, 224). However, if we avoid Western cultural prejudices associated with the term *aesthetics* and focus on the response to the object, which is what Thompson seems to have done, it may be possible to get close to an understanding of the aesthetic and, indeed, to see if there are universals involved. For example, do all African peoples tend to prefer symmetry, delicacy, and/or ephebism? Also, we must judge responses according to the role and place of the informant in his culture. Thompson, quite rightly, depended heavily on chiefs, artists, and other seemingly knowledgeable Yoruba.

But more than words may be needed in cultures less verbally complex than the Yoruba. It may be that responses can be noted that are positional or gestural. As I have discussed elsewhere (Sieber 1973, 428), many gestures in our society can be interpreted as judgmental, such as refusing to shake hands or holding one's nose. To observe the excited response of an African audience at a masquerade, to follow their expressions of approbation and, at times, awe, is to realize that "aesthetic" responses exist, although they may be neither finely drawn nor verbally realized. Such responses, if recorded and analyzed, could bring into focus the nature of response as a cue to a better understanding of aesthetics.

Another note should be made. It is necessary to be extremely cautious when asking an informant for a comparative response between two objects. The objects must be of the same type and the same degree of importance to the informant. The alternative is to make the error I did in asking Igala informants for a critique of two masks, one an Egu Orumamu, the major mask of the Igala, the other a mask of significantly less importance. I realized my error when I found unanimous preference for the "more important" mask, the Egu Orumamu, over the other. Obviously the choice was based on importance, not aesthetics. Attempting to correct the situation, I asked informants to choose between two Egu Orumamu masks, only to discover that they refused to choose between the two quite distinct masks because they were equally powerful, equally important.

Finally, an open question as to whether the term for beautiful also means good. As we have noted, Biebuyck reports on the Lega that all Bwami association ritual objects were "good-and-beautiful," although no aesthetic choices were made (1973, 177). Vogel argues that beautiful and good are equivalent and are the opposites of ugly and evil (1980; 1985, XIII). She notes that nearly all words used in aesthetic judgments by the Baule have a moral as well as a physical sense; thus she suggests that good/beautiful and bad/ugly be read as opposite pairs (1980, 8). There is perhaps another reading; works of art in Africa are predominantly used positively and are part of an open, often public, reinforcement of positive social values. Only the black arts of witchcraft and sorcery are secret and antisocial. Therefore the public arts are by definition good in the sense that a larger social benefit is meant.

Style

The reader of this catalogue or the viewer of the exhibition will have seen more types and styles of African sculpture than any traditional African would have experienced. This is because each sculpture had its particular reason for being among the people that supported it. And each culture and the sculptural style it developed had a limited geographical distribution. Thus most Africans would know little of what was produced at any distance from their home area.

Style will be identified in terms of the people of origin of the work. As is usual for works of African art, the name of the people who produced the piece or to whom it can be attributed serves doubly as a style designation and as an identification of the group of origin.

This does not mean that each style and type is a hermetically sealed unit, differing from all others in form and meaning. Africans did travel and come to know neighboring peoples, at times peacefully, at times during warfare. The rigid concept of tribal styles, each discrete, each unique, and to all intents and purposes ending at the group's borders, is very much an oversimplification.

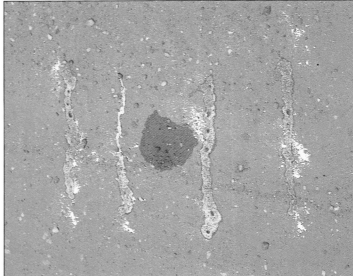

FIGS. 2 and 3. Spring agricultural festival, Prampram, Ghana, 1967. Some art that is used in rituals may be intentionally ephemeral. These symbolic marks were painted with fugitive materials that quickly disappear.

As peoples interacted with one another, art forms were exchanged, copied, or adapted.

Yet there remain discrete styles that can be identified with particular groups of people, and the names of those peoples are still the best style designators that we have. Thus Akan is a term that can be applied to the works of all Twi speakers, even though the styles of different groups of Akan, such as the Baule of Côte d'Ivoire (cat. no. 26) and the Asante of Ghana (cat. no. 6), have been identified. From their oral histories we know that they are historically related.

The Yoruba of southeastern Nigeria never considered themselves a single ethnic unit before the arrival of the Europeans, but now they are spoken of as a single large group with a number of subgroups and having an overall Yoruba style and recognizable substyles. The names of the ethnic groups used in this catalogue are generally accepted, even though they reveal their origins in tribal designations. It must be noted that the term *tribe,* long used by anthropologists and art historians, has in recent years taken on the pejorative connotation of "tribalism," which is suspect because it is in opposition to the sense of polyethnic nationalism that is stressed in the new African nations. Instead, the terms *people* and *peoples* will be used to refer to the cultures or groups that are discussed. The characteristics of a people are very much like the characteristics in the old definition of a tribe, that is, they have their own language, occupy a particular geographical region, and share a common culture with its distinctive social, political, and religious systems. Normally a person must be born into the group to be a member (Mbiti 1969, 100–104). It should be added that for the most part the members of each group share an art style. Thus, as has been noted, the name of the people, for example, Dogon or Pende, identifies both a culture and an art style.

Depending too heavily on the concept of "one people, one style" is, however, somewhat deceiving on two counts. First, some peoples support more than one style. Among the Bamana, for example, different styles are evident when the solid rounded forms of the maternity figure (cat. no. 5) are contrasted with the more two-dimensional, tracerylike forms of the antelope headdresses (cat. no. 22). A second possibility is that a style may be shared across cultural boundaries; for example, the Asante stool-carving style (cat. no. 43) is shared by a number of neighboring groups who experienced the military and economic influence of the Asante. Thus it is clear that too heavy a dependence on the concept of group styles will lead to a serious misrepresentation of African art styles. René Bravmann, in an important essay and catalogue, *Open Frontiers,* has written, "Certainly one of the most glaring distortions that has affected the notions and writings of those who have concerned themselves with the arts of Africa . . . is the concept of the tribe as a closed artistic entity" (1973, 9).

William Bascom had earlier warned of the pitfalls of the concept of tribal styles in a paper presented in 1962 but not published until 1969 (1969c, 98–119). He acknowledges the usefulness at one level of ethnic or tribal styles, each of which is the end product of a particular history of development. At the same time, he refers to the diversity of styles within a single group and notes the necessity for refining that concept in two directions: first, the recognition of substyles and individual styles within the group style and, second, the acknowledgment of suprastyles, of larger-than-tribal styles, such as regional styles. Further, he recognizes the existence of "blurred" styles, the borrowings of foreign style elements that affect the group style, and the rare appearance of archaisms or revivals (ibid., 102–6).

The cautions of Bravmann and Bascom are very important. Yet the concept of naming the style for the people responsible for its appearance seems useful as long as the possibilities of substyles and individual artists' styles are acknowledged and as long as cultural contacts and suprastyles are recognized where they occur.

Further, to confuse the issue, the Berlin Conference of 1884–85, which divided much of Africa among European colonial powers, did so in ignorance of the geographical regions occupied by particular peoples. Thus many peoples were split by arbitrary colonial boundaries, which, with independence, became fixed national borders, often causing problems that are still not solved today.

Artists

The artists who produced these works, if we can judge from recent times, were mostly male. Indeed, only males are reported to carve figurative sculpture in wood or ivory or to work metals. They are part-time specialists, smiths, or agriculturalists who carve, cast, or forge. Among some peoples, for example, the Bamana in Mali, the blacksmiths are a people apart from the agriculturist core of the society. The men are ritual specialists who work iron and sculpt wood for the farmers; their wives are potters. Farther south and east, this castelike separation is not evident; rather, specialization is taught by apprenticeship and is not necessarily a family affair, and some sculptors are self-taught. But it is only rarely that a

sculptor achieves sufficient recognition or enough commissions to become a full-time artist.

The artist is not a passive copiest, even though one of his major responsibilities is to replace destroyed works; in this fashion he is his generation's link with the past. Inventiveness is recognized and rewarded as long as it holds to the outlines of traditional form and style, that is, if it meets the expectancies of the audience. One artist, Namni, introduced in the 1930s a major change in the sculptural figure style of his people, the Montol of northern Nigeria. From a loose tradition of simplified and abstract forms, he developed a more naturalistic and detailed image of the human figure. His innovation was not only accepted, but he became quite famous and much copied. One owner of a piece by Namni said he had traveled many miles and waited several weeks to commission a figure carving. Thus an artist might introduce significant changes in the sculptural style of a people and, indeed, create a form that would be copied and become the norm.

Because of the impermanence of wood carving, it is impossible to guess either how often and to what degree individual genius has affected the development of the styles and forms of African sculpture as we know it or how long a style has persisted. From one instance it seems clear that the basic Yoruba style has not changed significantly since the mid-seventeenth century. A divination board (cat. no. 30) that was collected before 1659 is in form and style similar to works produced during the past hundred years.

It is clear that some styles have been more fixed and unchanging than others. In terms of these two examples, one Montol and one Yoruba, it is probably significant that the Yoruba are a large, centralized people with a strong emphasis on ceremonialism, whereas the Montol are a much smaller, less structured, and less centralized group. In the former the style, once fixed, would probably tend to be sustained with minor variations, while in the latter there would seem to be less insistence on prototypes and therefore possibly greater freedom for change.

Sculptors rarely produce objects except on commission from a patron. The product is discussed by the artist and client and the price agreed upon before the sculptor sets to work. The client quite confidently expects the artist to produce a familiar form in a familiar style. For the client it is the object, not the producer, that is important. Warren d'Azevedo reports on the Gola of Liberia that

craftsmen and performers were persons of low status who provided services for those who could afford them. The finest work from such persons became the property of wealthy patrons who used them to enhance their own prestige. When one admired the work of a singer, a musician, or woodcarver, one was usually informed of the name of the patron as though the identity of the actual producer was insignificant. (1973a, 332)

In contrast, Gola artists themselves have a high view of their work. They believe in a guardian spirit or muse that helps them to conceive and execute their works. There is an "intensive focus on self-conscious rationalization" of their role and the quality of their productions (ibid., 324). At the same time, the artist is conceived of by the "normal" members of society as aberrant, "the kind of individual whose behavior is strange—irresponsible yet marvelous, dangerous yet attractive, and childish though wise" (ibid., 323). For one thing, the male Gola artist carves masks for both the men's Poro association and the women's Sande association. This is extremely unusual. Like most other African cultures, most aspects of Gola society are strongly divided by gender, but the Gola and their neighbors are exceptional in that women wear masks (cat. no. 18).

Thus in some African societies the artist either is outside the group that uses his products, as with the Bamana blacksmith, or, if he is a member of the society, is considered (along with the musician) to be of low status. What should be stressed is that a clear distinction is drawn between the artist and the objects or events he produces. Unlike the leader, who is highly regarded as are his acts, or the criminal, who has low status because of his actions, the artist is often regarded as a person of low status yet "produces objects or performs acts which are not only welcome in the society but which often, perhaps usually, reinforce the norms of that society" (Sieber 1973, 431). Thus the artist's aberrant behavior is tolerated because of the importance of his contribution to the society.

In some groups, such as the Akan, the wood-carvers (*duasenfoo*) "belong to a carvers' association whose head is known as the chief (*ohene*) of the woodcarvers, the Duasenfoohene" (Warren and Andrews 1977, 11). Similarly, the metal casters of Benin belong to a guild.

It is necessary to counter the old assumption that the artist in African society is anonymous. It is clear that this is not the case among the Montol or the Gola. In fact, it is a fiction based on the failure of early collectors to ask the name of the artist when collecting specimens.

Along with other researchers, I have found that in many, if not most, cases the name of the sculptor of a particular piece is remembered by the owner and often by others. Thus African carvers are not the anonymous producers of passive copies but are the respected, if somewhat culturally aberrant, creators of works whose requirements of familiarity of style and form can be inventively modified by particularly talented artists.

Techniques

The working method of wood-carvers seems much the same over the subcontinent. They often work in secret, particularly in the production of objects relating to secret cult practices and masks, which, when worn, are said to be the spirit forces they represent.

It must be noted that wood carving, like stone and ivory carving, is a subtractive technique. That is, wood is removed to "reveal" the sculpture. Wood-carvers use axes, adzes, and knives, usually working from broad, generalized forms through an increasingly greater definition of forms to carefully finished final cuts. Thompson discusses the four "stages of the process of carving" of Bandele Areogun, a Yoruba artist from Osi-Ilorin: "1) the first blocking out, 2) the breaking of initial masses into smaller forms and masses, 3) the smoothing and shining of forms, 4) the cutting of details and fine points of embellishment into the polished surfaces of the prepared masses" (1973, 34). Other Yoruba artists describe the process somewhat differently (ibid.), but all work from the broad blocking to the fine finishing touches, a process also described by Marcel Griaule ([1938] 1963, 405ff, pl. XVII), who outlines the Dogon artist's working procedure from the required initial sacrifice to the spirit of the tree that furnishes the wood for the sculpture to the final application of colors (fig. 1). Colors are vegetable or mineral in nature and consist primarily of black, red, and white and occasionally yellow and blue. The blacks are from charcoal or river sediment; the reds from ochres, camwood, or *tukula* (the latter two from woods); the white usually from kaolin; the yellow from ochre; and the blue from indigo. In addition, many substances may be added to the basic wooden sculpture to enhance the aesthetic or meaning of the object: skins, fibers, beads, seeds, or metals.

In his discussion of the carving technique of the Dogon, Jean Laude suggests:

> We can observe a process parallel to the method that in Dogon thought regulates the passage from the general to the particular. The sculptor gradually releases an anthropomorphic image which becomes more and more particularized by means of conventional signs that, taken as a whole, constitute a repertoire (or a code), and convey a message. (1973, 43)

In contrast to the subtractive technique of wood carving, modeling in clay and wax is an additive technique. Working in wax is essential to the technique of metal casting, for example, the lost-wax castings from Benin (cat. nos. 45–46). A clay core, roughly shaped to the form of the final product, is carefully covered with a thin layer of wax, into which are worked the final surface details of the finished sculpture. The whole is then encased in clay, which after drying is heated to allow the wax to melt and be removed, hence lost, leaving a hollow where it had been. That hollow is then filled with molten metal, usually a copper alloy, most often brass. After cooling, the clay investment is removed, and the sculpture is revealed. Traditionally no files or burins were used; there was no chasing of the metal after casting. What one sees is what had been modeled or incised in the wax.

Religion

Mbiti, an African scholar, states that "Africans are notoriously religious" (1969, 1). Indeed, much of what we consider social, political, or cultural and thereby secular is considered religious in African thought. "The whole organization of society is maintained by the spiritual forces that pervade it" (Parrinder 1954, 27). The pervasiveness of religion involves all aspects of the culture: kinship; health and disease; fertility of crops, animals, and men; leadership; and war. It offers a general sense of security and well-being. "For Africans, the whole of existence is a religious phenomenon; man is a deeply religious being living in a religious universe" (Mbiti 1969, 15).

There is belief in the hierarchy of spirit forces. First, there is God, who is seen to be "in and behind . . . objects and phenomena: they are His creation, they manifest Him, they symbolize His being and presence . . . The invisible world presses hard upon the visible: one speaks of the other, and African peoples 'see' that invisible universe when they look at, hear or feel the visible and tangible world" (ibid., 57).

God is conceived of as a distant, relatively unapproachable deity. "The great Creator has very few temples or images, but is almost everywhere believed in" (Parrinder 1954, 16). Ordinarily there is little direct contact between man and the supreme deity. "The gen-

eral picture in Africa is that regular communal prayers to God are rare" (ibid., 39). However, "in times of great distress many Africans turn to God in desperation. He is the final resort, the last court of appeal" (ibid., 24).

Below God are the spirits, which Mbiti describes as invisible, ubiquitous, and unpredictable. They live all around: in the sky, the sun, the earth, bodies of water, rocks, or trees (Mbiti 1969, 75ff).

"There are spirits of mountains and forests, of pools and streams, of trees and other local objects" (Parrinder 1954, 43). In addition to the beliefs in the spirits of geological formations and vegetation, there are spirits of animals, storms, thunder and lightning, and household spirits. Men's and women's associations "have their own presiding spirits, crafts have their particular gods, villages have their guardians" (ibid., 53). The spirits can be protectors or they can bring illness or madness, particularly if they have been neglected or angered through the breaking of taboos.

A special category of spirits is the living-dead, the recent ancestors, still remembered, who can intercede with other spirits or even God for the good of the living (Mbiti 1969, 75–83). Thus although Africans may believe in a high God from whom all mystical power flows, it is through the spirits, including the ancestors, that man is able to make contact with the deity to tap that mystical power. "That means that the universe is not static or 'dead': it is a dynamic 'living' and powerful universe" (ibid., 203).

Nature is not conceived of as impersonal but is "filled with religious significance. Man gives life even where natural objects and phenomena have no biological life" (ibid., 56). Since this spirit power is manifested in all things, the term *animism,* the attribution of a living soul to inanimate objects and natural phenomena, has been applied to these beliefs. Africans thereby are described as being animists. The term is, however, inadequate and somewhat denigrating, for it oversimplifies the rich texture and the complexity of African religion. To the African this mystical power is potentially both good and bad. It can be used "for curative, protective, productive and preventative purposes" (ibid., 203), which may take forms ranging from broadly shared rituals to personal amulets. "The spiritual powers are ranked in hierarchies and approached according to need. Magical charms are made for teething troubles, ancestors are consulted over land disputes, sky gods are prayed to for rain, above all is the great Creator. All these powers are important, and in turn they may help man in his incessant fight against disease, drought or witchcraft" (Parrinder 1954, 26).

Such uses ensure a secure, healthful, and fruitful life for the individual or the group; obviously this is power put to positive, social use.

There is also a negative side to the use of spiritual power. "It is used to 'eat' away the health and souls of victims, to attack people, to cause misfortunes and make life uncomfortable" (Mbiti 1969, 203). The term *witchcraft* is usually applied to this antisocial use of mystical power.

But the essential point is that although this power can be used secretly for evil purposes, it is believed to be best and most profitably used for the good of the group. Thus African societies tend to use it openly, publicly, for the general well-being. The mask from the area of Bondoukou (cat. no. 29) is an example of a type of mask whose descendants harness spiritual power to purify and cleanse the village and its inhabitants of malevolent forces.

The workers-of-evil, those "who employ that power for anti-social and harmful activities" (ibid.), are called witches or sorcerers; the workers-of-good are called doctors, priests, diviners, shamans, or medicine men. At times the latter are referred to as witch doctors, which is confusing because they seek out and destroy witches and thus are antiwitch doctors, or, as Parrinder notes, "witch-doctors are what the name literally says, doctors of those who have been bewitched" (1954, 108). In reality, they "are the friends, pastors, psychiatrists and doctors of traditional African villages or communities" (Mbiti 1969, 171). The methods they use include divination, exorcism, and herbalism.

In order to heal, it is first necessary to know the cause of the disease. African diagnosticians must discover, often through divination, if the problem is natural or supernatural (cat. nos. 30–31, 34). Only if the cause is determined to be "natural" is the herbalist called in or, more recently, is the patient taken to a Western type of hospital.

Traditional treatment includes such medicines as purgatives, emetics, poultices, ointments, sweating baths, and bloodletting (Parrinder 1954, 106). Further, among some groups specialists exist, such as the doctor who treats poisonous snake bites among the Goemai of northern Nigeria or the Yoruba cult in southeastern Nigeria that both treated and inoculated against smallpox even before Western vaccination was introduced.

If the cause of illness is divined to be supernatural, then the spiritual powers at the command of the doctor are brought to bear to drive out or appease the causative agent. If it is a spirit or ancestor who has been slighted,

sacrifices and prayers, often addressed to a sculptured figure, will redress the situation. If the cause is witchcraft, then spells against the evildoer are necessary, or the object that is believed to cause the illness by being willed into the victim can be physically removed from the patient.

In working with the spirit forces, it is often necessary to observe certain controls or restrictions, such as the prohibition of sexual intercourse or the avoidance of certain foods. These taboos are necessary to ensure the ritual cleanliness of the doctor and the patient before approaching the deity. Similar restrictions may be observed before major rituals.

It is important to note that the "medicine-man or diviner is a respected figure in village life, he is consulted by nearly everyone and is well in the public eye" (ibid., 117). In contrast, the "sorcerer or wizard . . . is an evil person, feared and hated. He works in darkness because his deeds are evil" (ibid.).

What is most important to realize is that the spirit world, ranging from God to nature spirits and ancestors, can to some degree be manipulated. Many of the objects in this exhibition are concerned with the maintenance of the spiritual well-being and stability of the individual and the group.

What may appear, when viewed from a Western bias, as strange, possibly even grotesque beliefs and art forms will become comprehensible if viewed in the setting of the cultures that gave rise to them. Then the arts will be seen as expressive of the imaginative reach and aesthetic inventiveness of the parent culture. Those beliefs and the art forms must be approached scientifically, empathetically, and aesthetically if we are to attempt to grasp their significance.

Use

An object may have a number of uses and reflect a number of meanings. In the object's original setting, the uses and meanings would have been familiar and therefore comprehensible to the traditional audience. However, in a museum the object has been removed from its cultural setting. Indeed, at times only a portion of the complete form has been preserved, for example, a mask without its costume. Yet, to understand the objects it is necessary

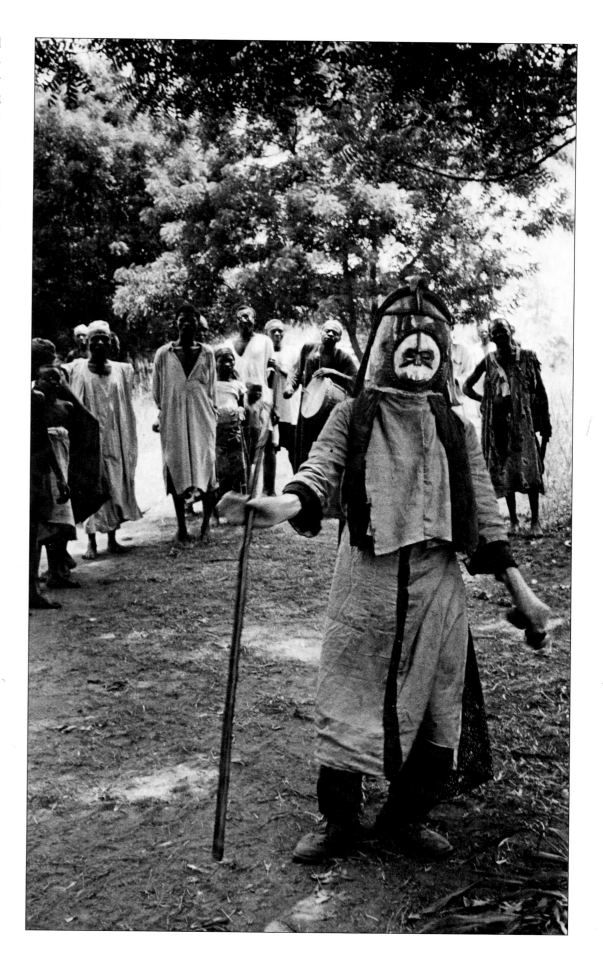

FIG. 4. **Janus-faced Egu Orumamu mask, carved by Ada, Okpo village, Nigeria, c. 1943. Egu Orumamu is the chief of the Igala masks and serves as a symbol of authority and social control.**

to know something of the setting. If it is not possible to retrieve the full complex of associations, the music, dance, myths, and beliefs that surrounded the objects, it may be possible to interpret something of their meaning and place in traditional African culture. At times the "objects" involved in ritual acts are ephemeral and cannot be preserved as "art." For example, at Prampram in southeastern Ghana a spring festival that is celebrated to ensure the coming of the rains and the success of the crops includes the production of "paintings" on the ground at all of the roads and paths leading to the farms. They are made of millet gruel, millet flour, and water (figs. 2–3). They symbolize the tilling of the soil (the four vertical strokes), the end product of a successful harvest (the millet flour and gruel), and the rains necessary for the successful harvest. These "products," which are a small part of a long ceremony, exist for only a few moments. By the end of the ceremony the water has dried, the flour has blown away, and the spectators at the ceremony have walked on them, obliterating them. As "objects" they have no significance, but as events they are a vital but ephemeral part of the call to the spirits for rain and agricultural success.

In many ceremonies the portion that survives—the sculpture, for instance—is but a small part of the full ceremony. At the same time, it may serve more than a transitory purpose in its own culture.

> Ritual acts and utterances may be experienced as ephemeral, even though their effects endure. Ritual objects, in contrast, provide a sustained physical presence, a constant tangible reminder of the rituals of which they have formed and will again form a part. They serve not only as a reminder but also as a stimulus, focus, affirmation, guide, and resource for ritual activity. They are activated by ritual acts and utterances, at the same time that they possess a power of their own. (Kirshenblatt-Gimblett 1982, 145)

It should be stressed that objects in a ritual setting are not passive symbols but rather, as Geoffrey Parrinder puts it, "symbols that men use, masks, colours, numbers, names, metaphors, all link up with the energy in the desired object; they are not dead symbols" (1954, 26). For objects that have been removed from their settings, from what Victor Turner has called the "resonant ambience of celebration" (1982b, 16), it is necessary in this exhibition to try to offer some explanation of the richness of the roles of those objects in their original setting. To attempt to achieve this, recurrent events or rites in the life of the individual and in the society have

been chosen to explicate the sculptures that were, at least in part, dedicated to them or used in the celebration of those rites.

Rites of Passage

It has been remarked that only humans acknowledge both time and changes. "The day, the month, the year, one's life time or human history, are all divided up or reckoned according to their specific events, for it is these that make them meaningful" (Mbiti 1969, 19). This marking of events is often done through rituals that set mankind apart, for "nothing remotely resembling a ritual marking transition from one life status to another has ever been seen among nonhuman beings. On the other hand no reliable observer has ever described a human society that did not have some ceremonial ways of marking such traditions" (Fried and Fried 1980, 13).

Early in the twentieth century, almost at the same moment that African art was being "discovered" in Germany and France, there was in the air another sense of discovery. It was the recognition that there exists a pattern to the human life cycle as it was marked and celebrated particularly in the so-called primitive societies. The idea of a cultural marking of transitions from one phase of life to another appeared in the writings of Robert Hertz in 1907–9 and Hutton Webster and Arnold van Gennep in 1908. Some were relatively isolated observations, as Hertz's ideas of transition relating to death. However, he did note, "societies . . . conceive the life of a man as a succession of heterogeneous and well-defined phases, to each of which corresponds a more or less organized social class" ([1907–9] 1960, 81). He also referred to "the passage from one group to another" (ibid.). Webster recognized the cross-cultural similarity of such transactions:

> Though varying endlessly in detail, their leading characteristics reproduce themselves with substantial uniformity among many different peoples and in widely separated areas of the world. The initiation by the tribal elders of the young men of the tribe, their rigid exclusion . . . from the women and children; their subjection to certain ordeals and to rites designed to change their entire nature; the utilization of this period of confinement to convey to the novices a knowledge of tribal traditions and customs; and finally, the inculcating of . . . habits of respect and obedience to the older men. ([1908] 1932, 32)

It was, however, in a small book, *Les rites de passage* ([1908]; English translation, 1960), that van Gennep presented a more complete view of the similarity of the cultural activities that accompany transitions in the lives

of human beings—transitions ranging from birth to death. Barbara Meyerhoff has suggested that all rites of passage have, as a subtext, the "interplay of biology and culture" (1982, 109).

Turner has noted that rites of passage are "found in all societies but tend to reach their maximal expression in small-scale, relatively stable and cyclical societies, where change is bound up with biological and meteorological rhythms and recurrences rather than technological innovations" (1967, 93).

Van Gennep in his formulation referred particularly to biological and sociological change:

> The life of an individual in any society is a series of passages from one age to another and from one occupation to another. Wherever there are fine distinctions among age or occupation groups, progression from one group to the next is accomplished by specialists, like those which make up apprenticeship in our trades. [Please recall that this was published in 1908.] Among semicivilized peoples such acts are enveloped in ceremonies, since to the semicivilized mind no act is entirely free of the sacred. In such societies every change in a person's life involves actions and reactions between the sacred and the profane. ([1908] 1960, 2–3)

Thus he argues that human life becomes

> a succession of such stages with similar ends and beginnings: birth, social puberty, marriage, fatherhood, advancement to a higher class, occupational specialization, and death. For every one of these events there are ceremonies whose essential purpose is to enable the individual to pass from one defined position to another which is equally well defined. (ibid., 3)

Many of these events and their attendant ceremonies have works of art of one sort or another associated with them. These events, these rites of passage, may be divided into phases, which have been termed rites of separation, transition, and incorporation: separation from a previous condition; transition, which may include instruction away from the community; and reincorporation into the community in the new condition (Turner 1982b, 25). A boy thus goes through three phases to become a man: first, he is separated from his mother and sisters; second, he is secluded in a place where he is submitted to certain ordeals, perhaps including circumcision, and taught the "secrets" of the men; and, third, he is reintroduced into society as an adult. The symbolism of death and rebirth is frequently found in rites of passage: the death of the initiate in a previous stage and his rebirth in the new stage (Turner 1967, 72).

Of the three phases, the first is a separation "that clearly demarcates sacred space-time from mundane space-time. Sometimes violent acts (circumcision, knocking out teeth, shaving hair, animal sacrifice) betoken the 'death' of the novice" (Turner and Turner, 1982, 202). The third phase "represents the return of the novice to society, and the desacralization of the entire situation. Symbols of birth or renewal are frequently displayed in reaggregation rites, which constitute a festive celebration, a triumph of order and vitality over death and indeterminancy" (ibid.).

Between these two stages—separation and reincorporation—there occurs a stage somewhat more difficult to describe. It is the "liminal stage, a period and area of ambiguity, a sort of social limbo. . . . In liminality the novice enters a ritual time and space that are betwixt and between those ordered by the categories of past and future mundane social existence" (ibid.). During this phase, the Turners point out that there are three aspects to liminality: the presentation of sacred things, which may be symbolic objects, including sculptures and actions or myths; the play aspect with the use of masks and costumes; and the "fostering of communitas," a "direct, spontaneous and egalitarian mode of social relationship" (ibid.). It is during this middle stage that instruction in responsibilities and secrets is undertaken. The three stages—separation, transition, and reincorporation—are characteristic of most biological and social changes in the status of the individual.

Van Gennep adds another category to biological and social changes: celestial changes. It can be argued that festivals celebrating changes in the seasons, such as planting and harvest festivals, are quite different from rites that are "responses to the crises of the transitional events of life like birth, death, marriage, initiation or physically moving on" (Abrahams 1982, 167). Seasonal rites tend to be repetitive, not transitional: one enters and leaves the ceremonies without a change of status.

Further, there are times of crisis such as infertility, illness, witchcraft, war, or drought that call forth rituals. When the calendrical, repetitive festivals are combined with crisis rituals and rites of passage, they all become part of the cycle of life, and art objects associated with them can be considered appropriate to this exhibition.

Conclusion

It is dangerous to try in as brief a fashion as this to generalize on the cultural traits and beliefs that gave rise to specific objects. The danger of oversimplification is

great in a subcontinent as large as Africa south of the Sahara with its many different groups speaking different languages. Thus it must be assumed that each object serves a particular purpose among a particular people. From the outside we might discern other objects from other groups that seem to serve similar or analagous purposes, and we can try, as we have tried here, to cluster them according to what seem to be larger, shared categories. Yet no two objects from different groups are entirely alike in use or style. Each is the product of a particular culture and must in the end be acknowledged in its uniqueness.

Sculptures often, perhaps usually, serve more than one purpose. A mask I observed in 1958 among the Igala of Nigeria may be used as an example (fig. 4). Egu Orumamu, the most important of the masks or spirits, serves as the symbol of authority for the chief and the elders. Its power derives from the spirits of the ancestors. It appears twice a year, at the times of planting and harvest, petitioning for a successful food supply, for the Igala are subsistence agriculturalists like most sculpture-producing peoples in Africa. Egu Orumamu also serves as a major symbol of social control: civil and criminal cases are brought before it for adjudication. Secondary masqueraders, whose masks and costumes are of painted, beaten barkcloth, carry out the edicts of Egu Orumamu, which include punishing offenders, collecting debts for the market women, or guarding the village water supply in the dry season. Murder is for the Igala the most serious crime of all; Egu Orumamu will demand that the family or village of the murderer seek out and give up the criminal. The village or family compound can be quarantined, cut off from the rest of society, and no one allowed to enter or leave until the murderer is apprehended. This is not an idle gesture, for it implies economic disaster: farms cannot be tended; water from the communal village source cannot be fetched; wood for cooking fires cannot be collected; and there can be no hunting. In short, all subsistence and communal activity comes to a halt; the group is effectively cut off from the rest of society until it has identified and surrendered the criminal. After the murderer is apprehended—and I was assured that this process never has failed—he is executed by a relative of the victim. This mask serves—even for Africa—in a large number of contexts: basic survival, several judicial functions, and peacekeeping. Thus it gives to the community a broad sense of security (Sieber 1961, n.p.). The elders who showed me the mask and told me of its meaning were excited by its abilities and activities. It is the epit-

ome of security, of social order for the group in an immediate, active, and practical sense. It is not an inert symbol of well-being.

Many of the objects in this exhibition also served more than one end, yet they have been selected and arranged rather arbitrarily as if they had but one primary area of use or meaning. Where possible, the descriptions for individual works will give some hint of the broader meaning of the sculpture while, at the same time, attempting to justify its inclusion in a particular section.

Now, there is no reason to believe that all Africans think of life as a cycle; that is an imposed concept into which can be fitted the various aspects of African life. The concept of cycles is meant to suggest that most peoples in Africa and, indeed, in the world share the same approximate sequence of events and activities, from birth to death. Not all cultures treat all of these activities in the same way, nor with the same intensity or emphasis. Yet in sub-Saharan Africa many peoples use sculpture to mark the events or stages of life.

Seven broad categories have been identified for the exhibition and this catalogue, each referring to an aspect of the cycle of life. Each is illustrated with examples drawn from widely separate African styles and cultures. The examples given are only samples of the many works that could have been included in each category. The categories include "Continuity," art associated with the assurance of the future through human reproduction; "Transition," art in the move from childhood to adult status; "Toward a Secure World," art in the service of adult activities that ensure the well-being of the group and the individual; "Governance," art in the expression of leadership; "Status and Display," art that reflects the cultural role of the owner; "Imports," art that expresses the impact of foreigners on traditional life; and "Departure," art associated with death and the ancestors.

To select only eighty-eight objects, the limit imposed by the exhibition space, to represent the full richness in the form and meaning of African sculpture is a goal impossible to achieve. What we have done is to select works that, in our view, meet several criteria. First, they must conform to the form and style expectancies of the culture that produced them as these are expressed in collections, published examples, and data collected in the field. That is, the work must be central to the form or type and to the style of the group that supported its production. Further, from field evidence or from evidence in the object itself, for example, the patination (signs of handling and care), the piece must have been used in the culture of origin. This establishes two points:

first, that by its use we know that it was acceptable in form and style and, second, that it met at least an aesthetic minimum, that is, it was not considered too crude or typologically or stylistically abnormal to be accepted. Further, any information about the status of the owner is useful. Thus a piece known to have been made for a leader may be expected to express an aesthetic high point for the group (cat. nos. 9, 45). An old piece, well handled, was probably admired (cat. no. 10); also, a work that can be tested and shown to have been long preserved would reflect the esteem of generations of owners (cat. no. 5).

Because we almost never have aesthetic evaluations from the people who made and used the works, it is almost invariably necessary to infer the opinion of the work held by its original owners. Admittedly, such are informed guesses at best.

In addition we must know, with some certainty, the role of the piece in its parent culture. This evidence comes almost totally from field research. The meaning of a work of art is contained in its form and subject matter, but it is accessible only from information from its original users. There is no doubt that it is necessary to learn to become adept at understanding the iconography of Western art. After all, there is no inevitable association, no natural basis upon which a lamb can be equated with Christ or a naked woman with truth. Similarly, it is necessary to learn the associations of form and meaning in African art. Just as there is no "reasonable" basis for assigned meanings in the West, there is no "reasonable" basis for us innately to grasp the meaning of African sculpture.

The object should also fit a historical sequence where one is known. Because little is known except for the very recent history of objects, we have to depend on pieces collected relatively early—say, the late nineteenth or the early twentieth century—to serve as a historical baseline. The absence of signs of recently introduced techniques or materials—saw marks, nails, or European paint in wood carvings; or file marks, aluminum, or certain types of brass in cast metal objects—are useful but not infallible signs of age. Works that survive longer than wood, particularly works in cast metals or fired clay, can often be placed historically either by dating them archaeologically (cat. no. 72) or by analyzing them stylistically (cat. no. 46).

Finally, after determining the centrality of styles and forms of a work of African sculpture, after determining that it was accepted and used in its own culture, and after determining its meaning, then and only then should we apply contemporary Western aesthetic judgments to the work. In brief, if the arts of Africa are to be treated as culturally, historically, and contextually valid, serious attention must be given to nonaesthetic considerations. This of course is in sharp contrast to the original approach to African sculpture by the artists and critics of France and Germany in the early years of the twentieth century. Their approach and appreciation was essentially aesthetic, for African and Oceanic art seemed to offer them viable alternatives to what they considered to be outworn Western concerns with classicism and naturalism.

Much of art history has lost touch with the intensity of the cultural reality that works of art once possessed. Instead, the focus is often on the life of the forms or styles as if they existed independently of the cultures that gave rise to them, cultures that in fact supported the creators and used the objects, not as isolates, but as functioning parts of a cultural whole. The study of art is neither one, the study of contexts, nor the other, the study of forms and styles, but a continuum that reaches from the cultural context in its historical setting through the forms and styles so that the aesthetics of the maker can become comprehensible to a viewer of another culture.

It is to be hoped that the exhibition and this catalogue may offer a window on the complex forms and diverse styles of the sculpture of sub-Saharan Africa. By focusing primarily on the cultural setting for the sculptures, the richness of their uses and meaning will become understandable, and the link between the contextual and expressive aspects will become accessible to the viewer.

I

CONTINUITY

One of the most pervasive concerns of African societies is continuity. The future of the family and the group depends on the ability of the present generation to sire and bear children. Additionally, an individual's sense of social and biological completeness lies in his or her ability to become a parent, for one must depend upon one's children for the proper respect and consideration that is due age. Children not only guarantee the well-being of the individual in life, they will also provide a proper burial and ensure the transition of the spirit of the parent to the afterworld to take its place as an ancestor and possibly to be reincarnated as a member of the family.

Thus it is not surprising to find in African thought and art a ubiquitous emphasis on human fertility. Yet among the ceremonies that are celebrated at the birth of a child, few are accompanied by sculpture. By and large, figurative carvings do not relate specifically to birth or infancy as events but rather to the concept of parenting as a sense of continuity.

Many groups believe in a pair of original ancestors involving a mythology not unlike that of Adam and Eve. Paired figures, male and female, not only depict the primordial couple but may at times refer more generally to "the powers of generation and the life cycle" (Laude 1973, 60). Cole suggests that "sculptured matched pairs," male and female, "are seen as catalysts for much desired large families" and argues that they "are fertility images in a general sense" (1983a, 15). They appear as primordial ancestors among, for example, the Dogon (cat. no. 1) and the Senufo (cat. no. 2).

Perhaps the most famous Dogon depiction of the primordial couple is the example in the Barnes Foundation, Merion, Pennsylvania (figs. 5–6). Laude, in the following passage, discusses a typical Dogon pair:

The man has one arm around the woman's shoulders Here the elements are dictated by the meaning: the couple is eternal. This is not the illustration of an event but a complete recapitulation of history, and the organization of society. The sculptures are commemorative (they recall the events involved in the creation of the world and the organization of society), etiological (they explain the system of the world and the social and political structures of the Dogon), and didactic (they teach the system of the world and those structures). (1973, 59)

As Pascal Imperato puts it, "They were the first human couple which later gave birth to all ancestors" (n.d., 62). They gave birth to four sets of twins, the original eight ancestors of the Dogon (ibid., 14), and they were created in human form by Amma, the creator god (ibid., 26). The Dogon male is often shown as provider and protector, a hunter-warrior with a quiver on his back, and the female as genetrix with a child on her back.

Among the Senufo, pairs of figures representing the ancestral couple are the "sacred possession of the *sinzanga*" (Glaze 1981, 197), "the sacred precincts of the Poro society" (ibid., 259). According to Anita Glaze, the pair symbolizes the civilized state of the initiate and expresses "the purity of the path of Poro" (ibid., 197), the way, in a word, of being a proper, contributing member of Senufo society. The figures "by their economy of form, gesture and facial expression, express an inward-directed energy, containment, and control" (ibid.). They become thereby a symbol of ideal behavior, the civilized aspects of the world (cat. no. 2).

The couples are placed in positions of honor at various events of the Poro association, including the funerals of important members, thus linking the concept of ultimate origin to the concept of death.

Standing in a posture of perfectly controlled strength and containment of gesture and expression, the guardian couple watches over the site where the body will be brought for final ancestral rites and where the maskers perform. In contrast to the idealized humanity of the couple, the aggressive, animalistic forms of the helmet masquerades project a world of dangerous and evil forces brought under the control of sanctioned authority. (ibid.)

Among the matrilineal Senufo, the role of the female is considerable. Indeed, in the statues of the ancestral pairs, the female figure is often larger than the male.

The dominating status of the female figure is a succinct declaration, in plastic terms, of core Senufo social and religious concepts: the procreative, nourishing, sustaining role of both mothers and Deity; the priority of the uterine line in tracing relationships and determining succession rights to title and property; and the special role of women as intermediaries with the supernatural world. (ibid., 51)

Similarly, the female is usually the larger of the pairs of much smaller figures used by diviners. They have as their "primary meaning a reference to the ancestors, the primordial couple, commemorative representations of recently deceased elders, the ideal social unit of man and wife, the twins, the idealized Poro [male] or Sandogo [female] initiate . . . and so on" (ibid., 67). The equipment of the diviner "at a minimal level *must* include a carved figurative male and female pair" (ibid., 69). The figures are, however, very small, averaging about six or eight inches high.

On a broader scale, Cole notes that paired male and female images have occurred "in a variety of media [and] in most of the great sculptural traditions of West and Central Africa since prehistoric times" (1983a, 2). There are references to the primordial couple as ancestors among the Kongo (Balandier 1969, 219) and the Lega (Biebuyck 1973, 52), for example. In some instances, it is difficult to know whether paired figures are meant to be an ancestral couple, and for many it is impossible to discern their meaning without accurate field data (cat. no. 3).

In addition to references to the primordial couple, as such, there are references to a founding mother, such as the Ancient Mother of the Senufo, who is invoked by the men of Poro, who state that they are "at our Mother's work," which is "a combination of formal greeting and password whenever members are engaged in the affairs of Poro" (Glaze 1981, 53). As Cole, depending on Bochet, writes, "Ancient Mother is the primary feminine deity, the genetrix, and her 'child' is culture itself in the

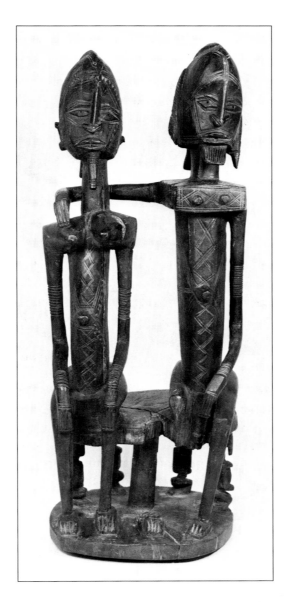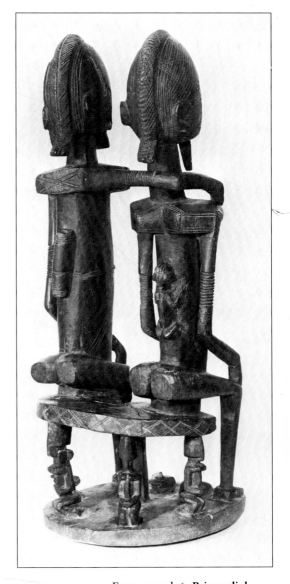

FIGS. 5 and 6. **Primordial couple, Dogon peoples, Mali. The primordial couple commemorates the creation of the world and humankind and epitomizes ideal social pairing.** *(Not in exhibition.)*

larger sense, educated adult males in the narrower" (1985, 9). He also describes the Igbo earth goddess Ala, depicted with children, as "the major tutelary deity [who] presides over community morality and health" (ibid., 15) (fig. 7). She is the greatest of mothers and can withhold or yield crops and children. "She nurtures, yet she kills swiftly and without mercy when offended. . . . She incarnates cyclical regeneration: life, death and rebirth. . . . All villagers and many deities are her children. She is feared and revered" (ibid.; see also Cole 1982).

In most African societies, the most important role of women is to bear children. Whatever else—farming, cooking, or their role in women's associations—their primary responsibility is to produce and nurture children (fig. 8). It is, as Cole puts it, a "biological imperative" (1985, 8) or, as Dennis Warren states, a "cultural

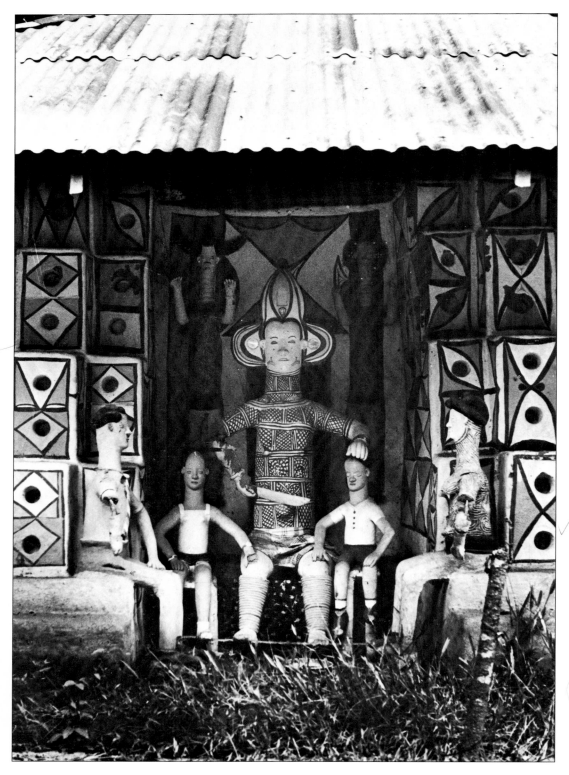

FIG. 7. Ala, the Igbo earth goddess, in an *mbari* shrine, sculptured in mud by Ezem and Nnaji, Owerri township, Nigeria, c. 1964. Ala is surrounded by her "children" and supporters.

duty" (1974, 237). Indeed, certain groups, such as the !Kung, "do not consider a marriage consummated until the birth of a child" (Fried and Fried 1980, 29).

"A person who . . . has no descendants in effect quenches the fire of life, and becomes forever dead since his line of physical continuation is blocked if he does not get married and bear children" (Mbiti 1969, 133).

> Unhappy is the woman who fails to get children for, whatever other qualities she might possess, her failure to bear children is worse than community genocide: she has become the dead end of human life, not only for the genealogical line but also for herself. . . . the childless wife bears a scar which nothing can erase. She will suffer for this, her own relatives will suffer for this: and it will be an irreparable humiliation for which there is no source of comfort in traditional life. (ibid., 110–11)

In such a setting, it is not surprising to find great numbers of images of women with children in Africa. The earliest known are several terra-cottas from Nok in northern Nigeria possibly dating as early as the sixth century B.C. Bernard Fagg writes, "There are two or three pieces, and the frieze of figures . . . which may possibly be representing the concept of motherhood" (1977, 38). The frieze has "repetitive modelling of what is probably a 'mother and child' motif" (ibid., pl. 42). Images of women holding children may reflect a number of ideas, for example, they may represent ancestors and serve as "symbols of lineage or clan forbears, the generalized and incarnate dead" (Cole 1985, 8). It can only be conjectured that the Djenné example (cat. no. 4) with its "mother" and adult "children" may be an instance of such a meaning.

In most cases, the child or children are not identifiable; indeed, they are often amorphous or even caricatural in form. William Fagg refers to the "unwritten law on the portrayal of mothers and children in sculpture, a law so general that it must surely have a philosophical basis. This is the rule that children are not given a personality or character of their own, but are treated as extensions of their mother's personality" (in Vogel 1981, 124). Others, such as Vogel, note:

> Because children are not fully "civilized" (or socialized), productive members of society, their depiction in art makes little sense. Infants, in contrast, often appear in a secondary role, representing the productivity of the mother. To cite a parallel from life, one often sees a woman dressed up and carrying a child (not necessarily her own) as a sort of costume accessory. A woman looks better with a baby. (1980, 13)

Thus we come at once to a major contrast between African maternity images and Christian images of Mary and the Christ child. In the latter, the primary focus is on the infant, and the mother is definitely a secondary figure. This is clearly the reverse of the roles of child and mother in African examples. The child, as a symbol of maternity, supports and reinforces the role of the mother as genetrix for the family and the group.

Examples are known where the mother is standing (cat. nos. 9, 11), kneeling (cat. nos. 4, 7, 10), or sitting (cat. nos. 5–6, 8); the child may be suckling or may be held on the lap or carried on the back, and there may be more than one child (cat. no. 8). In contrast, scenes of birth are rare, and the rituals surrounding birth rarely make use of sculpture.

Henry Drewal (1978, 564) has pointed out that among the arts of the Yoruba, "Mothers shown nursing or carrying children represent the long weaning period (approximately two years), a time of sexual abstinence and suppressed menstruation . . . which is seen as a state of purity or ritual cleanliness." Elsewhere he states, "Pregnant and nursing women achieve a state related to that of elder women," who are past menopause and therefore free of the pollution of menses. Thus mother and child images

> denote a state of natural purity; for during the long nursing period . . . when the child is carried on the back, a woman's menstruation is suppressed and she practices sexual abstinence. . . . Thus images of women in ritual contexts and mother and child figures represent much more than symbols of fertility. They communicate sexual abstinence, inner cleanliness, ritual purity, female forces and spirituality. (1977, 5)

Some Yoruba figures (cat. no. 7) are shown kneeling, "a position of respect, devotion, and even submission to the gods. This posture is appropriate [because] most women in Yoruba sculptures represent royal wives or worshippers, not gods themselves" (Cole 1985, 19).

It is evident that although the specific meaning of images of maternity may vary from group to group and be associated with nature deities, ancestors, the group genetrix, or divination, they all ultimately and surely refer to human fertility and the future of the group that is grounded in that fertility.

There are images that are specifically approached when a woman wants to conceive. Such images are found on Yoruba doors or as shrine images in Ghana in the town of Anyinabrem where the sculpture of a

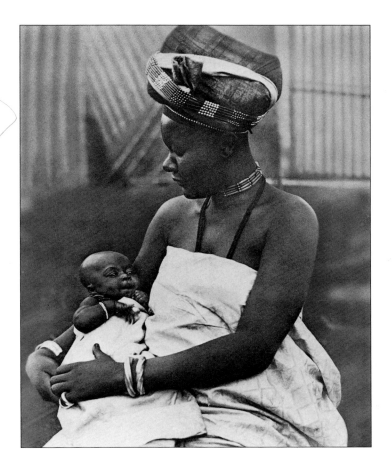

FIG. 8. Mother and child, Bamum Kingdom, Cameroon. Princess Ngutane cradles her firstborn son, Amidou Mounde, who was born in 1915.

mother suckling a baby was visible and, "when barren patients come to the shrine and see this statue they know the god can help them to get a child" (Warren 1974, 386).

Much more common in southern Ghana among several groups are *akua'ba* images, which are believed to relate directly to human fertility (cat. no. 13). These may be used by a priestess, as Warren reports (ibid., 388), to help barren women have children, or they may be carried by a woman after she conceives to ensure that she will have a healthy and handsome child. Others, quite similar in form, may help a woman "keep" a child that has been born several times but has not lived. It is believed that the intervention of the fertility deity will ensure a successful birth.

R.S.

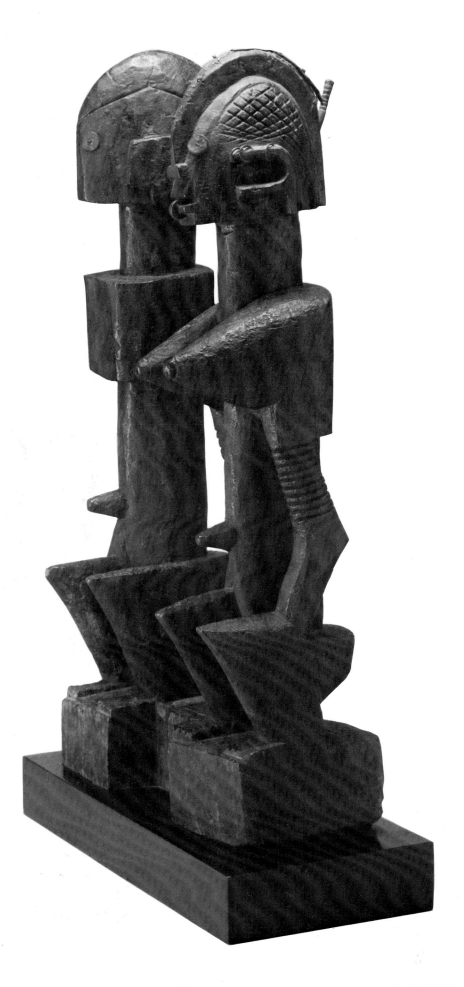

PRIMORDIAL COUPLE
Dogon peoples, Upper Ogol or Lower Ogol village,
 Mali, 20th century
Wood, iron
H. 23¾ in. (60.3 cm)
Collection of Murray and Barbara Frum

The Dogon explain the origin of human beings in
complex, often confusing myths about the creation of
the world. Through trial and error, Amma (God)
eventually created a pair of human male and female
twins that in turn gave birth to three other sets of
twins. Together, all of these sets of twins constitute
the eight original ancestors of the Dogon lineages.
However, they did not stay on earth but were
transformed into the Nommo, or heavenly twins in
nonhuman form, and went to live with Amma in the
sky. The Nommo carried in them the seeds of
civilization—smithing, weaving, and agriculture—
which they introduced to the human world upon
returning to the earth (Griaule and Dieterlen 1965;
Imperato n.d., 13–15).

 Large seated male and female figures, exemplified
by this piece, are thought to represent the Dogon
primordial couple in human form (Imperato n.d., 15).
Or, in reference to the nonhuman Nommo, such
figures can be a metaphorical visual statement of
Dogon ideology expressing interdependence and
complementarity of male and female, as well as order
and harmony in the universe (Flam 1970; DeMott
1982, 28–37).

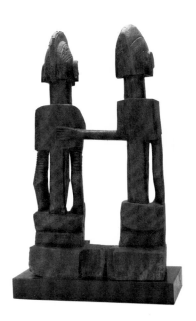

2

PRIMORDIAL COUPLE
Senufo peoples, Côte d'Ivoire and Mali, 20th century
Wood, traces of pigment
H. of male 45⅝ in. (115.9 cm); H. of female 38⅛
 in. (96.8 cm)
Collection of Milton F. and Frieda Rosenthal

Large sculptured male and female figures represent the Senufo primordial couple. Their secret names are "ones who give birth" or "ones who bear offspring." To the Senufo, "the couple represent the ideal social unit, the 'reborn' initiated man and woman as the ideal standard of social, moral, and intellectual formation, the reverence for the ancestral lineages of *Poro* graduates who have 'suffered' for the group during their lifetime" (Glaze n.d., n.p.).

The male is shown wearing an open-worked headdress and holding a fly whisk, which are emblems of the Kwonro (also known as Kworo) age-grade of the men's Poro association. The female is depicted as a fully initiated woman, as indicated by the ritual scarification and adornments of women's Sandogo association initiates. Together they represent complementary spheres of Senufo life. Poro is the sociopolitical educational institution for men that transcends kinship lines and household ties. Although all males must be initiated into Poro to become full adults, not all men acquire the specialized knowledge to achieve its highest grades. The women's Sandogo association exercises social control through its knowledge of genealogy and kinship (thereby guarding kin-group relations), as well as through the activities of its divination specialists (Knops in Goldwater 1964, 20; Glaze 1981, 46–48).

Figures representing the primordial couple are traditionally displayed at commemorative funerals of important Senufo elders and, among some dialect groups, at other rites of passage, such as coming-of-age ceremonies. Often referred to as "rhythm pounders," the figures may be carried by Poro initiates and struck against the ground during certain stages of the funeral.

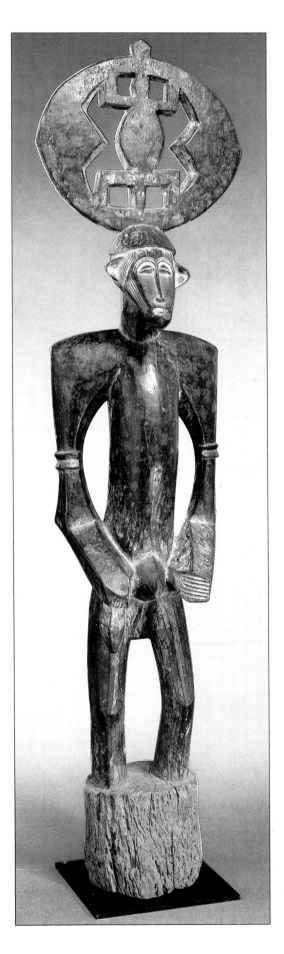
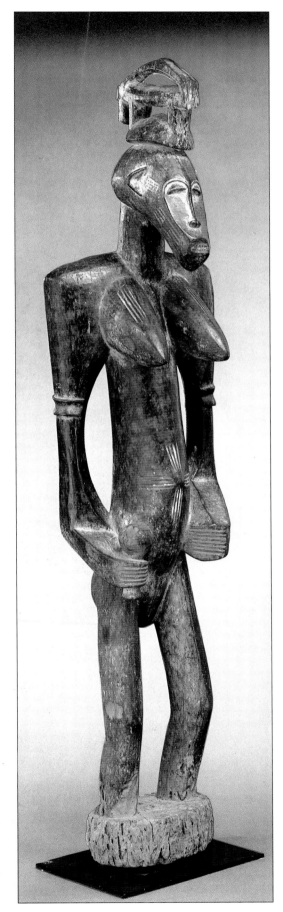

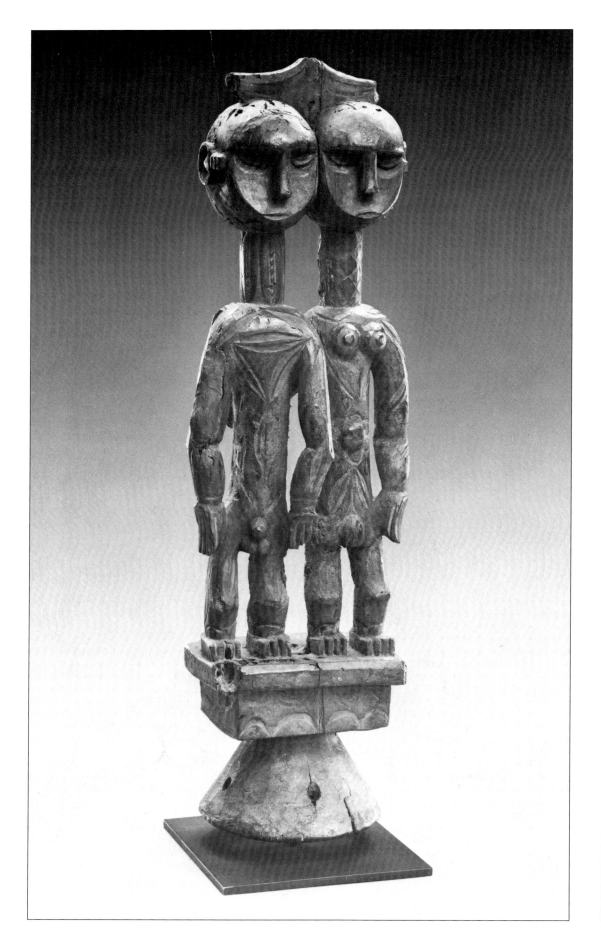

HEADDRESS
Eket group, Ibibio peoples, Nigeria, 19th–20th
 century
Wood, traces of pigment
H. 23 in. (58.4 cm)
Private collection, Belgium

Isong (also known as Ekong) is the Ibibio goddess of
the earth. She was especially worshiped by the Eket
group living near the Atlantic coast. They honored
her in the elaborate Ogbom masquerades, which
celebrated her role as the source of fertility and
increase among humans, animals, and plants. The
details of the Ogbom cult and masquerade are not
well known because worship of Isong declined in the
face of increased conversions to Western Christianity
early in the twentieth century. However, it is
probable that the pair of figures depicted on this
headdress represents Isong and her consort, the sky
god (Neyt 1979, 20–23; Jones 1984, 198).

 This carved wooden superstructure was attached to
a basketry frame and carried on the head of a
costumed dancer.

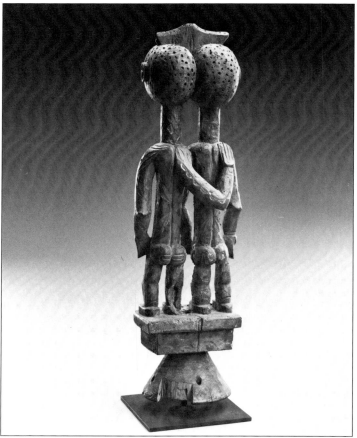

4

MATERNITY FIGURE
Inland delta region of the Niger River, Mali, late
 12th–late 14th century
Terra-cotta
H. 15⅛ in. (38.4 cm)
Collection of Count Baudouin de Grunne, Belgium

Since the 1940s, the excavations in the inland delta
region of the Niger River near Djenné in Mali have
yielded numerous sculptured terra-cotta, cast copper-
alloy, and gold figures representing humans and
animals. These sculptures originated in advanced,
flourishing cultures that may have existed as early as
the eighth century A.D. or as late as the seventeenth
century.

Figures representing a mother and child seem to
occur less frequently than other subjects, such as
chiefs or warriors on horseback, reclining or kneeling
females, or animals, especially snakes. The meaning
of these ancient maternity figures is unknown. In this
example and in other instances, the "children" are
obviously mature adults, as indicated by the beard on
one of the males in this figure. Perhaps such figures
served as symbols of the primordial mother or
another mythical figure in the history of a clan in
which the sculpture originated. Regrettably, the
stratigraphic context in which most of these objects
have been discovered and other pertinent data are
unknown. Even so, it is possible to date the objects.
In 1979 this figure was dated by the thermolumines-
cence method to 690 ± 105 years earlier (de Grunne
1980, 27, fig. 1.15).

The proliferation of decorative details on the figure
includes serpents, which are depicted as zigzags.
Snakes commonly occur in the visual arts as well as
in the oral traditions of numerous peoples of the
inland delta region. Snakes play an important role in
the cosmology and mythical origins of the clan. For
example, snakes are king makers, designating the
successful candidate by touching him with the nose
(ibid., 17–35). Snakes are often considered to be
symbols of immortality throughout sub-Saharan
Africa because they "renew" themselves by shedding
their skin (Parrinder 1954, 51).

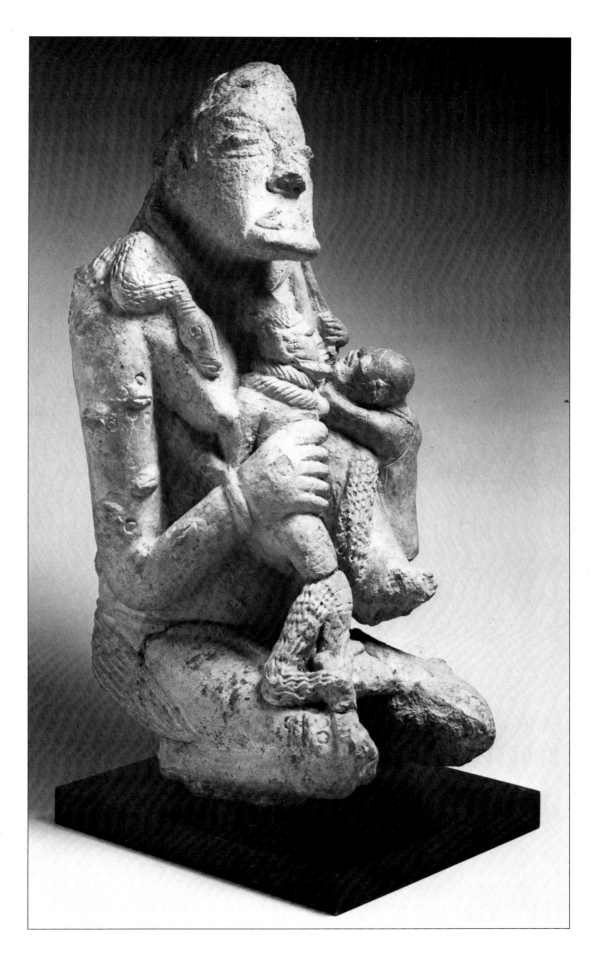

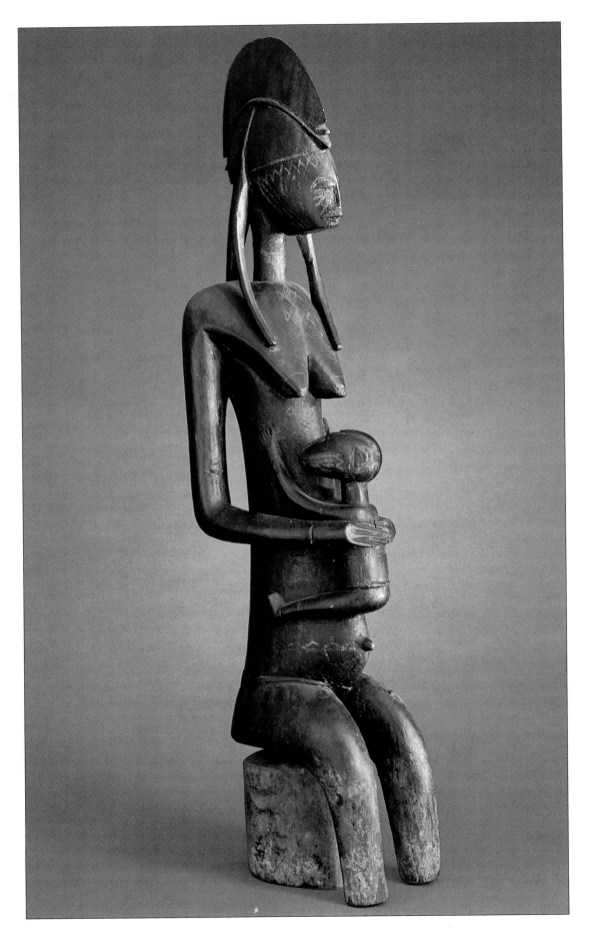

5

MATERNITY FIGURE (*Gwandusu*)
Bamana peoples, Mali, 17th–19th century
Wood
H. 46½ in. (118.1 cm)
Collection of Gustave and Franyo Schindler

In traditional African societies, a childless marriage is a grave problem that has serious repercussions on the relationships between wife, husband, and in-laws and on the village as a whole. Further, childlessness seems to be the wife's problem to resolve. According to Kate Ezra (1986), women with fertility and child-bearing problems in Bamana society affiliate with Gwan, an association that is especially concerned with such problems. Women who avail themselves of its ministrations and who succeed in bearing children make extra sacrifices to Gwan, dedicate their children to it, and name them after the sculptures associated with the association.

Gwan sculptures occur in groups and are normally enshrined. An ensemble includes a mother-and-child figure like this one, the father, and several other male and female figures. They are considered to be extremely beautiful, that is, "things that can be looked at without limit" (ibid., 22), because they achieve the Bamana standard for sculpture: they illustrate ideals of physical beauty and ideals of character and action. The figures are brought out of the shrine to appear in annual public ceremonies. At such times, the figures are washed and oiled and then dressed in loincloths, head ties, and beads, all of which are contributed by the women of the village.

Sculptures depicting a seated female figure clasping an infant to her torso are called Gwandusu. The name implies such ideal attributes as "extraordinary strength, ardent courage, intense passion and conviction as well as the ability to accomplish great deeds" (ibid., 30).

This figure has not been scientifically dated. However, a seated female figure in the Metropolitan Museum of Art that is stylistically and iconographically similar dates at least from the seventeenth century (ibid., 28, 44).

6

MATERNITY FIGURE
Asante group, Akan peoples, Ghana, 19th–20th
 century
Wood
H. 20 in. (50.8 cm)
Collection of Gustave and Franyo Schindler

Fertility and children are the most frequent themes in
the wooden sculptures of the Asante. Thus the most
numerous works are *akua'ba* fertility figures (cat. no.
13) and mother-and-child figures. In traditional
Asante society, in which inheritance was through the
maternal line, a woman's essential role was to bear
children, preferably girls to continue the matrilineage
(McLeod 1981a, 164). Sculptured mother-and-child
figures show the mother nursing or holding her
breast, as exemplified by this figure. Such gestures
express Asante ideas about nurturing, the family, and
the continuity of a matrilineage through a daughter
or of a state through a son.

This figure does not depict an ordinary mother.
Rather, as indicated by her elevated sandaled feet, the
figure represents a queen mother as she would sit in
state on formal occasions. Such royal maternity
figures were kept with the venerated seats of
ancestral chiefs in special rooms, or they were housed
in the shrines of powerful deities that were
particularly concerned with the well-being of a royal
person, perhaps a queen mother (Cole and Ross
1977, 111).

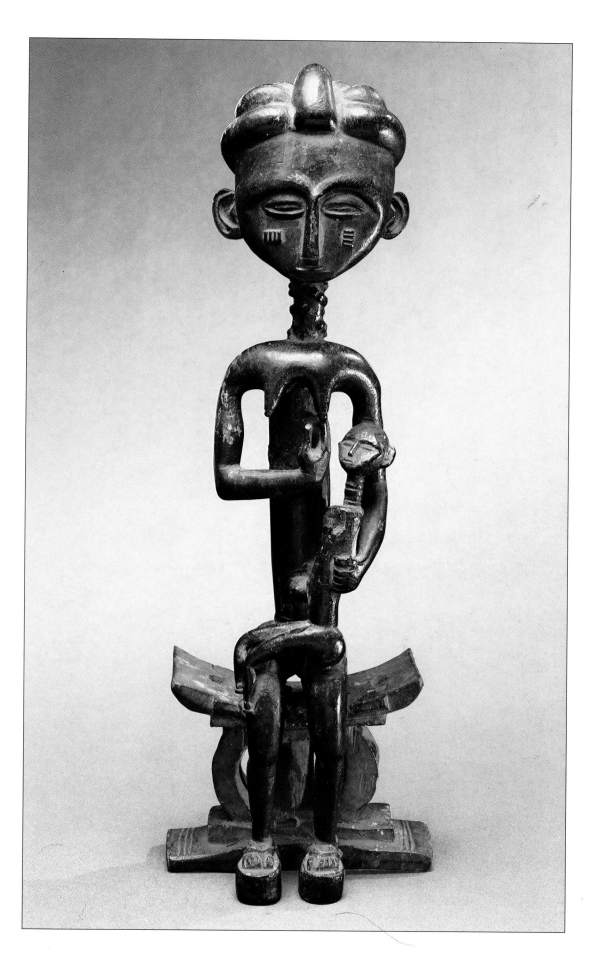

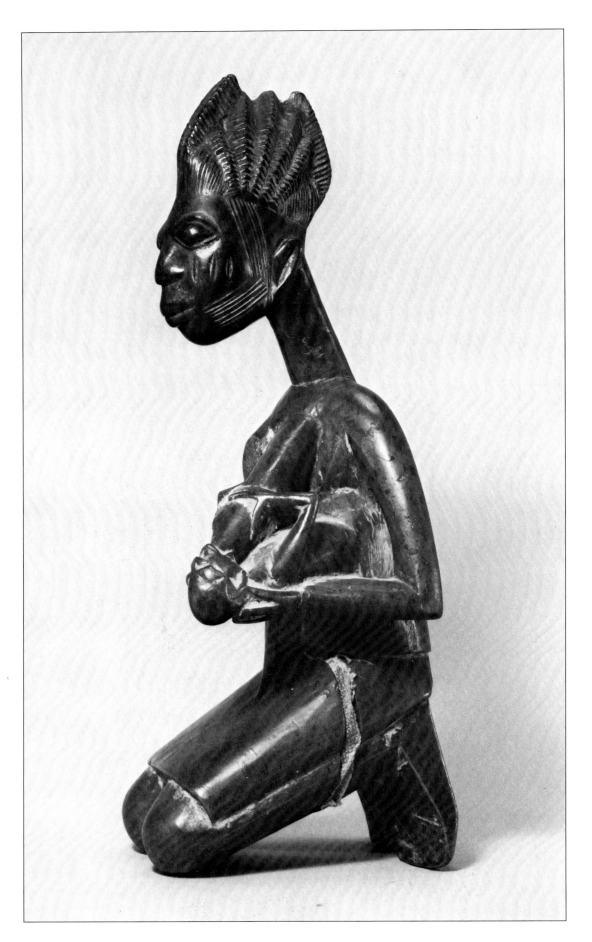

7

MATERNITY FIGURE
Yoruba peoples, Nigeria, 19th–20th century
Wood
H. 16¾ in. (42.5 cm)
Collection of Rita and John Grunwald

According to Yoruba belief, children are blessings from the gods. Before the advent of modern medicine, women petitioned certain deities for fertility and the birth of a healthy infant. The shrines to these deities—Erinle, Yemoja, Shango, Ogun, and others—were adorned with sculptured figures representing a mother and child, as exemplified by this figure. The absence of cult attributes makes specific identification of this figure impossible. The kneeling position is a gesture of respect, devotion, and submission. Thus the figure represented in the carving is probably a petitioner rather than a deity. The sculpture may have been a votive offering from a woman who had successfully petitioned for a child, a priest or priestess of a cult, or even the entire body of worshipers (Bascom 1969b, 107; Cole 1985).

8

MATERNITY GROUP FIGURE
Afo peoples, Nigeria, 19th century
Wood
H. 27¾ in. (70.5 cm)
Horniman Museum, London
31.42

Afo maternity figures are thought to represent an ancestral mother (Fagg 1963, fig. 143b) and are owned by individual villages. These figures are brought out of their shrines once a year for the Aya ceremony. At this time, men pray for increased fertility in their wives and make gifts of food and money to the ancestor (Tschudi 1969–70, 93; Leuzinger 1972, 208; Kasfir in Vogel 1981, 163).

Extant maternity figures from the Afo are usually monoxylous, that is, carved from one piece, and are usually shown with only one child. This female figure is carved from one piece of wood; however, the child on her lap, the arms of that child, and the head of the child clinging to her back are carved separately. The separate pieces are fitted on with wooden pegs.

The Horniman Museum acquired this maternity figure in 1931 from Major Fitz Herbert Ruxton, a British colonial officer in Nigeria. The figure is believed to date from before 1900 (Fagg 1963, fig. 143b).

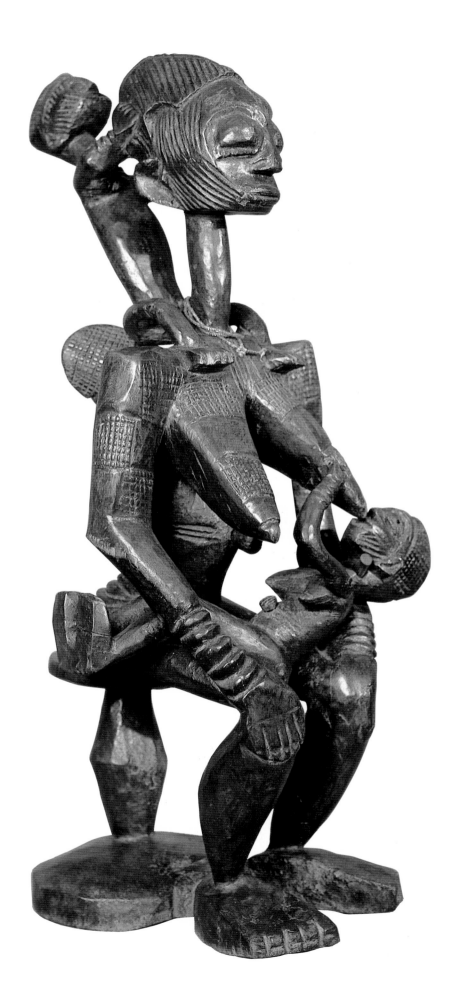

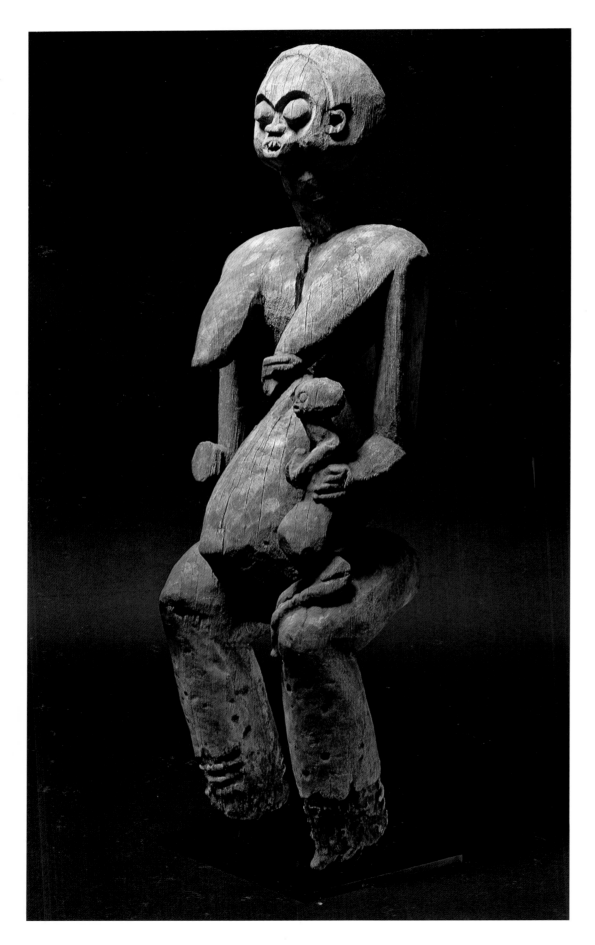

9

MATERNITY FIGURE
Artist: Mbeudjang, Batufam Kingdom, Bamileke
 peoples, Cameroon, c. 1912
Wood, pigment
H. 39⅞ in. (101.3 cm)
Collection of Murray and Barbara Frum

It was customary in the grasslands Batufam Kingdom
to have portrait statues carved of the new *fon* (king)
and the wife who bore his first child. According to
royal custom, the heir to the throne could not rule
until he proved his fertility. The sculptures were
executed within two years of the beginning of the
reign and were used in the rites of installation of the
successor. The female figure shown here is a portrait
of Queen Nana, the wife of Metang, who was
installed between 1912 and 1914, and their first
child. Mother-and-child figures and those of kings
were erected outside the palace, where they were on
permanent display, protected by the roof of the
verandah (Harter in Fry 1978, 118–22; Harter 1986,
54).

10

SCEPTER (*Mvuala*) FINIAL
Yombe group, Kongo peoples, Zaire,
 probably 18th century
Ivory, metal
H. 8¼ in. (21 cm)
Collection of Count Baudouin de Grunne, Belgium

The Kongo Kingdom flourished from c. 1300 to the mid-seventeenth century. The Kongo were the first people of Central Africa to make contact with the Portuguese navigators, who first arrived in 1482 and brought with them Catholic missionaries, merchants, and artisans. The Kongo aristocracy embraced Christianity and Western culture, and trade with Portugal resulted in increased wealth and military power. From the capital at São Salvador in present-day Angola, Kongo rule extended into portions of Zaire, Congo, Cabinda, and numerous small coastal and inland chiefdoms in Angola. Around the mid-seventeenth century, the once-powerful kingdom began to founder and shrink. Finally, it collapsed and became decentralized.

Among the symbols of rank belonging to Kongo kings and chiefs were scepters (*mvuala*) made of hardwood and usually topped by an ancestor figure carved of precious ivory. Very often the ancestor so represented was a female (Cornet 1971, 48). Because power was transmitted through the female line, rulers were selected from among the matrilineage. The king's mother was titled the "queen mother," and although she did not share rule with her son, she held a position of respect and privilege (Murdock 1959, 297).

Although the precise meaning of this Yombe mother-and-child figure is not known, it probably symbolizes woman as the source of human fertility and the bearer of healthy children—in this case, healthy future rulers. Clearly this mother belongs to the ruling class, as indicated by her cap ("chief's hat") and carefully coiffed hair, filed teeth, and jewelry. A similar cap is worn by the infant, who, as real babies do, holds his mother's breast with one hand and tugs on her hair with the other.

Despite the submissive pose, Kongo women were powerful, and images like this are a reminder of their importance.

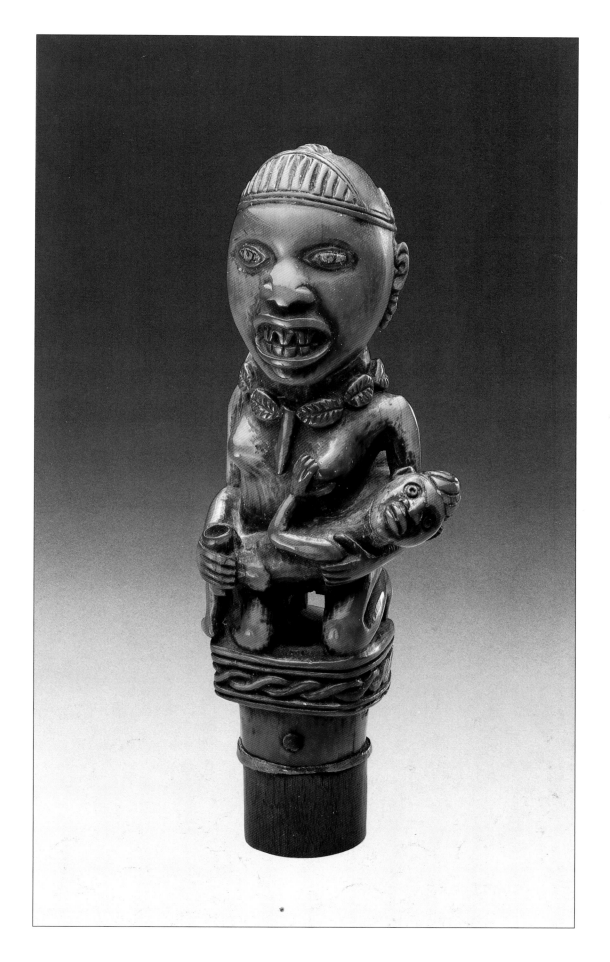

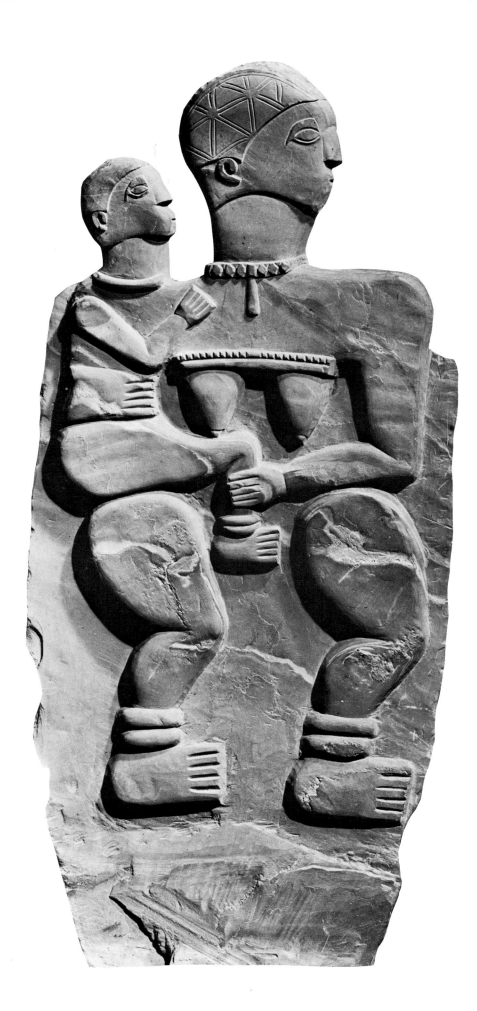

11

GRAVE STELE WITH MOTHER AND CHILD
Musurongo group, Kongo peoples, Angola, 19th
 century
Steatite
H. 46½ in. (118.1 cm)
Rijksmuseum voor Volkenkunde, Leiden, Netherlands
449/3

Among the Kongo peoples, large families were desirable. A mother who had many children and grandchildren was honored like a great chief (Laman 1957, 16–18).

In Musurongo society, expectant mothers who died before or during delivery were believed to be victims of malevolent or unhappy spirits. Stelae bearing low-relief images of a mother and child were carved from soft steatite and erected in the vicinity of the graves of such women. These stelae were considered to be receptacles for the spirits of dead mothers, from whom protection against the same fate was solicited (Verly 1955, 523–24).

The mother represented on this stele probably belonged to the Kongo aristocracy, as indicated by several symbols of prestige: a pineapple leaf fiber cap ("chief's hat"), a necklace probably made from precious glass beads and metal, a pectoral cord, and metal anklets.

Most extant stelae from the Musurongo were collected before 1916 from the coastal town of Ambrizete and its vicinity on the northern coast of Angola. This stele was acquired by the Rijksmuseum voor Volkenkunde in 1884.

12

MATERNITY FIGURE
Lulua peoples, Zaire, 19th–20th century
Wood, copper alloy
H. 14 in. (35.6 cm)
The Brooklyn Museum
50.124

Among the Lulua, the Buanga Bua Cibola, a fertility cult, addresses the plight of mothers whose babies were stillborn or died in infancy. The cult ensures that the soul of the deceased infant returns to its mother's womb to be reborn. Figures representing a pregnant woman or a mother and child, carved as a complete figure or ending in a point like this one, are used in the cult. During pregnancy a woman is isolated for a specified period of time as imposed by the cult and commissions a figure from a sculptor. Upon the delivery of the sculpture, the period of isolation ends. Once it is in her possession, she keeps the figure in a basket near her bed and regularly rubs it with oil and *tukula*, a paste made from a hardwood. The figure is brought out on nights when there is a full moon, a symbol of fertility (Maesen 1982, 55).

Characteristic of Lulua statuary and people, this maternity figure has elaborately coiffed hair and a gleaming skin that is covered with detailed scarification. These are more than expressions of the Lulua aesthetic; rather, *buimpe* (beauty) is simultaneously a moral and a physical quality, which is manifested in the quality of one's skin. Without a beautiful skin, one is considered evil. Thus the "healthy skin" of the figure must be achieved by the woman to ensure the moral and physical integrity of her newborn child, the reborn ancestor.

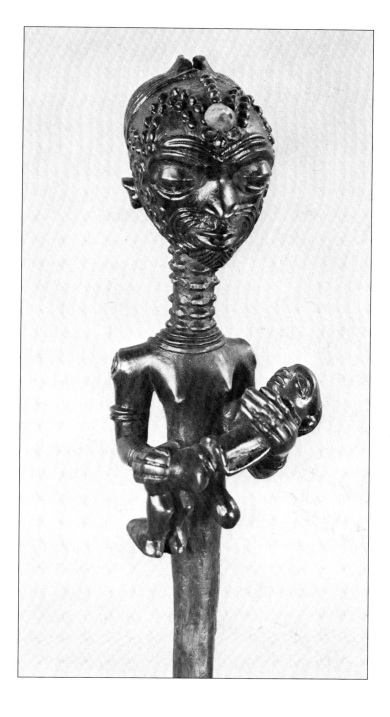

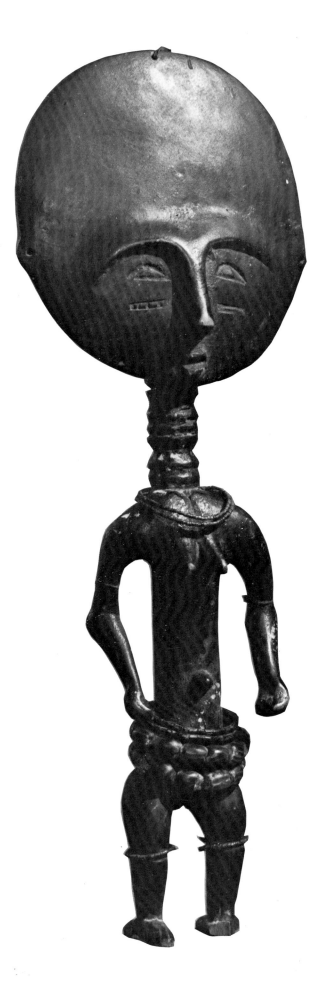

FERTILITY FIGURE (*Akua'ba*)
Asante group, Akan peoples, Ghana, 20th century
Wood, beads, string
H. 10¾ in. (27.3 cm)
The Metropolitan Museum of Art, The Michael C.
 Rockefeller Memorial Collection, Bequest of
 Nelson A. Rockefeller, 1979
1979.206.75

Akua'maa (sing., *akua'ba*) are sculptured wooden figures that are believed to induce pregnancy and ensure a safe delivery and a beautiful, healthy infant. After the *akua'ba* is blessed by the fertility deity in rites conducted by a priest, the woman carries it and treats it like a real child; she adorns it with beads and earrings, "nurses" it, and puts it to bed. After a successful birth, a mother may give the *akua'ba* to a daughter to play with or use it to teach child care (Cole and Ross 1977, 103–7; McLeod 1981a, 162–65).

Females are, with rare exceptions, the only sex represented in *akua'maa*. There are several reasons for this, but the essential one is that Asante society is matrilineal and the family line is passed from the mother to the daughters, not from the father to the sons (McLeod 1981a, 19, 164). Thus it is essential that a woman have daughters to perpetuate the family line, and it is desirable to have daughters to help with household chores and take care of younger siblings.

Akua'maa illustrate Asante concepts of beauty: a high oval, flattened forehead that in reality is achieved by massaging an infant's soft skull; a small mouth; and a neck ringed to depict creases caused by subcutaneous fat, indicating the good health of the infant. In contrast to typical *akua'maa,* which have truncated bodies, this *akua'ba* has naturalistic arms and legs. It has been estimated that such figures constitute less than 1 percent of the total number of *akua'maa* and may be a twentieth-century innovation (Cole and Ross 1977, 105).

2

TRANSITION

Life may be interpreted as a series of transitions from one status or condition to another. In most instances, the transition is a step forward or upward. Every person moves from a

> fixed placental placement within his mother's womb, to his death and . . . final containment in his grave as a dead organism—punctuated by a number of critical moments of transition which all societies ritualize and publicly mark with suitable observances to impress the significance of the individual and the group on living members of the community. (Warner in Turner 1977, 168)

Possibly the most noteworthy of transitions, and one that is most frequently celebrated with works of art, is the move from childhood to adulthood. During that period the youths must be prepared for adult activities and responsibilities and the community prepared for the new adult status of the initiates.

Mbiti notes, "Initiation rites dramatize and effect the incorporation of the young into the full life of their nation. Only after initiation . . . is a person religiously and socially born into full manhood or womanhood with all its secrets, responsibilities, privileges and expectations" (1969, 134–35). As we have noted earlier, initiation rites almost always include the symbolism of the death of the child and the rebirth of the novice as an adult.

In initiation the transition is from the relatively ignorant and irresponsible state of childhood to the state of responsible adulthood, which includes a readying for marriage. "One could say then that initiation is a ritual sanctification and preparation for marriage, and only when it is over may young people get married" (ibid., 135).

There have been a large number of reports of initiation ceremonies, some dating from the nineteenth century (Webster [1908] 1932, 206–11; Kingsley 1897, 526ff). They refer to male and female secret associations that were reported for most of Africa south of the Sahara. It has been argued by a number of authors that many secret organizations had lost much of their power and influence by the beginning of the twentieth century. As instances, Webster cites in particular the Simo association of Guinea and also other associations in Gabon and Zaire ([1908] 1932, 172). Further, George Harley states, "The ritual of the Poro [men's association among several groups in Liberia] as it was in the old days can never be described in full because those who saw it were bound by an inviolable oath never to reveal its secrets on pain of death" ([1941b] 1974, 123). In contrast to those who argue that associations are a thing of the past, d'Azevedo reports that the Poro association among the Gola of Liberia "has continued to exert enormous conservative pressure to the present day, and political leadership is largely responsive to Poro sanctions" (1962, 515; see also Glaze on the Senufo of Côte d'Ivoire 1981). However, it is clear that modern ways have tempered the effect and importance of traditional initiation, so that in many places it has been reduced in time and intensity to accommodate modern life.

Yet in traditional life the "initiation of the young is one of the key moments in the rhythm of individual life, which is also the rhythm of the corporate group of which the individual is a part" (Mbiti 1969, 121). Most descriptions of initiation ceremonies describe the process as it pertains to males. Further, nearly all descriptions relate the three-step process that has been described in the section of the Introduction concerning rites of passage: separation, or removal from a previous state; transition, or learning adult secrets and responsibilities; and incorporation into a new, adult status. In discussing rites of passage, Meyerhoff writes:

FIG. 9. Boys' initiation, Gabon, 1926. When a boy is initiated into adulthood, he wears special clothing or a mask. His body may also be painted with white clay.

Initiation rites firmly separate the boy from maternal figures, sever his identity with the mother and place him psychologically and socially within the father's group. A male is, in these conditions, twice-born, once into the world of the mother and female society, then at puberty he symbolically dies and is reborn into manhood and the world of men. (1982, 132)

Thus the child is removed, often forcibly, from the company of mother and younger siblings. This is the "death" of the child, who at times is said to have been eaten by a forest monster. Harley has described the operation of the men's Poro association among several groups in Liberia ([1941b] 1974, 13ff). The heads of the Poro and the Sande women's association met to plan the "bush school." After a site was chosen for the boys' encampment and things were ready, masked men warned villagers of the arrival of the spirits; then,

at the entrance the boys went through a ceremonial 'death.' In the old days they were apparently run through with a spear and tossed over the curtain. Onlookers heard a thud as he was supposed to hit the ground inside, dead. . . . The boys were actually unharmed, and were quickly carried away into the deep forest which is the Poro grove. (ibid., 13–14)

Special dress and special food were ordained for the novices. Women were not to see or know of any of the activities of the Poro bush school, nor were they to see the—supposedly dead—novices. If a woman saw an initiate, she was told it was a spirit and she should run away or be heavily fined, though formerly she would have been killed (ibid., 14).

Secrecy is an important part of the initiation process; to learn the secrets is to become a member of a closed group. "The purpose of secrecy sometimes is to keep the magic power from the hands of unbelievers or of enemies who may use it for sorcery, but in many other cases it is intended to make those who are excluded believe that the initiates have superior powers" (Bettelheim 1954, 228). The revelation of secrets is an extremely serious breach of proper behavior. For example, among the Mano of Liberia, it is believed that leprosy and insanity are caused by breaking the taboo of secrecy of the Poro and Sande associations (Harley [1941a] 1970, 35). A similar belief concerning leprosy is held by the Ndembu of Zambia (Turner 1967, 302).

The boys are circumcised during the initiation. "The boy was still an outsider even after being circumcised

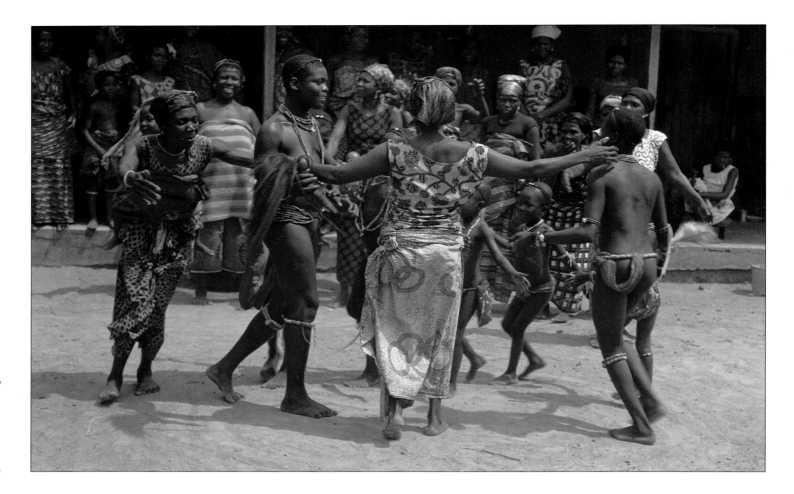

FIG. 10. Girls display their dancing skills, Ga peoples, Dodowa, Ghana, 1967. The girls' progress in their initiation is expressed by their hairstyles, the number of beads they wear, and the songs and dances they have learned.

until the spirit had 'eaten him,' that is until he had been scarified with the special marks of the Poro" (ibid., 15). Van Gennep notes that "mutilations are a means of permanent differentiation; there are also temporary differentiations such as the wearing of a special dress or mask, or body painting" ([1908]1960, 74). The body painting is often with white clay (fig. 9). Circumcision and scarification are marks that signal the changed status of the child who has entered a new state and can no longer return to the status of childhood. He has been abruptly removed from the comforting shelter of the mother and moved to the world of the father. "These are rites of separation from the asexual world and they are followed by rites of incorporation into the world of sexuality and . . . into a group confined to persons of one sex or the other" (ibid., 67).

The bush spirit that "devours" the boys is in some groups a large horizontal mask with a crocodile-like mouth called Dandai or Landai (cat. no. 17). "He was supposed to swallow the boys and give them rebirth at the end of Poro. The scarifications were marks of his teeth" (Harley [1941b] 1974, 27). Dandai accompanied the boys on their return to the village and the assump-

tion of their responsibilities as adults.

During the stay in the Poro encampment, the boys are taught the responsibilities of adulthood and the "secrets" of Poro. At times in the old days, they would also learn a craft. Among the Ndembu, "it is not a mere acquisition of knowledge but a change of being. His apparent passivity is revealed as an absorption of power which will become active after his social status has been redefined in the aggregation rites" (Turner 1967, 102). Part of the learning process is the revelation of the secrets, often referred to as "sacra" (van Gennep [1908] 1960, 79; Turner 1967, 103–8). These secrets may be verbal or musical, or they may be physical objects and their revelation part of the training process, although the objects will continue to be used as instructional devices, as among the Lega (cat. nos. 50–51). Masks, for example (cat. nos. 14, 16–21), are revealed to the initiates as objects, not as spirit forces. Often the word that names a procedure or an object is itself a secret and cannot be revealed to the uninitiated.

Art works, then, may be associated with the learning phase of "initiations of various types (boys' and girls' initiations; men's and women's associations), [where]

complex systems of learning prevail. In such contexts the artworks are not simply used for the external purposes of dance, social control, and spirit control; they serve as devices of learning and as symbols of knowledge" (Biebuyck 1973, 234).

Generally in Africa, there is a surprising similarity among boys' initiation programs. Details may vary, masks may be absent or quite different in form and action, languages and myths may differ, but the essential three phases of the initiation into adulthood are followed.

The initiation of girls into adulthood is often simpler than that of the boys. Only rarely are masks involved (cat. no. 18), and the initiation tends to have "fewer teaching elements than [for] boys" (Bettelheim 1954, 239). Girls' puberty is marked physiologically with the onset of menstruation. Boys have no equivalent sign of adulthood. Yet both boys' and girls' initiation rites may take place earlier or later than sexual maturity. Thus initiation ceremonies are generally associated with social puberty. As van Gennep asserts, "Physiological puberty and 'social puberty' are essentially different and only rarely converge" ([1908] 1960, 65).

Harley discusses girls' initiation less knowledgeably than he describes Poro. He defines the women's Sande secret association as "an organization for the education of the girls" ([1941b] 1974, 27), although he admits to little knowledge in detail. The bush camp is prepared by the men; the connection between the highest levels of Poro and Sande is reiterated (ibid.). D'Azevedo describes the relationship among the Gola thus:

Poro leaders are ritually the "husbands" of their female agnates who lead the women's Sande society, and who, as "obedient wives," train all the women in correct deportment as wives and mothers toward the efficient operation of "true Gola laws." In this sense the Poro leaders and the leaders of Sande represent an ideal family in which all members are agnates, symbolically married to one another against all normative prescriptions for the good of the collective. (1962, 514)

In discussing the relationship between the men's and women's associations of the Senufo of Côte d'Ivoire, Glaze writes:

Significantly, the mere presence of both a women's society and a men's society is by no means the critical aspect of "balance." This would be far too static an image to portray what in reality is an ingeniously graded series of structured opportunities for dynamic interaction between the male and female sectors of the community. (1981, 50)

As with the boys, sexual intercourse or indeed any contact with the opposite six is taboo, as is revealing the secrets of the society. "The girls are circumcised . . . taught all matters pertaining to sex, as well as the art of pleasing a husband. They learned to cook, take care of a household, sing and dance, the art of poisoning, and especially how to make simple herbal remedies for sickness" (Harley [1941b] 1974, 27–29).

In general, the idea of death and rebirth is not as marked among members of the Sande association as among members of the Poro (ibid., 29). More important, in most groups the girl, after an initiation ceremony, is considered ready for marriage. For example, among the Bono of Ghana, the girls go through a ceremony at the end of which they are "considered to be of a marriageable age" (Warren 1974, 47).

A similar situation exists among the Ga of southeastern Ghana. The girls are instructed in their adult responsibility and taught to sing and dance. Young girls are permitted to join their elder sisters and go through the training more than once. Over several months, their hair arrangements change, and they are decorated with an increasingly large number of beads (fig. 10).

Masks are rarely worn by women anywhere in sub-Saharan Africa. The Sande association of the western Guinea Coast is an exception (cat. no. 18; fig. 12). The masks, however, are carved by male sculptors. Writing of the Bundu (another name for Sande) masquerades in 1901, T. J. Alldridge offers a typical description:

Her distinctive costume is unvarying, all Bundu devils being similarly attired, except as regards their headpiece, which admits of some slight variation. No part of the body may be visible . . . and in each covered hand the devil carries a little bunch of twigs with which she goes through a sort of dumb show— as she never does any talking. He dress is of long shaggy fiber, dyed black, and over her head she wears a grotesque wooden mask. (141)

By and large, however, "the various ceremonies which take place on the arrival of girls at puberty are distinctly less impressive than those of the boys" (Webster [1908] 1932, 45).

Rites of passage are concerned with more than coming-of-age ceremonies. For example, among the Senufo there is nearly a lifelong involvement with transitions from one level to another within Poro.

The process of growth from what the Senufo term "a child of Poro" to a "finished man of Poro" who can take his (or her) place as an adult member of the community is structured according to an initiation cycle of successive age grades, each lasting approx-

49

P. 45.

Comme les Singes portent des Enfans sur les Arbres

Habillement des Circoncis

Negre Iouant du Baluto

FIG. 11. Engraving of a "costume of the circumcised," Gambia River area of Senegambia, 1698. This may be the first European depiction of an African mask. *(From Froger 1698, courtesy of Frank Willett.)*

imately six and one-half years. . . . Advancement is celebrated periodically with a series of graduation ceremonies. Age sets are formed at successive intervals, and members of the same set will retain close bonds for the rest of their lives. Each set progresses through a series of fixed grades, distinct stages of training and status in the Poro system. (Glaze 1981, 93)

"The age-grade system of Poro traditionally ensured that village males, from childhood to as late as the mid-thirties, remained firmly under the control of the elders" (ibid., 94). Webster suggests that in many instances, "the tribe becomes, in fact, a secret organization, divided into grades or classes. . . . The passage from one class to another immediately higher is usually attended with various ceremonies of a secret and initiating character" ([1908] 1932, 20). Three Senufo sculptures should be referred to: the Kwonro (an age-grade of Poro) headdress on the male figure of the Senufo pair (cat. no. 2); the female of that pair, who is shown as an initiated woman; and the *kpelié* face mask worn by one grade of Poro (cat. no. 75).

Possibly the earliest reference to an illustration of a mask associated with initiation is that of François Froger, who in the 1690s observed that a wickerwork cap with cow's horns was worn by the circumcised (fig. 11) "for a week after their circumcision, which permits them to perpetrate all the crimes imaginable without any one daring to complain about it" (in Willett 1971, 98–99, fig. 80). In a recent historical study of the Basse Casamance area, Peter Mark notes that Froger's illustration of a mask closely resembles a Diola mask type called Usikoi (1985, 36), although he cannot establish a continuous tradition (ibid., 42). Usikoi is associated with male initiation. The masks "are worn and danced by the young men when they leave the sacred forest at the end of the initiation retreat" (ibid., 38).

From southwest Zaire southeastward to Zambia, many groups have a boys' initiation ceremony that is known by some variant on the word *mukanda*. These include, among others, the Yaka, Suku, Pende, Kuba, Chokwe, and Ndembu. Most use masks in association with initiation, sometimes during the beginning phases of the period of seclusion and sometimes later or at the end—the rites of return of the novices as adults. The Suku Kakungu mask (cat. no. 19) and the Pende *mbuya* mask (cat. no. 20) are associated with boys' initiation rituals. Writing of the Ndembu of Zambia, Turner reports:

From being 'unclean' children, partially effeminized by constant contact with their mothers and other women, boys are converted by the mystical efficacy of ritual into purified members of a male moral community, able to begin to take their part in the jural, political, and ritual affairs of Ndembu society. (1967, 265–66)

In his descriptions of the initiation to manhood of the Yaka and Suku of southwestern Zaire, Arthur Bourgeois describes the three phases of initiation: circumcision and various forms of hazing; "a period of instruction that may last from one to three years"; and celebrations that mark the end of initiation (1984, 120). He goes on to note that masks appear during all phases.

There are some groups, such as the Bono of Ghana, that have "no formal puberty ceremony, initiation, or bush-school for males" (Warren 1974, 47). Others do not have masks or other sculptural works of art associated with transitions. Nevertheless the ceremonies are of great importance, as among the Nyakyusa of Tanzania, where "the public acknowledgment of change in status, of new responsibilities . . . impresses on individuals their changing obligations within the kinship group. The rituals are a symbolic weaning from childhood, from a former marriage, or from deceased parents, and compel acceptance of a new position" (Wilson 1954, 239).

In addition to initiation, special roles in a given society are often reached by ceremonies of transition. For example, the procedures for training priests and priestesses are at times very like initiation rites, containing a ritual death and rebirth (Parrinder 1954, 102–3; Mbiti 1969, 174–75). Among the Zande the

> chief rite . . . is a ceremony of public burial and resurrection, a transitional rite. The neophyte is prepared for this by observing chastity and certain taboos on food. He is loaded with medicines and placed in a shallow grave, out of which however both his head and feet protrude. . . . Eventually the novice is raised up and rests while more medicines are applied to him. At the end he is fully dressed. . . . He takes a new name and sets up now as a new person. (Parrinder 1954, 108)

The novitiate of the Dahomean Vodu priesthood undergoes "an initiation, during the course of which he is confined to the temple, where he becomes dead to his previous life and is born again as a *vodunsi*" (Calame-Griaule 1974, 327).

Thus transitions other than initiation may contain the symbolism of death and birth. For example, van Gennep notes that the Hova of Madagascar "consider a preg-

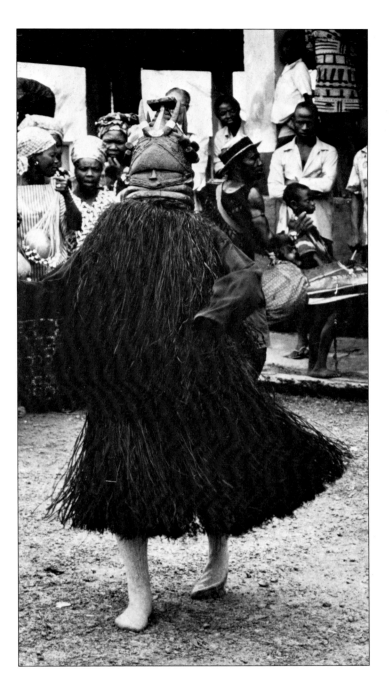

FIG. 12. Sande masquerade, Bumpe, Sierra Leone, 1976. Women affiliated with the Sande, or Bundu, association wear masks carved by men. In most societies, only men wear masks.

nant woman *dead*, and after childbirth she is congratulated on being *resurrected*" ([1908] 1960, 43, fn. 3).

Turner reports that certain colors are widely associated with initiations and life-crisis rites. White "seems to be dominant and unitary, red ambivalent, for it is both fecund and 'dangerous,' while black is . . . in a sense opposed to both white and red, since it represents 'death,' 'sterility,' and 'impurity' " (1967, 68). Thus in rites of passage the novices are released from a structured state into a stage of liminality for instruction, only to be returned to another usually advanced structured state revitalized by the transition (1977, 129).

R.S.

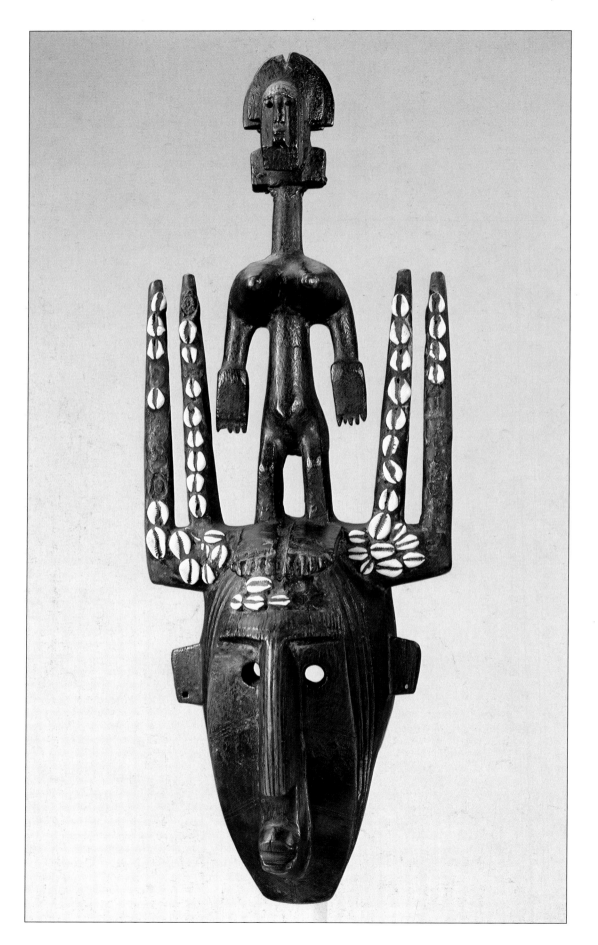

14

MASK (*Ndomo*)
Bamana peoples, Segou region, Mali, 20th century
Wood
H. 24 in. (61 cm)
Collection of Marc and Denyse Ginzberg

Among the Bamana, all males receive social and religious instruction. This is accomplished in six stages, each of which increasingly reveals more knowledge about man and the universe. The ultimate goal of the instruction is to free a man from his *wanzo*, that is, "an inner blindness of the human mind in all that regards self-knowledge, but refers also to physical malformations, impurity and evil in general" (Zahan 1974, 16).

The first stage is Ndomo. Uncircumcised preteen boys spend five years in Ndomo, advancing through five levels of instruction. During the fifth year the boys are circumcised, thereby removing from them the female characteristic (foreskin) with which all men are born. This done, a young man can search for his female social partner.

Each stage of instruction has a mask emblem. The mask shown here is the emblem of Ndomo and represents the primordial man in his uncircumcised, androgynous state. The horns of the mask, the number of which varies from two to eight, are intended to "reveal the inner life of the human being" (ibid., 28). The reason for depicting a female on such masks is unknown. It simply may be to increase the allure of the work (Ezra 1986, 13).

15

HEADPIECE
Baga peoples, Guinea, 20th century
Wood, pigment
H. 65½ in. (166.4 cm)
Collection of Norman and Shelly Mehlman Dinhofer

Bansonyi is the men's secret association that, like Simo (cat. no. 16), unites autonomous villages among the Nalu, Baga, and Landuman peoples. Its emblem is a headpiece, also called Bansonyi, that is carved in the form of a python standing upright. Bansonyi lives in the sacred forest and emerges when it is time to begin the boys' coming-of-age rites. As a receptacle for the most powerful spirit, Bansonyi is believed to be the strongest adversary of sorcery and destructive forces that could endanger the well-being of the village. It is especially protective of the boys during their initiation into adult society (Geertruyen 1976, 66–117). Bansonyi also appears at the funeral celebrations of the most important members of the community.

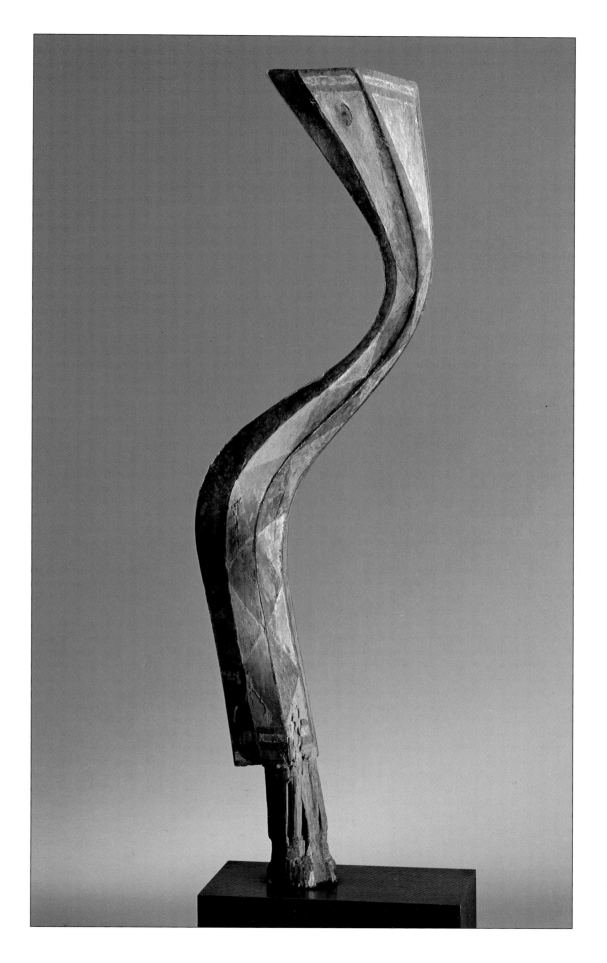

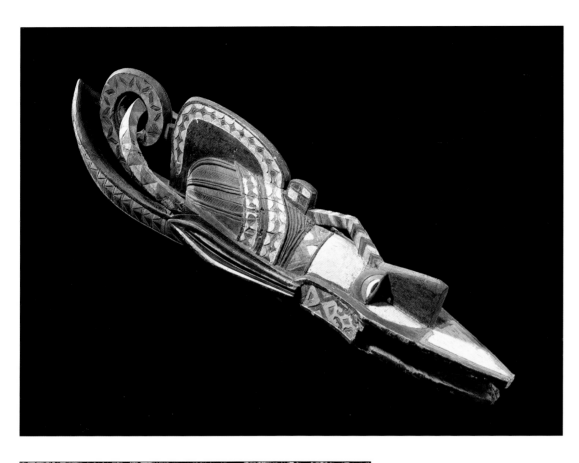

MASK (*Banda*)
Nalu peoples, Guinea, 20th century
Wood, paint
H. 56 in. (142.2 cm)
Museum Rietberg Zurich
RAF4

Banda masks, like the *ninte kamatchol* ritual object (cat. no. 23), are composed of attributes of man and different animals that live in the forest and sea. These large polychromed masks were worn horizontally on the head with a long, dense skirt made from grass fibers. According to a nineteenth-century description, the Banda mask assumed different disguises, for example, as a bird, an animal, or a shapeless leafy form (Caillie in Paulme 1962, 66), giving the impression that the mask could fly, swim, or crawl. Banda masks appeared at funerals of important individuals, at harvest celebrations, and on other celebratory occasions (Geertruyen 1976; Huet 1978, fig. 24).

In the past, the Banda mask was the venerable emblem of the highest grade of Simo, a men's secret association that regulated fertility and initiation rituals of disparate villages among the Nalu, Landuman, and Baga peoples (Delange 1974, 33). Only Simo members could see the mask perform; when it approached, nonmembers hid in their houses for fear they would die if they looked at it (Leuzinger 1963, 82).

This Banda mask was collected in the early 1950s by Emil Storrer.

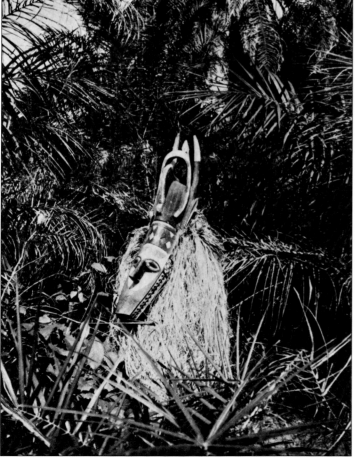

FIG. 13. **Banda mask,**
Nalu peoples,
Guinea, c. 1950.

17

MASK (*Dandai*)

Toma (also known as Loma), Bande, and Kissi
 peoples, Liberia, Guinea, and Sierra Leone, 20th
 century
Wood, pigment, feathers, fiber, cloth, fur, hair, skin,
 aluminum
H. 65 in. (165.1 cm)
Harrison Eiteljorg Collection
E74.2

Large horizontal masks called Dandai (also known as
Landai) were affiliated with the multiethnic men's
Poro association. These masks symbolized the
legendary ancestor and spoke a secret language.
Because of their great size, they did not dance
(Harley [1941b] 1970, 27; Celenko 1983, 9).

The Dandai mask appeared in public when it was
time for male youths to be initiated into adulthood.
The mask captured the boys and seemed to chew and
swallow them, keeping them in its body until it was
time to be born again. In reality, the youths so
consumed were hidden under the mask's voluminous
fiber skirts, and the blood dribbling from the mouth
of the mask was achieved by the wearer of the mask
chewing kola nuts. During the three years the school
was in session, the boys learned discipline and the
traditions of their peoples, as well as etiquette, a
trade, and the art of warfare. Dandai appeared again
in public when it brought the youths back to town as
initiated adults (Harley [1941b] 1970, 5).

FIG. 14. Dandai mask, Liberia.
The large Dandai initiation
mask, carved from lightweight
wood, was worn horizontally
atop the head. A voluminous
fiber skirt concealed the body.
(*Drawing from Harley [1941b]
1974, fig. 2.*)

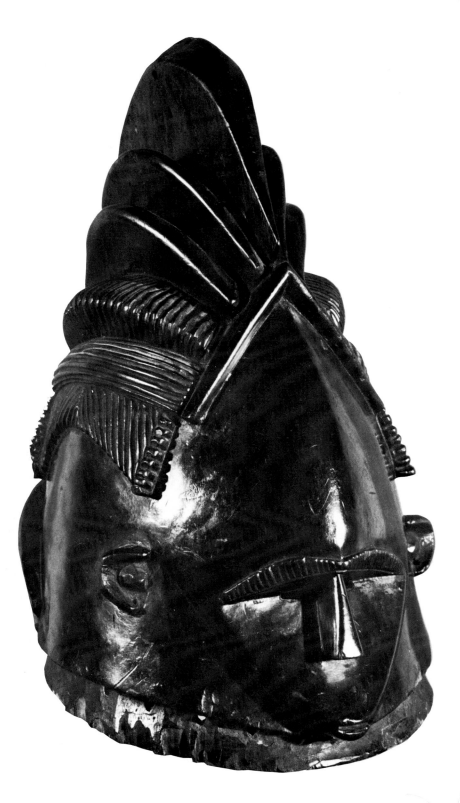

Mask
Gola or Vai peoples, Liberia, 20th century
Wood
H. 17½ in. (44.5 cm)
Collection of Robert Jacobs

The education and socialization of young girls among the Gola, Vai, and other peoples bound by the multiethnic men's Poro association in western Liberia and southern Sierra Leone are the responsibility of the Sande (also known as Bundu) association. This women's secret association is the counterpart of the men's Poro association and likewise transcends ethnic and family concerns. In the Sande initiation school, which, like the boys', is isolated from the community, pubescent girls are thoroughly instructed over a three-year period in sex education, homemaking, and childrearing, as well as in all ritual practices. These courses and certain surgical procedures are essential preparation for a fruitful marriage and for full acceptance as a responsible adult woman (Phillips 1978, 265).

Sande exists to maintain a cooperative alliance between the human and spirit communities. Sande inculcates in the initiates this crucial tradition, stressing their sacred role as potential wives and procreators in the earthly and spiritual worlds and also their special responsibility to propitiate their real and spiritual ancestors (d'Azevedo 1973b, 127–28).

In most societies, only men are entitled to carve or wear masks. The exception is the Sande association, whose helmet masks used in girls' coming-of-age ceremonies, although carved by men, are worn exclusively by women. Among the Gola, these women are chosen from among the descendants of the founding families. They must be excellent dancers with exceptional stamina, have forceful personalities, and be morally above reproach (ibid., 128).

This mask represents a male water spirit, one of the *zogbe* (nature spirits), that was instrumental in helping to establish the original ancestors of the Gola. The water spirits cleared the territory of monsters and guaranteed the fertility of the land. In exchange the Gola gave them their women in marriage.

19

MASK (*Kakungu*)
Suku peoples, Kimbao area, Kwango region, Zaire,
 20th century
Wood, pigment, fiber
H. 23¹¹⁄₁₆ in. (60.2 cm)
Royal Museum of Central Africa, Tervuren
34.145

In Suku society, boys' coming-of-age preparation is
the responsibility of the Nkanda association. In the
seclusion of lodges located outside the village, boys
between the ages of ten and fifteen years are taught
the history and traditions of their people and undergo
obligatory circumcision. They also learn the songs
and dances that will be performed at their coming-of-
age ceremonies.

 Several different masks are used in the Nkanda
graduation ceremonies. One of them is shown here.
This large mask with massive features is called
Kakungu and is worn by the master of the Nkanda
circumcision rites. The mask appears on the day of
the circumcision and again when the young men
leave the lodges to return to the village. Kakungu
masks instill in the young men obedience and respect
for their elders. The masks are also protective,
threatening anyone suspected of harboring evil
intentions against the initiates (Bourgeois 1980, 42;
Biebuyck 1985, 201 and passim).

 This Kakungu mask was collected by O. Butaye, a
Jesuit missionary, in 1932.

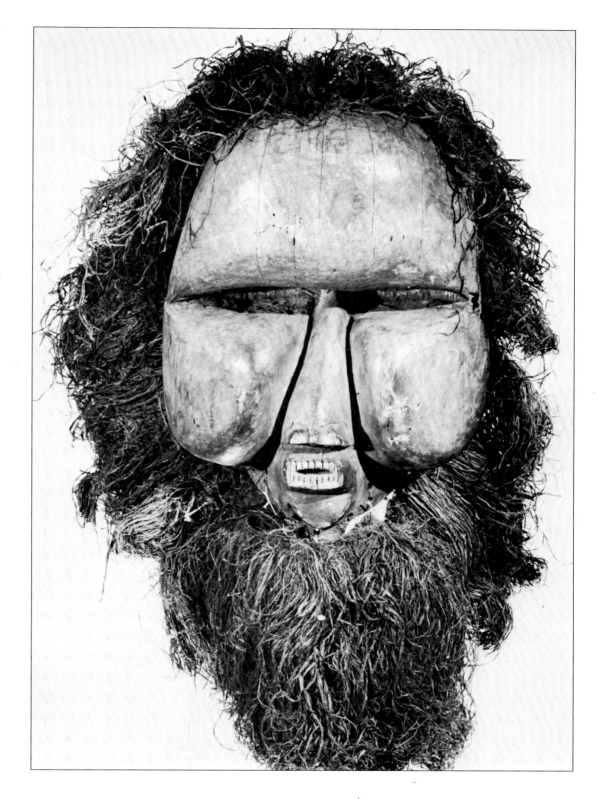

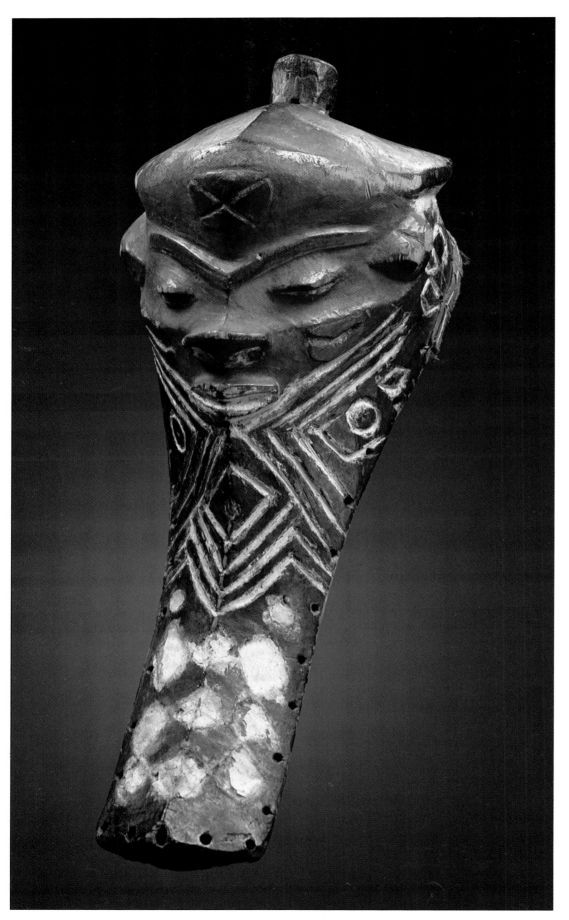

Face Mask (*Mbuya*)
Pende peoples, Katundu region, Zaire, 20th century
Wood, pigment, cloth
H. 26 in. (66 cm)
Collection Vranken-Hoet, Brussels

The Mukanda, the initiation school for Pende males, educated and prepared young men for their adult responsibilities. Preparation included circumcision, the most important prerequisite for adult status and virility. As in Bamana society, once young men attained adult status, they were eligible for membership in the more advanced men's secret associations.

Mbuya, or sculptured wooden masks in the form of human or animal faces, were worn with a prescribed costume by graduates of the Mukanda in their coming-out rites. These masks represented a great variety of village characters, including a clown, or "chief of the dance floor," and those whose behavior was admired or disapproved. Some masks were symbols of power and authority (Delhaise in Biebuyck 1985, 235; de Sousberghe, 1958, 29–69). Although the performance was entertaining, it taught moral lessons and reinforced Pende religiopolitical principles.

This mask appeared in the Mukanda coming-out rites and may represent Giwoyo, Muyombo, or Ginjinga. All three are ancient mask types with a wooden, beardlike appendage that the Pende brought with them from their original homeland along the upper Kwango River in present-day Angola over one hundred years ago. The appendage is said to represent a beard and the authority of the ancestors (Neyt 1981, 138). The precise identity of these masks, which combine the three functions of hunting, healing, and dancing, is determined as much by the context of their appearance as by the type of costume, the paraphernalia they carry, and the decoration affixed to the top of the mask, such as a tuft of goat hair or parrot feathers (Biebuyck 1985, 237; Naambi Munamuhega 1975, 137–49).

Until the 1930s the Mukanda initiation and coming-out rites were very important stages in the lives of Pende men (Biebuyck 1985, 223). Since then, performances have been income-generating public entertainments.

21

Face Mask
Makonde peoples, Tanzania and Mozambique,
19th–20th century
Wood, glass beads, hair, beeswax
H. 10 in. (25.4 cm)
Linden-Museum Stuttgart
43747

Following the Makonde girls' Unyago, or coming-of-age, ritual, pairs of masked dancers representing men and women performed in a public masquerade celebrating fertility and procreation. The carved wooden masks depict scarification patterns worn by men and women; the masks also include the *pelele,* or circular wooden lip disks, and nose ornaments that were the prerogative of young wives. Masks representing animals and *shetani,* described as a "devil," also appeared. As among most sub-Saharan African peoples, the masks were worn exclusively by young male dancers (Weule 1909, 230–36).

This mask, which was collected around the turn of the century, represents a male, as evidenced by the beard and the absence of feminine decoration, such as a *pelele.* The eyelashes, hair, and beard, as well as the coils of white trade beads, are affixed with beeswax. This mask is considered to be one of the most beautiful of the known early examples of Makonde face masks (Holý 1967, 29–31).

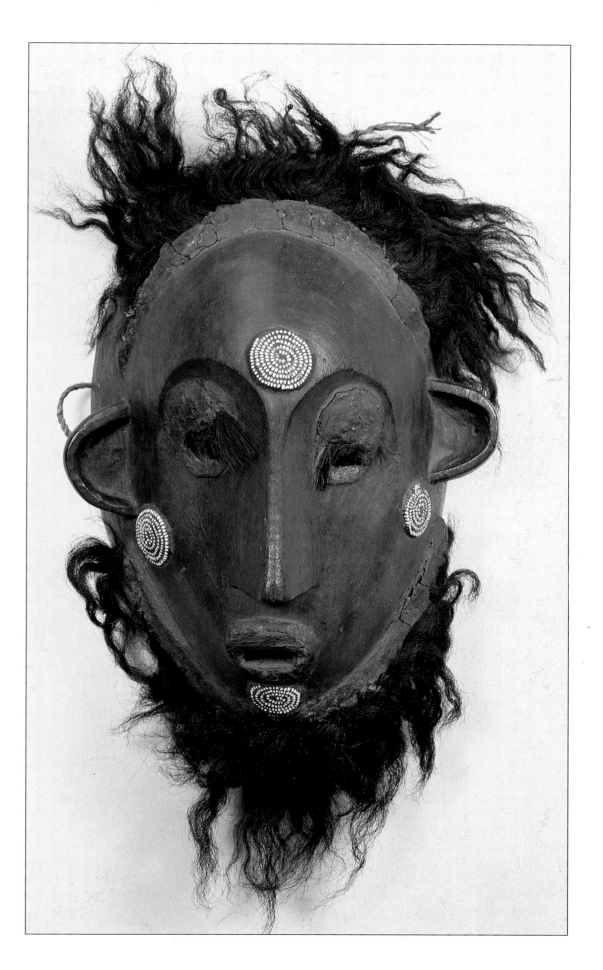

3

TOWARD A SECURE WORLD

In addition to the rites associated with transitions, wherein a change of status exists, it is necessary to note that there are festivals that celebrate seasonal events, particularly those related to agriculture and the food supply, and rituals that are brought to bear at times of crisis, such as infertility and disease.

Roger Abrahams notes that "ultimately, festivals are celebrations of the capacity of increase of the earth, carried on as a way of maintaining that cycle of fertility by acknowledging the powers of nature and the place of humankind in enhancing that process, on seizing it and magnifying it" (1982, 163).

Parrinder writes that "all African peoples have important communal ceremonies at the times of sowing and harvest. . . . when the land is tilled and planted, the blessing of the spirits is demanded. When the crop is ripe there are most important first-time ceremonies (not just harvests), of which the essential principle is that the spirits must eat of the fruits before men partake of them" (1954, 83).

Not all agriculturalists use sculpture in their celebrations, but many do. The spring festival at Prampram in southeastern Ghana, which ensures the success of the crops through sufficient rain (figs. 2–3), is an example in which no sculpture exists, while the appearance at planting and harvest time of the Egu Orumamu mask of the Igala of Nigeria (fig. 4) has been noted earlier. The antelope headdresses of the Bamana of Mali (cat. no. 22) are related to the preparation of the land at planting time. The role of many spirit forces, including the ancestors, is tied to the concept of increase, indeed of survival of the group dependent on agriculture. "These celebrations of significant spots in the yearly passage bring into high display . . . whatever bounties the earth provides for a group contending for continuity" (Abrahams

1982, 166). Thus many of the objects in the exhibition, whatever other functions they may serve, ensure the fertility and abundance of the food supply through hunting and fishing, as well as through agriculture (cat. no. 33).

The annual festivals emphasize the cyclic aspect of the seasons, reinforcing the sense of endless renewal. The objects and events associated with the festivals "explode with meanings, for they are invested with the accumulated energies and experiences of past practice. They epitomize not only the seasonal passage but the history of the culture, a history spelled out in terms native to the group and appropriate to the place and the season" (ibid., 161).

Rituals that are neither seasonal nor transitional tend to be associated with crises: drought, bad hunting, war, human infertility, illness. Often such events are believed to have been caused by special forces.

> The Ndembu, like the Azande, consider that calamities and adversities of all kinds are caused by mystical forces generated or evoked and directed by conscious agents. These agents may be alive or dead, human or extra human. They may operate directly on their victims or indirectly through mystical intermediaries. Ancestral shades cause suffering directly; living sorcerers and witches work evil through medicines or familiars or through a combination of both. (Turner 1967, 300)

In dealing with adversity, it is usually necessary to turn to specialists. Harley, speaking of Africa in general, states that "there are three kinds of medicine men: (1) the real doctor [or herbalist], who is sometimes called the 'man of the trees' . . . (2) the diviner, whose main duty is one of diagnosis, and (3) the witch doctor, whose duty is to catch the witch or exorcise the evil spirit" ([1941a] 1970, 200). He goes on to note that

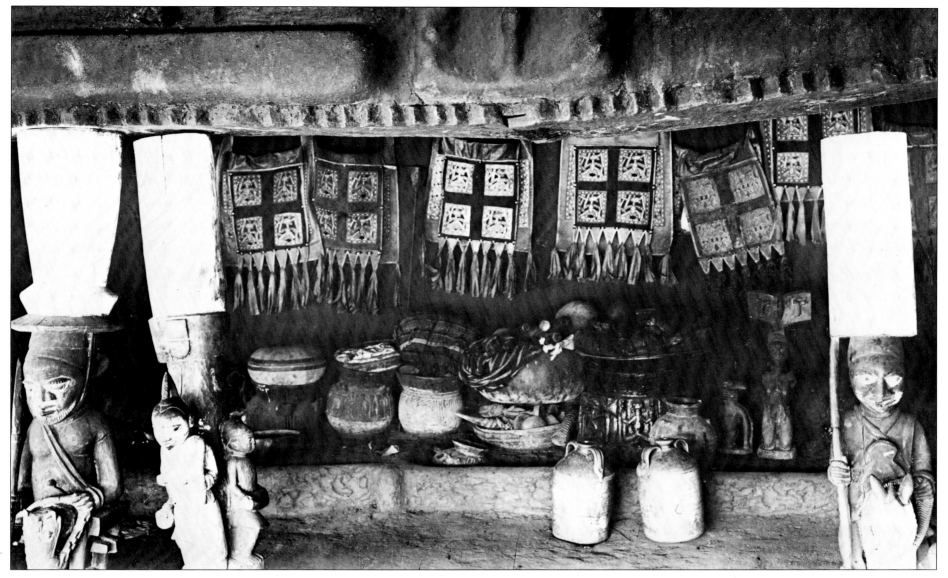

FIG. 15. **Shrine dedicated to Shango, the Yoruba god of thunder, Agbeni area of Ibadan, Nigeria, 1910. This photograph was taken by a member of an expedition led by ethnographer Leo Frobenius.**

these "flow easily one into the other and are sometimes combined in the same individual" (ibid.).

Turner notes that "the diviner, by means of one or another of various techniques . . . diagnoses a mystic cause as responsible, and a rite is performed either to propitiate a specific manifestation of a shade or to exorcise the familiars of sorcery or witchcraft" (1967, 301).

Divination, then, serves as a device for the diagnosis of the cause of a problem. It "links together in its own way the physical and spiritual worlds, making it a religious activity" (Mbiti 1969, 178). Although all "accidents, illness and death (except for old age)" are considered to be the result of witchcraft, slight or common diseases are not worth the bother "to search out the witch who is responsible. It is only in the stubborn cases of illness which refuse to respond to rational treatment that he reverts to the theory of witchcraft" (ibid.,

186). Thus some diseases are considered to be too minor to go to the expense of a diviner and medicine man. They are in most cases treated by what Harley calls "rational methods which employ many drugs of real therapeutic value" ([1941a] 1970, 192).

At the same time, some afflictions that we consider diseases may not be so considered by Africans. For example, Harley notes that yaws and malaria are so common in Africa that they are not recognized as diseases (ibid.).

More generally, "members of every society live in a state of flux between various states of health, and each society possesses a body of knowledge by which it defines and interprets the normal state and the symptoms or conditions which deviate from it" (Warren 1974, 231). And, as T. Adeoye Lambo, a Nigerian psychiatrist, suggests:

Health is not an isolated phenomenon but part of the entire magico-religious fabric; it is more than the absence of disease. Since disease is viewed as one of the most important social sanctions, "peaceful living with neighbors, abstention from adultery, keeping the laws of gods and men, are essentials in order to protect oneself and one's family from disease." (1964, 446)

Among the Bono of Ghana, diseases are characterized as "falling into two categories, each with its own causal implications. On the one hand are diseases whose causes are to be found in nature, and on the other there are diseases caused by supernatural forces" (Warren 1974, 233). According to Warren, persons suffering from the first sort only would be taken to a European type of hospital because a spiritual component is not necessary for their treatment. "Hence, a person suffering from a disease classified as [naturally caused] could find a cure equally well from a Bono herbalist, a Bono priest or priestess in the role of herbalist, or from a mission hospital where treatment for a naturally caused disease can be obtained" (ibid., 234). Yet, according to Harley,

even the simplest accident is thought to be the effect of some unseen cause. [The African] demands an explanation of why a cutlass in the hands of a skilled woodsman cuts his foot instead of the stick he tried to cut, or why a limb fell from a tree at the exact instant when he was under it. His explanation is that some hidden force was at work. Someone had made medicine . . . against him. This kind of [medicine] is bad medicine or witchcraft. ([1941a] 1970, 22)

Occasionally, particular works of sculpture may be used to achieve special ends. For example, among the Dan of Liberia, a mask appears in the case of epidemics (cat. no. 25).

To seek out the causes of disease or illness, recourse to a diviner is necessary. "Every kind of divination, trance, astrology and dreams" (Ackerknecht 1942, 506) is resorted to in the search for supernatural causes. A large variety of divination techniques are to be found in Africa.

[Diviners are] the agents of unveiling mysteries of human life. This is done through the use of medicines, oracles, being possessed, divination objects, common sense, intuitive knowledge and insight, hypnotism and other secret knowledge. . . . They play the role of counsellors, judges, 'comforters,' suppliers of assurance and confidence during people's crises, advisors, pastors and priests, seers, fortune-tellers and solvers of problems and revealers of secrets like thefts, imminent danger or coming events. (Mbiti 1969, 177)

Discussing the role of diviners among the Kongo of Zaire, Georges Balandier notes:

The diviner influenced the course of individual lives. He was the counsellor, the giver of confidence, the protector who defended people from insidious threats. He suggested which *mikisi* (or fetishes, as the earlier chroniclers called them) [cat. no. 40] ought to be honored or propitiated. He helped to discover personal taboos. He indicated which specialists should be consulted in case of illness . . . a trip could not be undertaken without the assurance of its happy conclusion. (1969, 224)

One of the best studied divination systems in Africa is that of the Yoruba of Nigeria. "Traditionally all Yoruba depend upon divination to know a newborn child's origins and what its destiny might be. Likewise, people also consult a diviner as a result of events such as illness, dreams, or visions, which they deem to portend the involvement of supernatural forces" (Drewal 1984, 89; see also Bascom 1969a) (fig. 19).

Divination has an impact on the works of art of the Yoruba in two ways. First, works of art often result from divination when it is determined that new masks or figures are to be made to reflect the new status of a subject as determined by divination. For example, it is often through divination that a woman who wishes for a child may approach a particular deity and, after a successful pregnancy, offer the image of a woman and child as a shrine image, as might have been the case with cat. no. 7.

Second, the process of divination itself uses a number of objects, which, reflecting the success of the diviner-priest, or *babalawo*, "father of the secrets," may be quite impressive and sculptural. These include a divination board (*opon*), which often bears the image of Eshu, a deity associated with divination, and other appropriate symbols (cat. no. 30) and a cup for holding the shells or palm nuts that are cast (cat. no. 31).

Among the Montol of northern Nigeria, there exists a men's association called Komtin, which seems primarily involved in divining the cause of illness and in curing rites (Sieber 1961, 10, 12). Carved wooden figures are used by the diviners as the focus of the supernatural power associated with divination (cat. no. 34). The nearby Mumuye use figure carvings in a similar fashion (cat. no. 35). Some Lobi, who live in Burkina Faso, Côte d'Ivoire, and Ghana, use sculptured heads as diviners' objects (cat. no. 28), and the diviners of the Lulua of Zaire own wooden divination figures (cat. no. 41). It is clear that the process of divination is widespread, al-

though its methods differ and the objects that diviners use are extremely varied.

Shrines are often created to house spirit forces and the objects used in ritual activities associated with those forces (fig. 15). Warren writes that "the term 'shrine' refers to the abode or potential abode of a spiritual element, entity or force" (1974, 374). Writing of the Bono of Ghana, he goes on to state that "the fundamental role of the various shrines can be categorized as prophetic, preventative, protective, providing, healing, martial, and politico-judicial (social control)" (ibid., 405). The spirit housed in a shrine may serve

> as a solver of problems, curer of illness, catcher of blasphemers, liars, cursers and backbiters. The deity is asked to provide long life, health, prosperity, the chance to improve in general and in one's work and to make money, to protect people from evil and to prevent auto accidents, to help women have children, and to ensure prosperity for the town and its inhabitants. Protection from blindness, deafness and impotency may be asked. (ibid., 205)

Shrines may be made to serve an individual, a family, a village, or a kingdom. The Baule couple (cat. no. 26) was most likely owned by an individual and kept in a shrine in his or her house. The Igbo *ikenga* (cat. no. 32) is an example of a personal shrine, dedicated by its male owner to his own success, strength, and well-being. The Kongo nail figure (cat. no. 40) almost certainly served a larger clientele, possibly a village or chiefdom. Quite likely most of the figurative pieces and some of the masks in the exhibition served as shrine furniture or were stored in shrines and played a protective role.

The existence of many African masqueraders may be explained under the general rubric of protection. For instance, certain early references, such as that of Francis Moore in 1738, describe a masquerader called Mumbo Jumbo. The description of that fiber mask closely resembles a recent Diola mask of the Basse Casamance area of Senegal. It is called Kumpo and is a protective, antiwitchcraft force. It belongs "to the category of spirit forces who possess supernatural powers which they place at the service of the community" (Mark 1985, 45–46).

In addition to the general sense of protection, some masks serve as cleansing or purifying forces. The formal descendants of the Sakrobundi antiwitchcraft mask from eastern Côte d'Ivoire (cat. no. 29) (Bravmann 1974, 102–3), called Bedu, have a "protective character" and are concerned with "human fertility. . . . curative potential, especially for children. . . . In addition, the Bedu seem to have a general apotropaic value, being able to avert every misfortune from agricultural disaster to a decimating epidemic" (ibid., 113). Warren reports that during the annual yam festival of the Bono of Techiman in west-central Ghana, ritual shrine objects may be carried "from one end of town to the other three times to remove evil" (1974, 400).

Many African sculptures serve more than a single purpose, yet generally they may be described as protective. The focus of the sculpture may be the family or the group; it may specialize in protection against witchcraft or the effects of witchcraft, such as disease or infertility, and yet appear at funerals or other rites or festivals. Whatever the complex of uses to which the sculpture may be put, it most often serves to reinforce belief in the acts that make the world a more secure and pleasant place in which to live.

R.S.

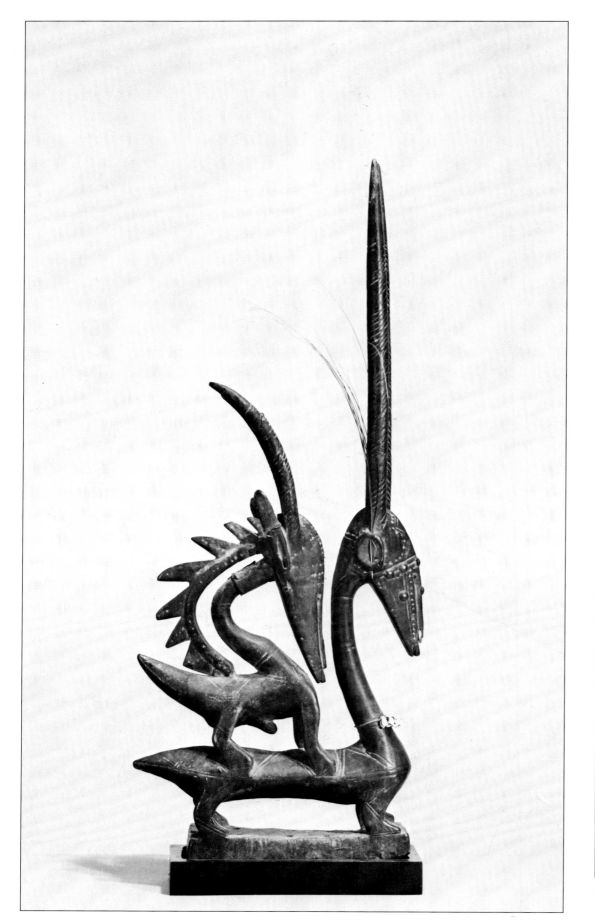

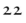

22

Pair of Headdresses (*Chi Wara*)
Bamana peoples, Segou region, Mali, 19th–20th
 century
Wood, brass tacks, string, cowrie shells, iron
H. of male 38¾ in. (98.4 cm); H. of female 31¼ in.
 (79.4 cm)
The Ada Turnbull Hertle Fund, The Art Institute of
 Chicago
1965.6, 1965.7

The Chi Wara association is the fifth of the six
graduated initiation associations of the Bamana.
Membership is open to women as well as men;
however, participation in certain initiation rites is
restricted to circumcised males (Zahan 1974, 20).
The association teaches its members all aspects of
food production, the success of which requires
cooperation between men and women.

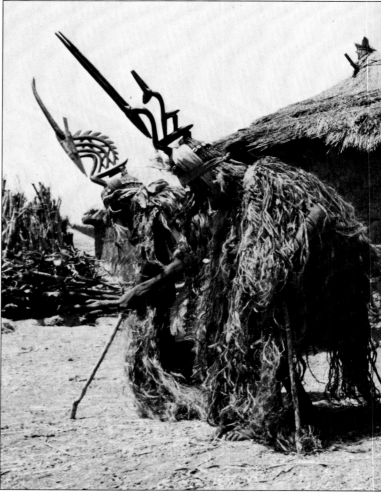

FIG. 16. **Pair of Chi Wara dancers perform during the agri-
cultural cycle, Bamana peoples, Bamako area, Mali, 1971.**

Paired male and female headdresses like these appear in the Chi Wara performance. The headdresses express many levels of meaning. For example, the animals carved on the headdress are composites of different species of antelopes. To the Bamana, these forest animals, with their grace and strength, embody the ideal qualities of champion farmers. The male is the sun, and the female is the earth; the fawn on the female's back symbolizes human beings. The fiber costumes worn with these headdresses represent water. As there must be a union of sun, earth, and water for plants to grow, there must be cooperation between men and women possessing the requisite physical and moral qualities to ensure that agricultural processes—including clearing the land, tilling the soil, planting the seeds, and tending the plants—take place on schedule to ensure a successful harvest (Zahan in Vogel 1981, 23–24; Brink in Vogel 1981, 24–25).

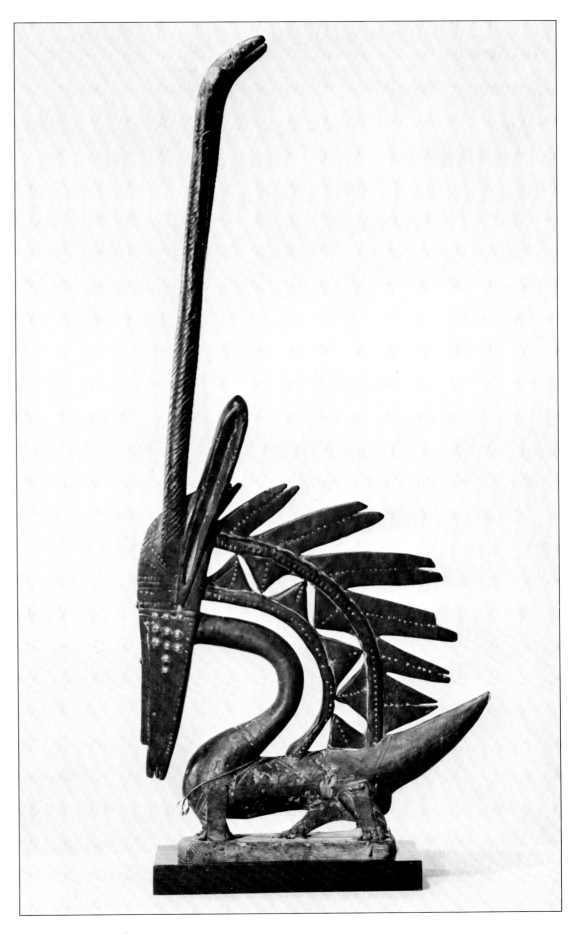

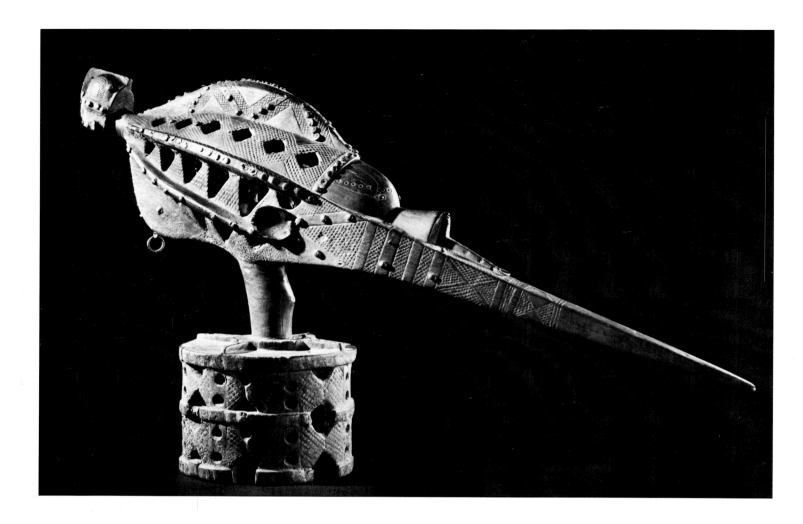

23

Ritual Object (*Ninte Kamatchol*)
Nalu peoples, Guinea, 20th century
Wood, brass
L. 37¾ in. (95.9 cm)
Museu de Etnologia, Lisbon
AO 335

Among the Nalu and the Baga, sculptured figures like this one are called *ninte kamatchol, elek,* and *anok* among other names. These figures are a composite of a human face, a bird beak, and the jaws of a crocodile. Antelope horns filled with medicine are placed into the geometric cutouts on the head, thereby empowering the figures to protect the lineages that own them against sorcery and other antisocial acts. Among the Nalu, such figures are used in initiation rites that are supervised by the men's Simo secret association (Museu de Etnologia 1972, 143). Among both groups, these figures play a role in agricultural rites and funeral celebrations of important people. They are kept in the home of a lineage representative, probably the eldest member, and serve as guardians of the lineage (Paulme 1959).

24

MASK
Wee peoples, Liberia and Côte d'Ivoire, 20th century
Wood, raffia, cloth, teeth, horn, feathers, hair, fiber
 cord, cowrie shells
H. 32 in. (81.3 cm)
Seattle Art Museum, Katherine White Collection
81.17.193

According to Wee (also known as Guere) oral
traditions, masks are spirits that live in the forest and
are made visible by means of appropriately costumed
human supports. As symbols of societal beliefs and
values, masks reinforce respect for the rules and
functioning of society (Tiabas 1978, 85–90).

 This fearsome mask displays the teeth and horns of
powerful wild animals. Its fierce countenance enables
the mask to do its job, which is to frighten away
negative forces that cause social tensions and
epidemics. Perhaps the unruly appearance of the
mask is in deliberate contrast to the orderly,
productive life of the civilized village.

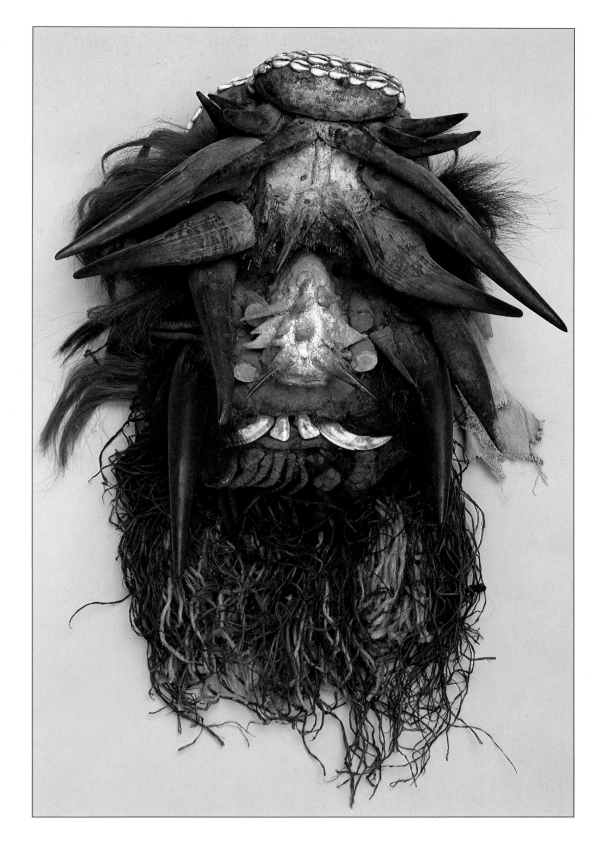

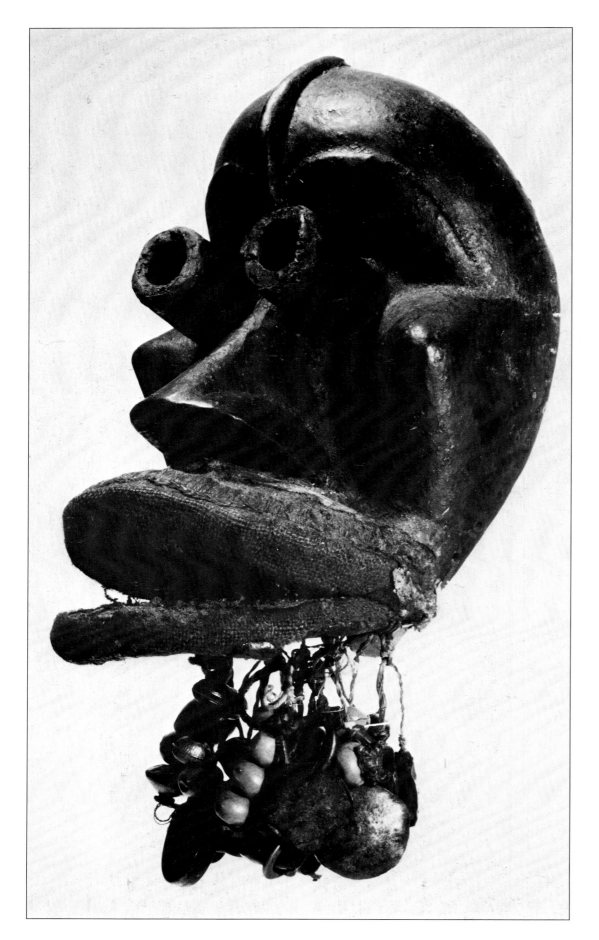

25

Mask (*Zo ge*)
Dan peoples, Liberia; 20th century
Wood, textile, iron, copper alloy, aluminum, ceramic,
 seeds, fiber, calabar beans
H. 10 in. (25.4 cm)
Peabody Museum of Archaeology and Ethnology,
 Harvard University
40-34-50/4588

This mask is called Zo ge and is used to control
epidemic diseases that do not respond to the efforts
of herbalists and diviners. In the belief that an
unknown pestilence is caused by men bewitching one
another, Zo ge emerges from his forest home to put
an end to such behavior. His tubular eyes, jutting
cheekbones, and hinged jaw with audible attach-
ments present an otherworldly appearance, thereby
reinforcing his role in social control. Individuals who
recover during the mask's appearance are obligated to
give a thanksgiving feast for the whole town in the
presence of the mask (Harley 1950, 34).

 This Zo ge mask was collected by Dr. George
Harley, a medical missionary, before World War II
(Wells 1977, 26).

26

STANDING MALE AND FEMALE FIGURES
Baule group, Akan peoples, Côte d'Ivoire, 19th–20th
 century
Wood, traces of paint, clay, beads
H. of male 21¾ in. (55.2 cm); H. of female 20½ in.
 (52.1 cm)
The Metropolitan Museum of Art, The Michael C.
 Rockefeller Memorial Collection, Gift of Nelson A.
 Rockefeller, 1969
1978.412.390, 1978.412.391

Baule figures in human form represent two kinds of
spirits that cause problems in individuals. A diviner
must identify the spirit and use figure carvings as part
of the treatment.

One kind of spirits are nature spirits. Known as
asie usu, they live in all natural phenomena. They
may be male or female, extremely beautiful or
hideous, often with their feet turned backward. *Asie
usu* possess selected individuals, thereby
communicating their will that the possessed will
become their spirit mediums and practice divination
in public performances or serve them privately. In
either case, an *asie usu* will dictate in dreams to the
diviner, carver, or individual how it should be carved
in a particular kind of wood, that is, that it should
be a male or female with the most attractive human
physical features (Vogel 1980, 2–3).

The other kind of spirits are spirit spouses. The
Baule believe that before a person was born on earth,
he or she had a spouse, which may manifest itself,
that is, cause misfortune such as infertility, infidelity,
business failure, or the like. As do the *asie usu,* spirit
spouses will dictate in dreams to the diviner, carver,
or human spouse how they should be carved. The
human spouse will establish an altar for the spirit
and devote one night each week to sleep with the
spirit spouse (ibid., 3–4).

The precise identification of the male and female
figures shown here is not possible because there are
no guidelines for determining how a figure is used
once it has left its original owner. Whether or not the
figure is a receptacle for an *asie usu* or another
nature spirit, it must be beautiful to ensure its
efficacy. The more beautiful the figure, the better it
will localize and placate the spirit for which it was
made and will in turn reward the owner with positive
behavior (ibid., 4).

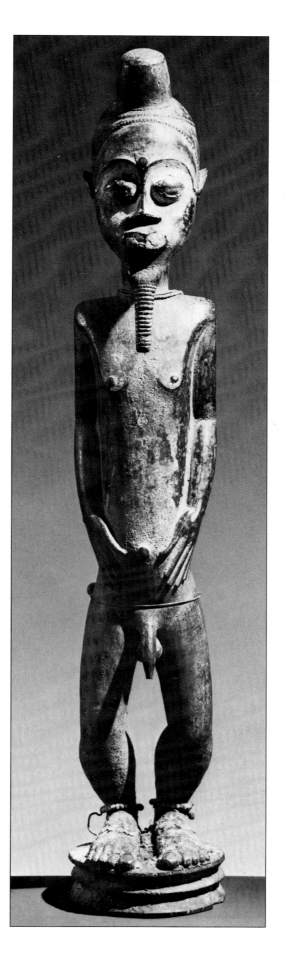
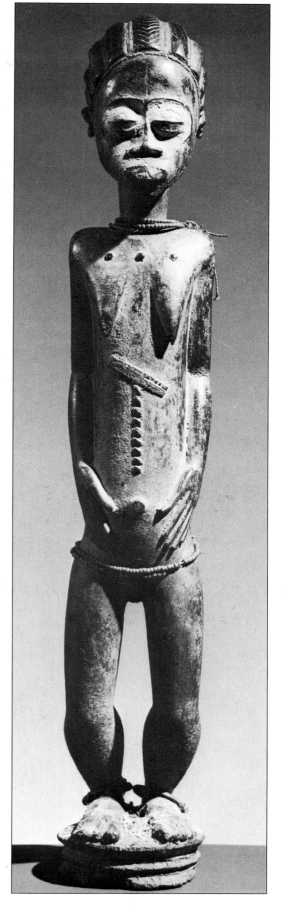

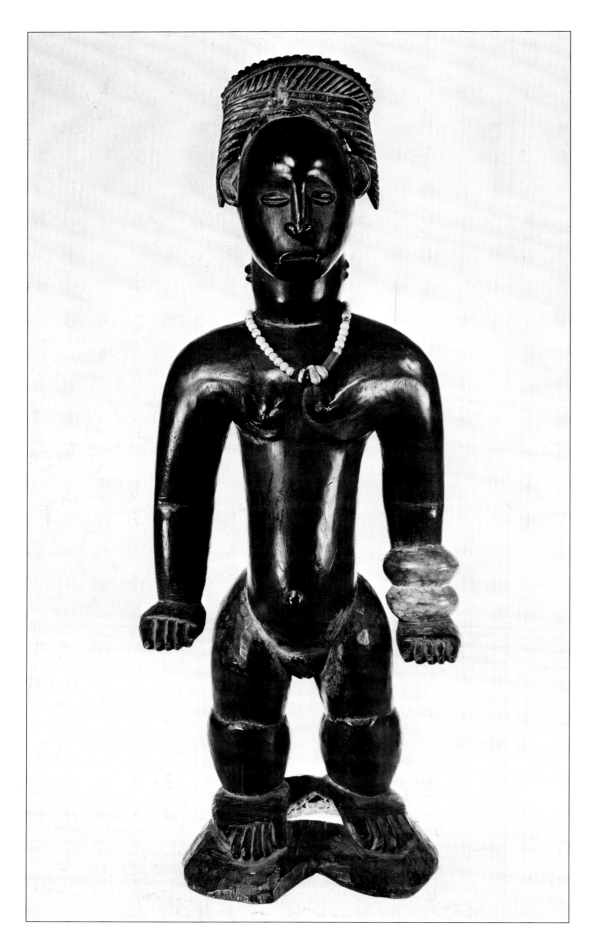

27

FEMALE FIGURE (*Mi iri ni*)
Guro peoples, Côte d'Ivoire, 20th century
Wood, beads
H. 20½ in. (52.1 cm)
Detroit Institute of Arts, Bequest of Robert H.
 Tannahill
70.95

The Guro call sculptured wooden figures like this one *mi iri ni*, meaning "small wooden people." They may be part of shrines dedicated to protective spirits called *zuzu*. *Mi iri ni* give people dreams in which the *zuzu* make known their wishes and help the individual solve difficult problems (Fischer and Homberger 1986, 10).

This figure is probably the work of a western-area Guro master (Homberger 1986). It is distinguished by a pair of bulbous bracelets that are lighter in color than the rest of the figure and represent ivory bracelets. Such bracelets were traditionally worn by chiefs and wealthy men and women (Tauxier in Siroto 1953).

FEMALE HEAD (*Yuo*)
Lobi peoples, Burkina Faso, Ghana, and Côte
 d'Ivoire, 20th century
Wood
H. 11¾ in. (29.8 cm)
Private collection, Paris

The Lobi consult a diviner to discover the cause of a problem they cannot solve and the means by which to remedy it. The diviner is not told the client's problem; rather, he must contact the *thila* (divinities; sing., *thil*) to identify the misfortune and to ascertain which *thil* caused it. Accurate identification of the misfortune assures the client that the diviner has actually contacted the *thila*. The appropriate *thil* reveals the cause of the misfortune and prescribes the remedy. The remedy usually entails providing that an altar for the *thil* on which an anthropomorphic figure called a *bateba*, which may be made by the diviner, will be placed in the client's home. The *thil* dictates the medium, such as wood, terra-cotta, or metal, and the pose of the figure (Meyer 1981a, 19–22). Among the *bateba* prescribed are *ti bala*, or "extraordinary persons," of which this female head is an example.

Ti bala manifest physiological characteristics that are not normally found in human beings: having only one arm, having three bodies on one pair of legs, or having a head (*yuo*), such as with this example, on a post or on a leg (Meyer 1981b, 95–103). Such figures are believed to have supernatural, dangerous powers that are used for the owner's benefit.

This *yuo* was brought to Europe between World War I and World War II (Kerchache 1982, n.p.).

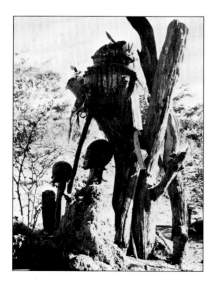

FIG. 17. Enshrined *yuo* (heads), carved by Biniathe Kambire, Lobi peoples, Tiamne, Côte d'Ivoire, 1965.

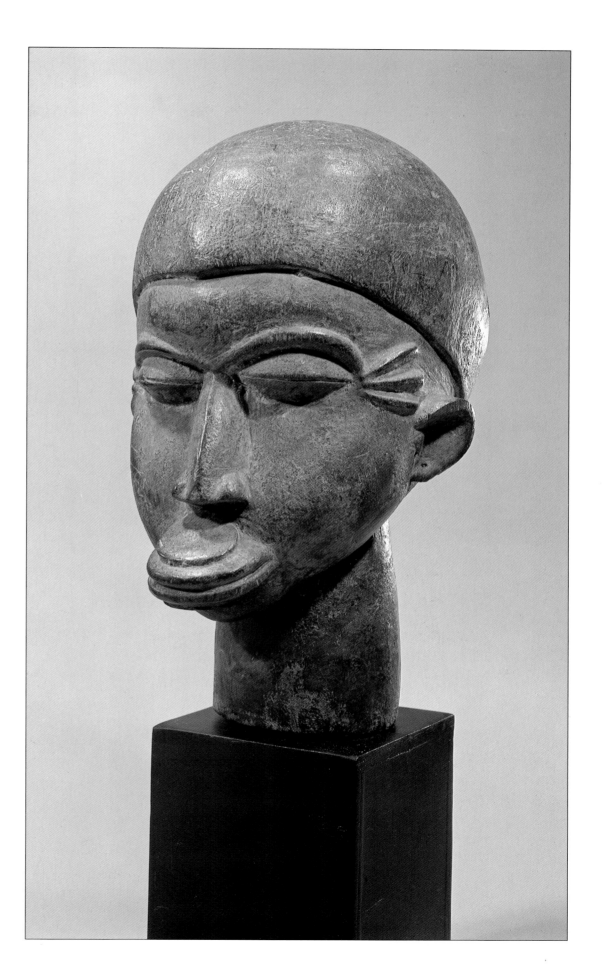

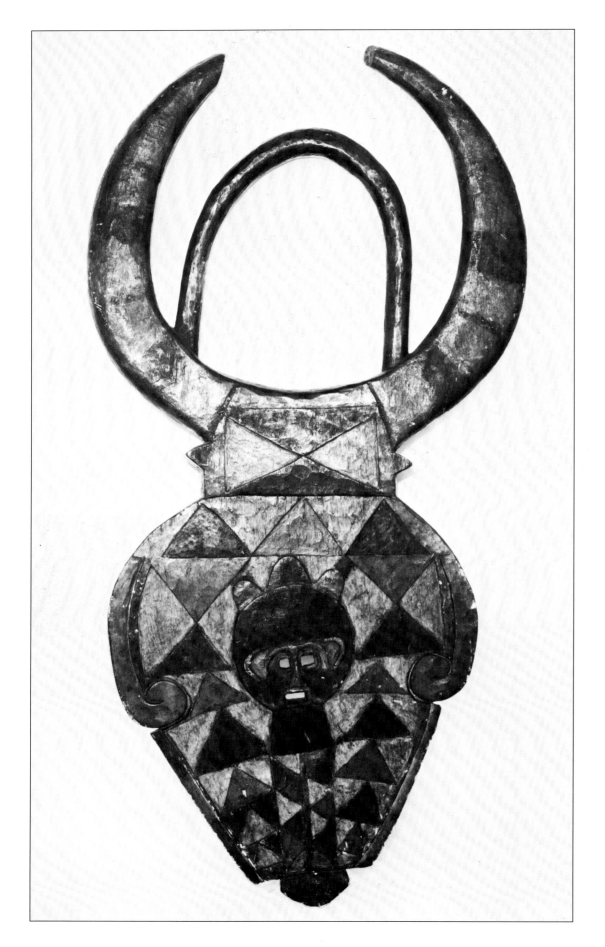

29

Mask (*Sakrobundi*)
Bondoukou region, Côte d'Ivoire and Ghana, 19th
 century
Wood, pigment
H. 57½ in. (146.1 cm)
Trustees of the British Museum
1934.2

The Sakara-Bounou was a powerful antiwitchcraft masked cult that flourished in the nineteenth century among the Bron, Degha, Kulango, and Nafana peoples in the Bondoukou region of Côte d'Ivoire and west-central Ghana (Freeman 1898, 148–55). Masquerades of this cult continued until the 1920s and 1930s, when Protestant and Catholic missionaries caused its masks to be destroyed. Despite the loss of its most visible manifestation, the protective spirit itself still exists (Bravmann 1974, 100; Bravmann 1979, 46–47).

This Sakrobundi mask was collected at the end of the nineteenth century by Captain Cecil Armitage (later Sir Cecil), who was a British colonial officer in the Gold Coast (present-day Ghana).

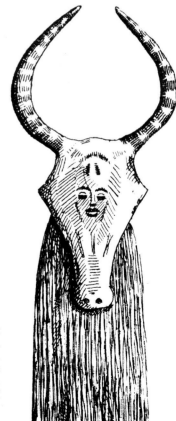

FIG. 18. **This drawing accompanies a detailed description of a Sakrobundi masquerade witnessed in the 1890s in the Bron town of Odumase, Ghana.** *(From Freeman 1898, 155.)*

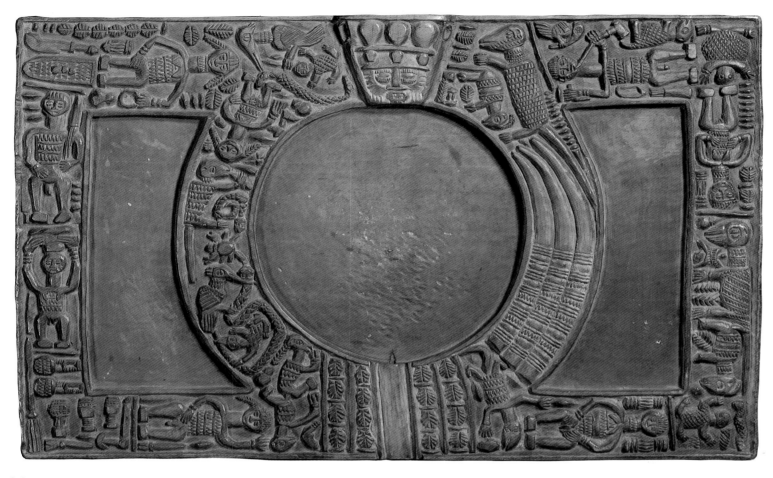

30

IFA DIVINATION BOARD (*Opon Ifa*)
Yoruba peoples, Benin, 17th century
Wood
L. 22 in. (55.9 cm)
Ulmer Museum, Ulm
AV 1486

Ifa (also called Orunmila and Agbonniregun) is the Yoruba god of divination. He transmits and interprets the wishes of Olorun, the sky god, who created all the other deities and prescribes the sacrifices that Eshu, the messenger/trickster god, must bring to him. Ifa is consulted in times of trouble in order to understand why misfortune occurred and how to prevent its recurrence. He is not approached directly, but through a *babalawo* (diviner-priest), whose equipment includes sixteen palm nuts that are manipulated according to a complex formula, a carved wooden board covered with wood dust on which to make marks determined by manipulating the palm nuts, and a cup or bowl in which to store the palm nuts. This equipment also includes a tapper made of wood or ivory with which to tap the board,

thereby calling Ifa's attention before beginning the ritual (Bascom 1969a, 70–71, 80; Bascom 1969b).

Divination boards are rectangular, circular, semicircular, or combinations thereof and always display the face of Eshu. The borders of the board may be decorated with animal and human figures and/or geometric patterns carved in low relief; the number and the variety depend upon the talent of the sculptor and the wherewithal of the client.

This elaborately decorated divination board was originally part of the collection of a famous seventeenth-century curiosity cabinet known as the "Weichmannianum," which was formed by a wealthy German merchant, Christoph Weickmann (1617–81). This Ifa divination board was brought to Europe before 1659 and was listed in the Weichmann catalogue, *Exoticophylacium*, of 1659. The board was brought from Ardra, on the coast of the present-day Republic of Benin, where it had been in the possession of the king of Ardra (Ulmer Museum n.d., n.p.; Vansina 1984, 3). It is the oldest documented Ifa divination board that can be called "Yoruba" in style.

FIG. 19. **Yoruba Ifa diviner and clients, Ife, Nigeria, 1937.**

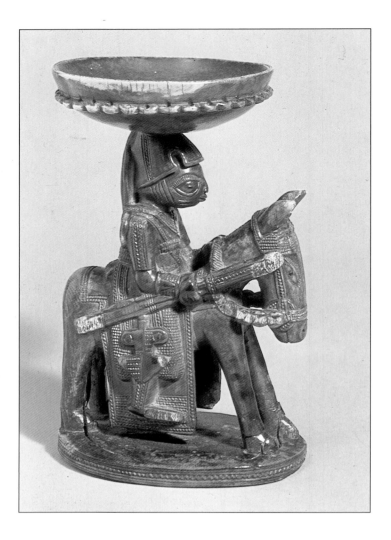
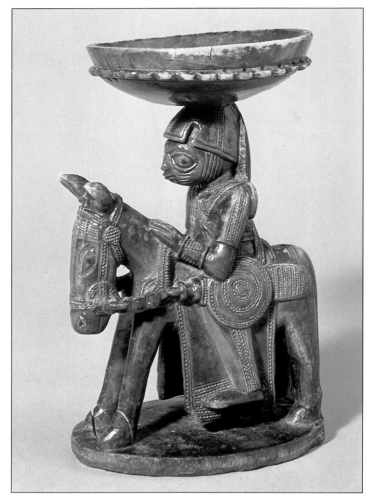

3 1

Ifa Divination Cup (*Agere Ifa*)
Owo group, Yoruba peoples, Nigeria, 17th–18th
 century
Ivory
H. 8¾ in. (22.2 cm)
Collection of Merton D. Simpson

Agere Ifa, or Ifa divination cups, are shallow
bowls used to store the sixteen sacred palm nuts a
babalawo (diviner-priest) uses in the Ifa divination
ritual. Such cups are invariably elevated, and most
are carved from wood. Rare examples, like this one,
are carved from elephant ivory, a costly, precious
material traditionally restricted to kings and high-
ranking chiefs. Ivory is an especially appropriate
material for an object so intimately associated with
the deity Ifa, as suggested by a praise name for him,
"*Gbolajokoo,* the offspring of the two tusks that
make the elephant's trumpet." This praise name

likens Ifa to the powerful elephant whose praise is
literally and figuratively sung by its trumpetlike ivory
tusks (Abiodun in Ezra 1984, 21–24).

The motifs of *agere Ifa* are varied because the cups
are commissioned works of art, the embellishment
of which depends upon both the resources of the
patron and the sculptor's talent and carving ability.
However, a frequent motif encountered on Ifa
divination cups is the equestrian representing a
mounted warrior, hunter, or ruler.

Horses were very important symbols of prestige
that, like ivory, were difficult to obtain. They were
introduced from the Western Sudan and, later, from
Europe and could be kept alive only with difficulty in
central forest localities such as Owo.

This horse-and-rider figure is carefully detailed. The
rider, exhibiting great confidence in his control of the
mount, rests one hand lightly on the reins while the
other firmly grasps his lance.

32

SHRINE FIGURE (*Ikenga*)
Igbo peoples, Anambra Valley, Nigeria, 20th century
Wood, pigment
H. 24 in. (61 cm)
Courtesy of Indiana University Art Museum,
　　Bloomington, Indiana
70.50

An *ikenga* is a ritual object in the cult of a man's
right hand. The right hand is used to do virtually all
important things, such as wield a tool or weapon,
feed oneself, offer a sacrifice, or make a gesture. The
ikenga symbolizes masculine strength and the ability
to achieve—through one's own efforts—the Igbo
ideals of status and success. In traditional Igbo terms,
these ideals consist of a large compound in which to
live; high rank in a title-taking association (that is,
having political power) and possession of the
requisite emblems of such rank; bountiful yam
harvests; many wives and children; and numerous
livestock. Although *ikenga* usually are personal
objects owned by individuals, they may also be
owned by entire communities (Aniakor 1984, 61–63;
Cole and Aniakor 1984, 24–33).

The essential feature of an *ikenga* is a pair of
horns, usually considered to be ram horns. The horns
symbolize qualities attributed to the ram: aggression,
perseverance, and restraint when required. The *ikenga*
may be in the form of a human head or a complete
figure. Its iconography may be minimal or elaborate.
For example, this elaborate *ikenga*, which was
owned by a high-ranking official in the men's Ozo
association, is carved in the form of a human figure
seated on a stool and holding an elephant-tusk
trumpet and an iron staff. His forehead bears the
distinctive *ichi* scarification, and he wears ivory
bracelets. The superstructure above his head is
composed of horned animals, snakes, and a
quadruped, probably a leopard, all suggestive of
power. The more successful the man, the more
inclusive the iconography on his *ikenga*.

This *ikenga,* although smaller, is so stylistically
and iconographically similar to one in the Kerchache
Collection, Paris, that it may be from the same hand.
The latter figure is attributed to a master from Nteje
who carved numerous pieces for villages and age-
groups in the Aguleri area of Nigeria (Cole and
Aniakor 1984, 28–29; Bentor 1986, 1–5).

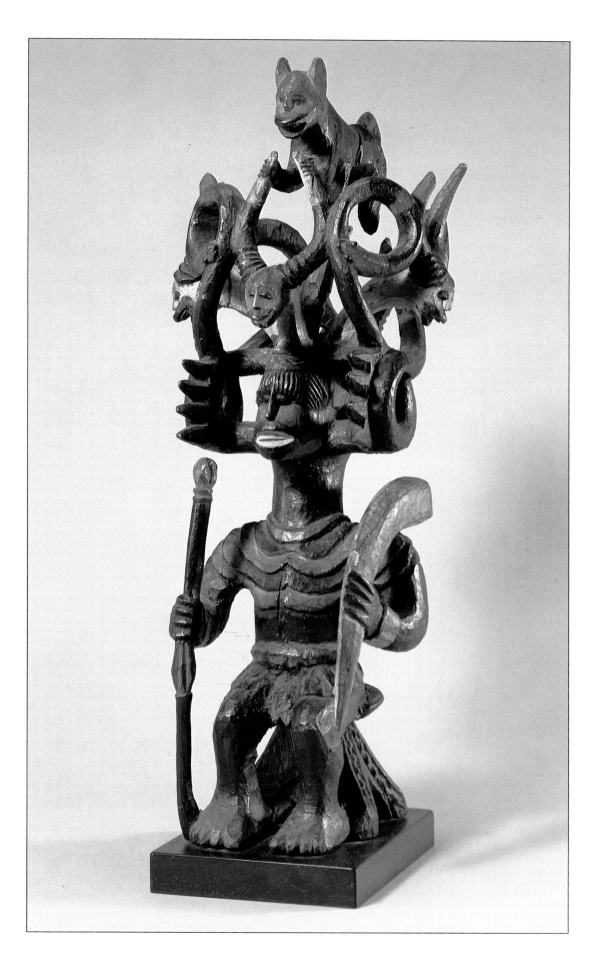

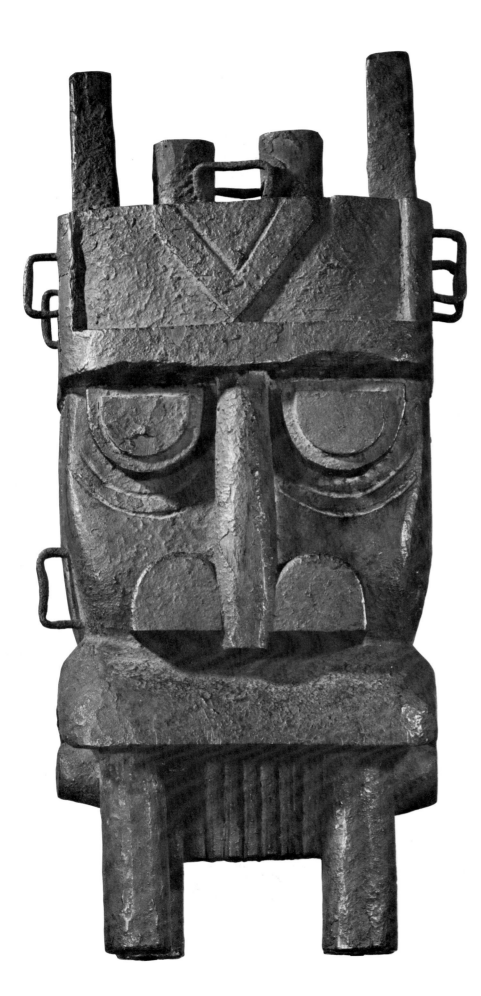

 33

HIPPOPOTAMUS MASK (*Otobo*)
Kalabari group, Ijo peoples, Degama area, Nigeria,
 19th–20th century
Wood, encrustation
H. 18½ in. (47 cm)
Collection of Raymond and Laura Wielgus

The Kalabari Ijo observed a ritual cycle that lasted about twenty-five years. The cycle could be prolonged by the death of a chief. After the introduction of currency, it was delayed because of the time it took a town or sponsoring family or association to raise sufficient funds to cover the expenses of the cycle. These ceremonies honored and appeased the powerful water spirits, or *owu,* which in turn blessed humans with fertility and ensured the food supply, especially fish, which was a staple in their diet (Talbot [1932] 1967, 309).

This mask, combining human and animal features, is called Otobo, meaning hippopotamus, and represents one of the *owu.* The mask was worn horizontally atop the head, its face directed upward toward the spirit world instead of the spectators. The mask was probably decorated with feathers and pieces of cloth, further obscuring the carved form (Horton 1965, 15; Jones 1984, 169).

This Otobo mask was collected from the Degama area of the Niger Delta in 1916 by P. Amaury Talbot, a British colonial administrator and ethnographer.

34

FEMALE FIGURE
Montol peoples, Baltip village, Nigeria, 1950
Wood
H. 15 in. (38.1 cm)
Lent by the Raymond and Laura Wielgus Collection,
 Courtesy of Indiana University Art Museum,
 Bloomington, Indiana
100.10.5.79

Among the Montol, sculptured figures were used in
divining rituals to ascertain the cause of illness. The
standing female figure shown here was used by
Komtin, a men's healing association.

This figure illustrates how objects travel from one
area to another. It was commissioned by a healer in
Baltip village in 1950 and was collected in 1958 by
Roy Sieber from Lalin village, a nearby settlement.

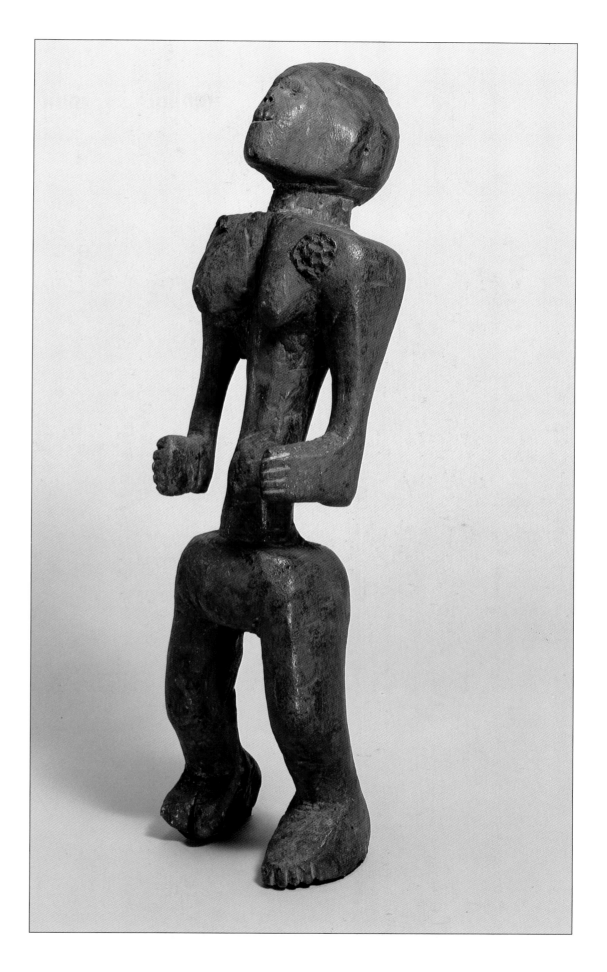

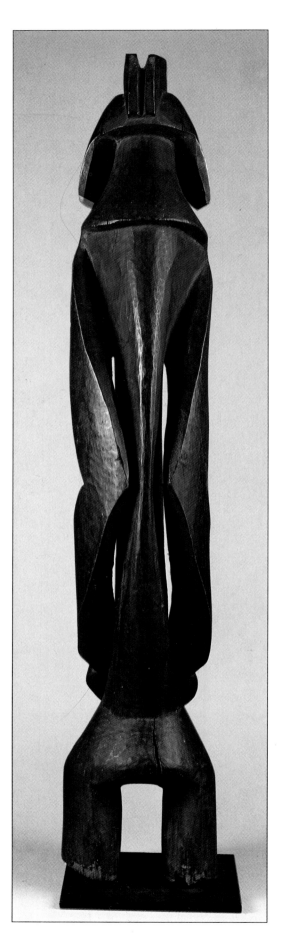

35

STANDING FIGURE
Mumuye peoples, Benue Valley, Nigeria, 20th century
Wood
H. 47¼ in. (120 cm)
Collection of Jack Naiman

There is great stylistic diversity in Mumuye statuary originating among several Mumuye groups in the Benue Valley. The functions of sculptured figures known as Jagana, Lagana, and Supa are similarly varied. They were used by both diviners and healers, whose professions included diagnosis and cure of ill health and other kinds of misfortune. The figures were used to greet a rainmaker's clients, guard the house, and serve as the owner's confidant. Elders used them to reinforce their status in society. It was not unusual for a figure simultaneously to serve two or more functions (Rubin in Vogel 1981, 155–58; Fry 1970).

36

HEADDRESS
Bamileke peoples, Bamendjo, Cameroon, 19th century
Wood
H. 21 in. (53.3 cm)
UCLA Museum of Cultural History, Gift of the
 Wellcome Trust
X65-5820

The precise function of Bamileke masks of this type is unknown. Wherever such masks were found, there was only one of them to a kingdom, where they may have been used in kingship rituals, such as an enthronement. They may also have been used during commemorative funeral celebrations or to designate a dead king's successor, who had been chosen during the funeral ritual (Harter in Vogel 1981, 183; Northern 1984, cat. no. 99). Such masks were worn atop the head, probably attached to a woven basketry frame (Harter 1969, cat. no. 99).

The collector of this mask, Father Frank Christol, a French Protestant missionary, photographed the mask in 1925 at the royal palace at Bamendjo. It was displayed on an elaborately carved stool/table with other royal insignia, including pipes, a sword, and two wooden panels with carved low-relief decoration (Harter 1972, fig. 5).

In 1932 Sir Henry S. Wellcome, an American-born British businessman, acquired this mask for the Wellcome Historical Medical Museum in London, which he had founded.

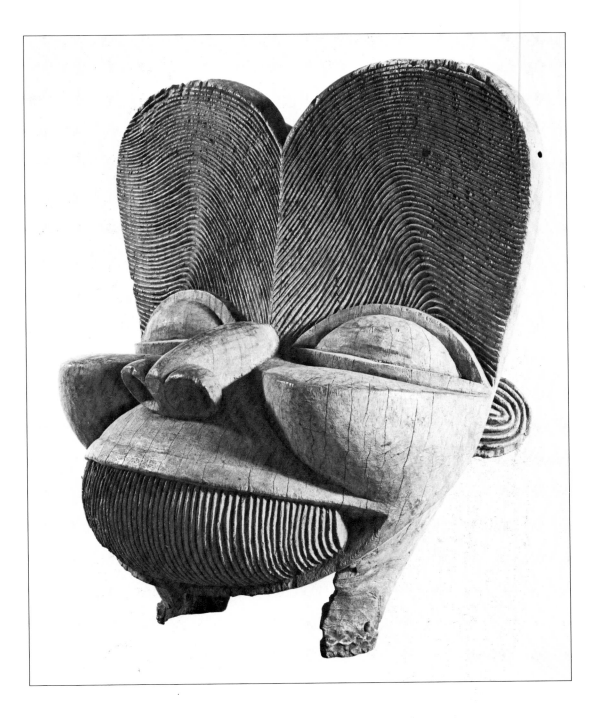

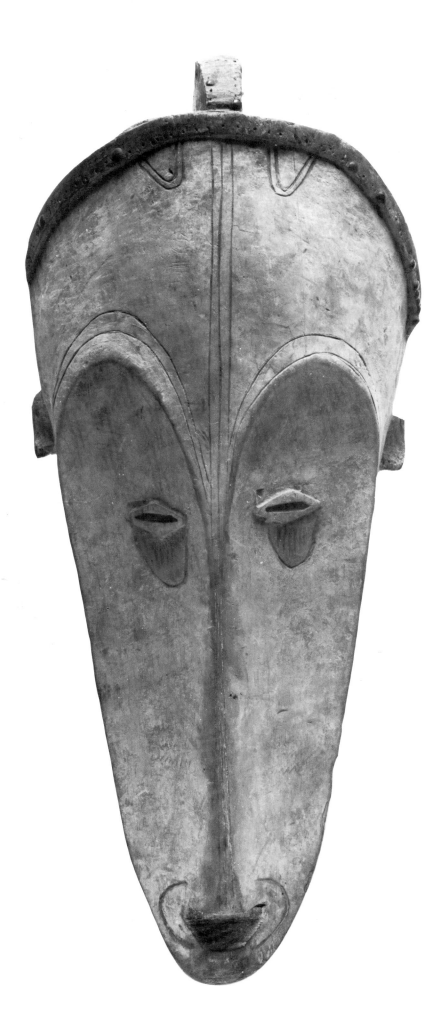

MASK

Fang peoples, Oyem region, Gabon, 19th–20th
 century

Wood, kaolin

H. 26 in. (66 cm)

Département de l'Afrique Noire, Laboratoire
 d'Ethnologie du Muséum National d'Histoire
 Naturelle (Musée de l'Homme), Paris

65.104.1

Large, elongated white-pigmented masks like this one
were used in the Ngi ritual, which has been defunct
since the turn of the century and, regrettably, is not
well known. It is believed that through ritual
performance, using kaolin with its protective and
curative properties, Ngi protected an individual
against evil spells and poisonings. It could also enable
an individual to increase his wealth. The mask was
prominent in the rites of passage of male youths, and
it punished all wrongdoers (Perrois 1985, 150–51).

38

MASK
Kwele peoples, Congo, 20th century
Wood, kaolin
H. 12 in. (30.5 cm)
Musée national des Arts africains et océaniens, Paris
1963-212

The Kwele believe that unexplained deaths, epidemic smallpox, and other mysterious threats to the well-being of individuals or the community are caused by witchcraft. Witches are believed to live in male or female hosts, from which they emerge at night to feed upon the internal organs of their victims. The antidote to witchcraft is the Beete ritual, which includes masked performances (Siroto 1979a, 250–62).

Masks used in the Beete ritual represent different *eluk*, or protective forest spirits, and "the children of *beete*." Some of these masks have obvious animal or bird attributes and bear their names; others are enigmatic in their identity. Most of the masks have white faces or white around the eyes. In contrast to widespread beliefs that white is the color of peace, ancestors, and the afterlife, the Kwele consider white to be a powerful color symbolizing light and clarity, two essential weapons in the fight against witchcraft. The white color is made from kaolin and derives its magical force from having been stored with powerful skulls preserved in reliquaries. In Kwele society, ancestors are worshiped not only because they represent links in the chain of descent from a common progenitor but also because they each hosted a witch, enabling them to become wise and brave leaders or diviners with supernatural powers. The Kwele say it takes a witch to fight a witch (ibid., 253–57). The kaolin white face and prominent eyes, which rise out of the heart-shaped depression of the facial plane, give it power and clear vision equal to that of the witches.

Forest spirit masks like this one with a human face and curving animal horns represent a ram. However, rams are domesticated, not forest, animals. The Kwele are unclear about the connection between the ram and witchcraft (ibid., 257).

This mask was shown at the Paris Exposition in 1937 and acquired by the Musée national des Arts africains et océaniens in 1938.

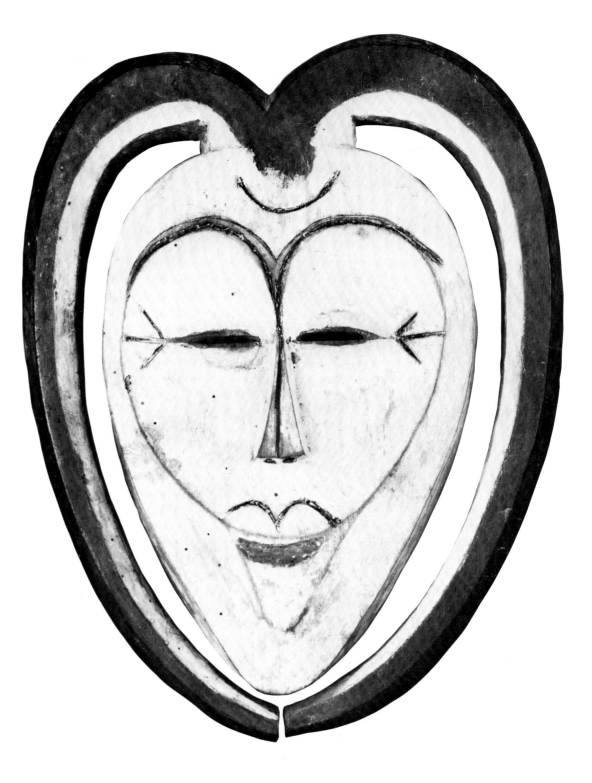

39

STANDING FEMALE FIGURE
Lumbo peoples, Gabon, 19th century
Wood, glass inlay, string
H. 15½ in. (39.4 cm)
Cincinnati Art Museum, Steckelmann Collection
1890.1545

The precise context in which this female figure was used is unknown. Generally, among the Lumbo, figurative sculpture is used for protection from malevolent forces and promotion of fecundity (Perrois 1985, 89–90).

This figure, which exhibits a detailed coiffure and raised scarification patterns, was originally acquired by Carl Steckelmann of Columbus, Indiana, an agent for an English trading company. The figure was part of an extensive collection of objects that Steckelmann amassed between 1885 and 1895 and is one of the earliest examples of Lumbo art. It was first exhibited at the Cincinnati Art Museum in 1889 and was later acquired for the permanent collection (Mount 1980, 40).

40

NAIL FIGURE (*Nkisi Nkondi*)
Yombe group, Kongo peoples, Shilango River area,
 Zaire, 19th century
Wood, metal, raffia cloth, pigment, clay, resin, cowrie
 shell
H. 44½ in. (113 cm)
Field Museum of Natural History, Chicago
91300

Figures like this one are called *minkisi minkondi*
(sing., *nkisi nkondi*) and are essentially containers for
powerful magical/medicinal ingredients (*bilongo*).
Such figures are used in healing or jural contexts
(Bassani 1977, 36; Isaki in MacGaffey 1977, 173;
Thompson 1978, 207–8).

An *nkisi nkondi* is made by a sculptor and an
nganga (ritual expert) working together. The sculptor
carefully carves a nude male figure, an animal, or
another form. Next, the *nganga* completes the figure
by placing the ingredients that have positive or
negative powers around its chin, creating a "beard,"
and in an abdominal or other cavity made by the
sculptor. The iron blades, nails, screws, and, in this
example, machine parts are driven into the figure
during use.

An *nkisi nkondi* may be used for many purposes.
For example, upon concluding peace between two
warring villages, representatives from both sides
would first take an oath before the *nkisi nkondi*, and
then each party would hammer iron wedges or a
knife into the figure and fire a salute. Or, an oath
sworn before the *nkisi nkondi* would make a title
search on real estate unnecessary because with the
driving in of a piece of iron, the title to the land
would be secured through the generations (Laman
1957, 159–60). Or, a blade could be driven into the
figure to activate its magical powers.

This figure was obtained in 1907 from W. D.
Webster, a London dealer in ethnographica.

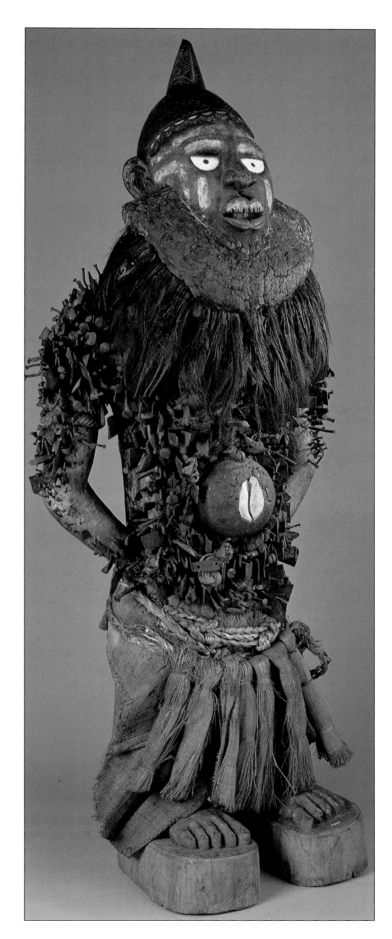

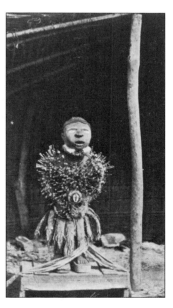

FIG. 20. Nail figure,
Kongo peoples, Zaire, 1896.
The figure is posed in
front of the house of
an *nganga* (ritual expert).

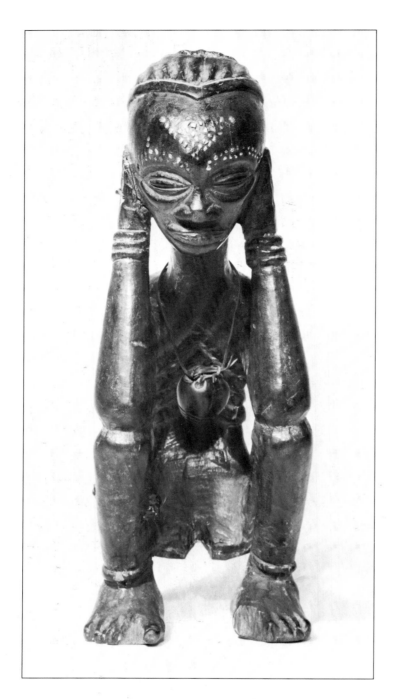

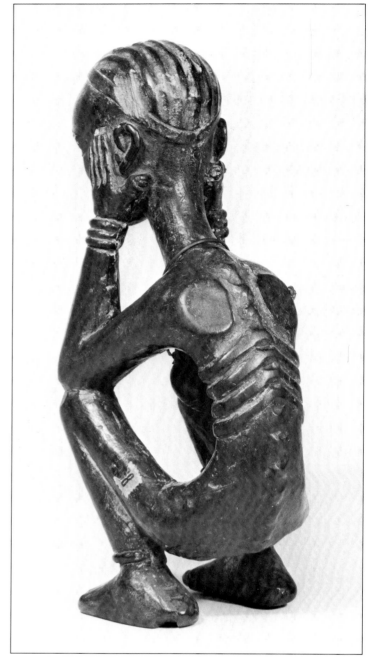

41

CROUCHING FIGURE
Lulua peoples, Kasai region, Zaire, 19th–20th
 century
Wood, fiber, seed pod, metal
H. 7 in. (17.8 cm)
Private collection

Small crouching figures from the Lulua are posed
with the elbows touching the knees and, like this one,
often appear to be emaciated. The precise function of
these figures is unknown. It has been suggested that
they were used by diviners to ascertain the cause
of illness or other misfortune (Felix, personal
communication, 1986), or they may represent a
person suffering from physical or spiritual illness. The
figure may represent a *kalamba* (chief) in the attitude
of contemplation before taking action, or it may a
represent a guardian spirit (Cornet 1971, 162).

42

MASK
Boa peoples, Zaire, 19th–20th century
Wood, pigment
H. 14 in. (35.6 cm)
Collection of Mr. and Mrs. Alain de Monbrison

The precise function of Boa masks is not known.
They have been described as belonging to warrior or
secret associations and are considered to be war
masks or disguises used in hunting. Typified by this
example, the planes of these masks are alternately
dark and light, and the masks have small eyes and
prominent, round ears, suggesting alertness. The
mouth is open, revealing teeth made from tiny pieces
of wood set into the mask (Walker Art Center 1967,
cat. no. 29; Cornet 1971, 315).

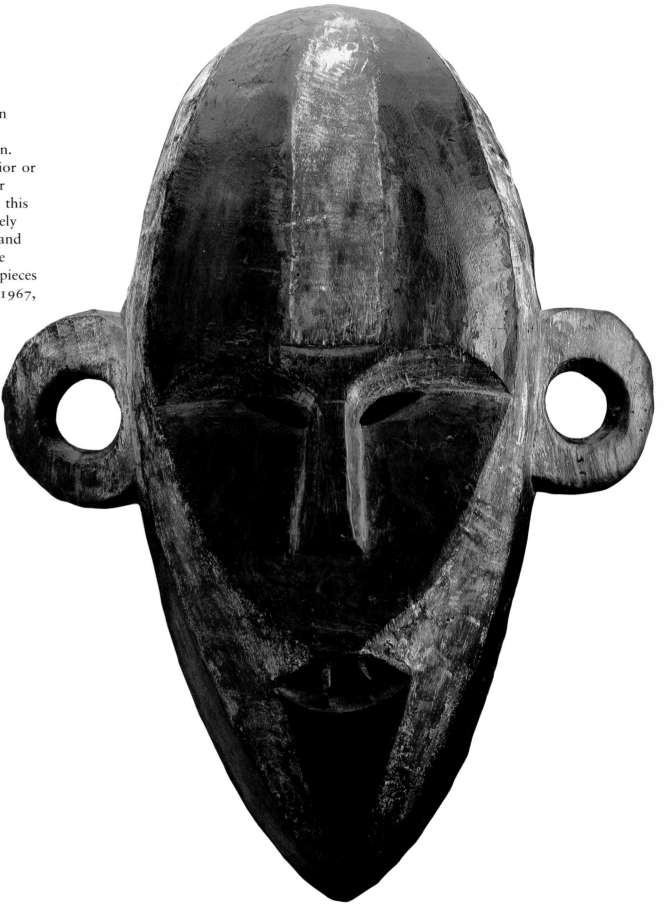

4

GOVERNANCE

Leadership in traditional Africa ranged from the head of a lineage or village to centralized chiefdoms, kingdoms, or even empires. Works of art may reflect not only the level of complexity of the political and spiritual leadership but indeed may also be central to its success. The leader is often tied to his constituency in spiritual as well as secular ways. For example, the senior chief of the Ndembu of Zambia, a group with weak political centralization, represents both the apex of the politico-legal hierarchy and the total community as an unstructured unit. Also the chief is symbolically the tribal territory itself and all its resources. Its fertility and freedom from drought, famine, disease, and insect plagues are bound up with his office and with both his physical and his moral condition (Turner 1977, 98).

In African societies with centralized leadership, the ruler is often considered a deity, a divine king. As Mbiti puts it, "the image and work of the human rulers tend to be readily projected on to the image of God" (1969, 45). He goes on to state that "where kings and chiefs existed, their office is usually regarded as having been divinely instituted or maintained. These kings and chiefs are looked upon both as political heads and religious personages who symbolize the prosperity and welfare of their nations" (ibid., 69).

> The position of chief is one of outstanding power and authority. He is father of his people, and the symbol of tribal unity. He is the central figure in all national activities. His person is sacred, and many peoples bow to their chiefs still in complete submission. . . . He had first choice of land, for cultivating or grazing. In Ashanti he was said to own the land and the gold, meaning that he was custodian of it all. He would preside over the highest courts, disburse the national wealth, control age groups, organize social gatherings, and impose the penalties of death and banishment. (Parrinder 1954, 77)

However, as Parrinder also reports, "not only are there royal prerogatives, there are also royal obligations. The monarchy is no sinecure. . . . The chiefs were surrounded by multitudinous taboos that must have made life wearisome" (ibid., 78). The leader played an important "part in the religious life of the people. The chief was leader and representative of the people in the great ceremonies of the seasons, purifications, initiations and warfare" (ibid.).

At the same time, it must be noted that the chiefs rarely acted alone. They were supported and advised by elders "who served greatly to limit the actual exercise of the chief's power" (ibid.).

Thus African leaders tend to be both ritual and secular heads of state, responsible for civil order and spiritual security. Should a candidate who is illegitimate be "put forward to a chieftaincy . . . The people may revolt. They will say, 'It is not possible for such a one to be chief. Nothing will grow any more on our soil, the women will bear no more children, the skies will not send rain, and all will be smitten with sterility'" (ibid., 28).

This attitude holds true for both the smaller and the larger states. The Asante of Ghana, for example, see in the well-being of the kingdom a reflection of the state of well-being of the king, the Asantehene. A good deal of the royal art of the Asante reflects that attitude, for example, both the cast copper-alloy *kuduo* carrying a depiction of a royal entourage (cat. no. 44) and the silver-encrusted stool (cat. no. 43), which was probably owned by a member of the royal court at Kumasi. Stools, whether owned by Asante royals or commoners, are believed to house the soul of the owner. Thus the higher the rank and importance of the owner, the greater the spiritual importance of the stool until the Golden Stool, the ultimate symbol of the Asante nation, is reached. It is believed to house the collective soul of

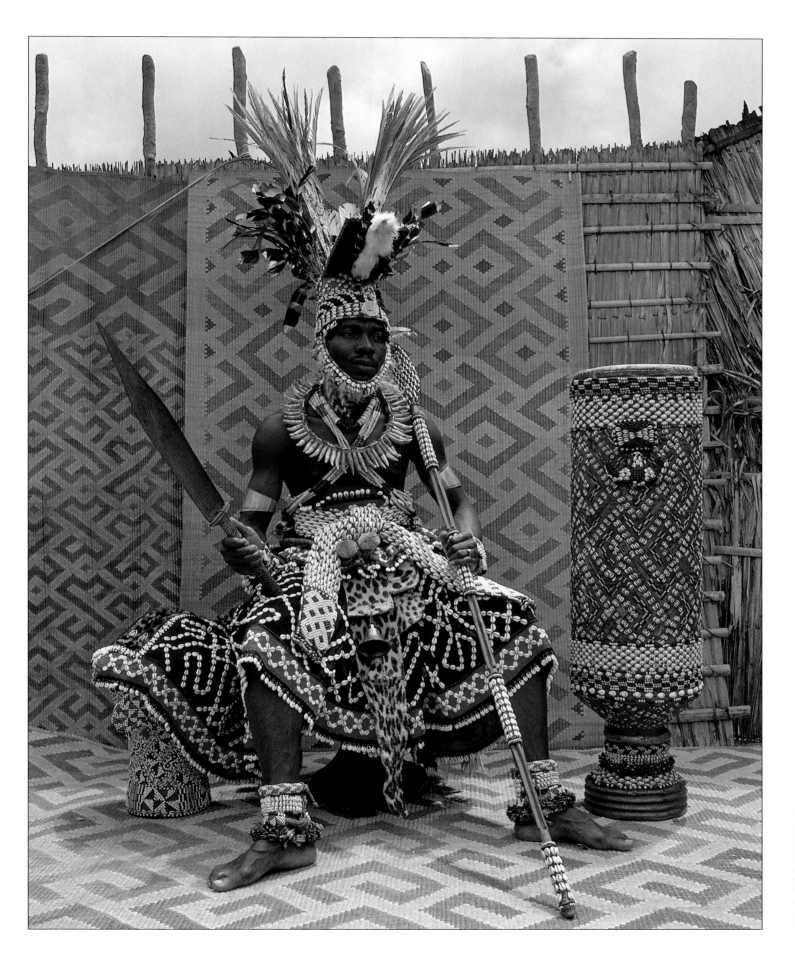

FIG. 21. Kot a-Mweeky III
sitting in state, Mushenge,
Zaire, 1971. This modern
Kuba king's regalia includes
the royal *shody*, a visor-
like headpiece, and a belt
embroidered with cowrie
shells like the one on Shyaam
a-Mbul a-Ngwoong's *ndop*
(cat. no. 47).

the people and is the most important symbol of the well-being of the nation.

Often, works of art commemorate leadership by depicting the ruler, not with an accurate portrait but as the symbolic leader, at times with identifying attributes. This is the case with the eighteenth-century Kuba *ndop* figure (cat. no. 47) with its depiction of royal sword, belt, crown, and *lyeel* game board. Carved of wood, its survival is limited by the comparatively fragile nature of that material.

In contrast, any copper alloy will normally survive longer than wood. In Benin, the use of copper-alloy castings was a royal prerogative, limited to the *oba* (king). Only the *oba* could commission works, whether they were in the form of heads or figures for ancestral shrines or plaques that depicted royal rituals and were mounted on palace walls. Two works in this exhibition associated with royalty represent, first, an equestrian figure of uncertain subject, although possibly representing a defeated enemy (cat. no. 45), and, second, a sixteenth-century queen mother, mother of the king, who was honored with a commemorative and highly stylized portrait (cat. no. 46). Both were destined to be placed on an altar of one of the *oba*s. Thus both the subject and the material tie these sculptures to the leadership of a centralized state.

In some situations, powerful foreigners take over the leadership of a noncentralized state. At times, the outsiders become the secular overlords of the now centralized state, and the former local leadership retains an important ritual role, which is often tied to agriculture and to the concept of the ownership of the land. Several peoples in Ghana and the Mossi of Burkina Faso have this two-layered leadership, a mix of centralized and noncentralized, secular and ritual, leadership, as do the Senufo of Côte d'Ivoire and Burkina Faso who, "besides the village chief [have] a 'master of the land' who is a representative of the first inhabitants and primarily a priest" (Paulme 1974b, 298).

Noncentralized, or acephalous, societies exist in much of sub-Saharan Africa. Family heads or village chiefs exercise some authority, but far less than that of centralized societies. Because noncentralized societies cannot support them, there are no standing armies or police. Therefore, much social control lies in the hands of the chief and the elders, who often use figures or masks as agents of social control, for example, the Egu Orumamu mask of the Igala of Nigeria (fig. 4).

In Zaire, leadership among a number of groups, such as the Lega and Mbole, is vested in the men's associa-

tion. In describing the men's Bwami association of the Lega, Jacques Maquet writes that "the society provides a strong structure uniting the small Balega groups, which are separated from each other in a vast region where nature is a formidable obstacle to communication. It takes the place of a political organization and helps give them a tribal consciousness" (1974c, 40). The association consists of several levels or grades, which may be attained by men and some women through a series of initiations. "As the passage from one grade to another depends not only on ritual trials, but also on ostentatious spending, [the masks and figure carvings] are a real indication of the social status and personal prestige of their owners" (ibid.).

Biebuyck, who has studied the Lega more closely than any other researcher, writes: "Bwami, as the perpetual search for moral excellence, beauty, prestige, wealth, authority, and power, is the goal of Lega life. In theory it is open to everyone in the society. In practice, most males and a considerable number of their wives achieve one level or another in bwami" (1973, 57).

He goes on to note that "in a society without chiefs, bwami members hold political power" (ibid., 65). Further, "it is also an arts club, for it enjoys and patronizes the fine arts. It is a school of art because it creates, produces, uses, and explains thousands of pieces of sculpture" (ibid., 66).

Biebuyck states that in general "bwami represents the effective system of power and authority" (ibid., 67); it "relates to two different but mutually nonexclusive institutions: exercise of power and authority on the one hand; initiation . . . and the resulting knowledge and moral behavior on the other" (ibid., 68); it "has all the major characteristics of a voluntary association" (ibid., 90); however, "it would be improper to call bwami a secret society, for its membership is publicly known," and its purposes and "the basic principles of its teachings, are known to all Lega" (ibid., 91). In summary, it "is a multipurpose association. Its secondary purposes include political, economic, social, artistic, religious, and recreational functions. All derive from its primary purpose, which is the pursuit of wisdom and moral excellence, a leit motiv that runs through all initiations" (ibid.; see also Biebuyck 1986).

The figure carvings, masks, and other objects of the Bwami association are related to the grade attained by the initiate. The highest grade, Kindi, supports some of the most spectacular objects (cat. nos. 50–51). "Proverbs and aphorisms, which are used by the thousands during bwami initiations, are sung and almost always

are accompanied by action: music, dance, gesture, display and manipulation of objects (ranging from natural objects to carvings)" (Biebuyck 1973, 54).

The Mbole association, called Lilwa, is similar to Bwami, although fewer objects are associated with Lilwa. Perhaps the most noteworthy are the *ofika* figures, which represent initiates who transgressed against the laws of Lilwa or committed other crimes and were publicly hanged in punishment (cat. no. 52) (Biebuyck 1976, 56; Biebuyck 1986, 241–43).

Many groups have objects that serve as agents of social control. Among them are the masks of the men's association of a number of groups in Liberia and Côte d'Ivoire. In a reference to the men's Poro association, Webster writes that "before the establishment of British law in the Sherbro Hinterland, it provided the chief governmental agency" ([1908] 1932, 210). Each mask served a particular function for the community, ranging from governance to war to policing (Harley [1950] 1975). One such agent of control is cat. no. 48, which served to protect the village from the very real danger of fire during the dry season.

The Igbo of southeastern Nigeria are a large decentralized group that places a strong emphasis on personal achievement. Leadership is earned through the successful acquisition of high status in a men's title-taking organization. In part, the ability to buy an exalted place among one's kin and age-mates depends on the degree to which a man is a successful yam farmer. A terra-cotta from the Kwale Igbo illustrates the importance a man might achieve. It is an altarpiece, dedicated to the deity of farming. It is made by a woman potter and depicts a successful man with wives and child and a personal shrine (cat. no. 49). This serves as an instance of individual achievement rewarded with authority.

These are but a few instances where authority is focused locally and power and social control are vested in the individual or in an association where rank and position are reached through personal ability and where sculptures are used as focal points of that authority.

R.S.

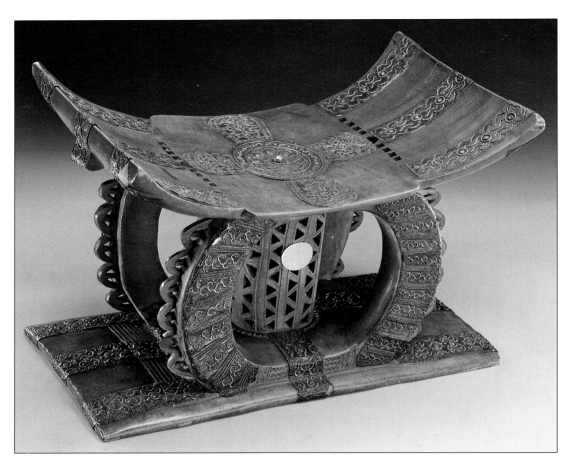

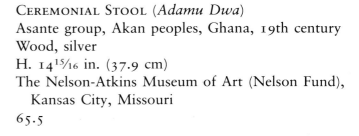

43

CEREMONIAL STOOL (*Adamu Dwa*)
Asante group, Akan peoples, Ghana, 19th century
Wood, silver
H. 14¹⁵⁄₁₆ in. (37.9 cm)
The Nelson-Atkins Museum of Art (Nelson Fund),
 Kansas City, Missouri
65.5

The supreme symbol of Asante leadership on all levels of its centralized political system is the ceremonial stool (*adamu dwa*). The most famous and important is the Golden Stool, which, according to tradition, was solid gold and miraculously descended from the skies to rest gently on the lap of Osei Tutu, the founder-king of the Asante Confederacy in the early eighteenth century. Regarded as a supernatural object, the Golden Stool enshrines and protects the collective soul of the Asante people and ensures their well-being (Kyerematen 1964, 11–25).

The ceremonial, or state, stool of an Asante chief symbolizes the unity of his state and his authority. If a chief rules well and dies during his reign, his official stool will be enshrined with other venerable relics of the state ancestor cult (ibid., 1–25).

This ceremonial stool allegedly belonged to Asantehene (King) Kofi Kakari, whose seven-year reign (1867–74) ended when he was deposed after the British sacked the capital at Kumasi. The plaque on the stool reads as follows: "King Koffee's State Chair from his Palace at Comassie brought home by Arthur Paget Feb.ʸ 1873." Scholars believe these data are suspect. Based on their examination of appropriate documents and knowledge of stool protocol, they conclude that there was an error in recording both the Asante owner and the date of acquisition (Ehrlich 1976, 439–44; Cole and Ross 1977, 137–38). The stool was most probably taken as war booty from the palace in 1874 during the Anglo-Asante war.

However, there is no question that the original owner of this stool was a member of the king's council of chiefs or a queen mother. It is larger than a domestic stool, and it is decorated with silver, which although inferior to gold is very valuable (Sarpong 1971, 19; Ehrlich 1976, 441; McLeod 1981a, 115).

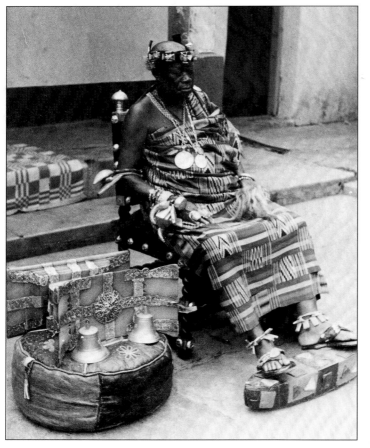

FIG. 22. The Omanhene of Asumegya, a major chief of the Asante, seated in state, Ghana, 1972. The chief's silver-decorated stool is placed on a cushion, calling attention to the importance of its owner.

44

VESSEL (*Kuduo*)
Asante group, Akan peoples, Ghana, 18th–19th
 century
Cast copper alloy
H. 11½ in. (29.2 cm); Diam. 10 in. (25.4 cm)
Département de l'Afrique Noire, Laboratoire
 d'Ethnologie du Muséum National d'Histoire
 Naturelle (Musée de l'Homme), Paris, Gift of
 Mrs. Dominique de Menil
65.17.1

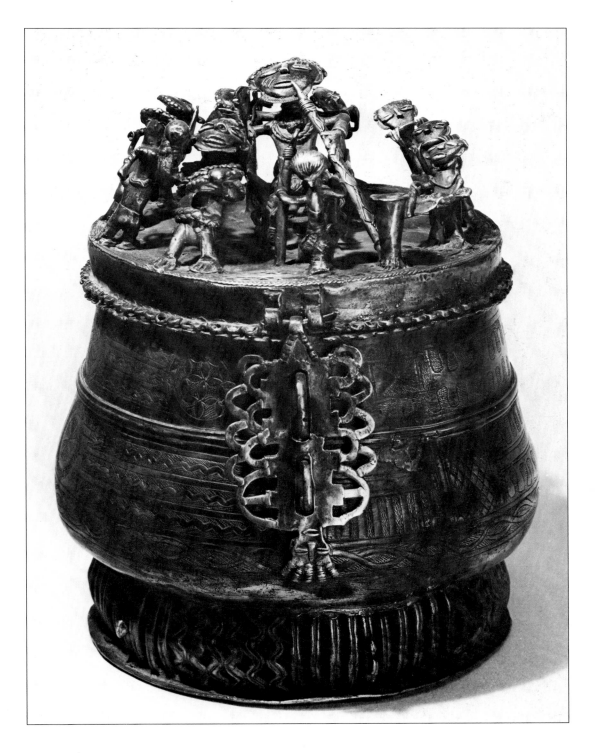

Kuduo are copper-alloy containers cast by the lost-wax process. Possession of large, elaborately decorated *kuduo* was the prerogative of Asante kings and chiefs of major states, who used them to store their treasures, gold dust, and precious beads. *Kuduo* were also used to keep sacred objects or sacrificial foods that were placed before the blackened stools of ancestral rulers in the stool room. They also functioned in other contexts shared by royalty and subjects alike, for example, rites connected with a man's *akra*, or soul (Rattray 1927; Kyerematen 1964, 43–45).

The form and decoration on the sides of *kuduo* derive from Islamic metal vessels that came from the north via the trans-Saharan trade during the fourteenth or the fifteenth century (Sieber 1967; Garrard 1980). However, sculptured lids on such vessels are often thoroughly Asante in concept. Depicting animal or human groups, the lid decoration may be symbolic or may illustrate commonly known proverbs. The lid on this *kuduo* shows a royal scene: a seated Asantehene (king) smoking a pipe while being entertained by court musicians. However, because the Asantehene is portrayed with facial marks and is unshod, it has been suggested that the lid depicts a "reverse" image of the king in state during the Odwira festival (McLeod 1979, 28–30). This festival marked the end of one year and the beginning of the next, a period when normal behavior was briefly reversed. For example, subjects could verbally abuse chiefs without fear of punishment.

This *kuduo* is one of three that are believed to have been made by the same master caster. The other two are in the collections of the Museum of Mankind, British Museum, in London and the National Cultural Centre Kumasi, Ghana.

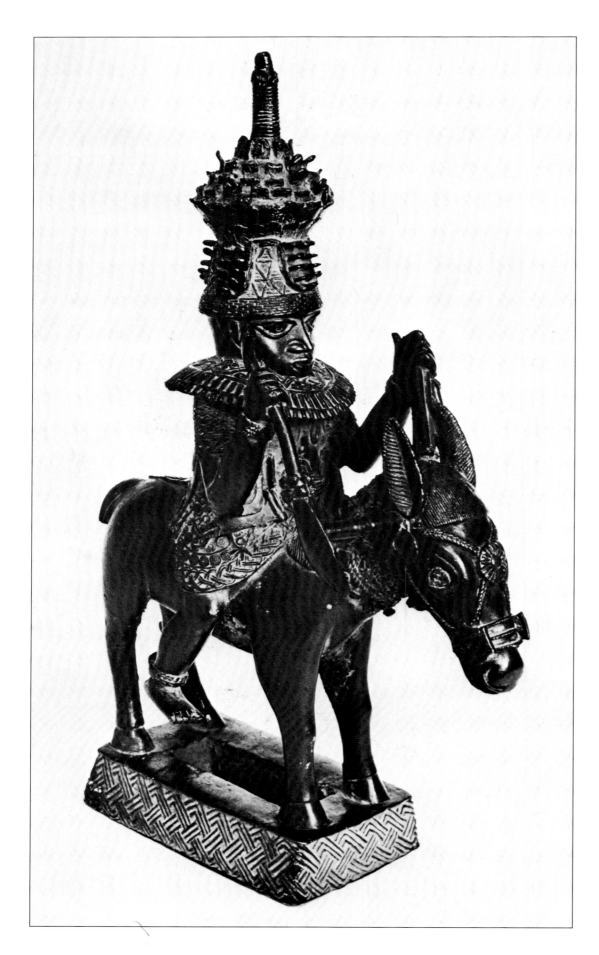

45

EQUESTRIAN FIGURE
Benin Kingdom, Edo peoples, Nigeria, probably
 17th–18th century
Cast copper alloy
H. 18½ in. (47 cm)
Private collection

Many different objects are placed on royal ancestral altars in the palace of the *oba* (king) of Benin. In the past, such objects included cast copper-alloy equestrian figures like this one.

Despite the expense and the difficulty of keeping horses alive in the tropical forest, the presence of horses was not uncommon in Benin, and the *oba* used them on ceremonial occasions, according to numerous accounts beginning in the early seventeenth century (Karpinski 1984, 56–57). However, because the rider's costume seems not to be a local one, the identity of the rider is controversial. He has been identified as a foreigner of unknown origin (Luschan [1919] 1968, 174), a Yoruba warrior (Forman, Forman, and Dark 1960, 47), an emissary from northern Nigeria (Fagg 1963, fig. 30) or North Africa (Fleming 1979, 49), or an *oba* of Benin dressed as a member of the cavalry from Oyo, Nigeria (Tunis 1979, 392–94). Additionally, the rider has been identified as Oranmiyan, a Yoruba prince from Ife who founded the present dynasty and who, it is believed, introduced horses to Benin (Ben-Amos 1980, fig. 37; Karpinski 1984, 55–61; Egharevba [1934] 1960, 8), or the *ata* (king) of Idah, ruler of the Igala people, whom the Edo defeated in a sixteenth-century battle (Nevadomsky 1986, 40–47). The figure may have originally commemorated a person or an event, but over a long period of time it became a generalized symbol of the power of the Benin monarchy.

Whatever the rider's identity, his depiction as an equestrian signifies real or spiritual wealth and power. The cast copper-alloy material used to produce the sculpture was a prerogative of the *oba*.

46

COMMEMORATIVE HEAD OF A QUEEN MOTHER
 (*Iyoba*)
Benin Kingdom, Edo peoples, Nigeria, probably 16th
 century
Cast copper alloy, iron inlay
H. 15½ (39.4 cm)
Trustees of the British Museum
97.10-11.1

Royal ancestral altars are major shrines in the palace
of the *oba* (king) of Benin. The current *oba*, as
caretaker of the shrines and chief-priest of the cult of
the royal ancestors, officiates in rites invoking the
protection of his ancestral fathers on behalf of his
subjects.

 According to oral tradition, the *iyoba* (*iye:* mother;
oba: king) of Uselu, the official title of the queen
mother, was established by Oba Esigie (Egharevba
[1934] 1960, 28). During his reign, he had a portrait
head of his mother, Idia, cast and placed in his
palace to commemorate her role in the Benin-Idah
war, thereby including, for the first time, queen
mothers in the cult of royal ancestors.

 Characteristic of the early period of Benin court
art, this commemorative head is finely modeled, has
thinly cast walls, and presents the subject wearing a
high beaded collar. She is depicted wearing a cap
made of red coral or stone beads over the distinctive
"chicken-beak" hairstyle that was the prerogative of
queen mothers (Ben-Amos 1980, 25). The supra-
orbital keloids on the brow are separated by two
narrow vertical bars of inlaid iron. As suggested
by two other nearly identical heads presumably by
the same master caster, this is probably an
idealization of youthful feminine beauty rather than a
faithful portrait (Fagg 1963, 13; Eyo and Willett
1980, 128; Dark 1973).

 This queen mother head was taken as war booty
along with great numbers of other art objects from
the Benin palace treasury during the punitive
expedition of February 1897. The expedition was in
retaliation for the massacre of a British mission to the
oba of Benin the previous month. This piece was
acquired by the British Museum in 1897.

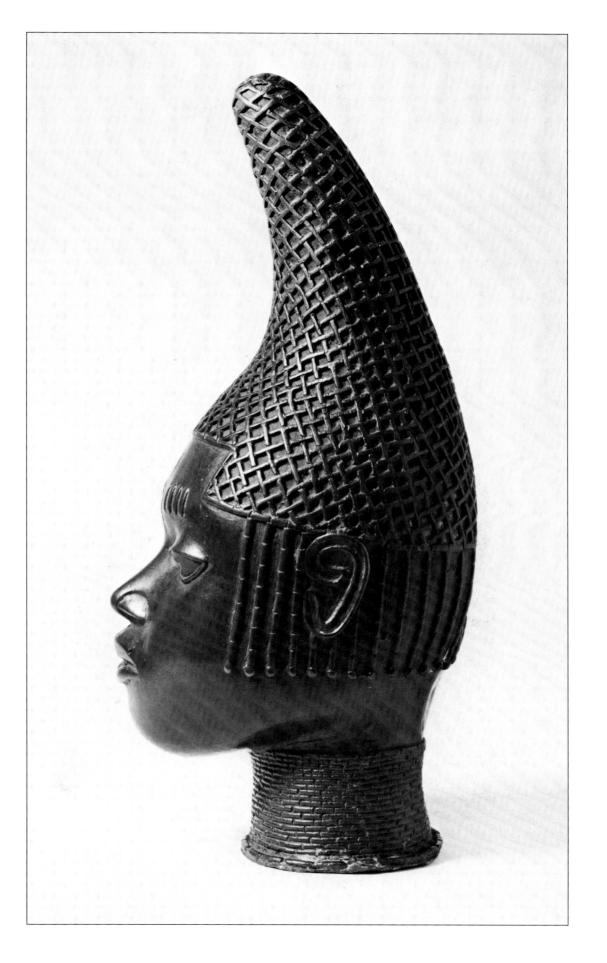

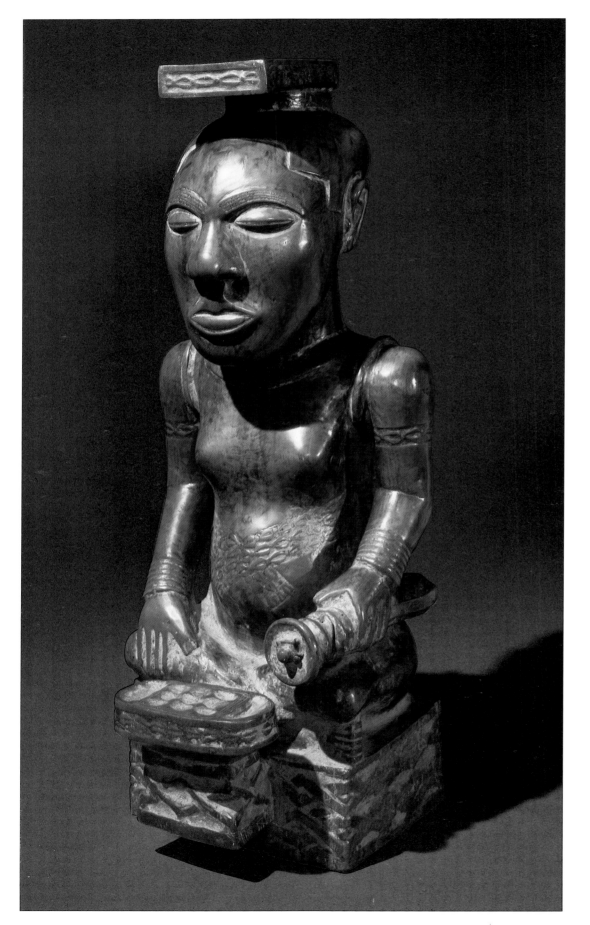

47

COMMEMORATIVE DYNASTIC STATUE (*Ndop*)
Bushoong Kingdom, Kuba peoples, Sankuru region,
 Zaire, 18th century
Wood
H. 21½ in. (54.6 cm)
Trustees of the British Museum
1909.12-10.1

Kuba kings are commemorated in conventionalized carved wooden portrait statues called *ndop*. An *ndop* does not accurately depict the physical features of the subject, but it is distinguished by details of the regalia and by the *ibol*, an object carved in full relief and placed before the ruler, which symbolizes his reign.

This *ndop* depicts Shyaam a-Mbul a-Ngwoong, the dynastic founder of the celebrated Kuba Kingdom and a culture hero whose reign scholars date to the late sixteenth or the early seventeenth century. Shyaam's *ibol* is a game board for *lyeel*, which, according to oral tradition, he introduced and which was played during the enthronement to demonstrate the monarch's supremacy in all matters (Vansina 1964, 115; Cornet 1982, 44, 97). However, the game board may be an analogy for Shyaam's succession to the throne. He did not inherit the throne, but with luck and cunning usurped it (Belepe Bope Mabintch 1977–78, 167).

A king's *ndop* functioned during his reign and after his death. It was considered to be his "double" and, as such, reflected the ruler's state of well-being. This attribution suggests that *ndop* were carved from life, and this one would date from c. 1700. Survival for so long in a tropical environment being unlikely, it has been suggested that the four oldest extant *ndop*, including this one, were carved in the late eighteenth century as replacements for lost or deteriorated *ndop* (Cornet 1982, 78–110).

The British Museum acquired this *ndop* in 1909. It was given to Emil Torday, a Hungarian ethnographer, for the British Museum by Nyim (King) Kwete Peshanga Kena, who wanted it to be preserved and made available for peoples of other kingdoms to see (Torday 1925, 149–50).

48

MASK (*Zakpei*)
Dan peoples, Liberia and Côte d'Ivoire, 20th century
Wood, fiber
H. 10 in. (25.4 cm)
Collection of Patricia Withofs, London

Traditional Dan society was acephalous, that is, its political organization was not centralized. Leadership was vested in a council of elders. Masks, serving as agents of social control, enforced the council's rules and orders (Murdock 1959, 33–39; Fischer and Himmelheber 1984, 4–5).

One of these social control masks is shown here. Called Zakpei, it was in charge of fire prevention. In some Dan villages, there was only one such mask; in others there were several. Zakpei masks were considered to be male spirits but without ancestral connection. They appeared only during the dry season, when the villages, with their fiber-roofed houses, were particularly susceptible to fires. At such times, when wind velocity increased significantly, these masks, covered with red cloth or painted red, scouted the villages for cooking fires. If such fires were found, the masks overturned the cooking pots and severely punished the disobedient women. Zakpei became defunct with the introduction of corrugated roofs and were never known in villages located in the lower plains (Fischer and Himmelheber 1984, 45–46).

It should be noted that masquerades in which Dan masks appear often survive many generations and may be assigned new functions by subsequent owners. For example, at some time in its history, this round-eyed mask may have appeared in the Gunyege, or "foot-racer," masquerade, which had a purely entertainment function. In all cases, the identity of a Dan mask is determined not only by its facial features but also by the headdress and costume it wears, its musical accompaniment, and the way it behaves in the context of its appearance (ibid., 8–9, 35–37).

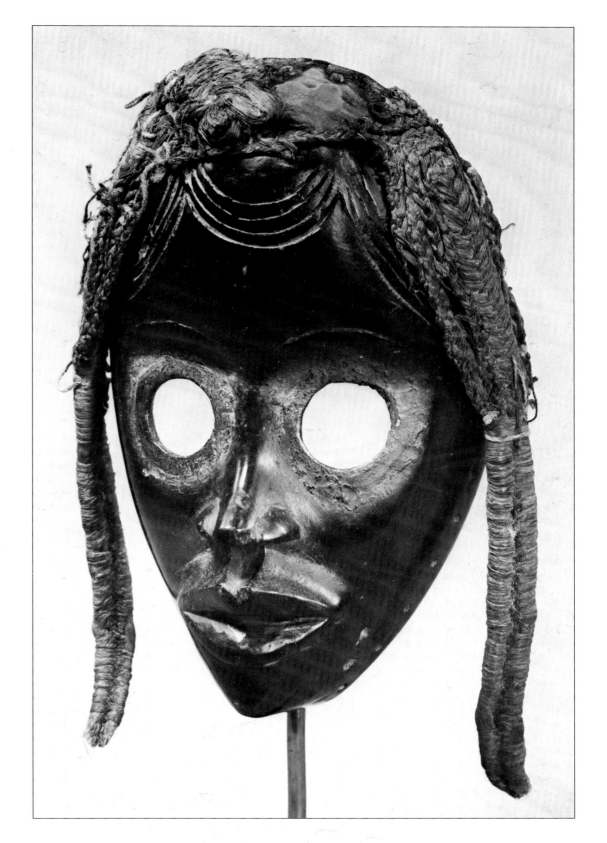

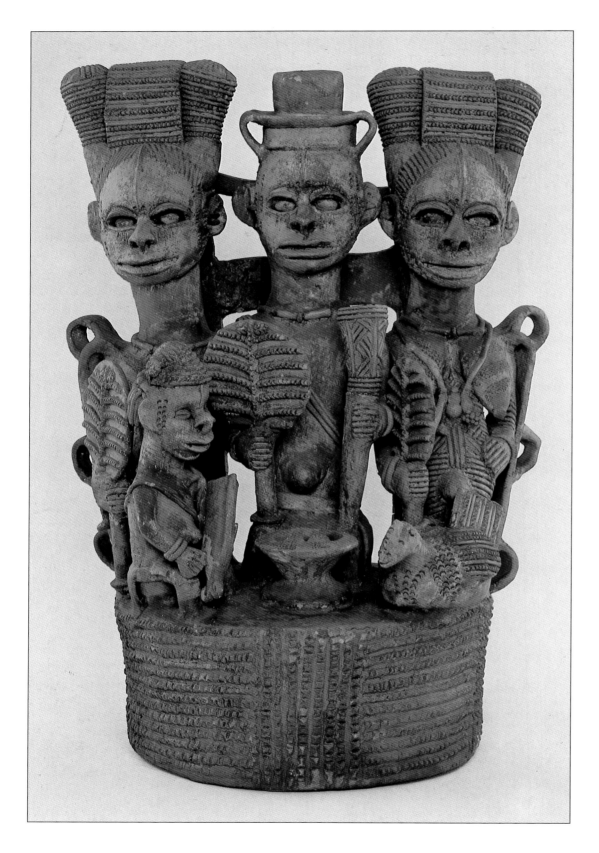

49

ALTARPIECE
Kwale group, Igbo peoples, Osisa village, Nigeria,
 19th century
Terra-cotta
H. 17½ in. (44.5 cm)
The Trustees of the National Museums of Scotland
1905.8

In traditional Igbo society, political, moral, and
spiritual authority was decentralized and usually
vested in elders, heads of extended families, and
holders of elevated rank in the men's title-taking
association. These men gained their positions of
authority with the support of their age-mates and
kinship networks, but they were especially dependent
on good yam harvests. Yams have traditionally been
a staple food of the Igbo and many other peoples of
southern Nigeria.

 Figural altarpieces like this one were made by
female potters among the Kwale Igbo for shrines to
Ifejioku, the god of farming, especially the cultivation
of yams. This figure represents the head of the
family, distinguished by his top hat, ivory tusk
trumpet, and fan, all emblems of titled status (cat.
no. 32). He is flanked by two elaborately decorated
and pregnant wives, who, reflecting their husband's
elevated status, also hold fans. A child holding a
double gong sits on one side; a fowl for sacrifice is
on the other. Placed before the family head is an
ikenga, a man's personal shrine to his right hand,
that is, his ability to succeed. Altarpieces were
consecrated in annual rites that took place during the
yam harvest (Talbot [1926] 1969, 145; Cole and
Aniakor 1984, 80).

 Terra-cotta altarpieces for Ifejioku are rare. The
few extant examples were collected in the 1880s and
are preserved in museums in the United Kingdom and
Nigeria.

50

CROUCHING FIGURE
Lega peoples, Zaire, 20th century
Wood
H. 11½ in. (29.2 cm)
Collection of Raymond and Laura Wielgus

Bwami is the effective system of power and authority among the noncentralized Lega peoples and affects every aspect of human life, from maintaining and reinforcing kin-group bonds, to educating and socializing youth, to regulating the economy. It is a voluntary association reputedly open to all Lega, but in reality its membership is confined to circumcised males and the wives of men who have achieved high rank. Those members who ascend the grades succeed because of kinship support and their own character and wealth (Biebuyck 1973, 66–67).

Objects play an important role in Bwami because they are used as proverb-images illustrating principles of moral perfection to which Bwami members aspire. Each grade has its own insignia of rank. Sculptures made of wood, elephant ivory, elephant bone, or elephant leather are prestige objects, the prerogative of the elevated grades. For example, this carved wooden crouching figure belonged to an initiate of the Kindi, the highest grade of Bwami. It is called *kukulukamwenne kumasengo*, or "great old one," and represents an elderly initiate who bends under the weight of having seen many association objects. Such figures were shown to candidates to reinforce the importance of taking care of their older, able tutors. The posture is assumed by elderly dancers to symbolize the spiritual weight of Bwami initiation objects (ibid., 143–49).

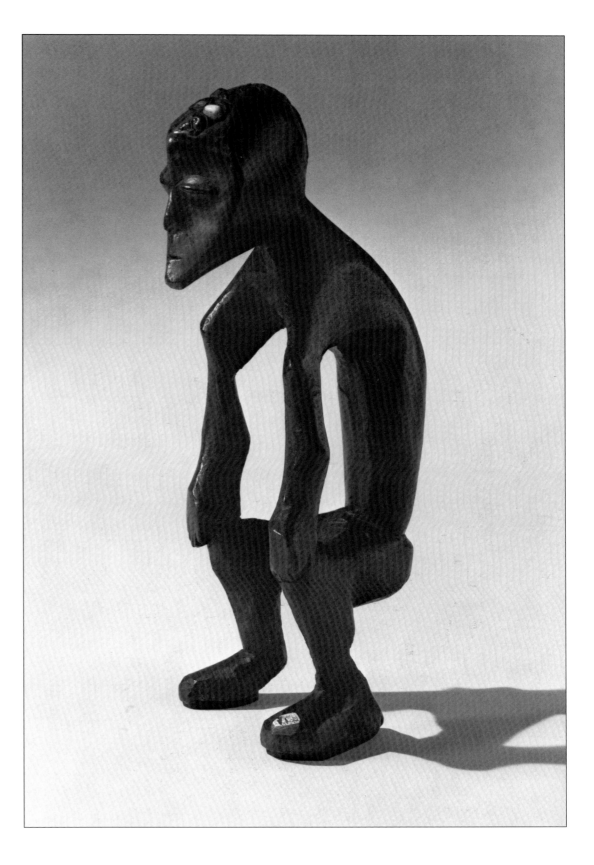

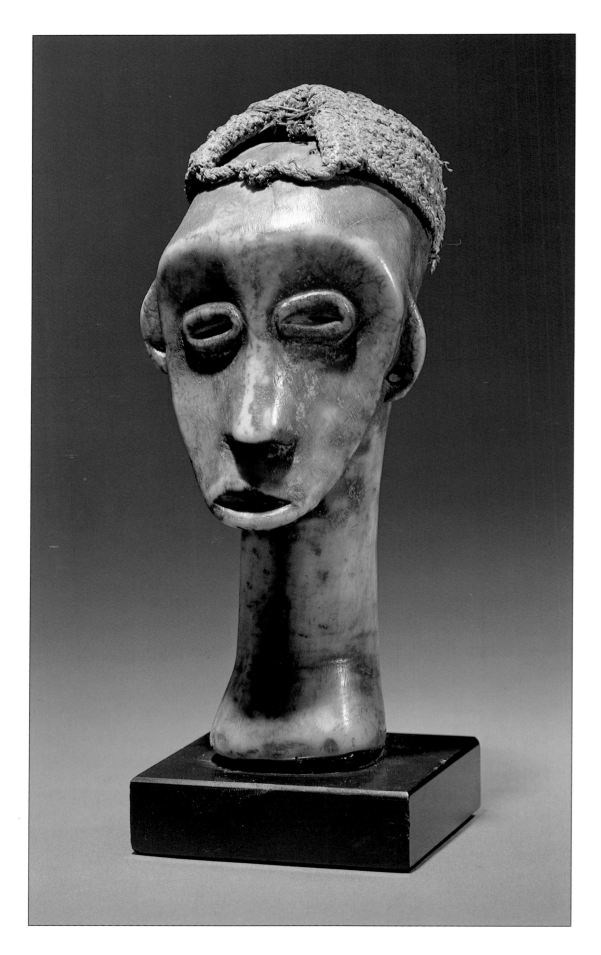

HEAD
Lega peoples, Zaire, 20th century
Ivory, fiber, resin, unidentified matter
H. 6¾ in. (17.1 cm)
Collection of Drs. Daniel and Marian Malcolm

In Lega society, governance is vested in Bwami, a graded initiation association. The highest grade in Bwami is Kindi, and its members are privileged to own and use anthropomorphic ivory sculptures as emblems of their rank. Among such emblems is a carved ivory head on a neck or pole, such as this piece.

Bwami sculptures are used as proverb-images illustrating principles of moral perfection to which the members aspire. Although it is not possible to give the precise name and meaning of this object, the ensemble of its features can be interpreted. The large bald head adorned with a braided fiber skullcap, the toothless mouth, the eyes made of cowrie shells, and the smooth luminous surface constitute the attributes of a beautiful high-ranking Bwami elder who has, through successive initiations, acquired heightened vision and achieved supreme wisdom (Biebuyck in Vogel 1981, 221; Preston 1985, 86).

52

HANGED FIGURE (*Ofika*)
Mbole peoples, Opale and Isangi zones, Zaire, 20th
 century
Wood, pigment
H. 32½ in. (82.6 cm)
The Metropolitan Museum of Art, The Michael C.
 Rockefeller Memorial Collection of Primitive Art,
 Purchase, Nelson A. Rockefeller Gift, 1968
1978.412.571

Among the decentralized Mbole, the Lilwa
association performs educational, jural, political,
economic, and ritual functions (Biebuyck 1976, 55–
58). Essentially a men's association, it is open to
some women in the community. For example, the
daughters of the highest ranking members are
initiated into the lowest level along with all male
youths. Because of their special abilities and talents,
wives of ranking members can be elected to occupy
the highest offices in the association.

Ofika figures, like this one, represent men or
women who were hanged for transgressing the moral
and legal laws of the Lilwa. Such figures were shown
to youths during their initiation into the association
to illustrate the consequence of immoral conduct and
also to instill in them respect for the authority vested
in elders and ranking Lilwa members. The figures
symbolized the power and authority of the Lilwa and
were the exclusive prerogative of high-ranking
members. *Ofika* were displayed on other solemn
occasions, such as during executions by hanging,
during periods of persistent bad hunting, when oaths
were taken, and when serious conflicts between
parties were settled (Biebuyck 1986, 243).

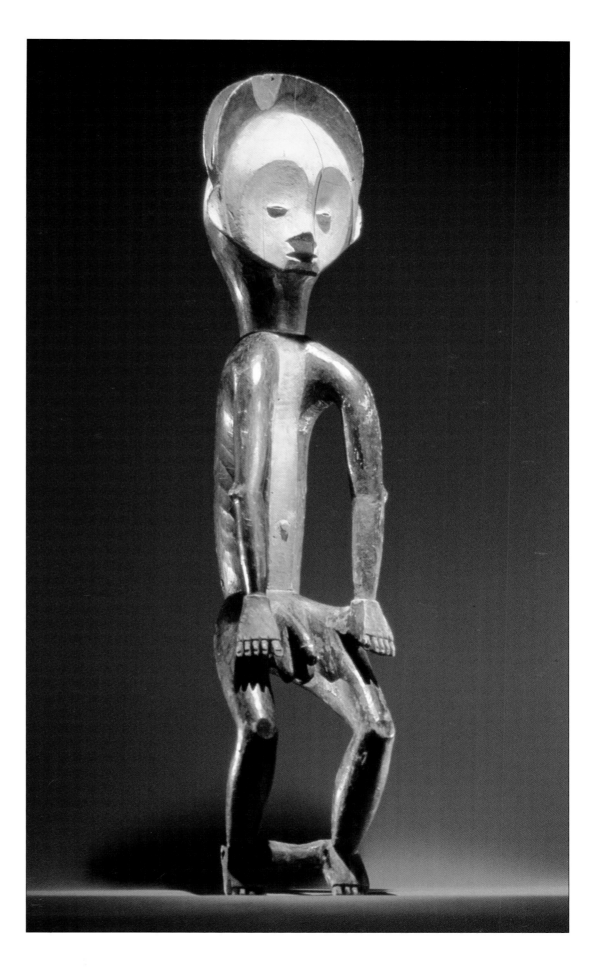

5

STATUS AND DISPLAY

In most African cultures, the position of an individual is apparent to a knowing viewer through a series of signs. These include body markings, hair arrangement, dress, and accouterments, which distinguish the gender, age, and status of a person.

These basic signs not only indicate membership of a particular group but register a form of communal solidarity, a strong sense of belonging. To these are added other signs; for example, certain scars may tell further if the person is a member of a particular men's or women's association. Certain beads or amulets show that the wearer belongs to a particular religious cult. Hair arrangement may reveal membership in an association, as among members of Sande, or reflect the marital status of a person.

In many instances, particular accomplishments or status are recognized by special objects. For example, champion cultivators may be privileged to wear hats of a certain type, as in Liberia, or possess carved staffs, as among the Senufo of Côte d'Ivoire.

Thus the arts of display intersect all elements of society. However, it is not surprising that the objects of a subsistence farmer will be eclipsed by the regalia of a chief. For example, Akan chiefs have control of the use of gold and reserve it for signs of high ritual or secular status (cat. nos. 53–54). Among the Yoruba, ivory is usually reserved for high-status symbols, as with the ivory sword from Owo (cat. no. 57). The richness of wood carving among the Yoruba is well documented, and among the thousands of objects produced by Yoruba sculptors are those associated with leadership. At times, these record events enhancing the importance of the ruler. For example, the wooden door from the palace of the *ogoga* (king) of Ikere introduces the image of the British administrator, Captain Ambrose, on a ceremonial visit to the king (cat. no. 55). Olowe, from the village of Ise, was the sculptor of the door and also of the large wooden prestige bowl with figures (cat. no. 56). Enough is known of Olowe so that it is possible to follow his career in producing prestige carvings in eastern Yorubaland, where he flourished in the first quarter of the twentieth century.

Every man of accomplishments among the Kuba peoples of Zaire, as his status permitted, owned finely

carved boxes and cups. The boxes were used for storing *tukula,* a red powder used as a cosmetic, or feathers or razors. They were usually decorated with geometric carvings and, more rarely, with the image of a human face (cat. no. 58). The cups, carved in a variety of shapes, were used for drinking palm wine. Exceptionally well-carved examples in the form of human heads with horns (cat. no. 59) were limited to royalty.

It appears that the types of objects that seem to us to be particularly well made were in most instances so recognized by the Africans and limited to use as objects associated with high status. This is also the case of the Luba bow stand, which, unlike the normally simple wooden or iron examples, is richly carved and part of the regalia of a Luba chief (cat. no. 60).

In many groups the "throne," or seat of the ruler, is crucial to his prestige, whether it is a royal mat among the Igbo, a rock, a gold throne in Ethiopia, the pelts of such animals as leopard or lion, the European-influenced chair of the Chokwe (cat. no. 71), or the wooden carved stools that appear in a large number of groups

(Irstam 1944, 108–12). Some are reserved for royalty, some are sacred, some are even tied to royal funerals, as is the case at Igbo-Ukwu, where a tenth-century priest or priest-king was buried seated on a wooden stool with decorative copper bosses (Shaw 1970, vol. 1, frontispiece; vol. 2, pls. 137–44).

It may be assumed that the double-figured Songye stool (cat. no. 61) and the Hehe stool (cat. no. 64) were made for high-status individuals in their cultures. Even the carefully made Mangbetu harp (cat. no. 62) is exceptionally well carved with its full figure, in contrast to most similar harps, which are far simpler, some with a human head depicted at the top.

Unlike the example in this exhibition, most headrest boxes of the Zande do not have human heads carved on them (cat. no. 63). But even the simplest natural form adapted for use, such as the ostrich egg shells that the Nharo San (Bushmen) use for water storage, may be decorated and become thereby special and perhaps reflect or enhance the status of the owner (cat. no. 65).

R.S.

53

SOUL-WASHER'S DISK (*Akrafokonmu*)
Asante group, Akan peoples, Ghana, 19th century
Gold
Diam. 3⅞ in. (9.8 cm); Depth ½ in. (1.3 cm)
The Cleveland Museum of Art, Dudley P. Allen Fund
CMA 35.310

A gold pectoral disk, *akrafokonmu*, worn by young male officials of the Asante court identified them as the soul (*akra*) washers of the Asantehene (king). They were responsible for "cleansing" the king's soul in rites of purification or soul renewal. The disk could be decorated with either repoussé rosette or foliate motifs, like this one, or cast by the lost-wax process. It was worn suspended from a whitened pineapple-fiber necklace (Kyerematen 1964, 83; Cole and Ross 1977, 153–55; McLeod 1981a, 83–84). Although soul disks were usually associated with *akra*, they were also worn by kings, paramount chiefs, and state sword-bearers on occasions other than the soul-washing ritual.

This soul-washer's disk originally belonged to Asantehene Prempeh I. It was made before Prempeh I was exiled by the British to the Seychelles in 1896 (Wixom 1977, 19).

FIG. 23. Portrait of officials at Kumasi, Ghana, 1884. The soul washer of the Asantehene (king) wears a large gold pectoral disk with repoussé decoration.

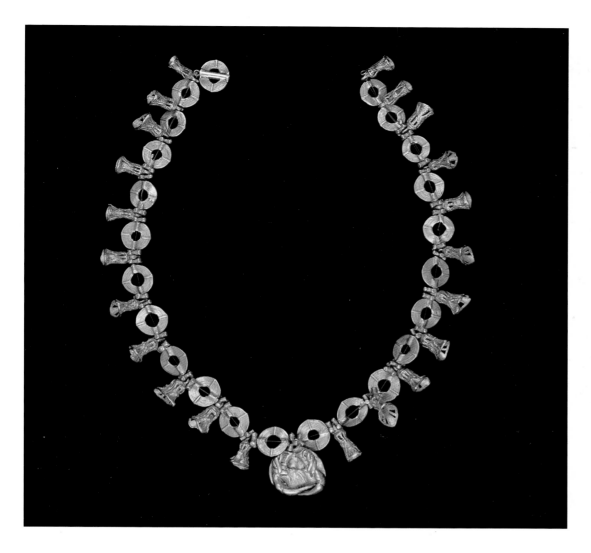

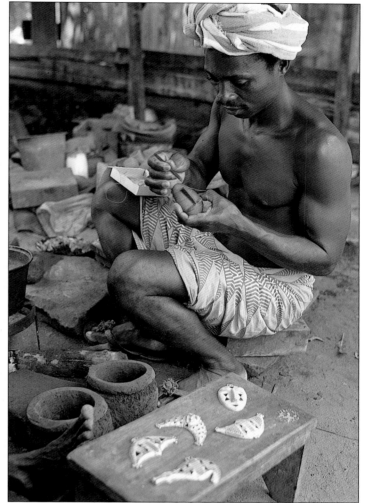

54

NECKLACE
Asante group, Akan peoples, Ghana, 19th century
Cast gold
Circum. 15¾ in. (40 cm)
Virginia Museum of Fine Arts, The Williams Fund
80.73

In traditional Asante society, gold jewelry is an important indicator of wealth and status. Gold jewelry is also considered to be protective, and it expresses well-known proverbs. The form of a bead may be significant; for example, a bell-shaped bead symbolizes calling the attention of spirits. Cast gold beads of various forms are usually randomly strung with glass beads, gold nuggets, stone beads, or other items and worn as necklaces, bracelets, anklets, or bands below the knee.

This gold necklace is composed of circular medallions, cruciform beads, bells, and a pendant in the form of a land crab. All but the land crab were cast by the lost-wax process. The land crab was cast directly from a crustacean. The beads are representative of the type of casting done by the Akan in the nineteenth century. Because the beads are strung in a symmetrical arrangement, it has been suggested that the necklace was purposely made to European taste in the late nineteenth century (McLeod 1980). However, the original owner of the individual elements was undoubtedly an Asante, most probably a queen mother because in Asante proverbs the land crab is her symbol (Ross 1981).

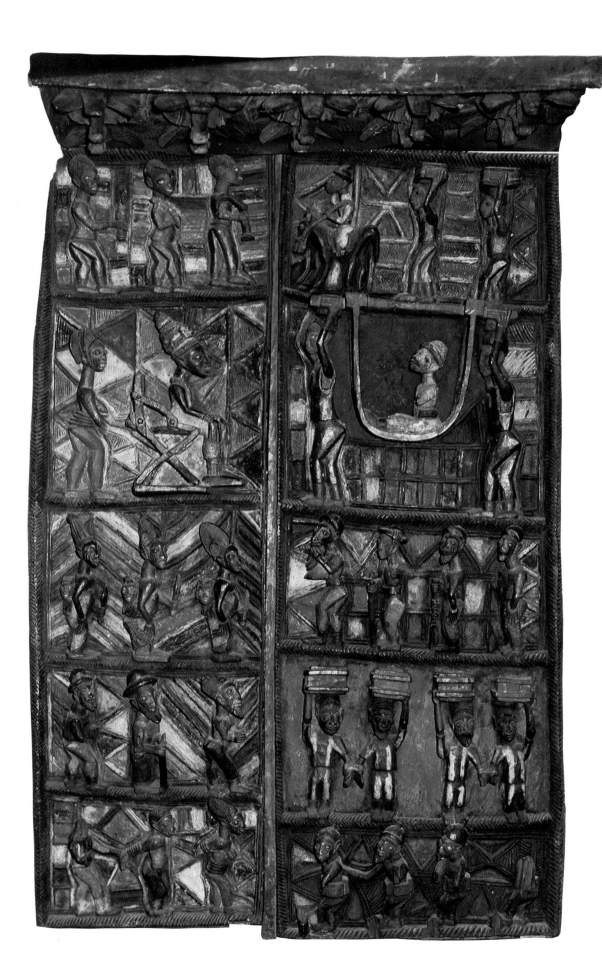

55

PALACE DOOR
Artist: Olowe of Ise (d. 1938)
Yoruba peoples, Nigeria, c. 1906
Wood, pigment
H. 90½ in. (229.9 cm)
Trustees of the British Museum
1979.AF.1.4546

This is a door from the palace of the *ogoga* (king) of Ikere in southwestern Nigeria. It was carved about 1906 by the famous Yoruba sculptor Olowe of Ise.

The door, which is composed of two rectangular panels, commemorates an actual event that took place about 1897 (Allison 1944, 49–50). At that time a British colonial administrator, Captain Ambrose, whose title was "Travelling Commissioner for the Ondo Province," was received by the *ogoga*. Captain Ambrose is shown in the second register from the top on the right-hand panel. He is carried in a litter by two porters. Directly across from this scene, the Yoruba king is shown seated on a European-derived folding chair-throne, and his wife appears to be approaching the visitor from behind the throne. The figure on horseback in the scene above Captain Ambrose is probably Reeve Tucker, his assistant. Other scenes show shackled prisoners carrying the captain's loads, the captain's entourage of Englishmen, the king's attendants, and the king's wives carrying children on their backs.

Olowe creates the illusion of movement throughout this composition. The relief work in each panel is composed of opposing geometric patterns that are highlighted with pigment. The polychromed figures are carved in higher relief, some almost free from the background, and cross the viewer's path or walk toward him.

This door was sent to London at the behest of the *ogoga* for display in the British Empire exhibition at Wembley in 1924. The British Museum wished to acquire the door, but the king refused to sell it. Instead, he agreed to exchange it for a British-made throne designed to his specification and commissioned Olowe to carve a replacement door for the palace (Fagg and Pemberton 1982, 43).

56

BOWL WITH FIGURES
Artist: Olowe of Ise, sculptor (d. 1938)
Yoruba peoples, Nigeria, c. 1925
Wood, pigment
H. 25½ in. (64.8 cm)
Private collection

In traditional Yoruba society, prestige bowls carved from fine woods or made of calabash were used for storing valuables, presenting gifts of kola nuts or food to very important visitors, or storing divination equipment belonging to a highly successful *babalawo,* or diviner-priest (cat. nos. 30–31). The elaboration of design and decoration and virtuosic carving exhibited on this bowl indicate it is a prestige object that is the work of a master carver. It was carved by Olowe of Ise, who also carved the palace door (cat. no. 55).

Olowe was a native of Efon, but from an early age he lived and worked in Ise, a village near Ado in southwestern Nigeria. He was an *emese* (messenger) of the *arinjale* (king) of Ise, as well as a sculptor in the latter's employ. Olowe's specialties were sculptured doors and figurative verandah posts, which were produced for the palaces of the *arinjale* of Ise, the *ogoga* of Ikere, the *owa* of Ilesha, and other rulers among the Yoruba (Fagg and Pemberton 1982, 42–44).

The lidded bowl shown here is supported by a large kneeling female figure carrying an infant wrapped in a "baby tie" on her back and by several male and female figures, all of which are carved from one piece of wood. The bearded head shown on the base, which also is carved from the same piece of wood, can be moved; however, it cannot be removed from the cage created by the caryatids.

This bowl is believed to have been carved about 1925 (Willett 1971, 234) and to be Olowe's later version of a bowl in the Tishman Collection that was collected about the turn of the century. Although both bowls have a separately carved head within the cage and the sculptor's signature, a rectangular and saltire device, in this later work Olowe created a more dynamic effect (Fagg in Vogel 1981, 104–6).

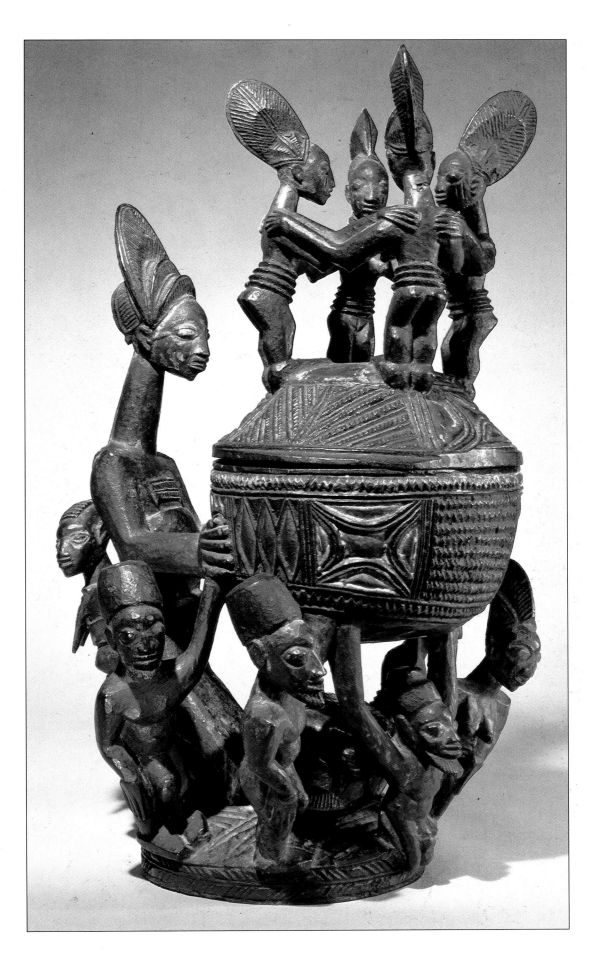

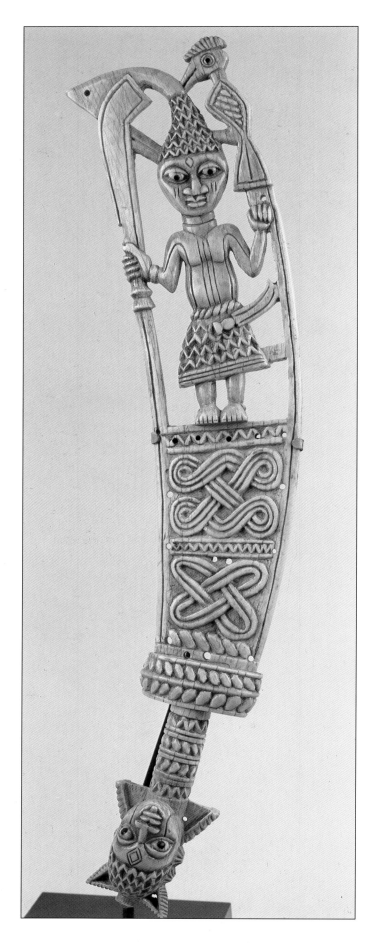

57

CEREMONIAL Sword (*Udamalore*)
Owo group, Yoruba peoples, Nigeria, 19th century
Ivory
H. 19¼ in. (48.9 cm)
Private collection, N.Y.

The *olowo* (king) of Owo, an eastern Yoruba kingdom, granted the privilege of carrying a specially carved ivory *udamalore* (ceremonial sword), like this one, to the highest ranking chiefs. The sword was part of the most prestigious costume worn by such chiefs. According to tradition, the costume originated in the court of Benin and was introduced to Owo in the early seventeenth century (Poyner in Vogel 1981, 133).

The hilt of the sword is carved in the form of a human head. The open-worked blade is decorated with intricate geometric designs and a standing human figure, the latter representing a chief wearing the *orufonran* costume. The *udamalore* is shown suspended from his left hip. He holds an *ada* state sword in the right hand and a fowl, probably for sacrifice, in the left hand.

There are perforations on the hilt and along the sides of the blade. Originally, the sword was further embellished with strands of precious colored glass beads, which were added to the head carved on the hilt. Several carved ivory chains were suspended from the edges of the blade (Fagg and Pemberton 1982, 49; Poyner in Vogel 1981, 133–34).

58

BOX WITH LID
Bushoong Kingdom, Kuba peoples, Sankuru region,
 Zaire, 19th–20th century
Wood, shell, traces of kaolin and *tukula*
H. 8½ in. (21.6 cm)
Staatliches Museum für Völkerkunde, Munich
15-26-26

The Kuba used lidded boxes to store *tukula*, a red
pigment made from the inner bark of a locally grown
hardwood tree of the *Baphia* or *Pterocarpus* family.
This material was an all-purpose colorant used as a
dye for human hair and cloth, as a cosmetic on ritual
occasions, and, when formed into hard bars, as
funeral mementos.

Kuba sculptors carved boxes in a variety of shapes,
including the human face, to store *tukula*. It has been
suggested that the carved decoration on the face
imitates the polychrome designs on masks such as
Ngaady Mwaash, the sister-wife of the Kuba founder,
Woot (Torday and Joyce 1910, 210; Cornet 1971,
143–44).

This elaborately decorated box and some other
household objects were acquired by Leo Frobenius in
1915 for the Staatliches Museum für Völkerkunde
(Kecskési 1980, 39).

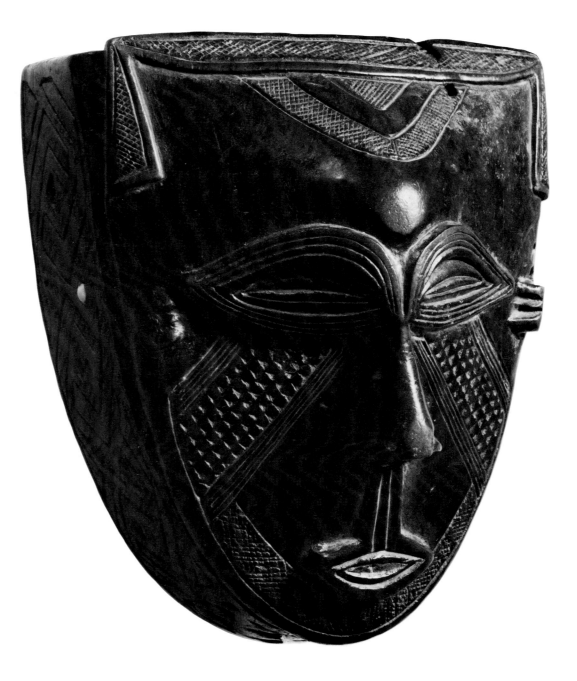

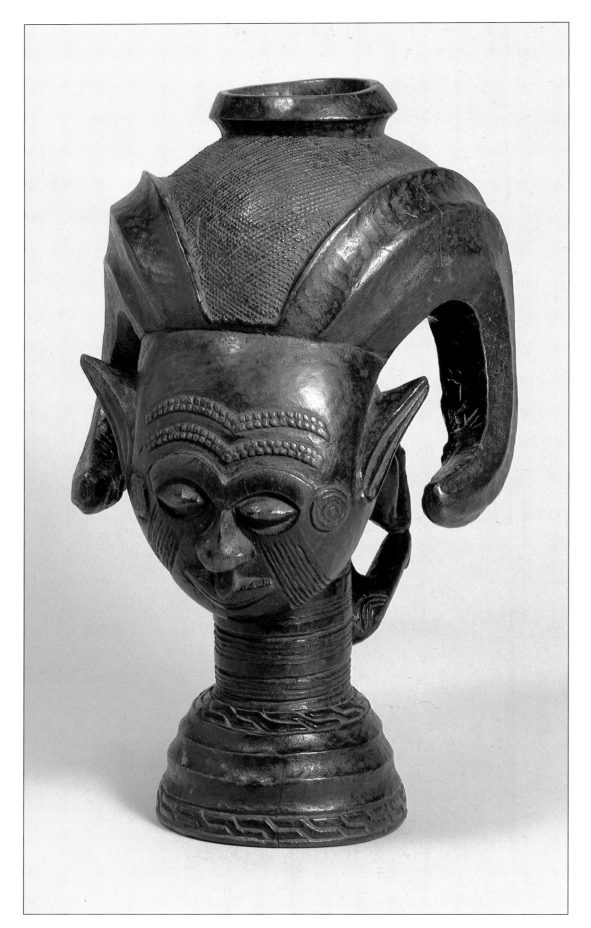

59

Cup
Bushoong Kingdom, Kuba peoples, Sankuru region,
 Zaire 19th–20th century
Wood
H. 10¹¹⁄₁₆ in. (27.1 cm)
Courtesy of Indiana University Art Museum,
 Bloomington, Indiana
77.34.2

The Kuba customarily decorate drinking cups with
chip-carved geometric designs. However, cups
intended for use by rulers are elaborately decorated
like this one, which is carved in the form of a human
head with a pair of ram horns. In traditional Kuba
society, the ram was a royal animal, the horns of
which symbolized the supernatural powers of kings
and princes (Vansina 1983, 36; Mack 1981, 55).
Kings were served palm wine in such cups, usually
during certain ceremonies and rituals. A servant took
the first sip, then presented the cup to his king
(Sheppard 1921, 403).

 Cups carved in the form of a human head with
ram horns are fairly numerous. However, the
presence of a crouching figure at the back makes this
cup unique.

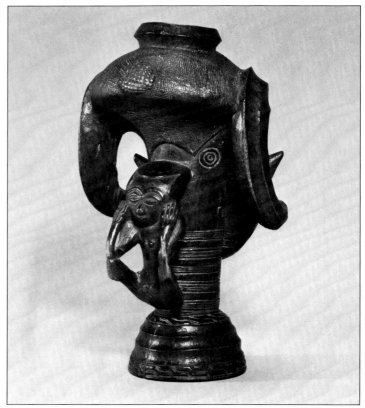

60

BOW STAND
Luba peoples, Zaire, 19th–20th century
Wood, beads, fiber
H. 26 in. (66 cm)
Collection of Amy and Elliot Lawrence

Luba men used three-pronged stands made of iron or wood to hold their bows and arrows. Elaborately decorated bow stands were part of a Luba chief's regalia and symbolized his supreme power and authority. One of his principal wives guarded them along with his ceremonial stool (Cornet 1971, 210). As part of the royal treasury, bow stands, as well as other relics and emblems of past rulers, were kept in private enclosures where they regularly received sacrifices (Preston 1985, fig. 81). Unadorned bow stands belonging to ordinary people were kept next to the conjugal bed, stuck either into the ground or into the wall (Colle 1913, 167–68).

The elaborately carved top of a prestige bow stand is shown here. The prongs are supported on the head of a standing female figure. It has been suggested that a feminine motif was chosen not only for aesthetic reasons but also because of woman's role in the Luba myth of creation and the founding of clans, as well as her supernatural and political role in Luba society.

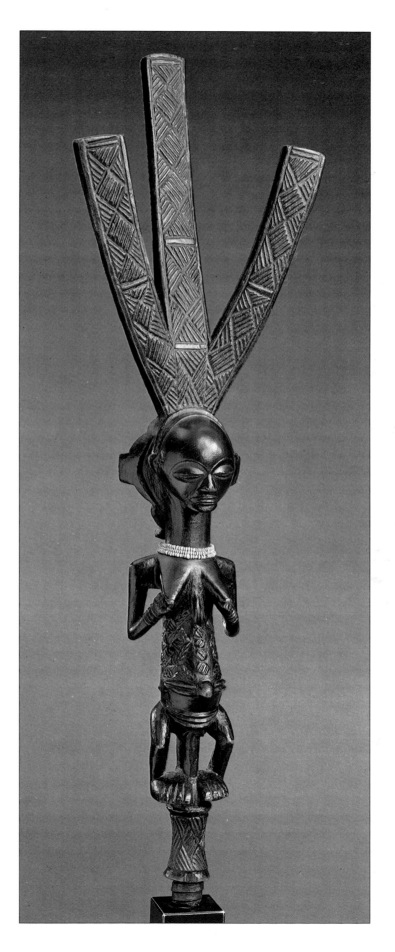

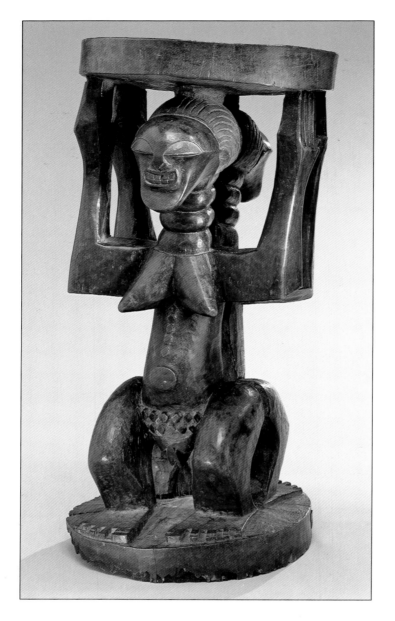 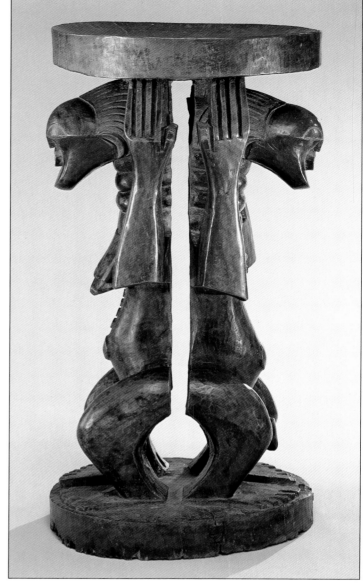

61

STOOL
Songye peoples, Zaire, 20th century
Wood
H. 24 in. (61 cm)
Collection of Marc and Denyse Ginzberg

Songye prestige stools have decorated support columns in contrast to plain, undecorated stools. The support is often carved in the form of a single supporting figure (Cornet 1971, 249). However, in this example, the support is carved in the form of two figures, a male and a female, standing back to back. Elaborate, even virtuosic, carving suggests that this stool was owned by a chief or another man of elevated social status. It probably came from the same workshop and may have been carved by the same master as that of the double caryatid stool illustrated in Olbrecht's 1946 catalogue of the *Plasteik van Kongo* exhibition in 1937 (pls. 161–62).

HARP
Mangbetu peoples, Zaire, 19th century
Wood, hide, metal, beads
W. 19¼ in. (48.9 cm)
Detroit Institute of Arts, Founders Society Purchase,
 Henry Ford III Fund, Benson and Edith Ford Fund
82.29

The strings are missing from this Mangbetu version of the bow harp. Originally the strings were stretched from the sounding board to the arched frame, which is in the form of a standing female figure. Holes are bored into the sides of the figure to accommodate decorated tuning pegs carved from wood. The sounding board is covered with animal hide that is appropriately perforated for the strings and a circular sound hole.

Among the Mangbetu, Zande, and other peoples of Central Africa, such elaborately decorated harps were prestige objects and were owned by diviners, oral historians, storytellers, and kings, who kept resident harpists at their courts (Schweinfurth 1874, 167).

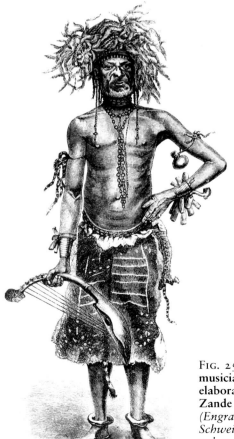

FIG. 25. A court musician holding an elaborately carved harp, Zande peoples, Zaire. (*Engraving from Schweinfurth 1874, vol. 1, 445.*)

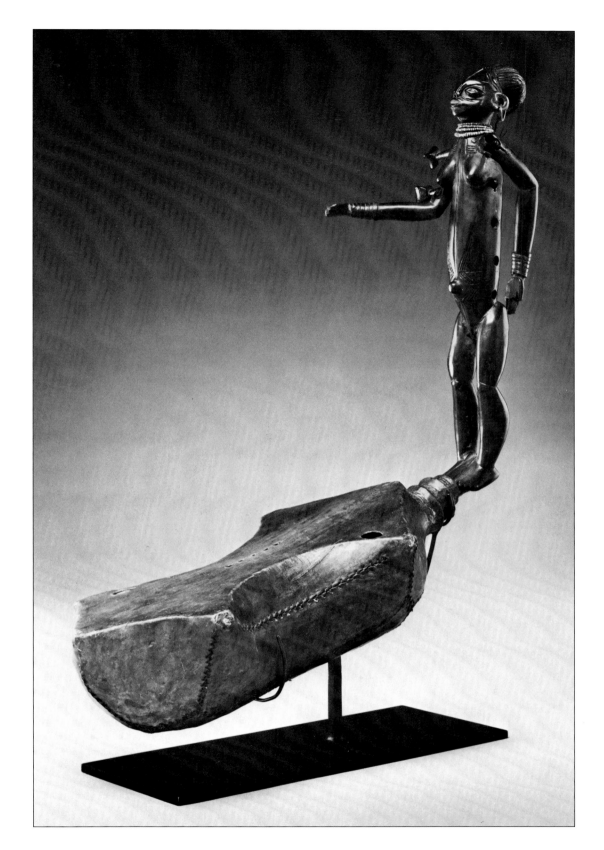

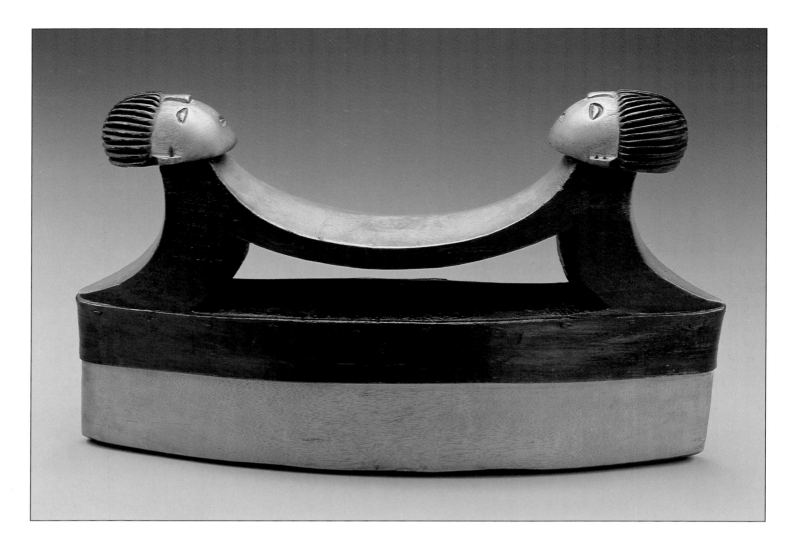

63

HEADREST
Bandia group, Zande peoples, Eringu village, Zaire,
 19th–20th century
Wood, pigment
L. 14¾ in. (37.5 cm)
Royal Museum of Central Africa, Tervuren
24905

This is a dual-purpose utilitarian object that served
as a container for storing valuables and also as a
headrest. The lid, which is decorated with two carved
human heads and contrasting colors, served as a
pillow. Such headrest-boxes were carved for the
Zande aristocracy (Cornet 1971, 310). This one was
collected in 1909 by J. Renkin.

64

THRONE
Hehe peoples, Tanzania, 19th century
Wood
H. 31½ in. (80 cm)
Collection of Robert and Nancy Nooter

The Hehe live in central Tanzania, where they have traditionally subsisted on farming combined with livestock raising on a small scale. They were ruled by a chief whose authority was absolute and who was believed to possess divine attributes.

Carved low stools with a backrest, like this one, distinguished the chief's throne from other seats. The backrest of the throne is carved in the form of a female torso, and the choice of imagery may be in praise of feminine beauty or woman's supportive role. However, it may also express something about male power in Hehe society. The introduction of cattle raising in the distant past transformed the Hehe social structure from matrilineal to patrilineal. As men's property and their responsibility, cattle may neither be tended nor milked by women. A man compensates his bride's family with cattle, and children born to the couple belong to his kin-group (Murdock 1959, 358–63).

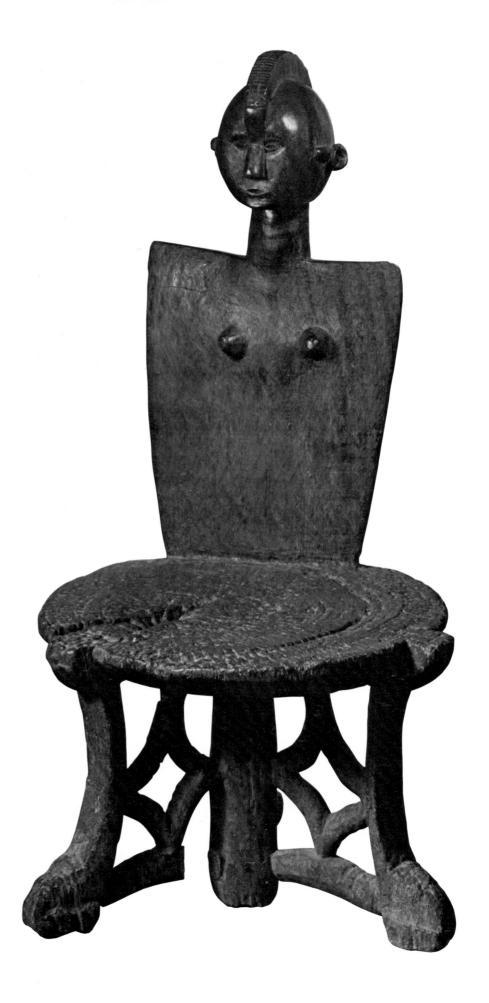

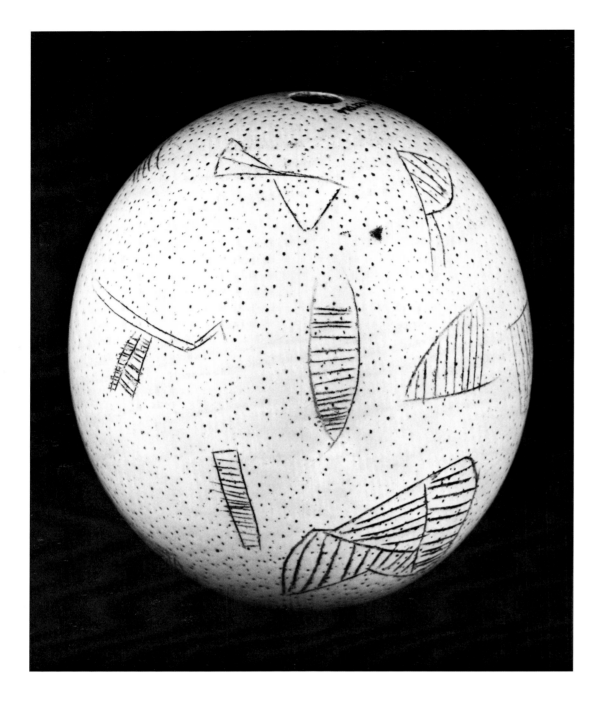

65

CONTAINER
Nharo group, San peoples, Ghanzi district, Botswana,
 20th century
Ostrich eggshell
H. 6 in. (15.2 cm)
Royal Ontario Museum, Toronto
970.224.45

The San, referred to as Bushmen in the literature, call themselves Zhu/twasi, or "real people" (Lee 1979, 29–32). They speak a unique click language and by tradition are nomadic hunters and gatherers. Because their nomadic way of life dictates having a limited number of material possessions, artistic expression is focused in music, dance, and storytelling rather than in the plastic arts. However, they do decorate natural objects. For example, this ostrich eggshell, which was used to store water, is decorated with pigment-filled engraved designs.

 This ostrich eggshell was collected by Mathias Guenther, a Canadian anthropologist, during his 1968–70 research expedition to the Ghanzi district of Botswana, where the Nharo-speaking San reside (Guenther 1976, 120–34).

FIG. 26. San girl drinking from an ostrich eggshell, Lehututu, Kalahari Desert, Botswana, 1947. The nomadic San use found objects such as ostrich eggs as water vessels.

6

IMPORTS

The history of Africa, in common with nearly all other parts of the world, includes the impact of outsiders on the indigenous cultures. Although influences from outside the continent have been felt since prehistoric times, the focus here will be on two major forces, each of which includes a major religious aspect: the Arab world and the West; Islam and Christianity. The first to appear on the continent, in the fourth century, was Christianity, albeit in an early and eastern (orthodox) form. It arrived in northeastern Africa so long ago that some authors consider it indigenous. Egypt and Ethiopia "are the two main areas in Africa today where Christianity is rightly 'African,' indigenous and traditional, with its roots deeply established in the history and traditions of those who profess it there" (Mbiti 1969, 231). To this should be added Nubia, where Christianity survived until the sixteenth century, when it fell before a Muslim invasion. Indeed, in the Middle Ages, Europe was at least vaguely aware of Christian kingdoms in Africa and of a legendary ruler named Prester John.

The Coptic church is reputed to have been founded by St. Mark and, despite being cut off from the rest of the Christian world by Islam, its descendant survives in Ethiopia to the present. This persistence of Christianity in a corner of Africa has led Parrinder to write, "Christianity is the oldest of the great literary and universal religions which has been present in Africa for centuries" (1985, 131); and Mbiti points out that African Christianity produced "great scholars and theologians like Tertullian, Origen, Clement of Alexandria and Augustine" (1969, 229). Although the early church in northeastern Africa did make a significant contribution to Christendom, its influence was not felt in the great stretches of black Africa to the south and west. Christianity was not introduced to the coast of West Africa until the Euro-

pean voyages of discovery beginning in the fifteenth century.

The Islamic conquest of Egypt and North Africa took place within a century of the death of Muhammad the Prophet in A.D. 632. Muslim traders were along the east coast by the ninth century where, for the most part, they remained and "only began moving inland in the eighteenth and nineteenth centuries when Arab trade in ivory and slavery . . . went further into the interior" (ibid., 243). In contrast, Muslim North African traders ventured inland across the Sahara as early as the ninth century (ibid.).

> Certainly the oldest and most persistent feature [of the spread of Islam] was the continual operation of Muslim traders over vast sectors of West Africa. It was through the agency of individual merchants, small mercantile family groups, and highly dispersed trading corporations that the religion was first introduced into the western Sudan . . . extended into the southern savannah and Guinea Coast forest, and diffused throughout northern and central Nigeria. (Bravmann 1974, 6)

These merchant-clerics "served as advance agents of the faith" and paved the way "for deeper and more permanent religious and cultural penetration" (ibid., 7).

> It has been suggested that, the Muslim ethic as a whole is markedly favourable to trade, commerce, and industry. These indeed are all regarded as eminently respectable activities, and their practice in Africa has been favoured by the supra-tribal ethos of Islam, its common procedures and values, and the use of Arabic as a means of commercial communication and account keeping. (Lewis 1966, 20)

It is worth noting, as well, that artisan specialists such as blacksmiths, leather workers, dyers, and jewelers, although ethnically diverse, "seem often to have been the first bearers of Islam" (ibid., 26).

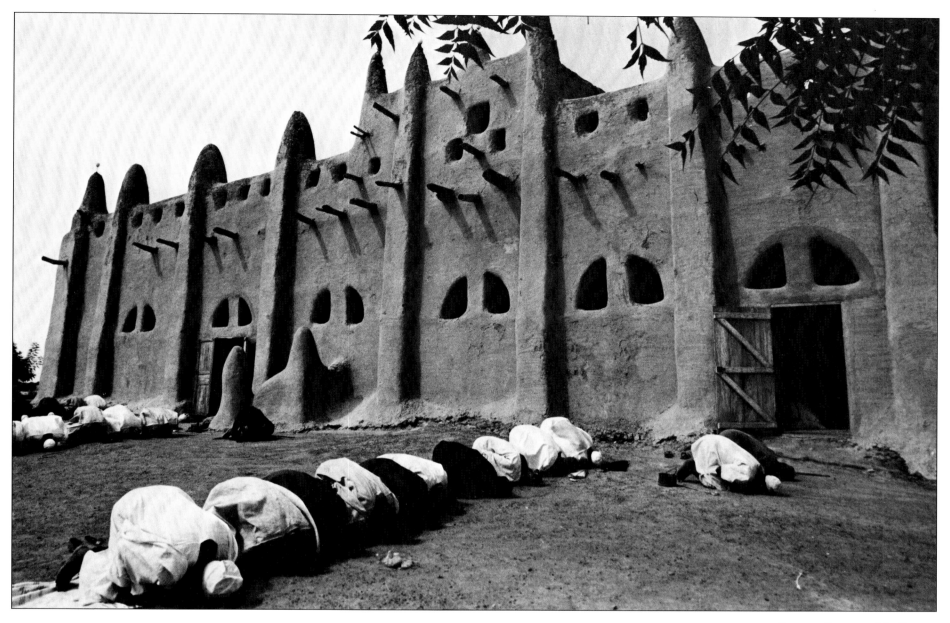

FIG. 27. Prostrate Muslims in front of a mosque in the town of San, Mali, 1971. The worshipers pray facing Mecca, the birthplace of Muhammad and the holiest city of Islam.

Indeed, during the peaceful penetration of West Africa, great trading centers were established and also centers of learning and scholarship. Further, the well-organized trader might have had associates that were widely separated. "Thus, an eighteenth century Dyula merchant in Timbuktu might well employ agents buying gold in Ashanti in the south, and others selling it in Fez in North Africa" (ibid., 25).

It was only in the eighteenth and nineteenth centuries, and then not very successfully, that control was attempted by the *jihad*, or holy war, "followed by the imposition of Muslim rule and an attempt to establish a theocratic state guided by Islamic religious, administrative, and legal precepts" (Bravmann 1974, 13). Yet it must be emphasized that

in no area of West Africa, including the most heavily Islamized portions of the western Sudan, has "classical" Islam taken root; instead, one finds a mosaic of Islamic communities that demonstrate a wide range of compromises between doctrines and the demands of culture contact. . . . Indeed, one could argue that it is precisely its adaptability that has enabled the religion to play such a vital role in the history of West Africa. (ibid., 28)

These compromises or concessions to local traditions include, in some instances, the retention of figurative art forms, even though they are expressly forbidden by Islamic law. Such occurrences appeared early and continue to the present day. Ibn Battuta, an Islamic traveler, describes and laments the appearance of masks in the

FIG. 28. Catholic mission school that served the Ngala peoples in present-day Zaire. (From a late-nineteenth-century stereoscopic photograph.)

Amulets based on writings from the Koran are found among many West African groups, including those that retain their traditional religion; and Islamic peoples often retain old ideas where amulets and other magical devices continue to be used against witchcraft. Thus there is a "doctrinal sympathy" between Islam and local religions (ibid., 174). Indeed, as Bravmann has noted, "In practice Islam is far more pragmatic than western religions when confronting the tribal world" (ibid.).

One form associated with Islam that appears throughout Africa is the writing board; of reasonably standardized shape, it is used by literate Muslims and by schoolboys learning the sacred writings of Islam (cat. no. 66). But it also has a magical connotation. Words written on the board may be washed off and the fluid drunk in cases of illness. Alldridge reports that "where people can afford it, they have charms prepared by the Mohammedan Mori men in the shape of bits of board covered with Arabic writings." One subchief, when in pain, sent for his Mori man, who, in turn, "sent for his Mori board, for his country-made ink, his reed pen and a small piece of cotton. . . . He then wrote a few words in Arabic upon the board. He wrote them three times;—called for some water, a little of which he dropped upon the writing and rubbed it out with the cotton." He gave the cotton to the subchief to put in his ear. The subchief was better the next morning (1901, 103).

In West Africa, among the Akan, a number of worked metal containers are known that show clear evidence of their Islamic prototypes. The *kuduo* (cat. no. 44) from the Asante is an example. The figurative sculpture on the top is fully Asante, but the basic shape of the vessel and the incised designs on the sides are clearly derived from North African, particularly from Muslim Egyptian, prototypes (Silverman 1983a; 1983b).

After the Muslim conquest of North Africa and the isolation of Ethiopia, there were no Christian missions until the explorations of the West African coast by the Portuguese in the fifteenth century. As A. Adu Boahen, a Ghanaian historian, points out, there are two reasons that it was the Portuguese that were "first to begin the systematic exploration of the coast of western and southern Africa, for [they were] technologically superior and politically more stable than any other European state" (1971, 307).

What was primarily a series of voyages of exploration for gold and other valuable items, as well as for a way to reach India for commercial reasons, also had a missionizing content. During the first century of travels, "the Portuguese took the work of converting Africans to

court of Mali in the fourteenth century. He "was told that this custom pre-dated the introduction of Islam in Mali and that it had persisted despite the fact that Islam had been adopted by the Mande royal family as the official religion of the state" (ibid., 47).

Bravmann is most insistent on the point that the appearance of Islam is not automatically the death knell of traditional figurative art:

> In long-and-well-established Muslim communities, masking and figurative traditions persist either because they function at a number of levels not treated by Islamic ritual or because they have proved more effective. . . . The acceptance of masking and figurative rituals in an Islamic context therefore cannot be construed simply as a case of massive backsliding or apostasy, but should be viewed as a reflection of the pragmatic results of the confrontation of Islam and traditional cultures. (ibid., 31)

In fact, Bravmann's study *Islam and Tribal Art in West Africa* documents the presence in the twentieth century of a number of masking traditions in Muslim communities in east-central Côte d'Ivoire and west-central Ghana. There are few if any discernible indications in the form or style of the objects that would distinguish them as Muslim. For example, the Do masks of the Ligbi, which appear during Muslim festivals, are well known in Western collections and were long identified as Senufo.

the Christian religion very seriously indeed and with the full blessing of the pope of the Catholic Church" (ibid., 309). At the same time, it is necessary to emphasize that "the Portuguese by and large remained on good relations with the people of the west coast and treated the African kings as equals and allies rather than subordinates or vassals" (ibid., 311).

Two major African kingdoms were missionized by the Portuguese: the kingdom of Benin and the kingdom of the Kongo. The *oba* of Benin, who requested that missionaries be sent from Portugal, also sent several men, including a son, to Portugal to be educated. Little of Christian imagery appears in Benin art, however, although Portuguese individuals, particularly soldiers, are represented (cat. no. 68).

Portuguese contact with the kingdom of the Kongo was first made in the 1480s; in 1491 the king was converted. The second emperor to be converted to Christianity, "Nzinga Bemba, was baptized in 1506 as Affonso I, and he acted as if he were a black Constantine or Clovis. One of his sons was enthroned as bishop of São Salvador in 1517" (Alexandre 1974, 86). A cathedral was built, and Africans were educated and trained as priests in Portugal. The high hopes held for the spread of Christianity were soon dashed, some argue by the introduction of the slave trade (ibid.).

The strangers who came to Africa were exotic creatures and brought with them many exotic items. For example, the horse, which the Portuguese introduced to west-central Africa, was a most exotic beast. Both the stranger and his mount are found on the pipe from the Songo of Angola (cat. no. 70), whereon is carved the image of a European on horseback. As has been noted, the Benin equestrian (cat. no. 45) possibly depicts a stranger who is African from north of Benin and to whom the horse has come from still farther north through Muslim traders. The Chokwe chair (cat. no. 71) demonstrates how an imported prestige object is absorbed and modified and thereby becomes a part of the borrowing culture.

One of the most characteristic types of Christianized African objects from Zaire to survive are cast copper-alloy crucifixes (cat. no. 69). Many include extra figures and are stylistically and iconographically clearly Africanized. After the collapse of the early missions, the crucifixes were used as power symbols by local chiefs.

There is one further sort of object associated with the early Portuguese contacts that needs to be noted. There have survived a number of objects carved in ivory by African artisans for export to European patrons. There

seem to have been three schools that produced these so-called Afro-Portuguese ivories. Stylistically they have been assigned to the kingdom of the Kongo, Benin, and the Sierra Leone coast. One major form was a saltcellar (cat. no. 67). Clearly made by African craftsmen, these objects were equally clearly unrelated to any traditional African objects. Rather, they copy condiment containers found on the dining tables of wealthy Europeans. None has ever been discovered in Africa, and only a few have survived in Western collections (Curnow, 1983).

After the early, primarily Portuguese, contacts, other Europeans appeared on the scene. At one time or another the Dutch, English, French, Spanish, Danes, Swedes, and Brandenburgers were active traders on the African coast.

Between the early contacts and the much later colonization came the great dark shadow of the slave trade. Attempts to introduce Christianity, technology, and education were abandoned, and "the goods traded became vital to the growing capitalist and industrial economy of western Europe, and the plantation economy of the New World" (Boahen 1971, 314). It is to the lasting shame of the European nations "and to the Portuguese in particular, that they abandoned almost all activities that would have benefited and improved the lot of the African, at least materially if not spiritually, to concentrate on the most inhuman, the most destructive, sale of man by man" (ibid., 326). The slave trade was dominant from the end of the seventeenth to the mid-nineteenth century. A large number of African coastal peoples were involved in the slave trade. Some of the states of West Africa, it has been argued, were sustained by the slave trade, including the Asante, Dahomey, Oyo (Yoruba), and Benin, all of which flourished during the eighteenth and early years of the nineteenth centuries. Certainly the presence of Europeans on the west coast and the importation of guns were important factors in the slave trade. Yet Boahen argues that "although these states expanded mostly by waging wars against their weaker neighbors, and although most of the captives . . . were sold as slaves it is wrong to see all wars as motivated primarily by the desired profit from the slave trade. Slaves were only accidental by-products" (ibid.). He goes on to state that "the feeling of equality and mutual respect that had characterized the first period of Afro-European contact was steadily replaced by one of superiority on the part of the Europeans, an attitude that has not entirely disappeared to this day" (ibid., 327).

Trading contacts and missionary activity remained

essentially coastal until the nineteenth century, when missions were part of the intensive European colonization of Africa. However, both colonization and extensive missionary activity only followed upon the suppression of the slave trade (ibid.; Mbiti 1969, 231). "Christianity from Western Europe and North America has come to Africa, not simply carrying the Gospel of the New Testament, but as a complex phenomenon made up of western culture, politics, science, technology, medicine, schools and new methods of conquering nature" (Mbiti 1969, 217).

All these forces tend to undermine traditional beliefs and patterns of life. In the mid-twentieth century, the rapid spread of political independence has led to the sense of nationalism and industrialization, two more body blows to traditional life.

Accompanying the changes that began in the nineteenth century was an active missionizing of both Islam and Christianity. They are literate "book" religions, they relate to centralized governments, and they tend to be aniconic and antianimistic. Yet Islam, perhaps because of its greater flexibility, has become more a part of traditional Africa, more fluid in its interpretation, more similar racially, and more willing to accept traditional beliefs and practices. It has been argued, however, that "neither faith has yet penetrated deeply into the religious world of traditional African life; and while this is so, 'conversion' to Christianity or Islam must be taken only in a relative sense" (ibid., 15). Islam has been numerically more successful than Christianity. Mbiti suggests the total number of Muslims in Africa to be between seventy and one hundred million and the number of Christians to be between fifty and seventy million (ibid., 243). To some extent, Islam flourished in the late nineteenth and early twentieth centuries in some areas, such as the Western Sudan, because the European colonial leadership saw Islam as more akin to colonial ideals than the beliefs and practices of the "pagans," as the traditionalists of northern Nigeria are still called. The Muslim leadership had writing and was familiar with bureaucratic practices, both useful to the European colonials.

It should be noted that "the contributions of Western science and technology may be enthusiastically received and accepted, but they are generally viewed as simply other avenues to security and success. They rarely supplant traditional ways but are pragmatically syncretized with pre-existing patterns, values, and beliefs" (Bravmann 1974, 31–32, fn. 12).

Parrinder suggests that "there are few, if any, Africans who have had no contact at all with European government and trade, and most have come into some contact with Christian or Islamic religion" (1985, 134).

For an example of the African manner of absorbing, using, and syncretizing outside beliefs without losing touch with traditional values, we can turn to the description of an Ewe priest-diviner in Ghana as reported by Drewal. The priest-diviner incorporates in his work Christian aspects and artifacts—crucifix, holy water, Bible, and saints' statues. All these are placed on a Muslim prayer mat. He also has Ewe shrine materials and divination equipment and a 1948 French book on divination on the Slave Coast. "While the Catholic Church might find him a 'marginal' member of its institution, his Ewe clientele find no contradiction to his beliefs. On the contrary, they regard him as more effective precisely because he can marshal the forces of several religious systems" (1977, 8).

As the African philosopher Mbiti has phrased it, "Africa must now search for new values, new identities and a new self-consciousness" (1969, 271).

The arts, like other aspects of traditional culture, prove to be adaptable, adjusting to new ideas and new forms. Some old forms disappear—and loss is often most difficult to document—and some have been adapted to include new images, as with the Benin musketeer (cat. no. 68) and the Songo equestrian (cat. no. 70). At times, totally new images appear for a foreign market, as with the early Sherbro-Portuguese saltcellar (cat. no. 67), while others are Africanized adaptations, such as the crucifix (cat. no. 69) and the Chokwe chair (cat. no. 71).

In recent years, Western art forms, along with imported tools and paints, have appeared in African settings. Although some have been adapted to traditional forms, they have, for the most part, come about through the influences of European painting and sculpture and closely reflect their outside inspirations.

Although to some extent appreciated by a small elite African audience, a significantly larger audience is found among non-Africans. Almost none of the traditional audience relates to newer art forms, be they "fine" or "tourist." Tourist arts, sometimes as copies of traditional forms, sometimes as inventive variations on Western forms, are almost totally directed to a foreign audience.

The study and presentation of recently developed art forms must be the subject of another exhibition.

<div align="right">R.S.</div>

Writing Board
Omdurman city, Sudan, 19th–20th century
Wood, ink
H. 38⅞ in. (98.7 cm)
The Brooklyn Museum, Robert B. Woodward
 Memorial Fund
22.231

Most scholars agree that of the many cultural contributions of Islam to Africa, writing is the most important. Writing boards made of wood are used in at least two contexts. One context reflects the way that Islam, like the early Christian church, assimilated the traditional animistic and magical elements of the religions it superseded. For example, an individual wanting protection against disease or misfortune will go to a ritual practitioner. The practitioner writes texts from the Koran, the sacred text of Islam, or from other sources on a writing board or an animal skin and washes off the writing. The liquid is given to the client to drink, thereby protecting him (Trimingham 1965, 163–68).

In another context, the writing board is a devotional object. On such boards Sura, chapters or sections from the Koran, are recorded. In this example, Sura 97, Al Kadr, honors the "Night of Power," that is, the eve of the twenty-seventh day of Ramadan, when Allah allegedly revealed the Holy Book to Muhammad. The text is decorated with geometric designs, land and sea creatures, and flags (Bravmann 1983, 60).

This writing board was obtained in 1922 from W. O. Oldman, a London dealer in ethnographica.

Fig. 29. Muslim schoolboys, Kano, Nigeria, 1959. The students learn Arabic from wooden writing boards. Arabic is the classical language of the Koran, the sacred text of Islam.

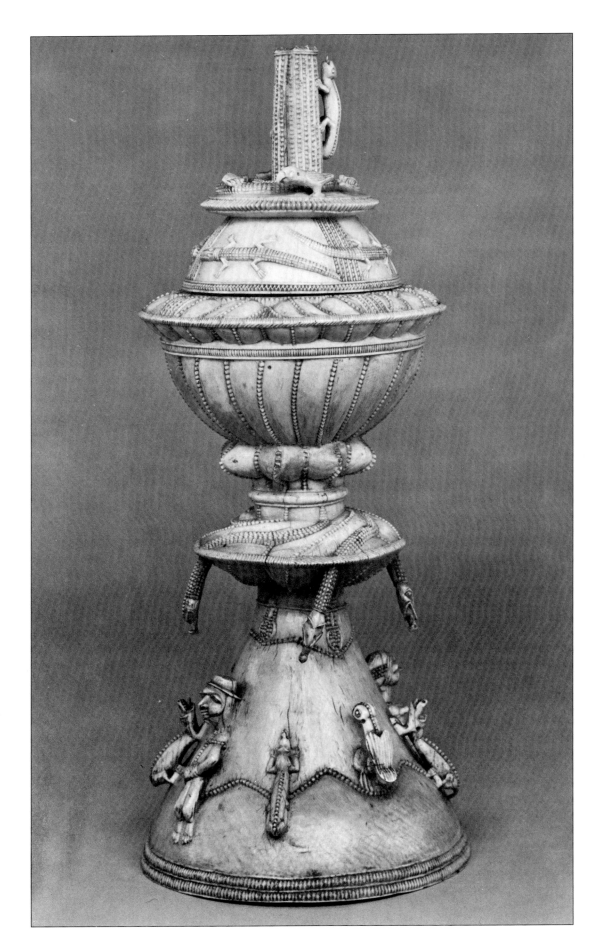

67

SALTCELLAR
Sherbro-Portuguese style, Sherbro Island, Sierra
 Leone, probably 16th century
Ivory
H. 13 in. (33 cm)
The Trustees of the National Museums of Scotland
1956.1157 and A

The Afro-Portuguese ivories are among the earliest
examples of African art made for export. From
the late fifteenth to the mid-seventeenth century,
Portuguese merchants commissioned African sculptors
to carve ivory spoons and forks, hunting horns, and
condiment bowls, or "saltcellars" as they are known.
They came into the possession of the Portuguese
royalty and nobility as well as royal or other wealthy
patrons in Austria and Germany (Fagg 1969, 17;
Willett 1971, 80–81; Gillon 1984, 29–32).

The saltcellar shown here is a part of the earliest
corpus of African art that appeared in Europe. The
decorations and style of carving are African. The
heads of the figures, although they represent Euro-
peans, are carved in the style of steatite *nomoli*
figures from Sherbro Island and Sierra Leone; the
nomoli can be dated from the ivories to the fifteenth
and sixteenth centuries.

James T. Gibson-Graig acquired this saltcellar in
Milan, and it was in his possession by at least 1876
(Curnow 1983, cat. no. 44).

68

PORTUGUESE MUSKETEER FIGURE
Benin Kingdom, Edo peoples, Nigeria, probably
 16th–17th century
Cast copper alloy
H. 14½ in. (36.8 cm)
Trustees of the British Museum
1928. 1-12.1

When the Portuguese arrived in Benin sometime between 1472 and 1486, they found a vast, highly organized, and flourishing kingdom in the process of territorial expansion. Diplomatic and trade relations were quickly established between the African and European kingdoms.

The Portuguese presence is well documented in Benin art. There are numerous sculptured depictions in different mediums of traders, soldiers, and officials. For example, this figure, cast by the lost-wax process, represents a Portuguese armored soldier holding an early matchlock musket with a distinctive serpentine lever.

The Portuguese introduced European firearms, but the extent to which they aided the army of the *oba* (king) of Benin is not known. However, the memory of their presence continues in the ancient Iwoki guild, whose armed members still protect the *oba* on ceremonial occasions. According to Iwoki oral traditions, Oba Esigie, who reigned in the sixteenth century, was on a certain occasion protected by two musket-bearing Portuguese soldiers, one at each side (Bradbury 1973, 35–36; Ben-Amos 1980, 26).

Benin art came to the attention of the Western world after the 1897 punitive expedition, which was organized by the British in retaliation for the massacre of members of a British mission to the *oba* of Benin. When the British sacked Benin, they took the palace treasures—art objects—as war booty. Some of the objects were kept by individuals on the punitive expedition; this figure, for example, was acquired by Ralph Locke. However, great numbers were sold at auction by the admiralty, the proceeds going to wounded soldiers and the survivors of those who had died during the expedition (Home 1982, 100–1; Fagg in Kaplan 1981, 21).

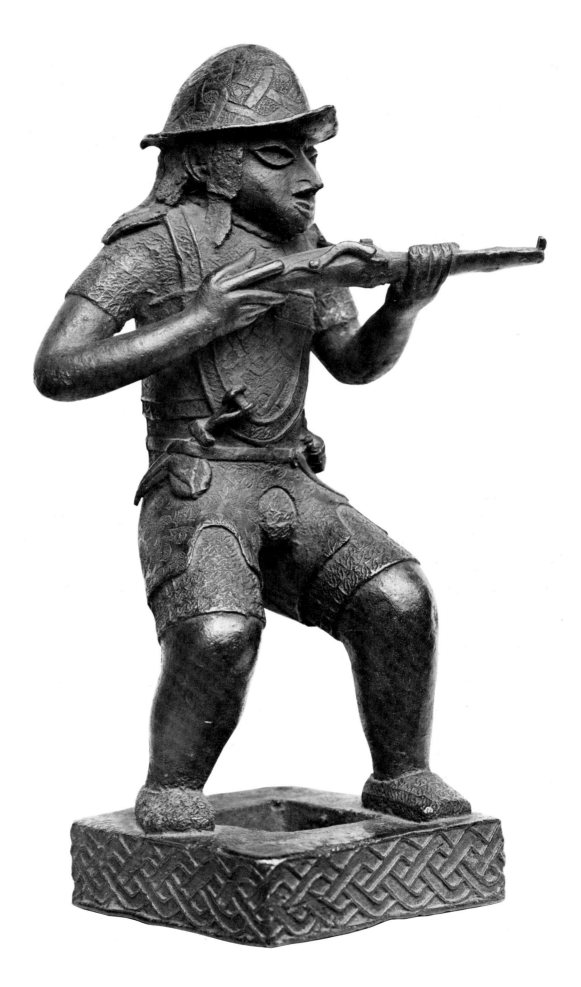

123

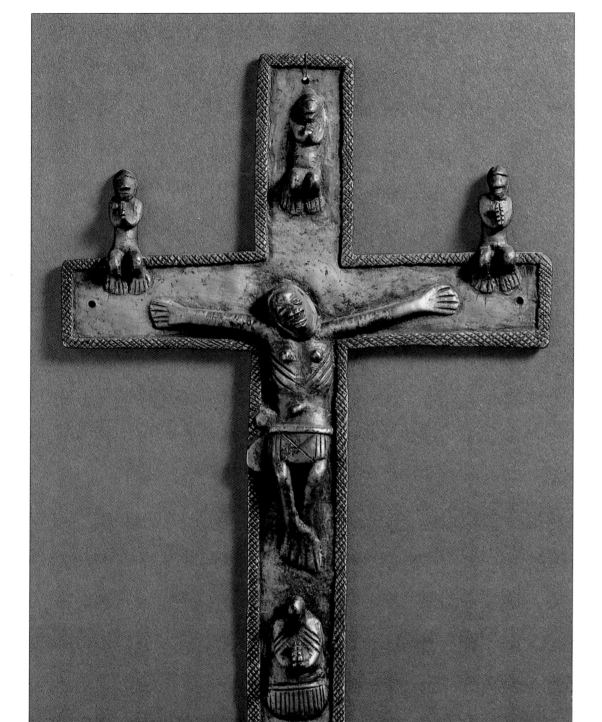

CRUCIFIX (*Nkangi* or *Nkangi Kiditu*)
Kongo peoples, Congo, Zaire, and Angola, probably
 16th–17th century
Cast copper alloy
H. 10 in. (25.4 cm)
Collection of Ernst Anspach

In 1482 Portuguese navigators arrived in the lower
Congo, bringing with them soldiers, artisans, and
Catholic missionaries. The first Kongo king to be
baptized was Dom João I in 1491 (Pigafetta [1881]
1970, 70–78), thereby creating the first Christian
state south of the Sahara. Aided by European
artisans, the Kongo built a stone cathedral and
monasteries and established schools. Conversions
continued until about the mid-eighteenth century, by
which time the Kongo Kingdom had completely
collapsed and the Portuguese, including missionaries,
had withdrawn (Balandier 1968).

During the period of concentrated missionary
activity, local artists produced devotional objects,
including crucifixes, rosaries, statues of St. Anthony,
and medals. When the missionaries left, there was a
reversion to the old religion and its cults. However,
these cults, which were devoid of Christian doctrine,
used Christian symbols. Crucifixes, especially, became
attributes of power and, as part of a chief's regalia,
were handed down from ruler to ruler. Their
presence was particularly important when chiefs sat
as judges in disputes (Monteiro 1875, 275–76;
Cornet 1971, 45–46).

This crucifix, while apparently derived from a
European model, has been Kongoized with the
addition of four figures. The identity of these figures
is uncertain. It has been suggested that the kneeling
and praying figures on the arms of the cross represent
an Apostle with the two thieves or with "God the
Father and the Holy Ghost assisting Jesus at the
moment of death" and the Virgin or a holy woman
(Wannyn 1961, 32–33).

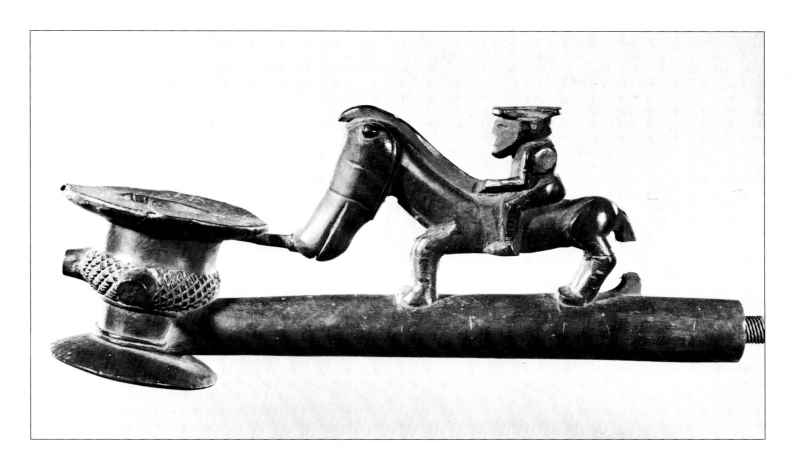

70

Pipe Segment
Songo peoples, Angola, 19th century
Wood
L. 8⅝ in. (21.9 cm)
Museu de Etnologia, Lisbon
AA 721

In the late nineteenth century, a Songo chief's royal insignia included his throne, a leopard skin, a fly whisk, several ceremonial clubs, an imported umbrella, and a locally made two-sectioned carved wooden pipe for smoking tobacco (Buchner in Bastin 1969, 57). Tobacco was originally imported from the New World or Portugal in the seventeenth century. In many traditional African societies, tobacco usage became the prerogative of the aristocracy (Hambly 1930, 16–38).

The equestrian figure depicted on this pipe represents a European trader, a theme that was inspired by the commercial dealings at Malange in present-day Angola. This important trading center was located in the northernmost region of Songo territory and was the beginning of a trade route deep into the interior. Not all Songo chiefs could afford to sponsor trade caravans into the interior, but many Songo men worked as porters, thereby coming into contact with Europeans and Western products (ibid., 55). The caricature-like rendering of the horse suggests that the carver never saw one but perhaps had heard one described by a porter who had seen a horse at Malange.

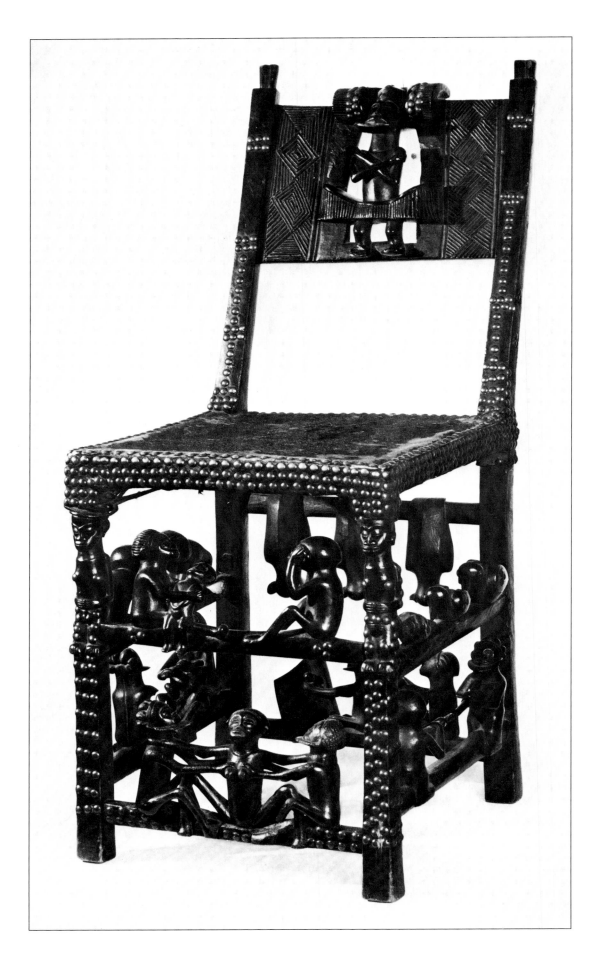

71

Chief's Chair
Chokwe peoples, Angola, 19th–20th century
Wood, hide, brass
H. 31⅛ in. (79.1 cm)
Courtesy of Indiana University Art Museum,
 Bloomington, Indiana
76.54

The typical sub-Saharan seat is a low rectangular or circular stool carved from a single block of wood. During the seventeenth century, many Chokwe chiefs were introduced to chairs imported by Portuguese officials (Bastin 1982, 251). Favoring these new multipiece chairs with backs, leather-covered seats, and brass nails as decoration, Chokwe chiefs adopted the foreign style for their thrones. However, as this example clearly illustrates, Chokwe canons of execution, style, and decoration were not abandoned when the new seat was adopted. The figures on the back, stretchers, and legs of this throne are executed in a bold, expressive manner characteristic of Chokwe carving. They reinforce the supreme religious and political power vested in the chieftaincy (Mason 1986). For example, the backrest bears the image of a masked figure. The mask, with its distinctive ceremonial headdress representing Cihongo, the primordial male ancestor, is the symbol of masculine power and wealth. Formerly Cihongo masks were exclusively worn by the chief or his sons while on tour to collect tribute. The addition of imported brass nails, which were precious objects, reinforced the chief's position in society.

7

DEPARTURE

This final section is devoted to what might be considered the end: death.

In America it is often believed that the death of an individual places him in a timeless state. "The funeral symbolically removes the *time*-bound individual from control by the forward direction of human time. He no longer moves from the past towards the future, for now (in the minds of the living) he is in the unmoving, sanctified stillness of an ever-present eternity" (Warner [1959] 1975, 281). Yet for many peoples death is not the end. It is but another transition. Turner, writing of the Ndembu, makes it quite clear that for them death

> does not have the note of finality that, despite Christianity, death seems to possess in Western civilization. For the Ndembu, "to die" often means to reach the end of a particular stage of development, to reach the terminus of a cycle of growth. When a person dies he is still active, either an an ancestral spirit . . . or as partially reincarnated in a kinsman in the sense of reproducing in the latter some of his mental and physical characteristics. (1967, 71–72)

He goes on to note that "death is a black-out, a period of powerlessness and passivity between two living states" (ibid.).

> Death is a transition. But it is only the last of a long chain of transitions. The moment of death is related not only to the process of afterlife, but also to the process of living, aging, and producing progeny. Death relates to life: to the recent life of the deceased, and to the life he or she has procreated and now leaves behind. (Huntington and Metcalf 1979, 93)

At the same time, no death is natural. Each has a cause, and that cause may be the result of sorcery. In many societies, it is necessary that the cause be determined before burial can take place (Mercier 1974a,

151). For example, among the Lega, "most deaths are attributed to sorcery, and women, in particular, are held responsible for sorcery practices" (Biebuyck 1973, 103). Various tests are undertaken to discover who is responsible. On a more general level, Mbiti writes that death "is unnatural and preventable on the personal level because it is always caused by another agent. If that agent did not *cause* it, then the individual would not die" (1969, 156).

Thus death "is always due to the action of spiritual powers, either because the deceased has brought disaster upon himself by violating some taboo, or because an enemy has 'killed' him by means of spells or magical practices" (Hertz [1907–9] 1960, 77).

The social status of the deceased affects the reaction to his or her death (Huntington and Metcalf 1979, 63). For example, the death of a chief will result in a "true panic" while "the death of a stranger, a slave, or a child will go almost unnoticed" (Hertz [1907–9] 1960, 76).

Often, as in the West, euphemisms will be used instead of the direct statement that someone has died. Thus in Madagascar, "when a sovereign is ill he must not be called 'ill' but 'warmish.' When dead he must be said to have 'turned his back.' His corpse is not called by the usual name for a corpse; it is termed 'the sacred thing.' And he is not buried but 'hidden'" (Webster 1942, 302; see cat. no. 84). Among the Asante, when the Asantehene dies, the queen mother announces his death by indirection, using lamentations such as "A great tree has fallen."

The actual death of a person is often greeted with deep sadness and lamentation. I recall early one morning in an Igala village in northern Nigeria when a number of people from a neighboring village came to announce a death with loud expressions of grief. In a

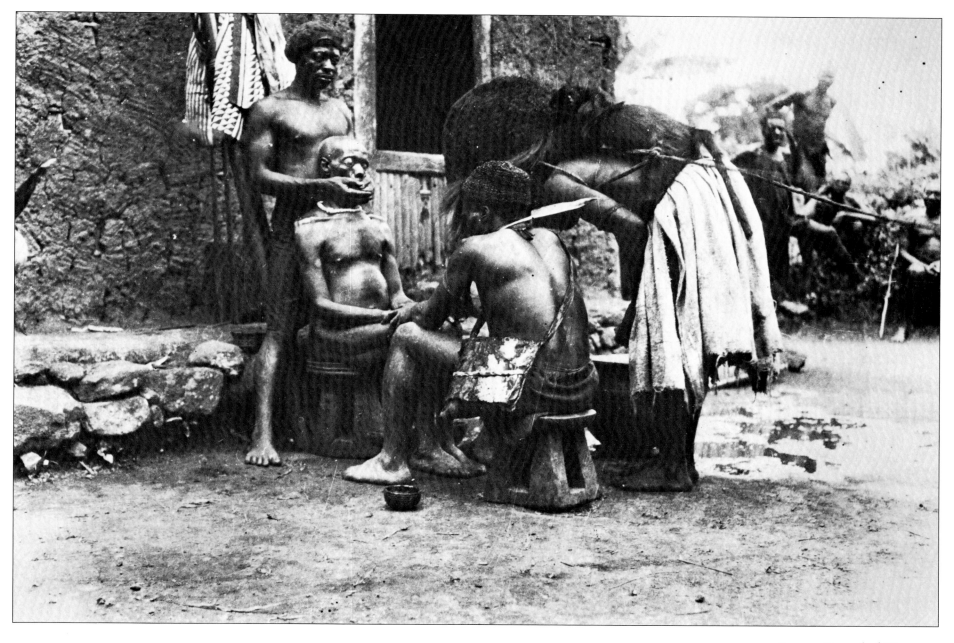

FIG. 30. **Funeral of Njong Nzüe, Weh, Cameroon, 1935. During his funeral, the deceased elder (*seated*) is honored by a visit from a masked dancer of the men's Kweifo association.**

description of death ceremonies among the Nyakyusa, Wilson writes that "crowds of relatives and neighbors gather to wail, to dance, and to feast; the greater the feast, the larger the crowd, the longer the mourning, and the greater the prestige of the family concerned" (1954, 230).

Death is nearly always unexpected, except after a long illness, and it comes as an interruption of normal activities. In that sense it is unlike birth, coming of age, or seasonal celebrations. Happening at any season, often without warning, it can interrupt other normal activities, such as farming or hunting. It nearly always catches the family unprepared; as a result, in most cultures the burial takes place quickly with a minimum of ceremony.

At some later time a formal funeral takes place. The family or village or kingdom will have had time to gather the food and drink and whatever else is deemed necessary for a proper funeral. "Burial" will be used to refer to the actual interment of the body soon after death; "funeral" will refer to the ceremonial activities that formally separate the dead from the living and ensure a place for the dead in the afterworld.

Only after the burial and the funeral is the period of mourning considered ended and the living members of the family can resume normal activities. For example, among the Nyakyusa the burial is followed by mourning dances. The process is one of separating the living from the dead "and pushing away the dead from their dreams

and waking thoughts. At the same time, it ensures the entry of the dead into the company of the shades of the lineages" (ibid., 231). Or, as Parrinder has written, "the varied rites of funerals aim at separating the dead person from his earthly family, although he will now be invited as an ancestor" (1954, 100). He also describes the process:

> After death the corpse is washed, shaved of all hair, and then dressed in the best robes and trinkets and visited by relatives. At the interment various objects are put in the grave; weapons, tools, utensils, tobacco, food, drink, beads or money. These are meant for the use of the deceased on his journey to the world beyond, and so that he should not appear before the ancestors empty handed. (ibid., 99)

It should be noted that this is a generalized description and that the actual practices differ from one group to another (fig. 30). There are, for example, some groups that dry or smoke the corpse—simple forms of embalming—so that burial and funeral may coincide. I was told that, among the Igala, the body of a dead chief was dried for a year and then buried in a boat-shaped coffin.

In discussing the process as a rite of passage, it would seem that funeral rites are essentially rites of separation. But as van Gennep notes:

> A study of the data . . . reveals that the rites of separation are few in number and very simple, while the transition rites have a duration and complexity sometimes so great that they must be granted a sort of autonomy. Furthermore, those funeral rites which incorporate the deceased into the world of the dead are most extensively elaborated and assigned the greatest importance. ([1908] 1960, 146)

There is some disagreement among authors about the exact identification of the three phases in the rite of passage at the time of death. Clearly, the first phase, that of separation, deals with the preparation of the corpse and its burial. This is a period when normal day-to-day activities are suspended. The treatment of the corpse, the digging of the grave, the building of the coffin, the removal to the cemetery, and the breaking of the tools of the dead, all are acts of separation of the dead from the living (ibid., 164). There follows the second phase, a period of transition before the funeral. The focus of the family is then one of preparing for the funeral, collecting the necessary food, and waiting for the date of the funeral. It is a period marked by formal mourning often expressed with particular forms of dress and hair arrangements and with limitations on certain actions, particularly for the spouse of the deceased. The third phase really has two aspects. First, it releases the living from the constraints of mourning and reincorporates them into the rest of society. It signals the end of "the time of mourning with festivities which clearly indicate the resumption of normal life" (Maquet 1974b, 103–4). In Madagascar the funeral thus "signals a return to normality, one important aspect of which is that the deceased's widow is finally free to remarry" (Huntington 1973, 74). It is also a time of incorporation of the dead soul into the other world, to take its place among the honored ancestors. Not to be part of the afterworld would be to allow the dead soul to roam, hostile, angry, and vengeful.

In a number of ways, the rites associated with death echo those of initiation (Hertz [1907–9] 1960, 80). They have similar stages but also carry with them the concept of birth. The Bara of Madagascar, for example, refer to burial using "the metaphor of birth. Just as one must be born into the world of the living so must one also be born out of it and into the world of the dead" (Huntington 1973, 82). Glaze, writing of the Senufo of Côte d'Ivoire, describes the dance of a Gbon masquerader. "The full raffia skirts swish as the masker twists from side to side, straddling the body and walking from its foot to its head. Three times he assumes this parturitionlike posture over the elder's body in remembrance of his service in the three grades of Pondo and symbolically marking his birth as ancestral spirit" (1981, 190). Glaze also refers to the "initiation of the cadaver" (ibid., pl. 88). Glaze's study of the place of art in the life and death practices of the Senufo demonstrates that the funeral is geared to the role the person played while alive and the role he will play as an ancestor. "Death per se does not qualify one for ancestral status. . . . ideally death comes only to the fulfilled adult, the initiated elder who has made his or her contribution to village life and who has many children and grandchildren . . . the more important the individual is in life, the greater will be his or her potential effectiveness as an intermediary between the world of the living and the universe of the supernatural" (ibid., 152). Because of the number of masks and figures that appear at important funerals, as well as the music and dances, it is clear that "the Senufo have chosen to employ aesthetic means as a primary way of dealing with the potential dangers of the spirits of the dead. . . . Not only does the funeral include works of art, but the total event can be viewed as an orchestrated 'work of art'" (ibid., 153). Among the sculptures present at the funeral are masks (cat. no. 75) as well as the primordial couple (ibid., pls. 3–4; cat. no. 2).

The ancestors play an active role in the beliefs of most African peoples. Among the Kongo, it was believed that "they lived outside of time and surrounded by riches, they possessed a power which enabled them to control nature and men. . . . they could mingle with the living (without being seen) and direct the course of events." Theirs was "a new life free from poverty, disease or death, but where they retained their position in the hierarchy" (Balandier 1969, 251–52; note that he relies on Cavazzi's 1687 account). Van Gennep suggests that the afterworld is "a world analogous to ours, but more pleasant, and of a society organized in the same way as it is here. Thus everyone re-enters again the categories of clan, age group, or occupation that he had on earth" ([1908] 1960, 152). More generally, the ancestors are "the protectors of the living, the guarantors of order in the society and its perpetuation and the ideal intermediaries between men and the Gods" (Mercier 1974b, 277).

Turner writes that "the living are dependent on the dead for long-term health, happiness, fertility, and good luck in hunting, for the ancestors are believed to have power to withhold those blessings . . . if [their living kin] neglect to make offerings to them" (1967, 75). The ancestors "return to their human families from time to time. . . . they enquire about family affairs, and may even warn of impending danger or rebuke those who have failed to follow their special instructions. They are guardians of family affairs, traditions, ethics and activities" (Mbiti 1969, 83). They "occupy the ontological position between the spirits and men. They in effect speak a bilingual language of human beings whom they recently 'left' through physical death, and of spirits . . . or of God" (ibid., 69).

Although the ancestors are normally benign, useful to their living descendants, and helpful in bringing up children and in times of crisis such as disease or war, they can be unpredictable, aggressive, or fearsome, responsible for death, illness, crop failure, or infertility (Parrinder 1954, 59–61). For example, Turner reports that the "Ndembu have come to associate misfortune in hunting, women's reproductive disorders, and various forms of illness with the spirits of the dead. . . . when-

ever an individual has been divined to have been 'caught' by such a spirit, he or she becomes the subject of an elaborate ritual . . . devised at once to propitiate and to get rid of the spirit that is thought to be causing the trouble" (1967, 9).

Some ancestors are believed to be waiting to be reborn as an infant, often in the same family (Parrinder 1954, 59). Fernandez points out that among the Fang, figures display both infantile and ancestral aspects (cat. no. 79); "the newborn are felt to be especially close to the ancestors and are only gradually weaned away by ritual and time to human status. Another explanation for the infantile quality lies in the primary concern of the ancestral cult in fertility and increase. An infantile representation is an apt expression for the desire for children" (1966, 59).

Among the Akan, the dead "have their obligations to the living—protecting and guarding them from harm and overseeing the conduct of their family and lineage members. The living, for their part, venerate the dead and invoke them through libations to participate in the affairs of the community. The living also show their hospitality and kindness to the dead by giving them food and drink and keeping the traditions and naming children after them" (Opoku 1982, 65).

Thus offerings are made to the ancestors, and, in some instances, shrines are dedicated to them. The shrines may contain many sorts of objects, including sculptures in human form. Some are believed to represent a particular person (cat. nos. 77, 81–84), while others are apotropaic images that protect the relics of the ancestors (cat. nos. 78–79).

With this section we come full circle. In some societies the spirits of the dead are believed to be reincarnated, and in their rebirth there exists a cycle of continuous spiritual renewal. In another sense the circle also may be thought to be unbroken if we return to a consideration of the primordial ancestors, those who symbolize the founding pair—the father-provider and the mother-of-us-all—and who symbolize the living, the dead, and those who are still to come.

R.S.

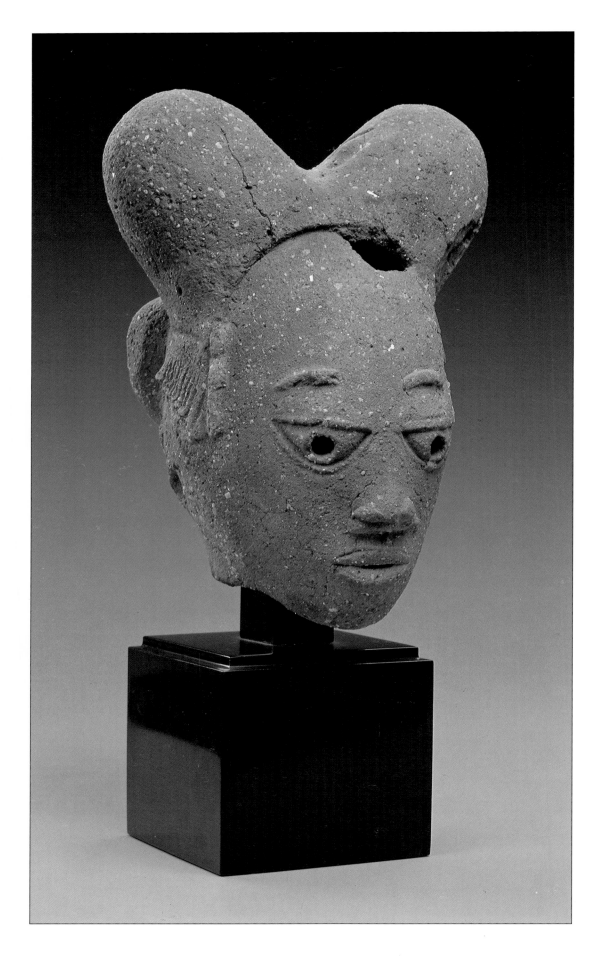

HEAD
Nok style area, Nigeria, 500 B.C.–A.D. 200
Terra-cotta
H. 12½ in (31.8 cm)
Collection of Count Baudouin de Grunne, Belgium

The oldest sculptures so far discovered in sub-Saharan Africa are the Nok terra-cottas of Nigeria, which are approximately two thousand years old. Masterfully modeled terra-cotta figures and domestic pottery have been found in tin-mining sites that are distributed over a large area in northern Nigeria. The culture was named after the site at Nok, where the first piece, a modeled head of a monkey, was found in 1928. Some terra-cottas were found in association with stone hoes and grindstones in sites where iron smelting had occurred, indicating that the Nok were very advanced and settled agriculturalists (Fagg 1977, 12–24; Shaw 1978, 70–84).

The corpus of Nok terra-cottas includes animal and human figures, many of which are fragmentary like this head. The context in which these objects were used is unknown. However, the subject matter suggests that they may have had a religious function since there are double figures and also a high incidence of snake figures. Many figures are depicted standing, suggesting that they represent gods or deified ancestors. Others are depicted kneeling, suggesting that they are devotees. Some figures hold their breasts, symbolizing total devotion and nurturing. Some figures may have been used in funerary contexts, perhaps as personal offerings for the dead (Fagg 1977, 24–40).

73

EQUESTRIAN FIGURE
Possibly Dogon peoples, Mali, c. 10th–13th century
Wood
H. 28¼ in (71.8 cm)
The Minneapolis Institute of Arts, The Centennial
 Fund: Gift of Aimee Mott Butler Charitable Trust,
 Anne S. Dayton, Mr. and Mrs. Donald C. Dayton,
 Mr. and Mrs. William N. Driscoll, Clarence G.
 Frame, and Mr. and Mrs. Clinton Morrison
83.168

This equestrian figure from Mali has been
scientifically dated by radiocarbon analysis to A.D.
945 to 1235 (Sotheby's 1983b). It is one of the
earliest extant wooden sculptures from sub-Saharan
Africa and dates from the beginning of a range of
dates for terra-cottas found in the inland delta region
of the Niger River (cat. no. 4).

In the absence of any collection data, it is not
possible to give a precise attribution for this figure or
to identify its subject and use with certainty. How-
ever, stylistically and iconographically, this equestrian
figure is related to the corpus of terra-cotta mounted
figures from the inland delta region. For example, he
wears a cap, which appears to be held on by a chin
strap, and a garment with a rosette in relief on each
hip. The figure wears a dagger on his left arm and
holds a bow in his left hand; a cylindrical quiver is
carried on his back.

The identity of the mounted figure may be
explained in the creation myths of some Western
Sudanic peoples, including the Dogon and Bamana,
whose visual art commonly depicts equestrians. For
example, in Dogon mythology, Lebe, the oldest
Dogon man and the first *hogon* (priest), became the
first to experience death, and he introduced it to
mankind. Sculptured images show him bearded and
wearing a cap. Because Lebe was also a political
leader, he is depicted on horseback. The horse, which
in Dogon mythology was the first creature to leave
the ark after it fell from the sky to earth, symbolizes
chiefly power and wealth (Laude 1973; Imperato
n.d., 27; Cole 1983b, 6–7).

The figure is perched atop a hollowed stopperlike
support, suggesting that this object may have been
the lid for a giant calabash (Sotheby's 1983b).

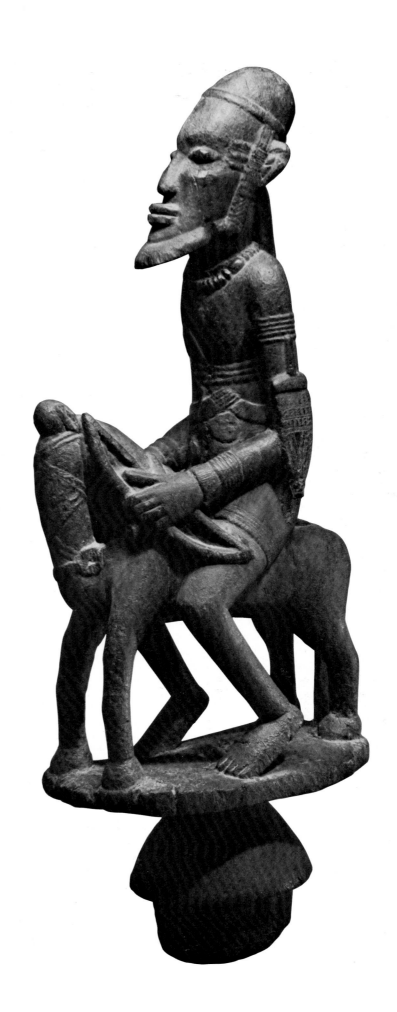

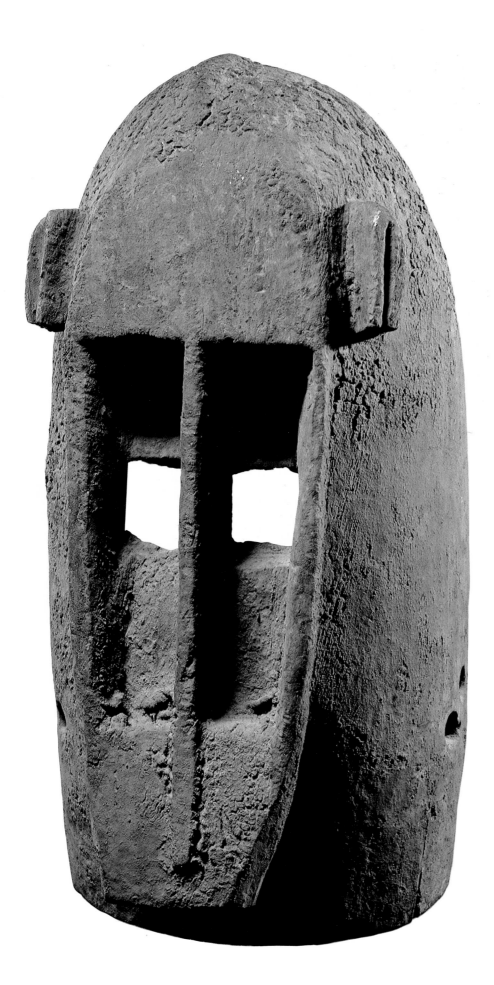

BLACK MONKEY MASK (*Dege*)
Dogon peoples, Mali, 20th century
Wood
H. 20 in. (50.8 cm)
Private collection, Paris

According to a Dogon myth, in the beginning men did not die but were transformed into serpents and entered a world where a spirit language was spoken. Lebe, the oldest Dogon man, had been transformed into a large serpent, but he had not yet entered the other world. One day he angrily reproached some young men in human language so they could understand him. This infringement resulted in his death, and he became the first Dogon to die, thereby introducing death into the world. To appease his anger, a mask in the form of a serpent to keep his spirit was made and funerary rites were developed (Griaule 1970, 169–78). Thus, Sigui, a festival honoring the ancestors that is held every sixty years, and Awa, a men's secret masking association, were established.

The function of Awa association masquerades is to lead the souls of the deceased to their final resting place and to consecrate their passage to the ranks of the ancestors, thereby restoring order and spiritual balance to the community (Imperato n.d., 15–23; DeMott 1982, 78 and passim). The masquerades are held during the Dama, or death anniversary ceremonies, which take place every few years to honor male and female elders who have died since the last Dama.

This black monkey mask, called Dege, is one of more than eighty different types of Awa masks representing mythological characters, including the Nommo (original ancestors), humans (both Dogon and strangers), and birds and animals. Black monkeys are the "male villains of the bush," whose behavior is characterized by wickedness, gluttony, and thievery. Dege's behavior must not be emulated because it is the antithesis of both the ideal Dogon male as a hardworking farmer and the cultural ideal of order, pairing, and fertility (Griaule 1963, 458 and passim; DeMott 1982, 109–10).

75

FACE MASK (*Kpelié*)
Senufo peoples, Côte d'Ivoire and Mali, 19th–20th
 century
Wood, cloth, fiber
H. (mask only) 14 in. (35.6 cm)
The Metropolitan Museum of Art, The Michael C.
 Rockefeller Memorial Collection, Purchase,
 Nelson A. Rockefeller Gift, 1964
1978.412.489

In Senufo society, commemorative funerals incor-
porating ancestral rites are held for "complete"
individuals—elderly men and women who were
initiated into the adult community, who contributed
to village life, and who had many children and
grandchildren. The funeral for such a person is an
initiation, the final rite of passage that transforms
him into a state of being that is beneficial to his
survivors, not only his own kin but also the entire
village community. In the afterlife, the deceased
serves as an intermediary between the world of the
living and that of the supernatural (Glaze 1981, 149–
57). The more important the person was in life, the
more elaborate the funeral will be. Elaboration in
Senufo terms means more aesthetic content: music,
dancing, colorful masquerades, and carved figures.

Carved wooden or cast copper-alloy face masks are
used in "face masquerades" that are held at both the
coming-of-age rituals of young men and the funerals
of complete individuals among four Senufo groups:
the Fodonon (farmers), the Fano (blacksmiths), the
Kpeene (brass casters), and the Kule (wood carvers).
The carved wooden masks are similar to the one
shown here and symbolize the concept of "beautiful,"
as in feminine beauty. Such masks are called the
"girlfriend," "wife," or "helpmeet" of zoomorphic
helmet masks with horns and other male attributes of
a male spirit that appear in a male-associated
masquerade. The face masquerade is a beautiful event
in praise of the deceased (ibid., 127).

Face masks are called *kpelié*, a term that is the
French version of *kpelié-yehe* in the Central Senufo
language. The mask has an oval face with two or
more projections flanking each side; the middle one is
the "ear," and the others are said to be "decoration."

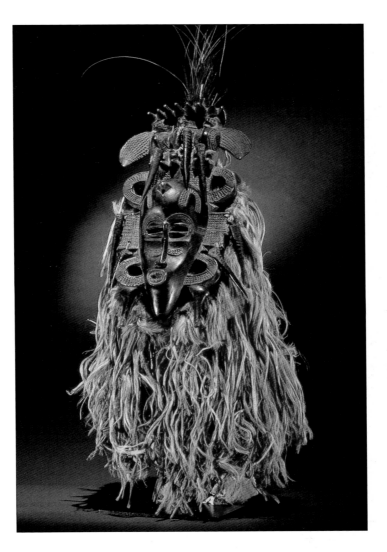

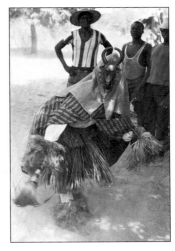

FIG. 31. Kodoli-yehe masked
dancer of the blacksmith
junior grade performs during
formal funeral rites, Senufo
peoples, Côte d'Ivoire, 1970.
Elaborate funerals are held to
honor highly esteemed elders.

The tapering forms at each side of the lower portion
of the mask symbolize the hornbill, one of the
primordial animals. It is also a hairstyle worn by
Senufo mothers. The mask may have horns, which
when turned up symbolize the ram. Such masks
usually have a central crest surmounting the forehead.
It is both representational and emblematic of a
particular group and occupation. However, such
crests are not unique and may not serve as elements
of identification. Rather, as elsewhere, the carved
wooden face covering is only one component of the
total masquerade. The other components include
things held by the masquerader (such as an iron staff
or a horsetail dance whisk), the instrumental
accompaniment, the lyrics sung, and the materials
and composition of the costume.

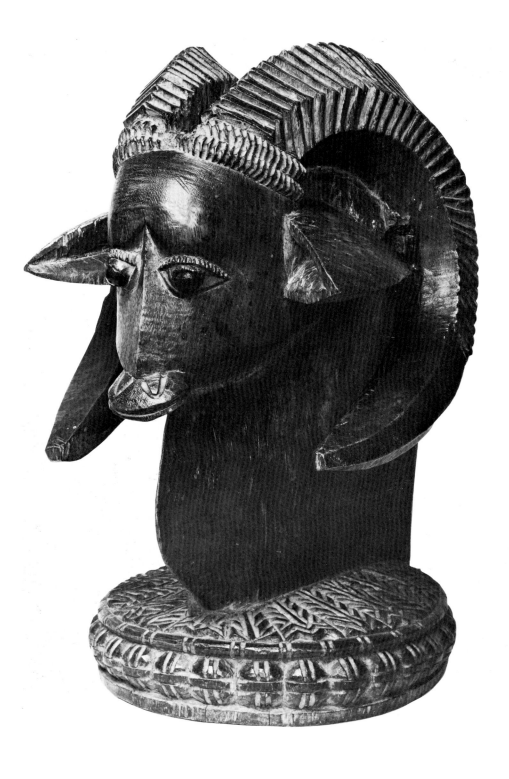

76

Ram Head (*Osamasinmi*)
Owo group, Yoruba peoples, Nigeria, 19th century
Wood
H. 19⅞ in. (50.5 cm)
Trustees of the British Museum
1984.AF.N.19

Carved ram heads, or *osamasinmi*, like this one, were placed on the altars of ancestral Yoruba chiefs of the royal lineage at Owo. The belief was held that ancestors were empowered to bestow fertility. Sacrifices were made to them at the time of the first yam harvest. It has been suggested that the form of the ram, with its powerful, curving horns and projecting chest bone, expresses the idea of fertility and increase (Fagg 1963, fig. 102). *Osamasinmi* were also carved in the form of human heads with ram horns (Poynor 1978, 320).

This *osamasinmi* was a gift from the *olowo* (king) of Owo to the late M. S. Cockin, a British colonial official, in 1909.

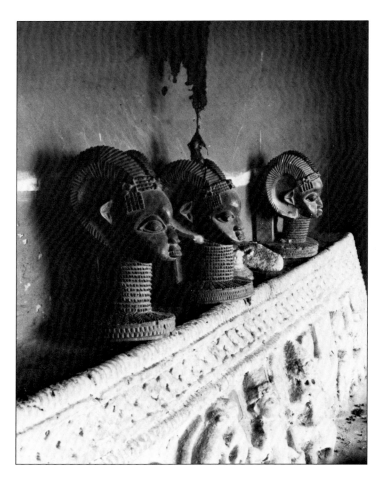

FIG. 32. **Ancestral altar, Owo group, Yoruba peoples, Nigeria, c. 1958.**

77

ANCESTOR MEMORIAL SCREEN (*Duen Fobara*)
Kalabari group, Ijo peoples, Abonnema village,
 Nigeria, 19th century
Wood, wicker, traces of pigment
H. 37½ in. (95.3 cm)
The Minneapolis Institute of Arts, The John R. Van
 Derlip Fund
74.22

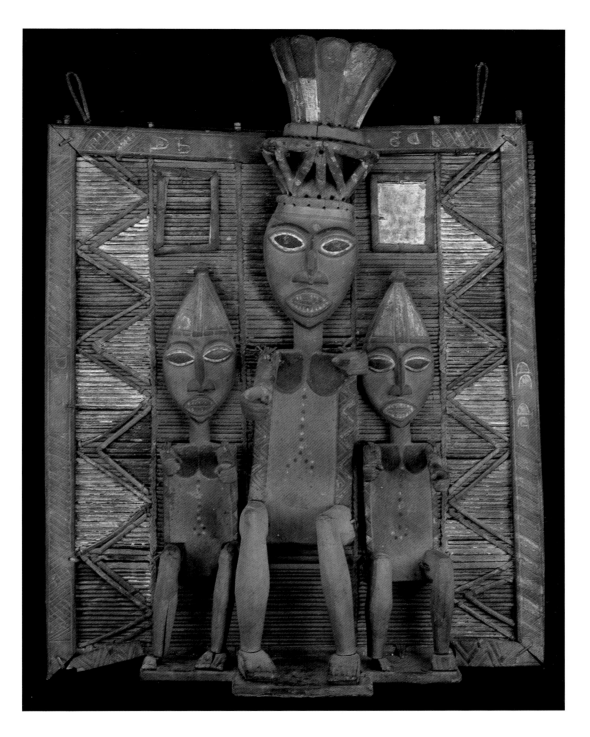

When an important male member of a lineage dies, a
sculpture called a *duen fobara* is made in his honor.
The words mean "ancestor" and "forehead of the
dead," respectively; the Kalabari believe that the
forehead controls a person's success in life. Upon
completion of the memorial screen, it is enshrined in
the compound. This is done not only to honor the
deceased but also to provide a receptacle for his spirit
in the belief that spirits of the dead continue to
pursue and preserve their values and desires in the
afterlife. Thus the ancestor remains interested in the
well-being and success of his survivors and the affairs
of the community (Horton 1965, 8–9).

All *duen fobara* are constructed from wood and
wicker and follow the same format: a large carved
figure flanked by smaller complete figures and small
heads (missing from this example) against a wood
and wicker screen. The venerated ancestor depicted
on a *duen fobara* is distinguished by his central
placement, size, and favorite headdress. The smaller
figures and the heads represent large numbers
of his dependents and followers.

Duen fobara are sacred objects that under normal
conditions would be impossible for an outsider to
obtain. However, in 1915 a self-styled prophet called
Elijah II set off an iconoclastic frenzy. Only a few Ijo
people resisted this incursion and kept their screens.
This one and several others were saved from
destruction by P. Amaury Talbot, a British colonial
administrator and ethnographer, who deposited them
in the British Museum (Bradbury and Anderson
1974, 67).

RELIQUARY GUARDIAN FIGURE (*Bwiti*)
Hongwe peoples, Mekambo area, Gabon, 19th–20th
 century
Wood, copper alloy
H. 22 in. (55.9 cm)
Collection of Raymond and Laura Wielgus

The skull and certain other bones of Hongwe
ancestors were preserved in reliquaries—cylindrical
bark boxes or woven bags—that were guarded by
figures called *bwiti* (also known as *bwete*). *Bwiti*,
exemplified by this figure, have a concave, semi-oval-
shaped head with a cylindrical projection at the top.
This projection is said to represent a hairstyle worn
by elder members of the ancestor cult (Perrois 1985,
188–89). The "body" is a stem swelling into an open
lozenge turned at a right angle to the head. The
wooden form is covered with narrow strips and
bands of copper and copper-alloy wire. The lower
part of the stem was thrust into the receptacle
containing the relics. It was believed that the skulls
and bones of important men retained their power
after death. These powerful relics were expected to
protect and benefit the families that owned them
(Siroto 1968, 22–27).

 According to the Hongwe, these highly abstract
figures are symbolic portraits of their ancestors. They
are composed of signs that are understood by all
initiated members of the cult. Large *bwiti*, like this
one, are said to represent clan founders; smaller ones
represent heads of lineages (Perrois 1985).

FIG. 33. **Reliquary baskets and
sculptured guardian figures
in shrine, Mindoumou group, Kota
peoples, Pongo village, Gabon.**
*(Nineteenth-century drawing from
de Brazza 1887, vol. 2, 50.)*

79

RELIQUARY GUARDIAN FIGURE (*Nlo Byeri*)
Ngumba group, Fang peoples, Cameroon, 19th–20th
 century
Wood, copper alloy
H. 21½ in (54.6 cm)
Collection of Jack Naiman

In the belief that an individual's vital force is situated
in the skull, the Fang venerated the skulls of their
most important ancestors. These included the founder
of the lineage and successive lineages, clan or family
heads, and extraordinary women who had super-
natural abilities or were the mothers of unusually
large families. The ancestral relics were preserved in
reliquaries (*nsekh o byeri*) made of pieces of bark
sewn together. A carved human head or figure
(*eyema* or *nlo byeri*), like this one, was secured to the
lid of the reliquary and served as a guardian. The
figure was a symbolic evocation of the ancestor, as
well as a source of magical protection for the relics
(Perrois 1972, 131–33; Perrois in Fry 1978, 132–33).

 The northern Fang origin of this figure is
exemplified by the extremely long torso, bulbous
forearms and calves, and the application of copper-
alloy strips.

FIG. 34. Reliquaries, Fang peoples, Cameroon, c. 1914.
The projecting stem and the flexed-knee pose allow
the sculptured guardian figures to be set atop bark boxes
containing sacred relics.

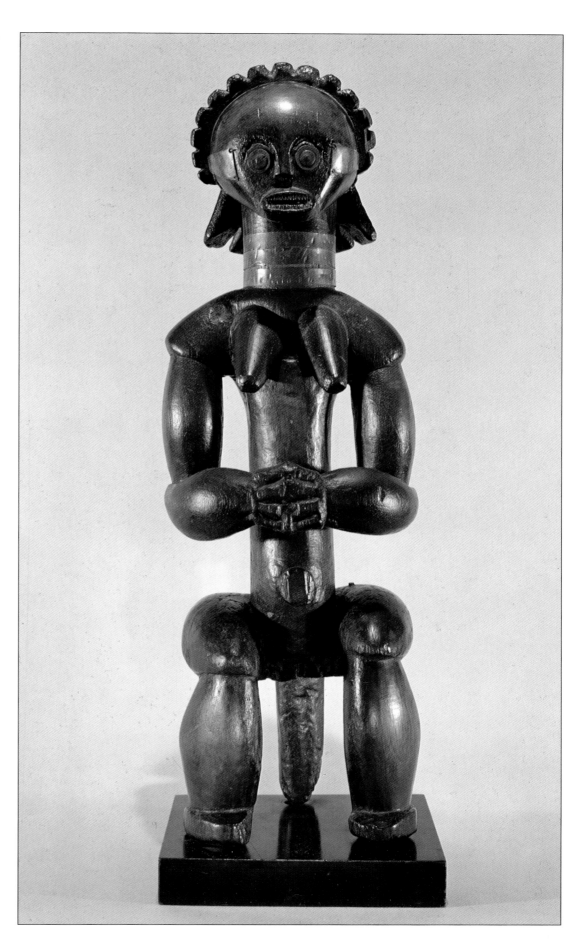

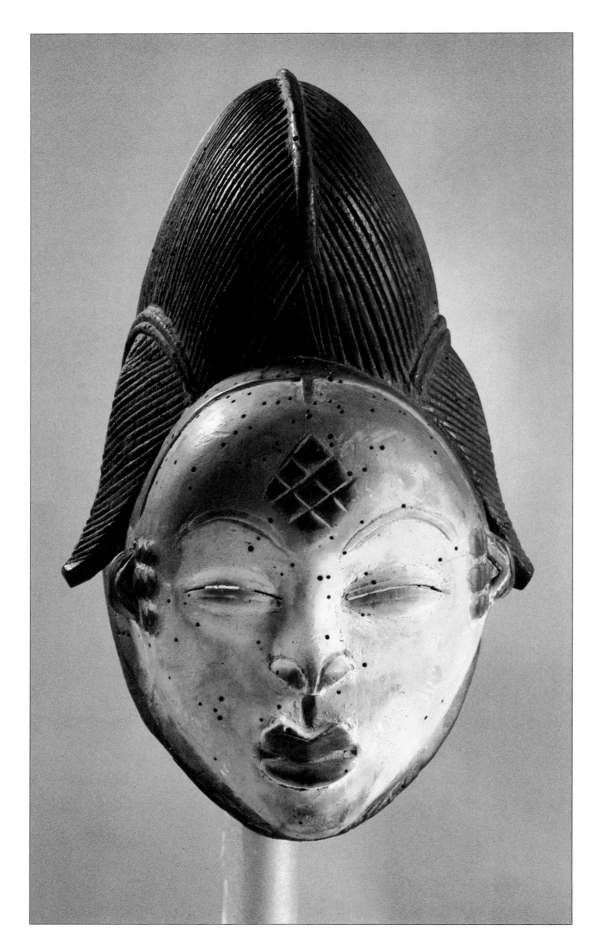

MASK (*Okuyi*)
Punu peoples, Gabon, 19th century
Wood, pigment
H. 10⅝ in. (27 cm)
Private collection

Masks called Okuyi, Mukuyi, or Mukudji, according
to their place of origin in southern and south-central
Gabon, appear in masquerades during funeral
celebrations. Wearing the mask tilted forward on his
head and a body-concealing costume of skins and
raffia cloth, the dancer performs acrobatic feats on
tall stilts. He carries a whip of dried grasses in each
hand and emits sounds in an unnatural timbre
(Fourquet 1982; Perrois 1985, 98–102).

Okuyi masks have feminine attributes, such as the
scarification pattern of a group of "fish scales"
arranged into a lozenge on the forehead and each
temple. The hairstyle, usually likened to a bivalve
shell, is also a feminine attribute (Perrois 1985, 206).
However, the white color of the mask is genderless;
white is a symbol for peace, deities, spirits of the
dead, and the afterlife. It is thus the predominating
color in funeral celebrations and memorials (Walker
1983, 6–7).

This mask was brought to Europe about 1900.

81

ANCESTOR FIGURE
Niembo Chiefdom, Hemba peoples, Mbulula region,
　Zaire, 19th–20th century
Wood
H. 34⅝ in. (87.9 cm)
City of Antwerp, Etnografisch Museum
A.E. 864

Among the Hemba, sculptured male bearded figures
wearing a cruciform hairstyle and posed standing
with their hands placed on the lower abdomen or at
the sides represent distinguished ancestors. They are
considered to be portraits of specific individuals and
were kept in the homes of the principal Hemba
families as genealogical references. This figure, carved
in the classical style, originated in the Niembo
Chiefdom, where one of the finest Hemba carving
workshops existed (Neyt in Fry 1978, 163–68; Neyt
1981, 435–36).

　The Hemba ancestor figure shown here was
acquired by the Etnografisch Museum in 1931. It was
exhibited in a 1937 landmark exhibition in Antwerp,
Plasteik van Kongo, organized by Dr. Frans M.
Olbrechts.

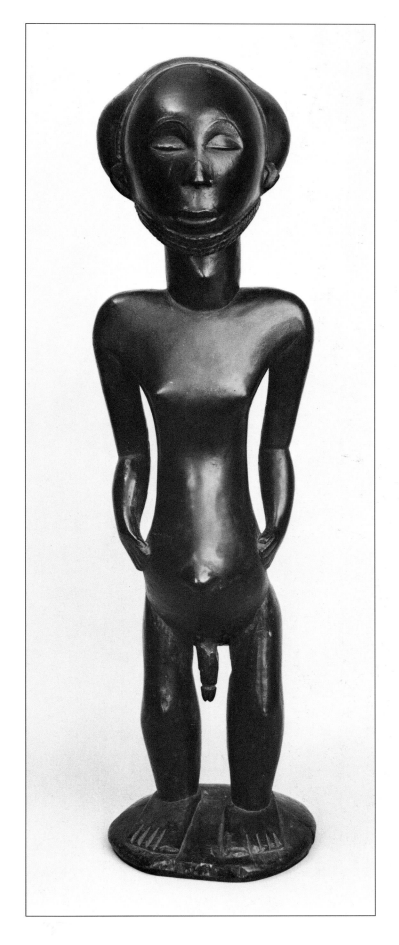

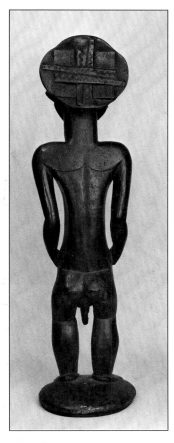

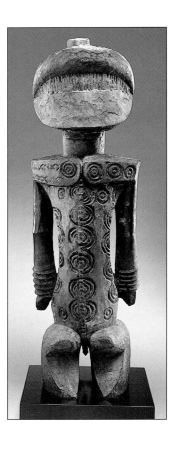

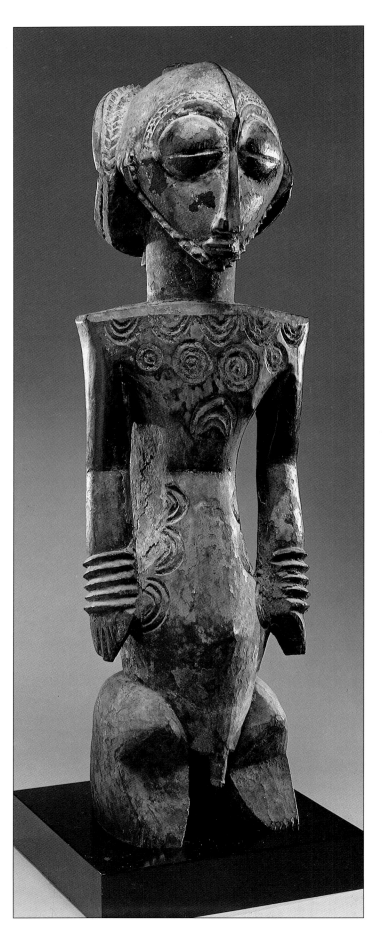

82

MALE ANCESTOR FIGURE
Hanga group, Buye peoples, Zaire, 19th–20th
 century
Wood, pigment
H. 34 in. (86.4 cm)
Collection of Gustave and Franyo Schindler

The Buye immortalize important village chiefs in
vigorous, monumental sculptured figures that are
characterized by a round face, globular eyes, and
bulging trunk. These sacred images were originally
dressed in handwoven cloths covering the shoulders
and the loins (de Kun 1979). The figures were
enshrined, and food offerings were made to them
(Neyt 1981, 303).

 In life, these venerated chiefs of the Buye led
migrations, founded villages, or provided exceptional
leadership. In death, as suggested by beliefs of their
better-known Bembe relatives, the ancestors made
their will to punish or reward known in dreams or
through divination (Biebuyck 1981, 24).

83

COMMEMORATIVE POST (*Kigango*)
Probably Kambe group, Mijikenda peoples, Kenya,
 20th century
Wood, pigment
H. 44½ in. (113 cm)
Detroit Institute of Arts, Founders Society Purchase,
 Eleanor Clay Ford Fund for African Art
78.14

Sculptured anthropomorphic posts called *vigango* (sing., *kigango*) were erected to honor important deceased members of Gohu, a men's graded initiation association of the Mijikenda. *Vigango* were erected in a specially built shelter that simultaneously served as a shrine to the ancestors and a meeting place for men. That spot became an abode of the ancestral spirits and the center of political and religious activities. The most important elders lived there (Siroto 1979b, 105–7; Brown 1980, 36–37; Parkin 1986, 17).

Within a year of his demise, a deceased elder made it known in a dream to his brother, son, or grandson that it was time to have a *kigango* carved in his memory. The cost of the sculpture was borne by a senior male relative or by the entire clan. Once installed, the *kigango* served as a medium of communication between the deceased elder's spirit and his survivors, who asked the former to intercede on their behalf with the more powerful spirits who were believed to control the universe. The elder's spirit was propitiated with offerings of food, palm wine, snuff, or the blood of slaughtered goats or fowls placed at the base of the figure. As long as the memory of the deceased was maintained, his spirit was honored.

This *kigango* has been attributed to the Kambe, one of the Mijikenda groups. Unlike most other *vigango*, which are usually planklike forms with flat disk-shaped or round heads, this figure has the suggestion of a human body and has arms, torso, and loins. It is similar to one that Joy Adamson saw and painted and seems to have been attributed to the Kambe (Siroto 1979b, 105). The carved rosettes and geometric decoration have been interpreted to represent the elders' shoulder cloths or bodily scarification (ibid., 109). They may be derived from Swahili chip-carved motifs (Sieber 1986, 31).

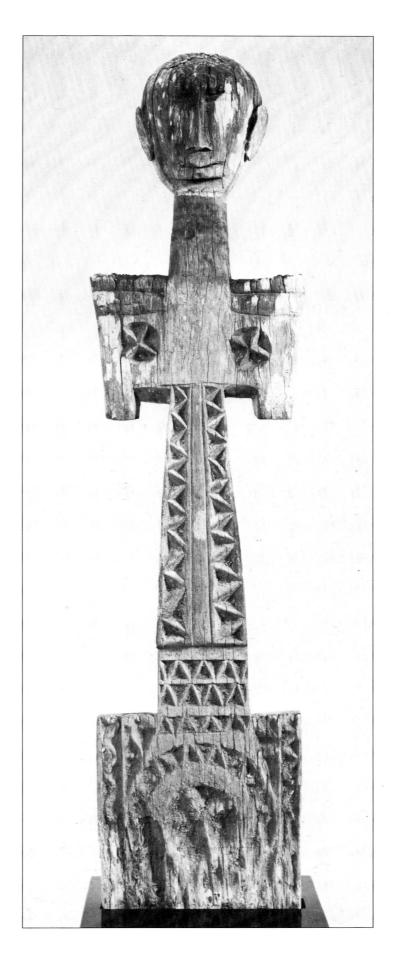

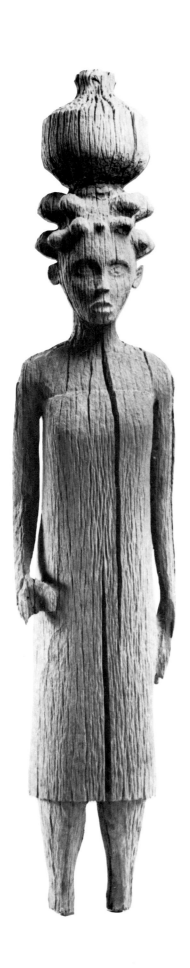
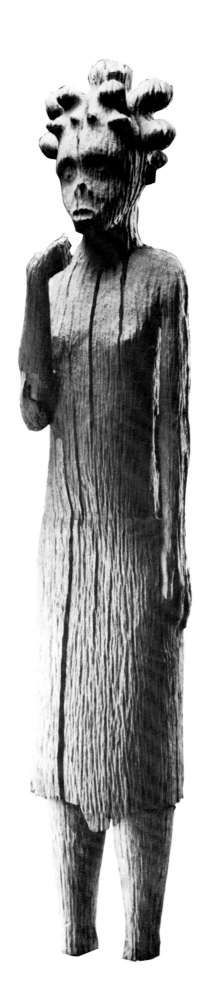

84

Male and Female Tomb Figures
Sakalava peoples, Belo-sur-Tsiribihina area,
 Madagascar, 19th century
Wood
H. of male 71 in. (180.3 cm); H. of female 62⅝ in.
 (159.1 cm)
Collection of Count Baudouin de Grunne, Belgium

It has been observed that cults of the dead prevail throughout Madagascar among the different ethnic groups. Tombs dominate the landscape, reflecting the peoples' profound respect for the dead and the need to keep them nearby. It has been suggested that this need probably derives from the initial peopling of the island. The first settlers, seafaring southeast Asians, having come such great distances, needed reassurance that their ancestors were always with them (*The World and Its Peoples 1967, Africa South and West,* vol. 1, 106).

Tombs vary from region to region and may be further differentiated by the social rank of the deceased. For example, among the Sakalava, who occupy the entire western side of the island, some tombs are piled stone structures with a bare post erected in front of them. Other tombs are enclosed with a rectangular wooden fence decorated with *aloalo* (posts), each of which is surmounted by a sculptured male or female figure, bird, or vase, placed according to a formula at the corners and midway between.

This pair of highly weathered figures was originally part of a royal tomb at Tsianihy for King Toera, whom the French massacred along with some of his supporters in 1897. These figures guarded the entrance to his tomb, which was constructed of stone and roofed with corrugated iron. The female figure carries a jar on her head. The male figure originally held a rifle and a lance (Oberlé 1979, 139).

CONCLUSION

In the conclusion of his important book *The Rites of Passage,* van Gennep writes:

> For groups, as well as for individuals, life itself means to separate and to be reunited, to change form and condition, to die and be reborn. It is to act and to cease, to wait and rest, and then to begin acting again, but in a different way. And there are always new thresholds to cross: the thresholds of summer and winter, of a season or a year, of a month or a night; the thresholds of birth, adolescence, maturity, and old age; the thresholds of death and that of afterlife—for those who believe in it. ([1908] 1960, 189–90)

And for those who believe, there are the arts—the songs, music, costumes, dances, and the sculptures—that intensify, activate, and bring life to the rituals that celebrate the times of transition, the crossings of the thresholds that are the focal points of the cycle of life.

Thus from the primordial ancestors to the most recent birth, there is a sense of flow and continuity, a basic pattern to the span of a life or a year or a day. To this pattern the sculptures of Africa lend substance and authority.

PROVENANCE AND PUBLICATION DATA

1 PRIMORDIAL COUPLE
Published: Fagg 1981b, cat. no. 5; Lehuard 1984,
17; Rubin 1984, vol. 1, 56.

2 PRIMORDIAL COUPLE
Provenance: Nelson A. Rockefeller; The Museum of
Primitive Art.
Published: Goldwater 1964, figs. 93–93a; *L'art nègre*
1966, cat. no. 372; Parke-Bernet 1967, fig. 25;
Meauzé 1968, 21 (male figure); Freyer 1974, figs. 21–
22.

4 MATERNITY FIGURE
Published: de Grunne 1980, fig. 1.15; "Expositions"
1980, 31.

5 MATERNITY FIGURE (*Gwandusu*)
Provenance: Nelson A. Rockefeller; The Museum of
Primitive Art.
Published: Goldwater 1960, figs. 93–94; Parke-
Bernet 1967, fig. 17; Hersey 1976, 41; Walker 1976,
front cover; Preston 1985, 31; Ezra 1986, fig. 33.

6 MATERNITY FIGURE
Published: Cole and Ross 1977, fig. 223.

8 MATERNITY GROUP FIGURE
Provenance: Major Fitz Herbert Ruxton.
Published: Sadler 1935, pl. 8; Underwood 1947, 21;
Fagg 1963, fig. 143b; Trowell 1964, pl. 20; Duerden
1968, fig. 40; Leiris and Delange 1968, fig. 360;
Trowell and Nevermann 1968, 124; Willett 1971, fig.
131; Anton et al. 1979, 374; Vowles 1981, fig. 7;
Rubin 1984, vol. 2, 445; Willett 1985, fig. 131;
University Prints n.d., N77.

9 MATERNITY FIGURE
Published: Lecoq 1953, figs. 94–95; Roosens 1967,
figs. 68–69; Fry 1978, 118, 120–22; Guidoni 1978,
fig. 366; Fagg 1981b, fig. 26; Northern 1984, fig.
14; Harter 1986, figs. 42, 46.

10 SCEPTER (*Mvuala*) FINIAL
Provenance: Nineteenth-century colonial Belgian
collection.
Published: Guimiot 1975, cat. no. 52; *La maternité*
1977, fig. 59.

11 GRAVE STELE WITH MOTHER AND CHILD
Provenance: A. de Bloeme.
Published: Roosens 1967, fig. 143; Allison 1968, fig.
86; Leiris and Delange 1968, fig. 278.

12 MATERNITY FIGURE
Provenance: Raoul Blondiau.
Published: *Tentoonstelling* 1937, fig. 283; Olbrechts
1946, pl. 18, fig. 94; Radin and Sweeney 1952, fig.
86; Brooklyn Institute of Arts and Sciences 1954, fig.
156; Christensen 1955, fig. 5; Plass 1956, fig. 35-B;
Elisofon [1958] 1978, fig. 278; Robbins 1966, fig.
301; Roosens 1967, fig. 200; Leuzinger 1972, fig.
U8; Leuzinger 1977, 104; Lehuard 1978b, fig. 1;
Williams 1980, fig. 52.

13 FERTILITY FIGURE (*Akua'ba*)
Provenance: Nelson A. Rockefeller; The Museum of
Primitive Art.
Published: Robbins 1966, 114; Cole and Ross 1977,
fig. 210.

15 HEADPIECE
Provenance: Pierre Matisse.

16 MASK (*Banda*)
Provenance: Emil Storrer.
Published: Leuzinger 1960, pl. 15; Wixom 1961, fig.
5; Leuzinger 1963, cat. no. 37; Leuzinger 1967, pl.
15; Leuzinger 1972, E1.

17 MASK (*Dandai*)
Published: Gilfoy 1976, fig. 3; Celenko 1983, fig. 49;
Preston 1985, cat. no. 9.

18 MASK
Provenance: Merton D. Simpson; Donald and
Florence Morris.

19 MASK (*Kakungu*)
Provenance: O. Butaye.
Published: *Kunst og Kunstindustrie* 1956, cat. no. 95;
Mask 1956, cat. no. 200; Musée royal de l'Afrique
Centrale 1959, fig. 16; Maesen 1960b, cat. no. 74;
Maesen and Kooyman 1960, cat. no. 15; Walker Art
Center 1967, cat. no. 5.3; Crédit Communal de
Belgique 1971, no. 65; Bourgeois 1980, fig. 4;
Biebuyck 1985, fig. 58.

20 FACE MASK (*Mbuya*)
Published: Lehuard 1980, 51.

21 FACE MASK
Published: Holý 1967, pl. 97; Leuzinger 1967, pl.
63; Leiris and Delange 1968, fig. 431; Trowell and
Nevermann 1968, 27; Leuzinger 1972, Z4; Linden-
Museum Stuttgart 1973, cat. no. 30; Anton et al.
1979, 227; Linden-Museum Stuttgart 1982, vol. 1,
A80; University Prints n.d., N146.

22 PAIR OF HEADDRESSES (*Chi Wara*)
Published: Art Institute of Chicago, 1964–65, 41;
Art Quarterly 1965, pl. 3; *African Arts* 1970, front
cover; *African Arts* 1975, 11.

23 RITUAL OBJECT (*Ninte Kamatchol*)
Published: Museu de Etnologia 1968, fig. 28; Museu
de Etnologia 1972, fig. 143; Geertruyen 1976, fig.
11; Oliveira 1985, fig. 36.

24 MASK
Provenance: Katherine White Collection.
Published: Thompson 1974, H-1; Seattle Art
Museum 1984, 116.

25 MASK (*Zo ge*)
Provenance: Dr. George Harley.
Published: Wingert 1948, cat. no. 14; Harley [1950]
1975, pl. V, b; Wingert 1950, fig. 14.

26 STANDING MALE AND FEMALE FIGURES
Provenance: Nelson A. Rockefeller; The Museum of
Primitive Art.
Published: Robbins 1966, figs. 90–91; Balandier and
Maquet 1974, 26; Museum of Primitive Art 1974,
fig. 68; Boltin 1978, 175; University Prints n.d., N39.

27 FEMALE FIGURE (*Mi iri ni*)
Provenance: Tristan Tzara, Paris; Kleinman, Paris;
Frank Crowninshield; Robert H. Tannahill.
Published: Parke-Bernet 1943, fig. 130; Plass 1959,
cat. no. 49; Detroit Institute of Arts 1970, 184;
Detroit Institute of Arts 1971, pl. 5; Detroit Institute
of Arts 1977, fig. 78.

28 FEMALE HEAD (*Yuo*)
Provenance: Mathias Komor; John A. Friede; Jacques
Kerchache.
Published: World Festival of Negro Arts 1967, 112;
Meauzé 1968, 48–49; Kerchache 1982, n.p.

29 MASK (*Sakrobundi*)
Provenance: Sir Cecil Armitage.
Published: Underwood 1952, fig. 20; Fagg 1969, cat.
no. 128; Bravmann 1974, fig. 23; Segy 1976, fig.
207; Bravmann 1979, fig. 2.

30 IFA DIVINATION BOARD (*Opon Ifa*)
Provenance: Christoph Weickmann.
Published: Luschan [1919] 1968, fig. 860; Fagg and
Plass 1964, 114; Willett 1971, fig. 59; Martin and
O'Meara 1977, fig. 39; Fagg and Pemberton 1982,
fig. 29; Vansina 1984, pl. 1.1; Willett 1985, fig. 52.

31 IFA DIVINATION CUP (*Agere Ifa*)
Published: Bastin 1984, fig. 427.

32 SHRINE FIGURE (*Ikenga*)
Provenance: Philip Goldman; Mr. and Mrs. Henry R. Hope.
Published: Purdue University 1974, cat. no. 33; Broudy 1975, cat. no. 27; Martin and O'Meara 1977, fig. 34; Odita 1978, cat. no. 2; Indiana University Art Museum 1980, 219; Sieber, Newton, and Coe 1986, cat. no. 124; *African Arts* 1987, front cover.

33 HIPPOPOTAMUS MASK (*Otobo*)
Provenance: P. Amaury Talbot; British Museum; The Webster Plass Collection.
Published: "Exhibition" 1955, fig. 40; Paulme 1956, pl. 16; Plass 1956, pl. 17-A; Sotheby's 1956, fig. 121; Elisofon [1958] 1978, fig. 177; Fagg 1961, fig. 56; Dräyer 1962, 35; Fagg 1963, 109; Willett 1971, fig. 168; Bascom 1973, fig. 60; "Raymond Wielgus Collection" 1973, 55; Rubin 1984, vol. 1, 124; Willett 1985, fig. 168; University Prints n.d., N80.

34 FEMALE FIGURE
Provenance: Roy Sieber.
Published: Plass 1959, cat. no. 103; Fagg 1961, fig. 68; Dräyer 1962, 44; Fagg 1964, pl. 37; Fagg and Plass 1964, pl. 58; Fagg 1965, fig. 45; Leiris and Delange 1968, pl. 359; Trowell and Nevermann 1968, pl. 18; Fagg 1969, cat. no. 53; "Raymond Wielgus Collection" 1973, 53; Balandier and Maquet 1974, 219; Anton et al. 1979, 268; Rubin 1984, vol. 1, 37; Sieber, Newton, and Coe 1986, cat. no. 128.

35 STANDING FIGURE
Provenance: Philippe Guimiot.
Published: *Arts d'Afrique noire* 1975, front cover; Guimiot 1975, cat. no. 43; Crédit Communal de Belgique 1977, cat. no. 61; Rubin 1984, 43.

36 HEADDRESS
Provenance: Father Frank Christol; Wellcome Historical Medical Museum; Wellcome Trust.
Published: California 1965, fig. 220; Robbins 1966, fig. 213; Altman 1967, 64; Harter 1972, figs. 5–6; Northern 1984, cat. no. 99.

37 MASK
Provenance: André Lefevre.
Published: Delange 1967, fig. 109; Paris, Musée de l'Orangerie 1972, fig. 233; Perrois 1979, fig. 99;

Rubin 1984, vol. 1, 64, and vol. 2, 406; Vogel and N'Diaye 1985, 12; University Prints n.d., N100.

39 STANDING FEMALE FIGURE
Provenance: Carl Steckelmann.
Published: Christensen 1955, fig. 46; Plass 1959, cat. no. 127; Robbins 1966, fig. 244; Fagg 1969, fig. 74; Mount 1980, fig. 1.

40 NAIL FIGURE (*Nkisi Nkondi*)
Published: Pickett 1974, fig. 18; Bassani 1977, fig. 6; Thompson 1978, fig. 8; Powell 1984, fig. 23; Powell 1985, fig. 4; Thompson 1985, fig. 8.

43 CEREMONIAL STOOL (*Adamu Dwa*)
Provenance: Arthur Paget; Harry A. Franklin.
Published: Ehrlich 1976, vol. 2, fig. 273; Cole and Ross 1977, fig. 294.

44 VESSEL (*Kuduo*)
Provenance: Mrs. Dominique de Menil.
Published: Sotheby's 1962, 22; Delange 1965, figs. 1–4; Leiris and Delange 1968, fig. 225; Fraser and Cole 1972, figs. 8.6–8.7; Paris, Musée de l'Orangerie 1972, 27; Balandier and Maquet 1974, 33; McLeod 1979, figs. 10–12; Laude 1980, cat. no. 83; African-American Institute 1982, front cover; Brincard 1982, cat. no. G5; Vogel and N'Diaye 1985, fig. 43.

45 EQUESTRIAN FIGURE
Published: Detroit Institute of Arts 1977, fig. 85; Kan 1977, fig. 12; Tunis 1979, fig. 9; Nevadomsky 1986, fig. 1.

46 COMMEMORATIVE HEAD OF A QUEEN MOTHER (*Iyoba*)
Provenance: Sir William Ingram, Bart.
Published: Read and Dalton 1899, IX/4; Roth [1903] 1972, fig. 253; Einstein 1915, 61; Luschan [1919] 1968, pl. 52A; Radin and Sweeney 1952, fig. 131; Elisofon [1958] 1978, fig. 160; Forman, Forman, and Dark 1960, figs. 65–67; Trowell 1964, pl. XIV [A.]; Leuzinger 1967, pl. 26; Duerden 1968, fig. 5; Fagg 1970a, pl. 3; Attenborough 1976, 81; Fagg 1978, pl. 5; Anton et al. 1979, 416; McLeod 1980, fig. 84; *British Museum Guide and Map* 1981, 54; McLeod and Mack 1985, 47; University Prints n.d., N56.

47 COMMEMORATIVE DYNASTIC STATUE (*Ndop*)
Provenance: Nyim Kwete Peshanga Kena.
Published: Cunard [1934] 1969, 427; Olbrechts 1946, XI-51, XIII-63; Underwood 1947, pl. 4; Radin and Sweeney 1952, pl. 82; Elisofon [1958] 1978, fig.

256; Wingert 1962, fig. 31; Fagg 1964, pl. 77; Fagg 1965, fig. 92; Davidson 1967, cover; Parrinder 1967, 121; Meauzé 1968, 129; Trowell and Nevermann 1968, 174; Fagg 1970b, pl. 92; Willett 1971, 92; Vansina 1972, 3.2; Zaslavsky 1973, fig. 11-1; Balandier and Maquet 1974, 38; Rosenwald 1974, fig. 1; Faris 1978, fig. 7; Anton et al. 1979, 424; McLeod 1980, 34–35; Belepe Bope Mabintch 1981, fig. 1; *British Museum Guide and Map* 1981, 54; Cornet 1982, fig. 17; Gillon 1984, fig. 226; Vansina 1984, pl. 8.4; Mack and McLeod 1985, back cover; Willett 1985, fig. 92; Mack 1986a, 30; University Prints n.d., N118.

49 ALTARPIECE
Provenance: Collected from Osisa village before 1885.
Published: Royal Scottish Museum 1971, cat. no. 15; Stössel 1984, fig. 89.

50 CROUCHING FIGURE
Published: Arts Club of Chicago 1966, fig. 21.

51 HEAD
Provenance: Emil Deletaille.
Published: Neyt 1981, fig. III.12.

52 HANGED FIGURE (*Ofika*)
Provenance: Etnografisch Museum, Antwerp; Clark and Frances Stillman.
Published: Robbins 1966, fig. 258; Fagg 1969, cat. no. 101; Metropolitan Museum of Art 1969, 444; Brooklyn Institute of Arts and Sciences 1970, 40; Museum of Primitive Art 1973, fig. 22; Boltin 1978, 96.

53 SOUL-WASHER'S DISK (*Akrafokonmu*)
Provenance: Treasury of Asantehene Prempeh I; Dudley P. Allen.
Published: Cole and Ross 1977, fig. 324; Wixom 1977, fig. 7.

54 NECKLACE
Provenance: Lady Coryndon of Lowestoft, Suffolk, England; Lance and Roberta Entwistle.
Published: Sotheby's 1961, 110; Cole and Ross 1977, pl. 7; Woodward 1985, fig. 5; Woodward 1987, fig. 5.

55 PALACE DOOR
Provenance: Ogoga of Ikere.
Published: Sadler 1935, pl. 11; Crownover 1960, fig. 4 (detail); Henry 1965, 187 (detail); Roosens 1967,

fig. 60; Duerden 1968, pl. 32 (detail); Biebuyck 1969, pl. 24; Fagg 1970a, pl. 31; *Encyclopedia of World Art* 1971, vol. 8, pl. 131; Willett 1971, fig. 231; Fagg 1978, pl. 32; Blackburn 1979, 27 (detail); Fagg and Pemberton 1982, fig. 48; McLeod and Mack 1985, 7; Willett 1985, fig. 231; Pye 1987, 80; Carise n.d., 34.

56 BOWL WITH FIGURES
Provenance: Leon Underwood; Sidney Burney, C.B.E.; William Moore.
Published: Wingert 1948, pl. 36; Wingert 1950, fig. 36; Brooklyn Institute of Arts and Sciences 1954, cat. no. 105; Dräyer 1962, pl. 28; Robbins 1966, fig. 159; Roosens 1967, fig. 46; University of California, Los Angeles 1968, cat. no. 5; Biebuyck 1969, pl. 25; Teilhet 1970, fig. 80; Armstrong 1971, fig. 35; Willett 1971, fig. 232; Arneson 1974, pl. 6; Adams 1977, fig. 10; Armstrong 1981, pl. 3; Fagg and Pemberton 1982, 35 (detail), fig. 49; McClelland 1982, front cover; *Arts d'Afrique noire* 1985, 35; Christie's 1985, front cover, cat. no. 110; Willett 1985, fig. 232.

58 BOX WITH LID
Provenance: Leo Frobenius.
Published: Kecskési 1982, fig. 358; Kecskési 1986, fig. 358.

59 CUP
Provenance: Frederick R. Pleasants.
Published: Brooklyn Institute of Arts and Sciences 1954, 160; Leiris and Delange 1968, fig. 219; Indiana University Art Museum 1980, 228; Sieber, Newton, and Coe 1986, cat. no. 155; Darish 1987, fig. 21.

60 BOW STAND
Provenance: Merton D. Simpson.
Published: Preston 1985, fig. 81.

61 STOOL
Provenance: Vidal Collection; Merton D. Simpson.
Published: *African Arts* 1971, 1; Lehuard 1978a, 6; Gillon 1979, pl. 16.

62 HARP
Provenance: Jean-Pierre Jernander.
Published: Bastin 1984, 404; Detroit Institute of Arts 1985, 73.

63 HEADREST
Published: Wassing 1968, cat. no. 85.

64 THRONE
Provenance: Colonial German collection; Pre-World War II Dutch collection; Jeff Vander Straete; Prince Sadruddin Aga Khan.
Published: Gillon 1979, fig. 189; Sotheby's 1983a, 90; Mauer and Roberts 1985, ill. 62.

65 CONTAINER
Provenance: Mathias Guenther.
Published: Sieber 1980, 168.

66 WRITING BOARD
Provenance: W. O. Oldman.
Published: Bravmann 1983, fig. 44.

67 SALTCELLAR
Provenance: James T. Gibson-Craig.
Published: Fagg 1969, cat. no. 2; Dark 1973, pl. 2, no. 3; Idiens 1980, fig. 8; Curnow 1983, cat. no. 44.

68 PORTUGUESE MUSKETEER FIGURE
Provenance: Ralph Locke; Sidney Burney.
Published: Forman, Forman, and Dark 1960, fig. 49; Fage 1969, front cover; Fagg 1970a, pl. 23; Dark 1973, pl. 16, figs. 32–33; Fagg 1978, pl. 24; Ben-Amos 1980, fig. 26; Cable 1983, 120.

69 CRUCIFIX (*Nkangi* or *Nkangi Kiditu*)
Provenance: M. R. Wannyn; Jean Willy Mestach; Merton D. Simpson.
Published: Maes [1937] 1979, fig. 16; Olbrechts 1946, fig. 39; Brincard 1982, J3; Anspach 1984, 52.

71 CHIEF'S CHAIR
Published: Indiana University Art Museum 1980, 229; Sieber, Newton, and Coe 1986, cat. no. 151; Darish 1987, fig. 15.

72 HEAD
Published: Jacob and de Heeckeren 1977, 39; de Grunne 1980, III-2; "Expositions" 1980, 31.

73 EQUESTRIAN FIGURE
Provenance: Samir Borro; The Ben Heller Collection.
Published: *Arts d'Afrique noire* 1977, front cover; Lehuard 1981, 6; Sotheby's 1983b, fig. 111; Minneapolis Institute of Arts 1986, 17.

74 BLACK MONKEY MASK (*Dege*)
Provenance: Jacques Kerchache.
Published: Leuzinger 1972, A7.

75 FACE MASK (*Kpelié*)
Provenance: Charles Ratton; The Museum of Primitive Art.
Published: Goldwater 1964, fig. 22; Metropolitan

Museum of Art 1969, fig. 298; Boltin 1978, 96; Anton et al. 1979, 274; University Prints n.d., N23.

76 RAM HEAD (*Osamasinmi*)
Provenance: M. S. Cockin; The Celia Barclay Collection.
Published: Elisofon [1958] 1978, figs. 146–48; Fagg 1963, fig. 102; Poynor 1978, pl. 147.

77 ANCESTOR MEMORIAL SCREEN (*Duen Fobara*)
Provenance: P. Amaury Talbot; British Museum.
Published: Bradbury and Anderson 1974, fig. 1; Anderson 1975, 73; "Forehead of the Dead" 1984, 21.

78 RELIQUARY GUARDIAN FIGURE (*Bwiti*)
Provenance: Pierre S. Verité.
Published: Rousseau 1948, fig. 5; Champigneulle 1952, fig. 88; Radin and Sweeney 1952, pl. 142; Sieber 1956, fig. 102; "Sculptural Arts of Tribal Africa" 1957, 18; Museum of Primitive Art 1960, fig. 1; Huet 1963, 97; Bolz 1966, pl. XLIIA; Fröhlich 1966, pl. XLIII, 4; Fagg 1969, cat. no. 70; *New Bulletin* 1969, 8; Brooklyn Institute of Arts and Sciences 1970, 36.

80 MASK (*Okuyi*)
Provenance: Delcourt Collection.
Published: Leuzinger 1972, fig. 23; Perrois 1979, fig. 267; Fourquet 1982, fig. 2.

81 ANCESTOR FIGURE
Provenance: Possibly H. Pareyn; Bela Hein.
Published: Portier and Poncetton 1930, pl. 12; Olbrechts 1946, XXIX-138, XXXI-150; Kochnitzky 1952, front cover (detail); Brussels 1958, fig. 30; *Problèmes d'Afrique Centrale* 1959, front cover; *Catalogue de la Ville d'Anvers* 1960, pl. 283; Wassing 1968, cat. no. 46; Fagg 1969, fig. 96; Claerhout 1971, fig. 48; Leuzinger 1977, 195; Neyt 1981, 60.

82 MALE ANCESTOR FIGURE
Provenance: N. de Kun.
Published: Robbins 1966, fig. 275; de Kun 1979, fig. 7; Gillon 1979, fig. 16; Rubin 1984, 56; Maurer and Roberts 1985, ill. 37.

83 COMMEMORATIVE POST (*Kigango*)
Provenance: Marc Leo Felix; Jacques Kerchache.
Published: Siroto 1979b, figs. 1–2; Rubin 1984, 426.

84 MALE AND FEMALE TOMB FIGURES
Published: Oberlé 1979, 130; Mack 1986b, front cover.

BIBLIOGRAPHY

Abiodun, Rowland. 1975. "Ifa Art Objects: An Interpretation Based on Oral Tradition." In *Yoruba Oral Tradition,* edited by Wande Abimbola. Ile-Ife, Nigeria: Department of African Languages and Literature, University of Ife.

Abrahams, Roger D. 1982. "The Language of Festivals: Celebrating the Economy." In *Celebration: Studies in Festivity and Ritual,* edited by Victor Turner. Washington, D.C.: Smithsonian Institution Press.

Ackerknecht, Erwin H. 1942. "Problems of Primitive Medicine." *Bulletin of the History of Medicine* 2:503–21.

———. 1943. "Psychopathology, Primitive Medicine, and Primitive Culture." *Bulletin of the History of Medicine* 14:30–67.

Adams, Monni. 1977. "An Evening with William Fagg." *African Arts* 10 (4): 38–43, 88.

African-American Institute. 1982. *Annual Report 1982.* New York: African-American Institute.

African Arts. 1970. 4 (1): front cover.

———. 1971. 4 (3): 11

———. 1975. 9 (1): 11.

———. 1987. 20 (3): front cover.

Akinjogbin, I. A. 1967. *Dahomey and Its Neighbours, 1708–1818.* Cambridge: Cambridge University Press.

Alexandre, Pierre. 1974. "Christianity." In *Dictionary of Black African Civilization,* edited by Georges Balandier and Jacques Maquet. Translated by Lady (Mariska Caroline) Peck, Bettina Wadia, and Peninah Neimark. New York: Amiel.

Alldridge, T. J. 1901. *The Sherbro and Its Hinterland.* London: Macmillan.

Allison, Philip A. 1944. "A Yoruba Carver." *Nigeria,* no. 22:49–50.

———. 1968. *African Stone Sculpture.* New York: Praeger.

Altman, Ralph C. 1967. "African Negro Sculpture Has Many Faces." *African Arts* 1 (1): 60–4.

Anderson, Martha. 1975. "Expanded African Collection: The Minneapolis Institute of Arts." *African Arts* 8 (4): 72–73.

Aniakor, Chike. 1984. "Ikenga Art and Igbo Cosmos." *Ikoro* 5 (1 and 2): 60–71.

Anquandah, James. 1982. "The Archaeological Evidence for the Emergence of Akan Civilization." *Tarikh* 7 (2): 9–21.

Anspach, Ernst. 1984. "Profile: Ernst Anspach." *Art and Auction* 6 (7): 52–54.

Anton, Ferdinand, F. J. Dockstader, M. Trowell, and H. Nevermann. 1979. *Primitive Art.* New York: Abrams.

Armstrong, Robert Plant. 1971. *The Affecting Presence.* Urbana: University of Illinois Press.

———. 1981. *The Powers of Presence.* Philadelphia: University of Pennsylvania Press.

Arneson, Jeannette Jenson. 1974. *Tradition and Change in Yoruba Art.* Sacramento: E. B. Crocker Art Gallery.

Art Institute of Chicago. 1964–65. *Annual Report.* Chicago: Art Institute of Chicago.

L'art nègre: Sources, évolution, expansion. Exposition organisée au Musée dynamique à Dakar par le commissariat du [premier] festival mondial des arts nègres et au Grand Palais à Paris, par la réunion des musées nationaux. 1966. Dakar-Paris.

Art Quarterly. 1965. Nos. 1 and 2:111.

Arts Club of Chicago. 1966. *The Raymond and Laura Wielgus Collection.* Chicago: Arts Club of Chicago.

Arts d'Afrique noire. 1975. No. 14: front cover.

———. 1977. No. 24: front cover.

———. 1985. No. 54:34.

Attenborough, David. 1976. *The Tribal Eye.* New York: Norton.

Balandier, Georges. 1969. *Daily Life in the Kingdom of the Kongo from the Sixteenth to the Eighteenth Century.* Translated by Helen Weaver. New York: Meridian Books.

Balandier, Georges, and Jacques Maquet, eds. 1974. *Dictionary of Black African Civilization.* Translated by Lady (Mariska Caroline) Peck, Bettina Wadia, and Peninah Neimark. New York: Amiel.

Bascom, William R. 1969a. *Ifa Divination.* Bloomington: Indiana University Press.

———. 1969b. *The Yoruba of Southwestern Nigeria.* New York: Holt, Rinehart and Winston.

———. 1969c. "Creativity and Style in African Art." In *Tradition and Creativity in Tribal Art,* edited by Daniel Biebuyck. Berkeley: University of California Press.

———. 1973. *African Art in Cultural Perspective.* New York: Norton.

Bassani, Ezio. 1977. "Kongo Nail Fetishes from the Chiloango River Area." *African Arts* 10 (3): 36–40, 88.

Bastin, Marie-Louise. 1969. "Arts of the Angolan Peoples: 3. Songo." *African Arts* 2 (3): 51–57, 77–78.

———. 1982. *La sculpture tshokwe.* Translated by J. B. Donne. Meudon, France: Chaffin.

———. 1984. *Introduction aux arts d'Afrique noire.* Arnouville, France: Arts d'Afrique noire.

Beier, Ulli. 1982. *Yoruba Beaded Crowns.* London: Ethnographica in association with the National Museum, Lagos.

Belepe Bope Mabintch. 1977–78. "Les conflicts de succession au trone dans le royaume kuba." *Etudes d'histoire africaine* 9 and 10:155–82.

———. 1981. "Les oeuvres plastiques africaines comme documents d'histoire: Le cas des statues royales ndop des kuba du Zaire." *Africa-Tervuren* 27 (1): 9–17.

Ben-Amos, Paula. 1980. *The Art of Benin.* London: Thames and Hudson.

Bentor, Eli. 1986. "Notes on an Ikenga in the Indiana University Art Museum Collection." Typescript.

Bettelheim, Bruno. 1954. *Symbolic Wounds.* Glencoe, Illinois: Free Press.

Biebuyck, Daniel, ed. 1969. *Tradition and Creativity in Tribal Art.* Berkeley: University of California Press.

———. 1973. *Lega Culture.* Berkeley: University of California Press.

———. 1976. "Sculpture from the Eastern Zaire Forest Regions: Mbole, Yela, and Pere." *African Arts* 10 (1): 54–61, 99–101.

———. 1981. *Statuary from the pre-Bembe Hunters.* Tervuren: Royal Museum of Central Africa.

———. 1985. *The Arts of Zaire.* Vol. 1, *Southwestern Zaire.* Berkeley: University of California Press.

———. 1986. *The Arts of Zaire.* Vol. 2, *Eastern Zaire.* Berkeley: University of California Press.

Blackburn, Julia. 1979. *The White Men.* London: Orbis.

Boahen, A. Adu. 1971. "The Coming of the Europeans." In *The Horizon History of Africa,* edited by Alvin Josephy. New York: American Heritage.

Boltin, Lee. 1978. *Masterpieces of Primitive Art: The Nelson A. Rockefeller Collection.* New York: Knopf.

Bolz, Ingeborg. 1966. "Zur Kunst in Gabon." *Ethnologia,* no. 3:85–221.

Bourgeois, Arthur P. 1980. "Kakunga among the Yaka and Suku." *African Arts* 14 (1): 42–46.

———. 1984. *Art of the Yaka and Suku*. Meudon, France: Chaffin.

Bradbury, Ellen, and Martha Anderson. 1974. "Ijo Duen Fobara, or Ancestor Screen." *Minneapolis Institute of Arts Bulletin*, no. 61: 66–73.

Bradbury, R. E. 1973. *Benin Studies*. London: Oxford University Press for the International African Institute.

Bravmann, René A. 1973. *Open Frontiers: The Mobility of Art in Black Africa*. Seattle: University of Washington Press for the Henry Art Gallery.

———. 1974. *Islam and Tribal Art in West Africa*. Cambridge: Cambridge University Press.

———. 1979. "Gur and Manding Masquerades in Ghana." *African Arts* 13 (1): 44–51, 98.

———. 1983. *African Islam*. Washington, D.C.: Smithsonian Institution Press; London: Ethnographica.

Brincard, Marie-Thérèse, ed. 1982. *The Art of Metal in Africa*. New York: African-American Institute.

British Museum Guide and Map. 1981. London: British Museum Publications.

The Brooklyn Institute of Arts and Sciences. Museum. 1954. *Masterpieces of African Art*. Brooklyn: Brooklyn Museum.

———. 1970. *African Sculpture*. Text by Michael Kan. Brooklyn: Brooklyn Museum.

Broudy, Elizabeth. 1975. *Icon and Symbol: The Cult of the Ancestor in African Art*. Bloomfield Hills, Michigan: Cranbrook Academy of Art Museum.

Brown, Jean Lucas. 1980. "Miji Kenda Grave and Memorial Sculptures." *African Arts* 13 (4): 36–39, 88.

Brown, Karen Hull. 1986. "Pende Masks from Zaire in the Indiana University Art Museum." Master's thesis, School of Fine Arts, Indiana University, Bloomington.

Brussels. Exposition universelle et internationale. 1958. *Art in the Congo*. Translated and edited by Josef Kadijk. Antwerp.

Cable, Mary. 1983. *The African Kings*. Chicago: Stonehenge.

Calame-Griaule, Genevieve. 1974. "Voodoo." In *Dictionary of Black African Civilization*, edited by Georges Balandier and Jacques Maquet. Translated by Lady (Mariska Caroline) Peck, Bettina Wadia, and Peninah Neimark. New York: Amiel.

California. University at Los Angeles. 1965. *Masterpieces from the Sir Henry Wellcome Collection at UCLA*. Los Angeles.

Carise, Iracy. n.d. (c. 1980). *Arte-mitologia: Orixas, deuses iorubanos*. N.p.

Catalogue de ville d'Anvers. 1960. Antwerp.

Celenko, Theodore. 1983. *A Treasury of African Art from the Harrison Eiteljorg Collection*. Bloomington: Indiana University Press.

Champigneulle, Bernard. 1952. *Chefs d'oeuvre de l'Afrique noire: Exposition chez Leleu*. Paris: Leleu.

Christensen, Erwin O. 1955. *Primitive Art*. New York: Crowell.

Christie's. 1985. *Important Tribal Art*. Auction catalogue, date of sale June 24, 1985. London: Christie's.

Claerhout, Adriaan G. 1971. *Afrikaanse Kunst*. Amsterdam: Nederlandse Stichting Openbaar Kunstbezit.

Cole, Herbert M. 1982. *Mbari: Art and Life among the Owerri Igbo*. Bloomington: Indiana University Press.

———. 1983a. *Male and Female: The Couple in African Sculpture*. Los Angeles: Los Angeles County Museum of Art.

———. 1983b. *Riders of Power in African Sculpture*. Los Angeles: Los Angeles County Museum of Art.

———. 1985. *Mother and Child in African Sculpture*. Los Angeles: Los Angeles County Museum of Art.

Cole, Herbert M., and Chike C. Aniakor. 1984. *Igbo Arts: Community and Cosmos*. Los Angeles: UCLA Museum of Cultural History.

Cole, Herbert M., and Doran H. Ross. 1977. *The Arts of Ghana*. Los Angeles: UCLA Museum of Cultural History.

Colle, Pierre. 1913. *Les baluba (Congo Belge)*. Brussels: DeWit.

Connah, Graham. 1975. *The Archaeology of Benin: Excavations and Other Researches in and around Benin City, Nigeria*. Oxford: Clarendon.

Cornet, Joseph. 1971. *Art of Africa: Treasures from the Congo*. Translated by Barbara Thompson. London: Phaidon.

———. 1975. *Art from Zaire/L'art du Zaire: 100 Masterworks from the Institute of the National Museums of Zaire (INMZ)*. New York: African-American Institute.

———. 1982. *Art Royal Kuba*. Milan: Sipiel.

Crédit Communal de Belgique. 1971. *Art africain—Art moderne*. Brussels: Crédit Communal de Belgique, Centre Cultural.

———. 1977. *Arts premiers d'Afrique noire*. Brussels: Crédit Communal de Belgique, Centre Cultural.

Crowley, Daniel J. 1973. "Aesthetic Value and Professionalism in African Art: Three Cases of Katanga Chokwe." In *The Traditional Artist in African Societies*, edited by Warren L. d'Azevedo. Bloomington: Indiana University Press.

Crownover, David. 1960. "The Pink People." *Expedition* 2 (3): 33–35.

Cunard, Nancy, ed. [1934] 1969. *Negro: An Anthology*. New York: Negro Universities Press.

Curnow, Kathy. 1983. *The Afro-Portuguese Ivories: Classification and Stylistic Analysis of a Hybrid Art Form*. Ph.D. diss., 2 vols., Indiana University, Bloomington. Ann Arbor, Michigan: University Microfilms International.

Darish, Patricia J. 1987. "African Art at the Indiana University Art Museum." *African Arts* 20 (3): 30–41.

Dark, Philip J. C. 1973. *An Introduction to Benin Art and Technology*. Oxford: Clarendon.

Davidson, Basil. 1967. *The Growth of African Civilisation: East and Central Africa to the Late Nineteenth Century*. London: Longmans.

d'Azevedo, Warren L. 1962. "Common Principles of Variant Kinship Structures among the Gola of Western Liberia." *American Anthropologist* 64 (3, pt. 1): 504–20.

———. 1973a. "Sources of Gola Artistry." In *The Traditional Artist in African Societies*, edited by Warren L. d'Azevedo. Bloomington: Indiana University Press.

———. 1973b. "Mask Makers and Myth in Western Liberia." In *Primitive Art and Society*, edited by Anthony Forge. London: Oxford University Press for the Wenner-Gren Foundation for Anthropological Research.

de Brazza, Pierre Savorgnan. 1887. "Voyages dans l'ouest africain." *Le tour du monde*. Paris: Hachette.

de Grunne, Bernard. 1980. *Terres cuites anciennes de l'ouest africain/Ancient Terracottas from West Africa*. Louvain-La-Neuve, Belgium: Institut Supérieur d'Archéologie et d'Histoire d'Art.

de Heusch, Luc. 1947–50. "Les institutions, la religion et l'art des buye: Groupes ba sumba du ma nyema." *Ethnographie* 45: 54–80.

de Kun, N. 1979. "L'art boyo." *Africa-Tervuren* 25:29–44.

Delange, Jacqueline. 1965. "Un kuduo exceptional." *Objets et mondes* 5 (Autumn): 197–204.

———. 1967. *Arts et peuples de l'Afrique noire*. Paris: Gallimard.

———. 1974. *The Art and Peoples of Black Africa*. Translated by Carol F. Jopling. New York: Dutton.

DeMott, Barbara. 1982. *Dogon Masks: A Structural Study of Form and Meaning*. Ann Arbor: University of Michigan Research Press.

de Oliveira, Ernesto Veiga. 1985. *Escultura africana em Portugal*. Lisbon: Instituto de Investigação Cientifica Tropical, Museu de Etnologia.

de Sousberghe, Leon. 1958. *L'art pende*. Brussels: Académie royale de Belgique.

Detroit Institute of Arts. 1970. *The Robert Hudson Tannahill Bequest*. Detroit: Detroit Institute of Arts.

———. 1971. *A Check List of African Art in the Permanent Collection of The Detroit Institute of Arts*. Detroit: Detroit Institute of Arts.

———. 1977. *Detroit Collects African Art*. Detroit: Detroit Institute of Arts.

———. 1985. *100 Masterworks from the Detroit Institute of Arts*. New York: Hudson Hills.

Dieterlen, Germaine. 1957. "The Mande Creation Myth." *Africa* 27 (2): 124–38.

Dixon, Roland B. 1928. *The Building of Cultures*. New York: Scribner.

Dräyer, Walter. 1962. *Nigeria: 2000 Jahre afrikanische Plastik*. Munich: Piper.

Drewal, Henry J. 1977. *Traditional Art of the Nigerian Peoples: The Milton D. Ratner Family Collection*. Washington, D.C.: Museum of African Art.

———. 1978. "Art and the Perception of Women in Yoruba Culture." *Cahiers d'études africaines* 68 (XVII-4): 545–67.

———. 1984. "Art, History, and the Individual: A New Perspective for the Study of African Visual Traditions." In *Iowa Studies in African Art*, vol. 1, edited by Christopher D. Roy. Iowa City: School of Art and Art History, University of Iowa.

Duerden, Dennis. 1968. *African Art*. London: Hamlyn.

Ebohon, Osemwegie. 1972. *Cultural Heritage of Benin*. Benin City, Nigeria: Midwest Newspaper Corporation.

Egharevba, Jacob. [1934] 1960. *A Short History of Benin*. 3d ed. Ibadan, Nigeria: Ibadan University Press.

Ehrlich, Martha. 1976. *A Catalogue of Art Taken from Kumasi in the Anglo-Ashanti War of 1874*. Ph.D. diss., 2 vols., Indiana University, Bloomington. Ann Arbor, Michigan: University Microfilms International.

Einstein, Carl. 1915. *Negerplastik*. Leipzig: Verlag der Weissen Bücher.

Elisofon, Eliot. [1958] 1978. *The Sculpture of Africa.* Reprint. New York: Hacker.

Encyclopedia of World Art. 1971. Vol. 8. New York: McGraw-Hill.

"Exhibition of African Art, February 6–March 6." 1955. *Bulletin* (Allen Memorial Art Museum) 13:63–155.

"Expositions." 1980. *Arts d'Afrique noire,* 35:30–35.

Eyo, Ekpo, and Frank Willett. 1980. *Treasures of Ancient Nigeria.* New York: Knopf in association with Detroit Institute of Arts.

Ezra, Kate. 1984. *African Ivories.* New York: Metropolitan Museum of Art.

———. 1986. *A Human Ideal in African Art: Bamana Figurative Sculpture.* Washington, D.C.: Smithsonian Institution Press for the National Museum of African Art.

Fage, J. D. 1969. *A History of West Africa.* 4th ed. London: Cambridge University Press.

Fagg, Bernard. 1977. *Nok Terracottas.* Lagos: Ethnographica for the National Museum.

Fagg, William B. 1961. *Nigeria: 2000 Jahre Plastik.* Munich: Stadtische Galerie München.

———. 1963. *Nigerian Images; The Splendor of African Sculpture.* New York: Praeger.

———. 1964. *Afrique: Cent tribus, cent chefs-d'oeuvre.* Paris: Congrès pour la Liberté de la Culture.

———. 1965. *Tribes and Forms in African Art.* New York: Tudor.

———. 1969. *African Sculpture.* Washington, D.C.: International Exhibitions Foundation.

———. 1970a. *Divine Kingship in Africa.* London: British Museum.

———. 1970b. *The Tribal Image.* London: British Museum.

———. 1973. *The Webster Plass Collection of African Art.* London: Trustees of the British Museum.

———. 1978. *Divine Kingship in Africa.* 2d ed. London: Published for the British Museum by British Museum Publications.

———. 1981a. "Benin: The Sack That Never Was." In *Images of Power: Art of the Royal Court of Benin,* edited by Flora S. Kaplan. New York: New York University, Gray Art Gallery.

———. 1981b. *African Majesty: From Grassland and Forest.* The Barbara and Murray Frum Collection. Introduction by Alan G. Wilkinson. Toronto: Art Gallery of Ontario.

Fagg, William, and John Pemberton. 1982. *Yoruba Sculpture of West Africa,* edited by Bryce Holcombe. New York: Knopf.

Fagg, William, and Margaret Plass. 1964. *African Sculpture: An Anthology.* London: Studio Vista.

Faris, James C. 1978. "The Productive Basis of Aesthetic Traditions: Some African Examples." In *Art and Society,* edited by Michael Greenhalgh and Vincent Megaw. New York: St. Martin.

Felix, Marc Leo. 1986. Personal communication to author (Roslyn A. Walker).

Fernandez, James W. 1966. "Principles of Opposition and Vitality in Fang Aesthetics." *The Journal of Aesthetics and Art Criticism* 25 (1): 53–64.

Fischer, Eberhard, and Hans Himmelheber. 1984. *The Arts of the Dan in West Africa.* Translated by Ann Bundle. Zurich: Museum Rietberg.

Fischer, Eberhard, and Lorenz Homberger. 1986. *Masks in Guro Culture, Ivory Coast.* Translated by

Gornelia Lauf and Andrea Isler. New York: Center for African Art; Zurich: Museum Rietberg.

Flam, J. D. 1970. "Some Aspects of Style Symbolism in Sudanese Sculpture." *Journal de la société des africanistes* 40 (2): 137–50.

Fleming, S. 1979. "Of Igueghae and the Iguneromwen." *MASCA Journal* 1 (2): 48–49.

"Forehead of the Dead." 1984. *Arts* 7 (4): 20–21.

Forman, Werner, Bedrich Forman, and Philip Dark. 1960. *Benin Art.* London: Hamlyn.

Fourquet, André. 1982. "Chefs-d'oeuvre d'Afrique: Les masques pounou." *L'Oeil,* 321:52–57.

Fraser, Douglas, and Herbert M. Cole, eds. 1972. *African Art and Leadership.* Madison: University of Wisconsin Press.

Freeman, Richard Austin. 1898. *Travels and Life in Ashanti and Jaman.* Westminster, England: Archibald Constable.

Freyer, Bryna. 1974. "Male/Female." In *African Art as Philosophy,* edited by Douglas Fraser. New York: Interbook.

Fried, Martha, and Morton H. Fried. 1980. *Transition: Four Rituals in Eight Cultures.* New York: Norton.

Froger, François. 1698. *Relation d'un voyage fait en 1695, 1696 et 1697 au côtes d'Afrique.* Paris: Dans l'Isle du Palais et chez M. Brunet.

Fröhlich, Willy. 1966. *Beitrage zur Afrikanischen Kunst.* Cologne: Brill.

Fry, Jacqueline, ed. 1978. *Vingt-cinq sculptures africaines.* Ottawa: National Gallery of Canada.

Fry, Philip. 1970. "Essai sur la statuaire mumuye." *Objets et mondes* 10 (Spring): 3–28.

Garrard, Timothy F. 1980. *Brass in Akan Society to the Nineteenth Century.* Master's thesis, Department of Archaeology, University of Ghana.

Geertruyen, G. van. 1976. "La fonction de la sculpture dans une société africaine, Baga, Nalu-Landuman." *Africana Gandensia,* n.g., no. 1:63–117.

———. 1979. "Le style nimba." *Arts d'Afrique noire,* no. 31:20–39.

Gennep, Arnold van. [1908] 1960. *The Rites of Passage.* Translated by Monika B. Visedom and Gabrielle L. Caffee. Chicago: Unversity of Chicago Press.

Gilfoy, Peggy Stoltz. 1976. *African Art from the Harrison Eiteljorg Collection.* Indianapolis: Indianapolis Museum of Art.

Gillon, Werner. 1979. *Collecting African Art.* London: Studio Vista and Christie's.

———. 1984. *A Short History of African Art.* New York: Facts on File.

Glaze, Anita J. 1981. *Art and Death in a Senufo Village.* Bloomington: Indiana University Press.

———. n.d. (c. 1983). "The Children of Poro: A Reexamination of the Rhythm Pounder in Senufo Art, Its Form and Meaning." *Connaissance des arts tribaux bulletin* (20).

Goldwater, Robert. 1960. *Bambara Sculpture from the Western Sudan.* New York: University Publishers for the Museum of Primitive Art.

———. 1964. *Senufo Sculpture in West Africa.* Greenwich, Connecticut: New York Graphic Society for the Museum of Primitive Art.

Griaule, Marcel. [1938] 1963. *Masques dogons.* 2d ed. Paris: Institut d'ethnologie.

———. [1948] 1970. *Conversations with Ogotemmêli.* Translation of *Dieu d'eau: Entretiens avec*

Ogotemmêli. New York: Oxford University Press.

Griaule, Marcel, and Germaine Dieterlen. 1965. *Le renard pâle.* Paris: Travaux et mémoires de l'institut d'ethnologie.

Guenther, Mathias G. 1976. "From Hunters to Squatters: Social and Cultural Change among the Farm San of Ghanzi, Botswana." In *Kalahari Hunter-Gatherers, Studies of the !Kung San and their Neighbors,* edited by Richard B. Lee and Irven De Vore. Cambridge: Harvard University Press.

Guidoni, Enrico. 1978. *Primitive Architecture.* Translated by Robert Erich Wolf. New York: Abrams.

Guimiot, Philippe. 1975. *Afrikaanse Beeldhouwkunst Nieuw Zicht op een Erfgoed/Sculptures africaines nouveau regard sur un héritage.* Brussels: Guimiot.

Hambly, Wilfrid D. 1930. "Use of Tobacco in Africa." In *Tobacco and Its Use in Africa,* by Berthold Laufer, Wilfrid D. Hambly, and Ralph Linton. Field Museum of Natural History, Department of Anthropology Leaflet no. 29. Chicago.

———. 1931. *Serpent Worship in Africa.* Anthropological Series, vol. 21, no. 1. Chicago: Field Museum of Natural History.

Harley, George W. [1941a] 1970. *Native African Medicine.* Reprint. London: Cass.

———. [1941b] 1974. *Notes on the Poro in Liberia.* Reprint. Cambridge, Massachusetts: Kraus.

———. [1950] 1975. *Masks as Agents of Social Control.* Reprint. Millwood, New York: Kraus.

Harter, Pierre. 1969. "Four Bamileke Masks: An Attempt to Identify the Style of Individual Carvers or Their Workshops." *Man,* n.s. 4 (3): 410–18.

———. 1972. "Les masques dits 'Batcham.'" *Arts d'Afrique noire,* no. 3:18–45.

———. 1986. *Art ancien du Cameroun.* Arnouville, France: Arts d'Afrique noire.

Henry, Paul Marc. 1965. *Africa Aeterna.* Translated by Joel Carmichael. Lausanne: Bernier.

Herreman, Frank. 1985. *De Wenteling om de Aslijn: Mummuye, Beeldhouwwerken uit Nigeria.* Waasmunster, Belgium: Gallery of the Academy.

Hersey, Irwin. 1976. "Women in African Art Exposition au New York's African American Institute." *Arts d'Afrique noire,* no. 20:41–42.

Hertz, Robert. [1907–9] 1960. *Death and the Right Hand.* Translated by Rodney Needham and Claudia Needham. New York: Free Press of Glencoe.

Hodgkin, Thomas. 1975. *Nigerian Perspectives.* 2d ed. London: Oxford University Press.

Holý, Ladislav. 1967. *Masks and Figures from Eastern and Southern Africa.* Translated by Tim Gottheiner. London: Hamlyn.

Homberger, Lorenz. 1986. Letter to author (Roslyn A. Walker). July 23.

Home, Robert. 1982. *City of Blood Revisited.* London: Collings.

Horton, Robert. 1965. *Kalabari Sculpture.* Lagos: Department of Antiquities.

Huet, Michel. 1963. *Afrique, africaine.* Lausanne: Clairefontaine.

———. 1978. *The Dance, Art and Ritual of Africa.* New York: Pantheon Books.

Huntington, Richard, and Peter Metcalf. 1979. *Celebrations of Death: The Anthropology of*

Mortuary Ritual. New York: Cambridge University Press.

Huntington, W. R. 1973. "Death and the Social Order: Bara Funeral Customs (Madagascar)." *African Studies* 32:65–84.

Idiens, Dale. 1980. "African Art at the Royal Scottish Museum." *African Arts* 13 (3): 34–37.

Imperato, Pascal James. n.d. *Dogon Cliff Dwellers: The Art of Mali's Mountain People.* New York: L. Kahan Gallery.

Indiana University Art Museum. 1980. *Guide to the Collections.* Bloomington: Indiana University Art Museum.

Irstam, Tor. 1944. *The King of Ganda.* Statens Etnografiska Museum. Publication 8. Lund, Sweden: Ohlssons.

Jacob, Alain, and Aexel de Heeckeren. 1977. *Poteries, ivoires de l'Afrique noire.* Paris: ABC Décor.

Jones, G. I. 1984. *The Art of Eastern Nigeria.* Cambridge: Cambridge University Press.

Kan, Michael. 1977. "Detroit Collects African Art." *African Arts* 10 (4): 24–31.

Kaplan, Flora S., ed. 1981. *Images of Power: Art of the Royal Court of Benin.* New York: New York University Press, Gray Art Gallery.

Karpinski, Peter. 1984. "A Benin Bronze Horseman at the Merseyside County Museum." *African Arts* 17 (1): 54–62, 88–89.

Kauenhoven-Janzen, Reinhild. 1981. "Chokwe Thrones," *African Arts* 14 (3): 69–74, 92.

Kecskési, Maria. 1980. "African Art at the Staatliches Museum für Völkerkunde, Munich." *African Arts* 14 (1): 32–41.

———. 1982. *Kunst aus dem Alten Afrika.* Innsbruck: Penguin.

———. 1986. *African Masterpieces and Selected Works from Munich: the Staatliches Museum für Völkerkunde.* Translation of *Kunst aus dem Alten Afrika.* New York: Center for African Art.

Kerchache, Jacques. 1982. *Chefs-d'oeuvre de l'art africain.* Grenoble: Musée de Grenoble.

Kingsley, Mary H. 1897. *Travels in West Africa: Congo français, Corisco and Cameroons.* London: Macmillan.

Kirshenblatt-Gimblett, Barbara. 1982. "The Cut That Binds." In *Celebration: Studies in Festivity and Ritual,* edited by Victor Turner. Washington, D.C.: Smithsonian Institution Press.

Kjersmeier, Carl. [1935–38] 1967. *Centres de style de la sculpture nègre africaine.* Translated by France Gleizal. Reprint (4 vols. in 1). New York: Hacker.

Knops, P. 1956. "Contribution a l'étude des senoufo de la Côte d'Ivoire et du Soudan." *Bulletin de la société royale belge d'anthropologie et de préhistoire,* no. 67:141–68.

Kochnitzky, Leon. 1952. *Negro Art in Belgian Congo.* 3d ed., rev. New York: Belgian Government Information Center.

Kunst og Kunstindustrie fra Belgisk Kongo. 1956. Oslo: Kunstindustrimuseet i Oslo.

Kyerematen, A. A. Y. 1964. *Panoply of Ghana.* New York Praeger.

Laman, Karl. 1957. *The Kongo.* Vol. 2. Uppsala: Studia Ethnographica Upsalienia.

Lambo, Adeoye T. 1964. "Patterns of Psychiatric Care in Developing Countries." In *Magic, Faith, and Healing: Studies in Primitive Psychiatry Today,* edited by Ari Kiev. New York: Free Press of Glencoe.

Lamp, Frederick. "The Art of the Baga: A Preliminary Inquiry." *African Arts* 19 (2): 64–67, 92.

Laude, Jean. 1973. *African Art of the Dogon.* New York: A Studio Book, Brooklyn Museum in association with Viking Press.

———. 1980. *Esprits et dieux d'Afrique: Musée National Message Biblique Marc Chagall, Nice.* Paris: Réunion des musées nationaux.

Lecoq, Raymond. 1953. *Les bamileke.* Paris: Editions africaines.

Lee, Richard B. 1979. *The !Kung San.* Cambridge: Cambridge University Press.

Lehuard, Raoul. 1978a. "La collection Marc Ginzberg." *Arts d'Afrique noire,* no. 25:5–10.

———. 1978b. "The Brooklyn Museum." *Arts d'Afrique noire,* no. 26:8–12.

———. 1980. "La collection Vranken-Hoet." *Arts d'Afrique noire,* no. 34:49–51.

———. 1981. "Un test au C. 14: Lorsque la technique vient au secours du coup d'oeil." *Arts d'Afrique noire,* no. 38:6–7.

———. 1984. "Primitivism in Twentieth Century Art." *Arts d'Afrique noire,* no. 52: 9–17.

Leiris, Michel, and Jacqueline Delange. 1968. *African Art.* Translated by Michael Ross. New York: Golden Press.

Leuzinger, Elsy. 1960. *Africa: The Art of the Negro Peoples.* New York: McGraw-Hill.

———. 1963. *Afrikanische Skulpturen/African Sculpture: A Descriptive Catalogue.* Translated by Ann E. Keep. Zurich: Atlantis.

———. 1967. *Africa: The Art of the Negro Peoples.* Translated by Ann E. Keep. 2d ed. New York: Crown.

———. 1972. *The Art of Black Africa.* London: Studio Vista.

———. 1977. *The Art of Black Africa.* New York: Rizzoli.

Lewis, I. M. 1966. "Introduction." In *Islam in Tropical Africa: Studies Presented and Discussed at the Fifth International African Seminar, Ahmadu Bello University, Zaire, January 1964,* edited by I. M. Lewis. London: Oxford University Press for the International African Institute.

Linden-Museum Stuttgart. 1973. *Bilder des Menschen in fremden Kulturen.* Stuttgart: Linden-Museum.

———. 1982. *Ferne Völker, Frühe Zeiten.* 2 vols. Recklinghausen: Aurel Bongers.

Luschan, Felix von. [1919] 1968. *Die Altertümer von Benin.* Reprint (3 vols. in 1). New York: Hacker.

McClelland, Elizabeth M. 1982. *The Cult of Ifa among the Yoruba.* London: Ethnographica.

MacGaffey, Wyatt. 1977. "Fetishism Revisited: Kongo *Nkisi* in Sociological Perspective." *Africa* 47 (2): 172–84.

Mack, John. 1981. "Animal Representations in Kuba Art: An Anthropological Interpretation of Sculpture." *Oxford Art Journal* 4 (2): 50–56.

———. 1986a. "In Search of the Abstract." *Hall* 8 (3): 26–33.

———. 1986b. *Madagascar: Island of the Ancestors.* London: British Museum Publications.

McLeod, Malcolm. 1979. "Three Important Royal Kuduo." In *Akan-Asante Studies.* British Museum Occasional Papers, 3. London.

———. 1980. *Treasures of African Art.* New York: Abbeville Press.

———. 1981a. *The Asante.* London: British Museum Publications.

———. 1981b. Letters dated 9/4/80 and 9/23/80 in Collections Division files, Virginia Museum of Fine Arts, Richmond.

McLeod, Malcolm, and John Mack. 1985. *Ethnic Sculpture.* London: British Museum Publications.

Maes, J. [1937] 1979. "Sculpture décorative ou symbolique des instruments de musique du Congo Belge." *Artes africanae,* 8. Reprint. Nendeln, Liechtenstein: Kraus.

Maesen, Albert. 1960a. *Umbangu: Art du Congo au Musée royal du Congo Belge.* Brussels: Musée du Congo Belge.

———. 1960b. *Kunst fra Kongo.* Copenhagen: Kunstforening Lynby.

———. 1982. "Statuaire et culte de fécondité chez le luluwa du Kasai (Zaire)." *Quaderini poro,* no. 3:49–50.

Maesen, Albert, and S. Kooyman. 1960. *Vorm en Kleur.* Otterlo, Netherlands: Rijksmuseum Kroler-Muller.

Maquet, Jacques. 1974a. "Wisdom." In *Dictionary of Black African Civilization,* edited by Georges Balandier and Jacques Maquet. Translated by Lady (Mariska Caroline) Peck, Bettina Wadia, and Peninah Neimark. New York: Amiel.

———. 1974b. "Death." In *Dictionary of Black African Civilization,* edited by Georges Balandier and Jacques Maquet. Translated by Lady (Mariska Caroline) Peck, Bettina Wadia, and Peninah Neimark. New York: Amiel.

———. 1974c. "Balega." In *Dictionary of Black African Civilization,* edited by Georges Balandier and Jacques Maquet. Translated by Lady (Mariska Caroline) Peck, Bettina Wadia, and Peninah Neimark. New York: Amiel.

Mark, Peter. 1985. *A Cultural, Economic, and Religious History of the Basse Casamance since 1500.* Stuttgart: F. Steiner.

Martin, Phyllis, and Patrick O'Meara. 1977. *Africa.* Bloomington: Indiana University Press.

The Mask. 1956. Antwerp.

Mason, Lesa A. 1986. "The Chokwe Chief's Chair in the Indiana University Museum of Art." Typescript.

La maternité dans les arts premiers. 1977. Brussels: Fondation pour la Recherche en Endocrinologie Sexuelle et l'Etude de la Reproduction Humaine.

Maurer, Evan M., and Allen F. Roberts. 1985. *Tabwa: The Rising of the New Moon; A Century of Tabwa Art.* Ann Arbor: University of Michigan Museum of Art.

Mbiti, John S. 1969. *African Religions and Philosophy.* New York: Praeger.

Meauzé, Pierre. 1968. *African Art.* Cleveland: World.

Mercier, Paul. 1974a. "Funerals." In *Dictionary of Black African Civilization,* edited by Georges Balandier and Jacques Maquet. Translated by Lady (Mariska Caroline) Peck, Bettina Wadia, and Peninah Neimark. New York: Amiel.

———. 1974b. "Religion." In *Dictionary of Black African Civilization,* edited by Georges Balandier and Jacques Maquet. Translated by Lady (Mariska Caroline) Peck, Bettina Wadia, and Peninah Neimark. New York: Amiel.

———. 1974c. "Ashanti." In *Dictionary of Black African Civilization,* edited by Georges Balandier and Jacques Maquet. Translated by Lady (Mariska

Caroline) Peck, Bettina Wadia, and Peninah Neimark. New York: Amiel.

Metropolitan Museum of Art. 1969. *Art of Oceania, Africa, and the Americas from the Museum of Primitive Art.* New York: Metropolitan Museum of Art.

Meyer, Piet. 1981a. "Art et religion des lobi." *Arts d'Afrique noire*, no. 39:19–22.

————. 1981b. *Kunst und Religion der Lobi.* Zurich: Museum Rietberg.

Meyerhoff, Barbara. 1982. "Rites of Passage: Process and Paradox." In *Celebration: Studies in Festivity and Ritual*, edited by Victor Turner. Washington, D.C.: Smithsonian Institution Press.

The Minneapolis Institute of Arts. 1986. *The Art of Collecting: Acquisitions at the Minneapolis Institute of Arts 1980–1985.* Edited by Louise Lincoln and Elisabeth Sövik. Minneapolis: Minneapolis Institute of Arts.

Monteiro, Joachim John. 1875. *Angola and the River Congo.* London: Macmillan.

Mount, Sigrid Docken. 1980. "African Art at the Cincinnati Art Museum." *African Arts* 13 (4): 40–46, 88.

Murdock, George P. 1959. *Africa: Its Peoples and Their Culture History.* New York: McGraw-Hill.

Musée royal de l'Afrique Centrale. 1959. *Arte del Congo.* Rome: De Luca.

Museu de Etnologia do Ultramar. 1968. *Escultura africana no Museu Etnologia do Ultramar.* Lisbon: Junta de Investigações do Ultramar.

————. 1972. *Peoples and Cultures.* Lisbon: Junta de Investigações do Ultramar.

The Museum of Primitive Art. 1960. *The Raymond Wielgus Collection.* New York: Museum of Primitive Art.

————. 1967. *Masks and Sculptures from the Collection of Gustave and Franyo Schindler.* Greenwich, Connecticut: New York Graphic Society.

————. 1973. *Robert Goldwater: A Memorial Exhibition.* New York: Museum of Primitive Art.

————. 1974. *Primitive Art Masterworks.* New York: American Federation of Arts.

Ndambi Munamuhega. 1975. *Les masques pende de Ngudi.* Bandudu, Zaire: Ceeba.

Nevadomsky, Joseph. 1986. "The Benin Horseman as the Ata of Idah." *African Arts* 19 (4): 40–47, 85.

New, Charles. 1971. *Life, Wanderings, and Labours in Eastern Africa.* London: Cass.

New Bulletin (Algeria). 1969. 3 (May): 8.

Neyt, François. 1977. *La grande statuaire hemba du Zaire.* Louvain-la-Neuve, Belgium: Institut supérieur d'archéologie et d'histoire de l'art.

————. 1979. *L'Art eket: Collection Azar.* Paris: Abeille International.

————. 1981. *Arts traditionnels et histoire du Zaire/ Traditional Arts and History of Zaire.* Brussels: Société d'arts primitifs.

————. 1985. *The Arts of the Benue: To the Roots of Tradition, Nigeria.* Assisted by Andrée Désirant. N.p.: Editions Hawaiian Agronomics.

Northern, Tamara. 1971. "The African Collection at the Museum of Primitive Art." *African Arts* 5 (1): 20–27.

————. 1984. *The Art of Cameroon.* Washington, D.C.: Smithsonian Institution Traveling Exhibition Service.

Oberlé, Philippe. 1979. *Provinces malgaches.* Riedisheim, France: Kintana.

Odita, E. Okechukwu. 1978. *Traditional African Art.* Columbus: Ohio State University.

Olbrechts, Frans M. 1946. *Plasteik van Kongo.* Antwerpen: Uitgeversmij. N.V. Standaard-Boekhandel.

Opoku, Kofi Asare. 1982. "The World View of the Akan." *Tarikh* 7 (2): 61–73.

Paris. Musée de l'Orangerie. 1972. *Sculptures africaines dans les collections publiques français.* Paris: Editions des musées nationaux.

Parke-Bernet Galleries. 1943. *Paintings, Sculptures, Drawings and Lithographs by Modern French Artists and . . . Collection of Frank Crowninshield.* Auction catalogue, dates of sale October 20 and 21, 1943. New York: Parke-Bernet Galleries.

————. 1967. *African, Oceanic, American Indian, Pacific North Coast and Pre-Columbian Art: Duplicates from the Collection of Governor Nelson A. Rockefeller and the Museum of Primitive Art.* Auction catalogue, date of sale May 4, 1967. New York: Parke-Bernet Galleries.

Parkin, David. 1986. "The Society of Culture of the Mijikenda." In *Vigango: Commemorative Sculpture of the Mijikenda of Kenya*, by Ernie Wolfe. Williamstown, Massachusetts: Williams College Museum of Art.

Parrinder, Geoffrey. 1954. *African Traditional Religions.* London: Hutchinson's University Library.

————. 1967. *African Mythology.* London: Hamlyn.

————. 1985. *World Religions.* New York: Facts on File.

Paulme, Denise A. 1956. *Les sculptures de l'Afrique noire.* Paris: Presses universitaires de France.

————. 1959. "Elek, a Ritual Sculpture of the Baga of French Guinea." *Man* 59 (article 28): 28–29.

————. 1962. *African Sculpture.* Translated by Michael Ross. New York: Viking.

————. 1974a. "Art African." In *Dictionary of Black African Civilization*, edited by Georges Balandier and Jacques Maquet. Translated by Lady (Mariska Caroline) Peck, Bettina Wadia, and Peninah Neimark. New York: Amiel.

————. 1974b. "Senufo." In *Dictionary of Black African Civilization*, edited by Georges Balandier and Jacques Maquet. Translated by Lady (Mariska Caroline) Peck, Bettina Wadia, and Peninah Neimark. New York: Amiel.

Perrois, Louis. 1972. *La statuaire fan, Gabon.* Paris: O.R.S.T.O.M.

————. 1979. *Arts du Gabon.* Arnouville, France: Arts d'Afrique noire.

————. 1985. *Ancestral Arts of Gabon: From the Collections of the Barbier-Mueller Museum.* Translated by Francine Farr. Geneva: Barbier-Mueller Museum.

Phillips, Ruth B. 1978. "Masking in Mende Sande Society Initiation Rituals." *Africa* 48 (3): 265–77.

Pickett, Elliot. 1974. "L'art africain congloméré." Translated by Raoul Lehuard. *Arts d'Afrique noire*, no. 10:14–41.

Pigafetta, Filippo. [1881] 1970. *A Report of the Kingdom of Congo.* Translated by Margarite Hutchinson. Reprint. London: Cass.

Plass, Margaret. 1956. *African Tribal Sculpture.* Philadelphia: University Museum.

————. 1959. *The African Image.* Toledo: Toledo Museum of Art.

Portier, André, and François Poncetton. n.d. (c. 1930). *Les arts sauvages: Afrique.* Paris: Albert Morancé.

Powell, Richard J. 1984. "African and Afro-American Art: Call and Response." *Field Museum of Natural History Bulletin.* 55 (5): 5–25.

————. 1985. "African Art at the Field Museum." *African Arts* 28 (2): 24–36, 103.

Poynor, Robin E. 1978. *The Ancestral Arts of Owo, Nigeria.* Ph.D. diss., 2 vols., Indiana University, Bloomington. Ann Arbor, Michigan: University Microfilms International.

Preston, George Nelson. 1985. *Sets, Series and Ensembles in African Art.* Introduction by Susan Vogel and catalogue by Polly Nooter. New York: Abrams for the Center for African Art.

Prince, Raymond. 1964. "Indigenous Yoruba Psychiatry." In *Magic, Faith, and Healing: Studies in Primitive Psychiatry Today*, edited by Ari Kiev. New York: Free Press of Glencoe.

Problèmes d'Afrique Centrale. 1959. No. 44: front cover.

Purdue University, Department of Creative Arts. 1974. *Interaction: The Art Styles of the Benue River Valley and East Nigeria.* Introduction by Roy Sieber and catalogue by Tony Vevers. Lafayette, Indiana: Purdue University.

Pye, Michael. 1987. "Whose Art Is It, Anyway?" *Connoisseur* 217 (902): 78–85.

Radin, Paul, and James J. Sweeney. 1952. *African Folktales and Sculpture.* New York: Bollingen Foundation.

Rattray, Robert S. 1927. *Religion and Art in Ashanti.* Oxford: Clarendon.

Ravenhill, Philip L. 1980. *Baule Statuary Art: Meaning and Modernization.* Philadelphia: Institute for the Study for Human Issues.

"The Raymond Wielgus Collection." 1973. *African Arts* 6 (2): 50–58.

Read, Charles H., and O. M. Dalton. 1899. *Antiquities from the City of Benin and from Other Parts of West Africa in the British Museum.* London: British Museum.

Robbins, Warren M. 1966. *African Art in American Collections.* New York: Praeger.

Roosens, Eugeen. 1967. *Images africaines de la mère et l'enfant.* Louvain, Belgium: Editions Nauwelaerts.

Rosenwald, Jean B. 1974. "Kuba King Figures." *African Arts* 7 (3): 26–31, 92.

Ross, Doran H. 1981. "Comments" dated 3/24/81 in Collections Divisions files, Virginia Museum of Fine Arts, Richmond.

Roth, H. Ling. [1903] 1972. *Great Benin: Its Customs, Art, and Horrors.* Reprint. Northbrook, Illinois: Metro Books.

Rousseau, Madeline. 1948. "Découverte de l'Afrique ancienne." *Le musée vivant*, nos. 36–37:7.

Royal Scottish Museum. 1971. *Traditional African Sculpture.* Text by Dale Idiens. Edinburgh: Howie and Seath.

Rubin, Arnold G. 1969. *The Arts of the Jukun Speaking People of Northern Nigeria.* Ph.D. diss., Indiana University, Bloomington. Ann Arbor, Michigan: University Microfilms International.

Rubin, William, ed. 1984. *"Primitivism" in 20th Century Art*. 2 vols. New York: Museum of Modern Art.

Sadler, Michael E. 1935. *Arts of West Africa*. London: Oxford University Press for the International Institute of African Languages and Cultures.

Sarpong, Peter. 1971. *The Sacred Stools of the Akan*. Accra: Ghana Publishing.

Schneider, Harold K. 1956. "The Interpretation of Pakot Visual Art." *Man* 56 (article 108): 103–6.

Schweinfurth, Georg August. 1874. *The Heart of Africa*. Translated by Ellen F. Frewer. New York: Harper.

———. 1875. *Artes Africanae*. Leipzig: Brockhaus.

"Sculptural Arts of Tribal Africa." 1957. *Think* (June): 17–19.

Seattle Art Museum. 1984. *Praise Poems: The Katherine White Collection*. Seattle: Seattle Art Museum.

Segy, Ladislas. 1976. *Masks of Black Africa*. New York: Dover.

Shaw, Thurstan. 1970. *Igbo-Ukwu: An Account of Archaeological Discoveries in Eastern Nigeria*. 2 vols. Evanston: Northwestern University Press.

———. 1978. *Nigeria: Its Archaeology and Early History*. London: Thames and Hudson.

Sheppard, William. 1893. "Into the Heart of Africa." *Southern Workman* 22:182–87.

———. 1921. "African Handicrafts and Superstitions." *Southern Workman* 1:401–8.

Sieber, Roy. 1956. *African Sculpture*. Iowa City: 18th Annual Fine Arts Festival, School of Fine Arts, State University of Iowa.

———. 1961. *Sculpture of Northern Nigeria*. New York: Museum of Primitive Art.

———. 1967. "Islamic Characters in Akan Metalwork." Paper presented at meeting of the African Studies Association, New York.

———. 1973. "Approaches to 'Non-Western Art.'" In *The Traditional Artist in African Societies*, edited by Warren L. d'Azevedo. Bloomington: Indiana University Press.

———. 1980. *African Furniture and Household Objects*. Bloomington: Indiana University Press.

———. 1986. "A Note on History and Style." In *Vigango: Commemorative Sculpture of the Mijikenda of Kenya*, by Ernie Wolfe. Williamstown, Massachusetts: Williams College Museum of Art.

Sieber, Roy, Douglas Newton, and Michael Coe. 1986. *African, Pacific and Pre-Columbian Art*. Bloomington: Indiana University Art Museum in association with Indiana University Press.

Silverman, Raymond A. 1983a. *History, Art and Assimilation: The Impact of Islam on Akan Material Culture*. Ph.D. diss., University of Washington, Seattle. Ann Arbor, Michigan: University Microfilms International.

———. 1983b. "Akan Kuduo: Form and Function." In *Akan Transformations: Problems in Ghanaian Art History*, edited by Doran H. Ross and Timothy F. Garrard. Los Angeles: UCLA Museum of Cultural History.

Siroto, Leon. 1953. "A Note on Guro Statues." *Man* 53 (article 24): 17–18.

———. 1968. "Face of the Bwiiti." *African Arts* 1 (3): 22–89, 96.

———. 1979a. "Witchcraft Belief in the Explanation of Traditional African Iconography." In *The Visual Arts: Plastic and Graphic*, edited by Justine Cordwell. New York: Mouton.

———. 1979b. "A Kigangu Figure from Kenya." *Detroit Institute of Arts Bulletin* 57 (3): 105–13.

Smith, Fred T. 1979. *Gurensi Architectural Decoration in Northeastern Ghana*. Ph.D. diss., Indiana University, Bloomington. Ann Arbor, Michigan: University Microfilms International.

Sotheby's. 1956. *Catalogue of the Property of Mrs. Webster Plass*. Auction catalogue, date of sale November 19, 1956. London: Sotheby's.

———. 1961. *Catalogue of African Sculpture, Pre-Columbian Gold Ornaments, and North-West American Art*. Auction catalogue, date of sale November 20, 1961. London: Sotheby's.

———. 1962. *Catalogue of African, American, Oceanic and Indian Art*. Auction catalogue, date of sale November 26, 1962. London: Sotheby's.

———. 1983a. *Prince Sadruddin Aga Khan Collection of African Art*. Auction catalogue, date of sale June 29, 1983. London: Sotheby Parke Bernet.

———. 1983b. *The Ben Heller Collection*. Auction catalogue, date of sale December 1, 1983. New York: Sotheby Parke Bernet.

Stössel, Arnulf. 1984. *Afrikanische Keramik*. Munich: Hirmer.

Sydow, Eckart von. 1930. *Handbuch der Afrikanischen Plastik*. Vol. 1, *Die Westafricanische Plastik*. Berlin: Reimer.

———. 1954. *Afrikanische Plastik*. New York: Wittenborn.

Talbot, P. Amaury. [1926] 1969. *The Peoples of Southern Nigeria*. Vol. 2. Reprint. London: Cass.

———. [1932] 1967. *Tribes of the Niger Delta*. Reprint. London: Cass.

Teilhet, Jehanne, ed. 1970. *Dimensions of Black*. La Jolla, California: Museum of Art.

Tentoonstelling van Kongo-Kunst. 1937. Exhibition catalogue. Antwerp: Antwerpasche Propagandawekan.

Thompson, Robert Farris. 1968. "Esthetics in Traditional Africa." *Art News* 66 (9): 44–45, 63–66.

———. 1973. "Yoruba Artistic Criticism." In *The Traditional Artist in African Societies*, edited by Warren L. d'Azevedo. Bloomington: Indiana University Press.

———. 1974. *African Art in Motion*. Washington, D.C.: National Gallery of Art.

———. 1978. "The Grand Detroit N'Kondi." *Bulletin of the Detroit Institute of Arts* 56 (4): 207–21.

———. 1985. "Le Grand N'kondi de Detroit." *Arts d'Afrique noire*, no. 56:17–26.

Tiabas, H. B. 1978. "Masques en pays guere." *Annales de l'université d'Abidjan* (Abidjan), Serie G: ethno-sociologie, 7:85–90.

Torday, Emil. 1925. *On the Trail of the Bushongo*. London: Seeley and Service.

Torday, Emil, and Thomas A. Joyce. 1910. *Notes ethnographies sur les peuples communément appelés bakuba, ainsi que sur les peuplades apparentées, les bushongo*. Brussels: Ministère des Colonies.

Trimingham, J. Spencer. 1965. *Islam in the Sudan*. New York: Barnes and Noble.

Trowell, Margaret. 1964. *Classical African Sculpture*. New York: Praeger.

Trowell, Margaret, and Hans Nevermann. 1968. *African and Oceanic Art*. New York: Abrams.

Tschudi, Jolantha. 1969–70. "The Social Life of the Afo, Hill Country of Nsarawa, Nigeria." *African Notes* (University of Ibadan, Nigeria) 6 (1): 87–99.

Tunis, Irwin. 1979. "Cast Benin Equestrian Statuary." *Baessler Archiv*, n.f. 23:389–417.

Turner, Victor W. 1967. *The Forest of Symbols: Aspects of Ndembu Ritual*. Ithaca: Cornell University Press.

———. 1969. *The Ritual Process*. Chicago: Aldine.

———. 1977. *The Ritual Process: Structure and Anti-Structure*. Ithaca: Cornell University Press.

———. 1982a. "Introduction to the Exhibition." In *Celebration: A World of Art and Ritual*. Washington, D.C.: Smithsonian Institution Press.

———. 1982b. "Introduction." In *Celebration: Studies in Festivity and Ritual*, edited by Victor Turner. Washington, D.C.: Smithsonian Institution Press.

Turner, Victor, and Edith Turner. 1982. "Religious Celebrations." In *Celebration: Studies in Festivity and Ritual*, edited by Victor Turner. Washington, D.C.: Smithsonian Institution Press.

Ulmer Museum. n.d. (c. 1985). "Die 'Kunstkammer' des Christoph Weickmann." Gallery guide. Ulm: Ulmer Museum.

Underwood, Leon. 1947. *Figures in Wood of West Africa*. London: Tiranti.

———. 1949. *Bronzes of West Africa*. London: Tiranti.

———. 1952. *Masks of West Africa*. London: Tiranti.

University of California. Los Angeles Museum and Laboratory. 1968. *Ralph C. Altman Memorial Exhibition*. Los Angeles.

University Prints. n.d. (c. 1968). *African Art*. Series N, section I, by Paul Wingert. Cambridge: University Prints.

Vansina, Jan. 1964. *Le royaume kuba*. Tervuren: Musée royal de l'Afrique Centrale.

———. 1972. "Ndop: Royal Statues among the Kuba." In *African Art and Leadership*, edited by Douglas Fraser and Herbert M. Cole. Madison: University of Wisconsin Press.

———. 1983. "The History of God among the Kuba." *Africa* 38 (1): 17–40.

———. 1984. *Art History in Africa*. London: Longman.

Verly, Robert. 1955. "La statuaire de pierre du Bas-Congo (Bamboma-Mussurongo)." *Zaire* 9 (3): 451–528.

Vogel, Susan M. 1980. *Beauty in the Eyes of the Baule: Aesthetics and Cultural Values*. Philadelphia: Institute for the Study of Human Issues.

———. 1984. "The Question of Regional Styles in Baule Sculpture." In *Iowa Studies in African Art*, vol. 1, edited by Christopher D. Roy. Iowa City: School of Art and Art History, University of Iowa.

———. 1985. *African Aesthetics: The Carlo Monzino Collection*. Venice: Abbazia di S. Gregorio.

———, ed. 1981. *For Spirits and Kings*. New York: Metropolitan Museum of Art.

Vogel, Susan, and Francine N'Diaye. 1985. *African Masterpieces from the Musée de l'Homme*. New York: Center for African Art and Abrams.

Vowles, Valerie. 1981. "African Art at the Horniman Museum, London." *African Arts* 14 (3): 66–68.

Walker, Roslyn Adele. 1976. *African Women/African Art*. New York: African-American Institute.
———. 1983. *African Art in Color*. Washington, D.C.: National Museum of African Art, Smithsonian Institution.
Walker Art Center. 1967. *Art of the Congo*. Minneapolis: Walker Art Center.
Wannyn, Robert L. 1961. *L'art ancien du métal au Bas Congo*. Champles par Wavre, Belgium: Editions du vieux planquesaule.
Warner, W. L. [1959] 1975. *The Living and the Dead*. Reprint. Westport, Connecticut: Greenwood Press.
Warren, Dennis Michael. 1974. *Disease, Medicine, and Religion among the Techiman-Bone of Ghana: A Study in Culture Change*. Ph.D. diss., Indiana University, Bloomington. Ann Arbor, Michigan: University Microfilms International.
Warren, Dennis Michael, and Kweku J. Andrews. 1977. *An Ethnoscientific Approach to Akan Arts and Aesthetics*. Philadelphia: Institute for the Study of Human Issues.
Wassing, René. 1968. *African Art: Its Background and Traditions*. New York: Abrams.

Webster, Hutton. [1908] 1932. *Primitive Secret Societies*. 2d ed., rev. New York: Macmillan.
———. 1942. *Taboo: A Sociological Study*. Stanford: Stanford University Press.
Wells, Louis T. 1977. "The Harley Masks of Northeast Liberia." *African Arts* 10 (2): 22–27, 91.
Weule, Karl. 1909. *Native Life in East Africa*. Translated by Alice Werner. New York: Appleton.
Willett, Frank. 1971. *African Art*. New York: Praeger.
———. 1985. *African Art*. New York: Thames and Hudson.
Williams, Sylvia H. 1980. "African Art at The Brooklyn Museum." *African Arts* 13 (2): 42–52, 88.
Wilson, Monica. 1954. "Nyakyusa Ritual and Symbolism." *American Anthropologist* 56 (April): 228–41.
Wingert, Paul S. 1948. *African Negro Sculpture*. San Francisco: M. H. De Young Memorial Museum.
———. 1950. *The Sculpture of Negro Africa*. New York: Columbia University Press.
———. 1962. *Primitive Art: Its Traditions and Styles*. New York: Oxford University Press.

Wittmer, Marciline K. 1973. *Images of Authority: From Benin to Gabon*. Miami: Lowe Art Museum, University of Miami.
Wixom, William D. 1961. "Two African Sculptures." *The Bulletin of the Cleveland Museum of Art* 68 (March): 39–45.
———. 1977. "African Art in the Cleveland Museum of Art." *African Arts* 10 (3): 14–25.
Woodward, Richard B. 1985. "The Pre-Columbian and African Collections." *Apollo* 122 (286): 480–83.
———. 1987. "African Art at the Virginia Museum of Fine Arts." *African Arts* 20 (2): 28–34.
The World and Its Peoples: Africa South and West. 1967. 2 vols. New York: Greystone Press.
World Festival of Negro Arts. 1967. *Premier festival mondial des arts nègres*. Paris: Bouchet-Lakara.
Zahan, Dominique. 1974. *The Bambara*. Leiden: Brill.
Zaslavsky, Claudia. 1973. *Africa Counts*. Boston: Prindle, Weber and Schmidt.
Zimmermann, Karl. 1914. *Die Grenzgebiete Kameruns im Süden und Osten*. 2 vols. Mitteilungen aus den Deutschen Schutzgebieten, 9a and 9b. Berlin.

PHOTOGRAPH CREDITS

AFRICAN ART IN THE CYCLE OF LIFE

Designed by Christopher Jones

Typeset in Sabon with display lines in Kabel
by York Graphic Services in York, Pennsylvania

Printed on Warren Cameo Dull
by LaVigne Press in Worcester, Massachusetts